THINGS
AMERICAN

THE ARTS AND INTELLECTUAL LIFE
IN MODERN AMERICA

Casey Nelson Blake, Series Editor

Volumes in the series explore questions at the intersection of
the history of expressive culture and the history of ideas in
modern America. The series is meant as a bold intervention
in two fields of cultural inquiry. It challenges scholars in
American studies and cultural studies to move beyond
sociological categories of analysis to consider the ideas that
have informed and given form to artistic expression—whether
architecture and the visual arts or music, dance, theater, and
literature. The series also expands the domain of intellectual
history by examining how artistic works, and aesthetic
experience more generally, participate in the discussion of
truth and value, civic purpose and personal meaning that
have engaged scholars since the late nineteenth century.

THINGS
AMERICAN

Art Museums and Civic Culture
in the Progressive Era

JEFFREY TRASK

PENN

UNIVERSITY OF PENNSYLVANIA PRESS

PHILADELPHIA

Published by
University of Pennsylvania Press
Philadelphia, Pennsylvania 19104-4112
www.upenn.edu/pennpress

Printed in the United States of America on acid-free paper

10 9 8 7 6 5 4 3 2 1

Library of Congress Cataloging-in-Publication Data
Trask, Jeffrey.
Things American : art museums and civic culture in the Progressive
Era / Jeffrey Trask. — 1st ed.
 p. cm. — (The arts and intellectual life in modern America)
Includes bibliographical references and index.
ISBN 978-0-8122-4362-8 (hardcover : alk. paper)
1. Art museums—Social aspects—United States. 2. Art museums
and community—United States. 3. Art and society—United
States—History—19th century. 4. Art and society—United States—
History—20th century. 5. Metropolitan Museum of Art (New
York, N.Y.)—History. I. Title. II. Series: Arts and intellectual life in
modern America.
N510.T73 2012
708.1309—dc22
 2011016849

For F. V.

CONTENTS

ILLUSTRATIONS

INTRODUCTION

Museums and Society

In the early twentieth century a new generation of museum reformers ushered in an institutional revolution that redefined the relationship between art, museums and industrial urban society in the United States. Determined to overturn the image of museums as elite storehouses of art, those curators and administrators developed a progressive museum agenda that linked art and beauty to citizenship. Combining the era's impulses for civic and urban reform with new professional standards and a commitment to democratic access, they turned art museums into modern, efficient educational institutions in service to the people. At the center of this movement for museum reform stood the Metropolitan Museum of Art. Frequently seen as a bastion of elite cultural values and social exclusion, the Met presented itself as a model for new ideas about cultural democracy during the Progressive Era. While hardly alone in the movement for making museums more useful and accessible, the Metropolitan nonetheless stood apart because of its dominant economic and cultural position in the United States.

I call this generation of museum reformers who led the movement for more democratic museums *progressive connoisseurs*. Instead of seeing art museums as rarified institutions that preserved the sacred status of art, progressive connoisseurs established museum standards that introduced modern, bureaucratic business management and practical education programs that could produce measurable results, similar to other Progressive Era social reform. They integrated museums into the larger social reform movement because they recognized the important role the arts played in the health of the nation. Whereas an earlier generation of cultural leaders and philanthropists had believed that art could lift up the poor by providing civilizing influences, progressive connoisseurs insisted that American citizens had a civic right to beauty and tasteful surroundings. And they insisted that better cities and

better homes could assist people in becoming better citizens. For progressive connoisseurs like Metropolitan trustee Robert de Forest and museum administrator Henry Watson Kent, the alliance of art and industry stood at the cutting edge of museum reform. They thus turned to collections of decorative arts to implement their ideas about cultural democracy, and they used the Metropolitan's position of authority to advance a cultural agenda tied to the display and promotion of American art and design.

For reformers like de Forest and Kent, collections of decorative arts—the everyday things in people's homes—represented opportunities to both democratize museum collections (by expanding the art museum canon from the fine arts of paintings and sculpture) and to democratize the museum experience by presenting objects that could be used to teach practical skills of design and workmanship. Because progressive connoisseurs saw tasteful home environments as centers for the formation of good citizens, they argued that museums should use decorative art collections to improve public taste and enhance individual civic capacity. Reformers hoped decorative arts would seem more accessible to a broader public of potential museum visitors. But progressive connoisseurs also recognized the economic advantages of improving American design and the aesthetic quality of American industrial production. Thus, part of the progressive museum agenda involved linking museums more explicitly to American economic production and consumer capitalism.

Among progressive connoisseurs, Met trustee Robert de Forest was perhaps the most influential figure, and he took the lead in integrating the Metropolitan Museum into the Progressive Era reform movement. Frequently called New York's "first citizen," de Forest built local and national networks of social and cultural institutions dedicated to civic reform and cultural democracy. De Forest sat on the boards of multiple philanthropic organizations, chaired city commissions, and led national social-reform and cultural institutions. But the thread that tied all of his civic engagements together was his commitment to improving American cities, and his belief in the union of social and aesthetic reform. De Forest applied social-scientific theories of environmental determinism to older nineteenth-century ideas of moral uplift because he believed that improving the physical condition of industrial cities would enable people to improve their lives and become better citizens. By improving the quality of American industrial production, he hoped both to give American consumers better choices for their homes and to make American industry more competitive on an international market.

After the founding generation of Met trustees retired in 1905, de Forest and Kent recruited a staff of new professionals to the museum and brought together an expansive network of collectors, curators, businessmen, philanthropists and social reformers. Through institutional collaboration and the migration of professionals, their ideas about democratic museums spread to other museums across the nation. De Forest set the cultural agenda at the Met, while he used the American Federation of Arts and the Sage Foundation to replicate its programs for expanding access to art in almost every industrial city in the United States. While modernizing the Met's infrastructure, Kent pioneered new professional standards for museums and disseminated them through the professional publications and national associations he helped to found. Moreover, Kent and other museum reformers at the Met trained a generation of new professionals in the teens and twenties who then went on to implement a progressive cultural agenda in art museums from Cleveland and Detroit to Pittsburgh and Philadelphia. "The phrase 'Art for Art's sake,'" Kent proudly declared by 1922, "has no place in a healthy republic." "Art for the People's sake is the motto of the American museum today." "Art for the enjoyment, for the study, and for the profit of the people," Kent insisted, "is the cornerstone of the museum edifice, the object of its collecting, exhibition, and demonstration."[1]

Debates about the civic role of museums—whether museums should serve primarily as places to preserve the sacred status of fine art and reify cultural capital or as institutions to promote social cohesion through democratic programming and educational outreach—continue to this day. That these debates continue, along with the conviction that museums have only recently begun to grapple with them, underscores how completely the progressive museum agenda has dropped out of institutional and historical memory. Historians continue to see art museums as spiritual temples filled with treasures that reinforce cultural and social exclusion, and they see museum leaders as custodians of culture who fear industrial modernization. Museums of all types—art, anthropology and natural history—tend to be treated as agents of social control that incongruously both promote hegemonic messages about the progress of civilization to the masses, and at the same time restrict their galleries to elite patrons.[2]

Things American challenges such interpretations by looking to the people who themselves challenged what they considered to be old-fashioned, undemocratic policies of cultural restriction. Following the Metropolitan Museum's lead in the early twentieth century, progressive connoisseurs built

professional networks to expand museum audiences and disseminate ideas and images to promote American things. Indeed, it is the early twentieth-century focus on things—decorative objects for the home—that set the progressive museum agenda apart from visions of the museum as a place for uplifting ideas about the sacred status of fine art and the reification of cultural capital. Museum reformers across the nation teamed up with housing advocates and city planners, they borrowed education theories from European museums and research universities, and they tried to make American art museums laboratories for the improvement of public taste. Reaching far beyond museum galleries, they developed education programs that used objects from the past as models for modern industrial design. Rather than restricting knowledge about the cultivation of taste, progressive connoisseurs tried to democratize taste by presenting a diverse array of objects and using those objects to teach a broad public of museum visitors the principles of design, through examples in the everyday objects of domestic life.

Today the innovations that progressive connoisseurs made in museum policies of access, education and display hardly seem radical, but they nevertheless represented a significant rejection of many of the ideals upon which art museums had been founded in the nineteenth century. The museum had always been a product of industrial capitalism, from the origin of endowment funds to the bequest of collections, and ideas about the civilizing influence of cultural institutions informed the founding of many museums in the 1870s, alongside parks, libraries and theaters.[3] Most nineteenth-century Americans would have understood that the golden age of museum building had been a reaction to industrial modernization. In 1870, at the very moment postwar American industrialization took off, New York's civic and industrial elite founded the Metropolitan Museum and the American Museum of Natural History, while Boston Brahmans founded the Museum of Fine Arts. Philadelphia and Chicago later opened their own art museums following the world's fairs of 1876 and 1893.[4] All these institutions pursued nineteenth-century ideas of moral uplift linked to art, but the Metropolitan Museum most personified the social anxieties that accompanied industrialization, and the supposed balms that a museum could provide.

Nineteenth-century connoisseurs and taste critics had created a declension narrative of American art and design that linked industrialization to bad design and cultural insecurity. The decline in American taste, many critics feared, coincided with urbanization, sliding public morals and the dramatic social changes of industrialization. Machine production allowed manufac-

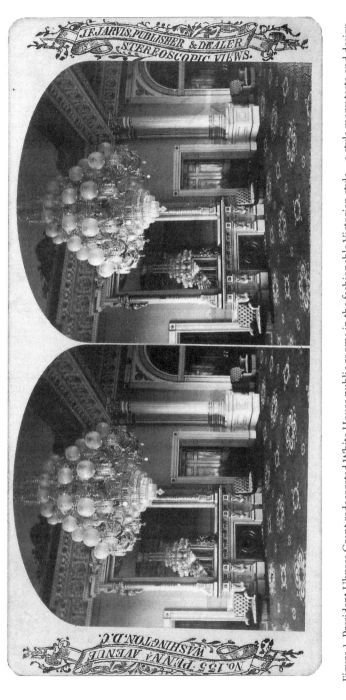

Figure 1. President Ulysses Grant redecorated White House public rooms in the fashionable Victorian style—a style many taste and design critics of the era found objectionable enough that they began referring to machine-made Victorian furnishings as "General Grant Gothic." East Room of the White House, 1874. Photographer: John F. Jarvis. Robert N. Dennis Collection of Stereoscopic Views, Miriam and Ira D. Wallach Division of Art, Prints and Photographs, The New York Public Library, Astor, Lenox and Tilden Foundations.

turers to churn out elaborately carved and ornamented decoration on everything from chairs and candlesticks to rugs and dishes and mantelpieces. Styles of ornament could be changed with the adjustment of machine parts, so consumers could choose between Etruscan, Rococo, Medieval and Spanish Renaissance-influenced objects. The speed at which objects and styles could be made, and the apparent consumer appetite for new and unusual designs, led to interior fashions that changed almost annually. After Ulysses Grant redecorated the East Room of the White House, critics derided Gilded Age interiors as "General Grant Gothic."

Once factory-produced Victorian furnishings hit the market, self-appointed taste experts and critics began issuing jeremiads and treatises to halt the further decline of public taste. Writers Clarence Cook and Charles Eastlake flooded popular magazines and decorating manuals with advice for uneducated consumers, while intellectuals like Matthew Arnold and Charles Eliot Norton articulated complementary definitions of art and culture that exalted the cultural production of established masters (whether painting, literature or music) to an almost sacred status, thus setting art and ideas about high culture apart from everyday life.[5] In contrast to the confusion and ugliness of industrial cities, art museums offered to nineteenth-century cultural critics the best examples of human creative capacity. Their spiritual elevation of art reinforced the conception of museums as sacred temples of culture.

Compounding the crisis, Americans in the nineteenth century felt acutely insecure about their nation's art and culture because they assumed that the United States had no established traditions. Instead of collecting American art, museum founders stocked their galleries with classical and European art in the hope that it would have a trickle-down influence on national artistic production. One patron declared in 1869 at the first organizational meeting to found the Metropolitan Museum: "In the year 1776, this nation declared her political independence of Europe." "The provincial relationship was then severed as regards politics." "May we not now," he patriotically implored, "begin institutions that by the year 1876 shall sever the provincial relation of America to Europe in respect to art?"[6]

The belief among museum founders and cultural critics that paintings and sculpture in museums would lead to better design in American factories and workshops followed the teachings of the British art and social critic John Ruskin. Ruskin had studied medieval architecture, and he saw in the work of its artisans a simplicity and purity that he argued resulted from their intimate knowledge of craft traditions and their personal commitment to the products

of their labor. Ruskin also linked good art and design to ideals of moral and artistic uplift, but he argued that modern craftsmen had lost sight of those ideals when machines and factories replaced artisanal guilds.

The international stage of world's fairs seemed to reinforce the arguments that linked industrialization to bad national design. Unlike French craftsmen, who maintained relative autonomy through the nineteenth century, both British and American producers had all but eliminated older craft traditions in their embrace of factory work, which critics blamed for the inferiority of British and American design. Ruskin and his admirers like Arnold and Norton argued that industrialization had severed the link between art and labor, so they turned to models for design reform that would once again fuse artistic knowledge and craft production. British arts and crafts reformer William Morris borrowed Ruskin's philosophy and implemented artistic and social reform through communal craft associations and emphasis on hand-crafted production. At the South Kensington Museum in London, Henry Cole also tried to implement Ruskinian reforms, but he did so by integrating craft techniques and principles of design into machine production. Cole used examples of British handicraft and folk art in the galleries of the South Kensington to teach students in his industrial art schools, in order to improve the quality of British industrial production.[7]

The South Kensington model of allying art and industry strongly influenced American design reformers and art museums. In fact, most art museums in the United States had included education goals similar to those of the South Kensington in their missions when they were founded in the 1870s. Museums in New York, Boston and Philadelphia all opened schools for craftsmen, but they kept students physically separate from museum galleries, and they restricted public access through policies that limited gallery hours in favor of elite audiences. The determination among museum trustees to protect their museums from commercial interests and the taint of industrial society thwarted efforts at design reform throughout the nineteenth century. Calls to improve American cultural production continued into the twentieth century, but as long as museums positioned themselves against industrialization, they continued to have minimal effect on public taste. This failure on the part of museums to improve American taste and design had to do, in large measure, with the profound fear and distrust most cultural leaders in the nineteenth century had of the public. But the failures of nineteenth-century museum education programs also reflected bourgeois anxieties about protecting art museums from the crass influences of commercialism. Beginning in the 1890s,

however, a new generation of progressive connoisseurs emerged in museums to challenge ideas of moral and artistic uplift and policies of exclusion.

The New Generation

Progressive connoisseurs, along with a contemporary generation of young intellectuals and cultural critics, rejected what many called the "genteel tradition" or the "cult of the best," as espoused by Ruskin, Arnold and Norton. This new generation of progressive intellectuals debated the contours of what cultural democracy would look like in the twentieth century and, in the process, articulated an entirely different relationship between art, labor and society. For many progressives, modernity offered the opportunity to throw aside many of the traditions that Arnold and Norton had defended. Unlike earlier critics, young intellectuals like Randolph Bourne and Lewis Mumford did not see industrialization and urbanization in stark opposition to social progress, nor did they see a need to separate cultural practices from industrial life. Instead they challenged exclusive canons that separated art and culture from everyday life, and they called for more fluid definitions of American taste and identity that incorporated multiple perspectives, which they felt more accurately reflected American society. Rather than setting art—or good design for that matter—aside for elite consumption, social theorists like John Dewey and Thorstein Veblen called for greater integration of art and labor that could link aesthetic appreciation to everyday activities. Progressive connoisseurs responded to these cultural debates by expanding museum canons to include decorative arts, and by arguing that museums should pursue pragmatic educational programs that could have a measurable impact on modern American design and taste.[8]

In addition to their engagement with intellectuals like Mumford and Bourne, Robert de Forest, Henry Kent and other progressive connoisseurs in museums also worked with and were influenced by social reformers more recognizable to us today as Progressives, such as Jane Addams, Lawrence Veiller, Mary Simkhovitch and Theodore Roosevelt. Indeed, ideas about cultural democracy and education reform in museums developed alongside similar shifts in other civic institutions in the last decade of the nineteenth century. By the 1890s, progressive reformers were looking for answers to social problems that stepped beyond moral uplift, and instead tried to confront social inequalities. Social reformers responded to these problems by attending international housing and public-welfare conferences, studying

new pedagogical methods in cultural and educational institutions, taking courses at new German research universities, and forging social and educational theories that they could implement in schools, settlement houses and social-service institutions in American cities.[9] Cultural reformers like de Forest also saw museums as quintessentially urban institutions, so they studied European models of museum reform to implement in American cities as they integrated museums into the larger network of public-service institutions.

What distinguished progressive connoisseurs from more radical intellectuals like Lewis Mumford and Randolph Bourne, and from later cultural reformers in the 1930s and '40s, was their insistence on defining a distinctly American style, and their adherence to traditions of connoisseurship that they believed art museums needed to uphold. The progressive museum agenda never entailed a salvage mission. Art museums never tried to document all of the American past, nor did they collect examples of vernacular craft traditions. Rather, they collected and presented examples of American craft that could be attributed to master craftsmen—whether in the past or the present. Museums pursued their ideals of cultural democracy by using those objects to influence the production of mass-produced modern American things, and by encouraging broadly defined audiences to consider museums places of their own. During the teens and early twenties, progressive connoisseurs popularized the colonial revival aesthetic, but by the late twenties functional modernism offered a new civic aesthetic that stood in tension with "old things." Both of these aesthetic movements encouraged museums and cultural policy makers in the 1930s: the Museum of Modern Art took over the institutional role of promoting modern design, while the Federal Art Project and other New Deal programs further expanded definitions of American aesthetics through documentation projects like the Historic American Buildings Survey and the Index of American Design.[10] One of the central questions of this book is how the tension between old things and social and aesthetic modernism in the 1920s influenced ideas about art, labor and democracy for the twentieth century.

Progressive connoisseurs negotiated these tensions between modern social philosophies and older tradition-bound ideas and cultural practices. They embraced bureaucratic modernism, pragmatic educational theory, and inclusive, democratic ideas about social protections and housing, while simultaneously hanging on to sometimes quite conservative notions regarding social relations of deference and liberal economic conceptions of industrial capitalism, which reveal the nineteenth-century roots of their social and

educational backgrounds. Progressive connoisseurs like Robert de Forest aligned themselves with social reformers like settlement leader Jane Addams to improve the built environment of homes and cities, and they encouraged the preservation and cultivation of immigrant craft and aesthetic traditions as a means of integrating new Americans into civil society. But the wide umbrella of progressive politics brought together advocates for cultural nationalism from multiple social perspectives that often fused selective interpretations of the colonial revival with more inclusive definitions of American taste and identity.

Like the larger progressive movement, progressive connoisseurs often pursued paradoxical goals, and they came to reform with contradictory motivations. A cultural leader like Robert de Forest, for example, was also a captain of industry and a member of New York's patrician elite, whereas his assistant Henry Watson Kent came from a middle-class background, with professional training in library science. De Forest's ideas about cultural democracy were always tinged with nineteenth-century vestiges of noblesse oblige, but he also responded to a broader philosophical commitment to improving civic landscapes for social betterment. De Forest thus pursued programs for civic improvement that reached far beyond museum galleries. Kent, on the other hand, came to institutional reform with a more specific commitment to improving American industrial production and making galleries "work" for the public. Kent also used his position in a prominent museum like the Metropolitan to increase his own stature within networks of antique collectors, who themselves wanted to increase the value of their collections. Unlike many of those collectors, however, Kent and de Forest hoped that decorative arts could be used to teach good design to craftsmen, both to improve American cultural production and to improve the material conditions of working Americans by offering them marketable skills. Just as the larger progressive movement embraced individuals as diverse as Theodore Roosevelt, Woodrow Wilson and Jane Addams, the movement for cultural democracy in museums frequently meant many different things for the various progressive connoisseurs who came together to revolutionize the relationship between museums and society.

Thus American art museums in the early twentieth century became crucibles for competing ideas about Americanization, industrial education, connoisseurship and consumer capitalism. Linking social and aesthetic goals through a focus on American decorative arts produced paradoxical results, in which contradictory definitions of social democracy and American identity

were pitted against one another. Museum reformers tried to provide aesthetic models to improve objects for the domestic realm because they believed that ordered, tasteful homes were central to citizenship. By reaching out to public schools to teach future citizens, and by coordinating with manufacturers during World War I to improve the quality of objects available to household consumers, they tried to make museum galleries useful for a large museum audience. Drawing from the educational theories of John Dewey, they offered museum galleries as laboratories for craftsmen and designers to study principles of good design, to improve the quality of American industrial production. To provide models of tasteful American things, museum educators and curators turned to older American craft traditions, and they teamed up with collectors in the emerging field of American antiques. Collectors of old American things, however, frequently had more conservative ideas about American identity and cultural politics. Their influence on decisions about what to collect in art museums, and how to interpret them to the public, had profound effects on the way the public history of the United States would be told. Period rooms of colonial and early republic American interiors ultimately defined a narrative of elite American history that most museums, historical societies and historic houses reproduced through the twentieth century.

The colonial revival inadvertently narrowed definitions of American taste in the 1920s, and it shifted programs for the education of civic taste away from making better citizens in favor of encouraging the American public to make better consumer choices. After World War I, progressive calls for cultural nationalism and the improvement of American industrial production also shifted, from training craftsmen to improve the material and cultural opportunities for working Americans to making American industry more competitive in international markets. Postwar attitudes of social conservatism and enthusiastic consumerism also placed museum programs for the promotion of American things in opposition with one another: on the one hand, art museums teamed up with Americana collectors to build colonial-revival period rooms; on the other, they also collaborated with industrial manufacturers and department stores to cultivate a modern American industrial design aesthetic. The Metropolitan Museum, for example, opened the American Wing of colonial-revival period rooms in 1924, while it also presented annual exhibitions of modern mass-produced industrial objects that promoters hoped would lead to a new modern American style in design. The tensions between aesthetic modernism and colonial-revival taste in the 1920s

illustrate the paradoxical nature of early twentieth century education reform in American museums, and the impossibility of simplifying its history. Progressive connoisseurs like de Forest promoted bureaucratic modernization, and the aesthetics of industrial modernism that could be mass produced, but they remained leery of what they considered avant-garde aesthetic movements such as cubist, abstract, and social-realist modernism in paintings and sculpture. Like other early twentieth-century intellectuals, museum leaders chose selective examples of a usable past to work out what twentieth-century modernity would mean, what it would look like, and what kind of modern society they wanted to safeguard.

CHAPTER ONE

Progressive Connoisseurs

The Intellectual Origins of Education
Reform in Museums

In 1889, the Metropolitan Museum of Art moved toward a more democratic relationship with the people of New York City as it tried to become an accessible educational institution. The museum doubled its size by expanding into a new building wing, and its board of trustees both elected a new president and started to bring in a new generation of museum leaders who would soon change the relationship between museums and their urban publics. Their leader was Robert de Forest. De Forest marshaled other younger trustees to help bring the museum up to date with other cultural institutions that had recently implemented European-influenced education reforms. In the 1890s, de Forest recruited museum professionals such as Henry Watson Kent, a curator and librarian at the Slater Museum, and Edward Robinson, a Boston Museum of Fine Arts curator, to revise and enlarge the Metropolitan's collection of plaster cast reproductions, which were used to teach history and appreciation of classical art. During the last decade of the nineteenth century, these professionals and other younger trustees were referred to by many of the Metropolitan's founders as the "de Forest faction." They challenged older trustees over free public access on Sundays, over the educational value of plaster-of-Paris reproductions of sculpture, and over the management of the museum—issues that cut to the heart of the founders' institutional philosophy.

The progressive connoisseurs who emerged in the 1890s saw museums as quintessentially urban institutions, so like their peers in social reform, they studied new European models to implement in American cities. Rather than simply emulate European palaces of art by stocking their galleries with mas-

terpieces, progressive connoisseurs instead looked for practical education programs that could produce measurable results. The two most influential models for museum reform in the late nineteenth century were the museums under the direction of Wilhelm Bode in Berlin, and the South Kensington Museum in London. Bode had been reorganizing Berlin's museums into a complex of educational institutions, admired for their systematic art-historical methods of exhibition and their comprehensive study collections of plaster-cast reproductions of classical and Renaissance sculpture. The South Kensington Museum in London allied art and industry by presenting collections of decorative and industrial arts—everyday products of industrial production—to teach British craftsmen the principles of good design. In the United States these two models, study collections of plaster casts and industrial arts, emerged as the most innovative educational movements in museums during the late nineteenth century.

Debates about cultural democracy in late nineteenth-century museums centered not only on concerns about access to galleries, but also on questions about the relationship between educational utility and traditions of connoisseurship. Progressive connoisseurs like Robert de Forest, Henry Watson Kent and Edward Robinson rejected the image of museums as temples of high culture, and instead worked to make them practical educational institutions. But their ideas about public access and the value of teaching collections created friction with older museum leaders, who had founded American art museums as places for moral uplift and the refining influence of fine art. Therefore, their interventions into museum management remained small-scale through the last decade of the nineteenth century. While these progressive connoisseurs awaited the moment when they could implement large-scale changes to museums like the Metropolitan, they spent the 1890s experimenting with institutional collaboration and working out their ideas of education reform, by opening access to museums, building teaching collections of plaster casts, and introducing study collections of industrial arts.

De Forest Comes to the Met

Robert de Forest joined the Metropolitan Museum's board during a moment characterized by both institutional growth and uncertainty about the future direction of the museum. De Forest's father-in-law, John Taylor Johnston, had just retired from his position as the museum's first president, and his

departure suggested the beginning of the end of an era at the museum, when trustees had struggled to keep the museum open while they put it and their city on the cultural map. During the Metropolitan's early years, trustees had difficulty raising funds, so they engaged directly in much of the museum's hands-on management, such as unpacking and hanging art and personally supervising galleries. By 1889, however, the Met had started to build an impressive endowment, and it had begun accumulating important collections of European masterpieces and classical antiquities. The Metropolitan's expanding collections and its increasing stature as a cultural institution provided the opportunity to negotiate with the city to add a new wing that doubled the museum's size, but these developments also raised questions about the future mission of the museum.

Robert de Forest's election to the Metropolitan's board of trustees in 1889 seemed to symbolize many of the possibilities for institutional change. Descendant of an old New York shipping family, married to Johnston's daughter Emily, and a successful corporate lawyer and owner of railroads, de Forest represented both the traditions of old New York and the modern impulses of the industrial era. De Forest had gone to Yale and Columbia, and had studied new scientific philosophies at the University of Bonn, which he implemented in both his business and philanthropic institutions. In 1888, he became president of the Charity Organization Society, which was formed to coordinate existing relief agencies more effectively; and he would later lead city and state tenement house commissions set up to improve public housing.[1] As a new trustee at the Metropolitan, de Forest tried to refine the museum's management the way he ran his business and philanthropic activities. Instead of the hands-on stewardship of the museum that founding trustees like his father-in-law had provided, de Forest delegated authority to experts who could more efficiently and systematically present museum collections to the people. In the process, de Forest and other new members of the board pushed the Metropolitan to be more responsive to public educational needs and more accountable to New York citizens, who paid for the museum's upkeep with their tax dollars.

The Metropolitan's new 1889 wing offered New Yorkers the promise of a world-class art museum, but it also revealed to many critics how far the museum still needed to go before it could be considered either useful to a broad public, or capable of putting New York prominently on the cultural map. The new wing not only doubled the amount of exhibition space, but for many critics it improved the public face of the museum—a consider-

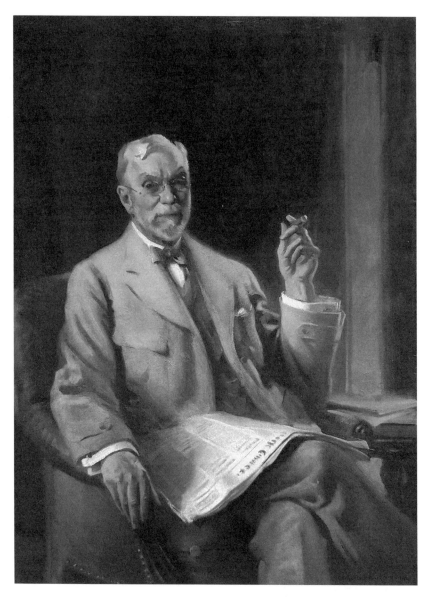

Figure 2. John C. Johansen's depiction of de Forest as a gentle, fatherly figure belies the power he wielded in cultural, political, economic and social institutions in New York City in the early twentieth century. This understated representation nonetheless reflects the way de Forest chose to see himself and the way he hoped his many professional associates and subordinates would see him. John C. Johansen, portrait of Robert W. de Forest, 1931. The Metropolitan Museum of Art, Gift of the Trustees of the Museum, 1931 (31.36). Image © The Metropolitan Museum of Art.

ation not immaterial for an institution that professed to cultivate public taste. The 1889 wing obscured the original red-brick museum building by shifting visitors' focus to a grand entrance at the new building's neoclassical façade. Popular writer Ripley Hitchcock considered the museum's new façade "a vast improvement upon the original hideous structure."[2] Hitchcock was certainly not alone in criticizing the Metropolitan's original 1880 building in Central Park—built in the stark barn-like style known as Ruskin Gothic, and always meant to serve as a nucleus for future museum wings, the building never had the Beaux-Arts pretensions that many New Yorkers wanted. Hitchcock called it a "casket" that he thought "stood naked and ashamed in all its dreary ugliness."[3] In contrast, the new 1889 wing offered a suitably imposing entrance, with grand stairs and arched entry bays. Museum visitors now moved through galleries that presented an abbreviated history of art, from ancient Egyptian and Assyrian antiquities on the first floor through old-master and modern nineteenth-century paintings on the second floor. Improved by recent donations, the Metropolitan's collection nevertheless revealed significant gaps in its history of art, and many critics argued that it represented the interests of individual donors rather than a systematic strategy of collecting.[4] Hitchcock charged that the Metropolitan had "chosen to cover a broad field imperfectly rather than to begin by perfecting a few departments of direct usefulness."[5] Further, the museum's management and the judgment of its leaders increasingly came under question through a series of public scandals over the authenticity and restoration of items in the collections. Critics especially targeted objects at the Met originally collected by the museum's flamboyant director Louis di Cesnola. Frequent museum critic Mrs. Schuyler Van Rensselaer seemed to sum up public disappointment when she expressed the hope that "at some not distant day the institution may be not only a storehouse of beautiful or instructive objects, but a museum in the strictest and most scientific acceptation of the term."[6] Hitchcock agreed that the Metropolitan Museum was "lamentably deficient" in presenting the usefulness of its collections.[7]

The museum's new wing also provided critics of the Metropolitan's policies of access the opportunity to demand that the museum open to the public on Sundays. The new wing gave city officials bargaining power over museum policy, because municipal funds had paid for the new building and also doubled the amount of public park land the museum now occupied. When J. Hampden Robb, president of the Department of Parks, officially presented the new wing to new Metropolitan president Henry Marquand, he warned, "I

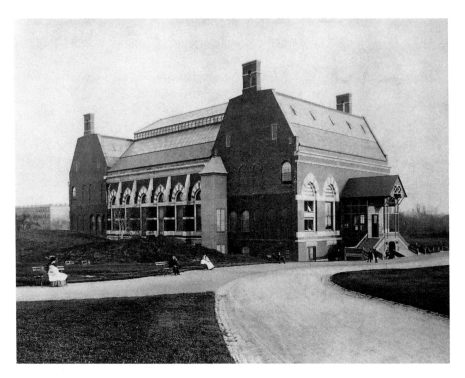

Figure 3. The Metropolitan's first permanent building in Central Park was designed by Calvert Vaux as a simple structure that (museum trustees hoped) would become a nucleus for future, more decorative museum wings. Nevertheless, critics disparaged it either as Ruskin Gothic or as looking more like a barn than a first-rate art museum. Metropolitan Museum of Art, 1880. The Metropolitan Museum of Art. Image © The Metropolitan Museum of Art.

believe I am voicing the sentiment of a great majority of the people of this city that the day is not far distant when the Museum will be kept open Sundays as well as all other holidays."[8] Having delivered the building, the city threw down the gauntlet.

This declaration on behalf of the city represented the culmination of a decade-long dispute between city leaders and museum trustees over expanded democratic access to the museum on the Christian Sabbath. The majority of New York's laboring population worked six-day weeks, which left Sundays their only day of leisure, and their only day to visit the museum. Demands to open the museum on Sunday, however, split the museum's board into ideological and generational factions. As early as 1880, trustee Joseph Choate

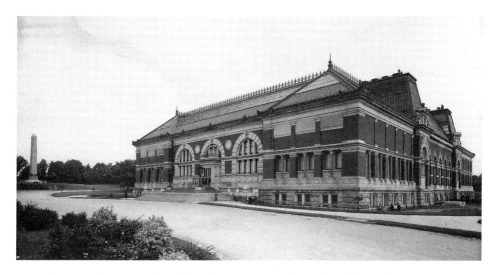

Figure 4. The Metropolitan's first addition in 1889 offered the public (and critics) a more suitable neoclassical façade, with arched window bays and a ceremonial staircase. This wing was built south of the original 1880 building, the façade of which can be seen at the upper far right of the photograph. Metropolitan Museum of Art, 1889. The Metropolitan Museum of Art. Image © The Metropolitan Museum of Art.

recognized the unfairness of the museum's access policy when he moved to open the galleries on Sundays, but conservative Presbyterian members of the board immediately tabled the motion. However, once the museum had moved into its first city-financed Central Park building in 1880, ten thousand New Yorkers signed a petition demanding that both the Metropolitan and the American Museum of Natural History open their doors on Sundays, and the Parks Department and the city's Board of Estimate threatened to withhold funding. Almost every city newspaper and labor union joined the appeal to open the museums, but to no avail.[9]

Demands like this represented many trustees' worst fears of the interference of professional politicians in museum policy. The trustees feared that reliance on city funds would make the museum as dependent as machine politicians who pandered to the masses for political gain. Further, many trustees' devout Presbyterianism made them recoil at the possibility of opening the museum to a public they feared would use it as cheap amusement on the Sabbath. John Taylor Johnston inherited his religious observance from his father John Johnston, who had once refused an audience with the pope because it had been scheduled on a Sunday.[10] In the 1880s, devout museum

trustee William Prime, himself the son of a Presbyterian minister, became the museum's most vociferous opponent to Sunday openings. When the city threatened to withhold its appropriations in 1885, Prime fumed, "they think the Museum is a public institution, in the management of which the public has a voice." Fearing further interference, he insisted, "they must be *forced* to think of it as a private institution" and "stop thinking they support the Museum and, be compelled to see that *we* own and support the Museum and give it in pure charity for public education."[11]

Perceiving Parks Department president Hampden Robb's statement upon delivering the new museum wing in 1888 as an ultimatum, Prime mounted the stage at the building's opening ceremony to deliver a lengthy speech explaining in no uncertain terms his own interpretation of the contract between the museum corporation and the city, which had provided city-owned land for a municipal museum. For Prime and many other trustees, the agreement between the city and the museum represented "that zeal for public good, the enlightened views of art education as a power in the moral and material growth of a city and state." But Prime made very clear: "This Museum is our property, bought with our money, managed by our Trustees, its current expenses paid by us out of our private treasury, its purchases all private purchases by ourselves."[12] Following Prime's personal testimony, Mayor Abram S. Hewitt ascended the dais to officially open the new wing. Barely veiling his contempt for Prime's old-fashioned oratory, Hewitt assured the audience that *his* speech would be brief. In sharp rebuttal, New York's mayor declared the wing open to the people "for the use and instruction and recreation of its citizens forever, and from that everlasting future I trust the time will come when on no day shall they be excluded."[13]

Proponents of Sunday openings flooded the museum and city legislature with petitions, demanding democratic access.[14] Meanwhile, dissent from within the museum's board steadily grew, especially among younger trustees eager to democratize the museum and ensure its public accountability. New to the board, de Forest deferred to Choate—whom he would later call one of the "heroes of the Sunday opening"—as the leader of the movement to expand the Met's policies of public access.[15] Faced with internal conflict and almost universal public support from newspapers, as well as a bill pending in the city legislature that would force the museum to open, the board met in the spring of 1891 at the home of trustee Robert Hoe to vote on changing museum policy. With tensions high and several opponents abstaining from the meeting, the board voted twelve to five in favor of extending museum hours to Sundays.[16]

Over ten thousand visitors attended the museum's first open Sunday on May 31, 1891. The *Annual Report* noted that "at first a certain amount of turbulence and disorder was noticeable," but by the end of the year most visitors had proved "respectable, law-abiding and intelligent."[17] Despite the fears of some trustees, democratic access proved a resounding success: the museum had almost 200,000 visitors in the first seven months and 900,000 within the first year of Sunday openings.[18] Nevertheless, the museum did experience reprisals. The *Annual Report* noted that the decision to open Sundays "alienated some who have given freely of their time and means to the institution."[19] William Prime resigned from his position on the board and the museum lost a bequest of $50,000.[20] The city, however, doubled its annual appropriation of $25,000 to $50,000 to offset the loss and cover the increased expenses of opening on Sundays.

Historians have argued that the battle over Sunday openings at the Metropolitan Museum and the American Museum of Natural History illustrated the tenuous status of private institutions in a public park, and by extension the contract between the museum and the city, in which various publics emerged to assert their interests.[21] But it also illustrates a shift in the institutional culture of museums. New trustees like de Forest emerged within boards of trustees to challenge the conservative, paternalistic relationship many older founding trustees had established. Their advocacy for change continued to create conflict as they jockeyed for power, promoting a new institutional outlook that would integrate democratic reforms like opening on Sundays with more practical educational programs that expanded on existing goals of moral uplift.

Collections of Casts

In November 1888, America's intellectual and cultural elite traveled by private railroad cars from New York and Boston to the provincial, industrial city of Norwich, Connecticut for the opening of the Slater Museum at the Norwich Free Academy. The *New York Times* marveled at the university professors, museum presidents, and celebrated artists in attendance, and it proclaimed that Norwich had added "to its natural beauty the attraction of a gallery of ancient sculpture in the East which no other city in the Union can equal."[22] While elaborate ceremonies and lofty dedication speeches certainly proliferated throughout the nineteenth century, public prep schools in small industrial cities rarely attracted the kind of crowds that streamed into Norwich that

afternoon, nor did they usually feature speakers as prominent as Harvard art history professor Charles Eliot Norton and Johns Hopkins University president Daniel Coit Gilman. For many of the dignitaries in the audience these two men represented the last word on art and culture, but their philosophical disagreements about the social function of educational institutions also represented the emerging divide between traditional ideas of moral uplift and newer, modern educational programs designed to produce practical results. Representing the humanist educational tradition of nineteenth-century American colleges, Norton called on the new museum in Norwich to provide "the great masses of our population" with the "love of beauty through steady and intelligent culture of the imagination." Gilman, on the other hand, who had founded Johns Hopkins on the model of German research universities, fused the practicality of using museum collections to teach classical history to academy students with democratic calls for "the influence of art upon industry." The pomp, the crowds, the press coverage, and the cultural debates illustrate how high were the stakes for a museum like this—the Slater Museum was the first museum in the United States dedicated to the display of plaster-cast reproductions.

Collections of plaster casts proliferated in American museums for only a brief period in the late nineteenth century, but during that moment they had enormous appeal to museum leaders, as well as the public. Beginning in the 1880s, museums in the United States built collections of plaster casts that could be used to teach both the history and appreciation of classical and Renaissance art. Fine art museums showcased casts of masterpieces of classical sculpture in their main galleries, newspapers and magazines extolled their virtues, and benefactors and curators scrambled to build their own collections across the country. This peculiar moment seems to contradict historical interpretations that American art museums, from the time of their mid-nineteenth-century founding, emulated European museums like the Louvre, and served Gilded Age interests by displaying recognized masterpieces as symbols of cultural power. In reality, few museum leaders at the time really thought they could compete with European institutions to acquire a representative collection of original classical and Renaissance artworks. Instead they presented reproductions in their galleries, so museum visitors who could not travel to Europe could nonetheless study these masterpieces. When museums did acquire masterpieces in the early twentieth century, they relegated their casts to storage.

Most historians of museums argue that the turn from casts to authenticated

originals marked the moment when American art museums abandoned their educational goals.[23] However, the young museum professionals who built galleries of casts in the late nineteenth century later moved on to positions of authority in prominent art museums, where they spent their careers trying to make museums useful democratic institutions. Robinson and Kent, for example, helped open the Slater Museum before consulting with museums around the country, and they eventually established themselves as leading museum professionals. Rather than Victorian oddities, cast collections represented introductory steps for men like Robinson and Kent, who worked out their ideas about museum education while they secured their professional credentials.

Industrialist William Slater built a museum on the campus of the Norwich Free Academy to serve as an educational resource for the people of Norwich, as well as an institutional model to encourage other cities to build similar museums.[24] Despite its provincial location in an industrial eastern Connecticut river town, its relative size, and its collection of reproductions, the Slater Museum not only influenced other museums, but it became a cultural destination in the 1890s. Dignitaries such as President Benjamin Harrison and industrialist and Social Gospel advocate Andrew Carnegie toured its galleries, and leaders from institutions as diverse as the Metropolitan Museum and Mount Holyoke College came to study and copy its education programs.

Edward Robinson, who assembled the Slater Museum's casts, represented the new breed of progressive connoisseurs who started to introduce practical education reforms into museums in the 1890s. Robinson, an emerging twenty-seven-year-old scholar of classical art, quickly established himself as a national expert as he built cast collections in museums and defined their canon. After five years studying art in Europe, which included formal study at the University of Berlin and fifteen months in Greece, Robinson returned to his native Boston in 1885 to become curator of classical antiquities at the Museum of Fine Arts. When he returned to America he was among an elite minority of men and women who could legitimately call themselves connoisseurs. Unlike most of his fellow Americans, who had neither exposure to recognized masterpieces through European travel nor access to formal education at colleges like his alma mater Harvard, he had acquired the necessary cultural capital and confidence in his taste to define aesthetic standards in public museum galleries. But unlike other nineteenth-century connoisseurs and aesthetes like Joseph Duveen and Bernard Berenson, who helped wealthy collectors locate rare art treasures and appraise their quality and authenticity,

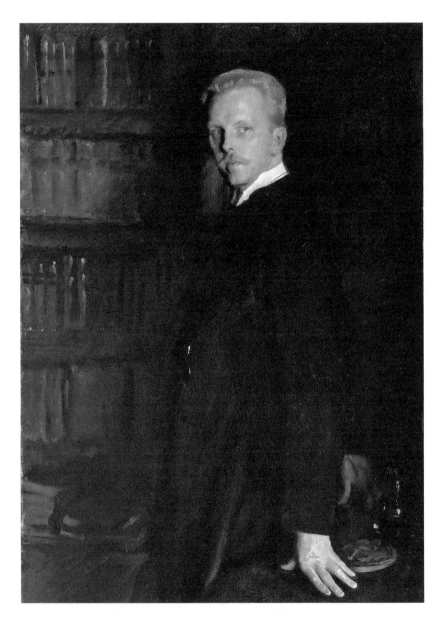

Figure 5. John Singer Sargent depicts Robinson as a powerful figure in the art world. Indeed, their friendship would ensure continued patronage for Sargent and several purchases of his works by the Metropolitan. John Singer Sargent, portrait of Edward Robinson. The Metropolitan Museum of Art, Gift of Mrs. Edward Robinson, 1931 (31.60). Image © The Metropolitan Museum of Art.

Robinson built his early reputation as an art historian, and he established his professional museum career by introducing academic art-historical standards into museums and democratizing access to art. For Robinson, the educational possibilities of reproduction galleries sometimes outweighed considerations of authenticity and attribution.

When Robinson came to the Museum of Fine Arts in 1885 it still occupied its original building in Copley Square, filled with an eclectic combination of original works of art and reproductions.[25] Robinson took over a classical department dominated by several galleries of casts on the museum's first floor, which had been assembled from various local institutions and private donors.[26] The collection needed reorganization, so Robinson introduced standards of academic art-historical scholarship he had learned in German museums and universities. Instead of displaying objects according to media or region, Robinson reorganized the collection based on linear progression of craftsmanship and schools of art. He based a catalogue for the Museum of Fine Arts' collection on a model from the Berlin Museum.[27] Robinson's catalogue served as a guide to help museum visitors understand the collection, but it also served as a template that other institutions could use to build their own collections of plaster casts—and of course the catalogue served as a calling card for Robinson's professional services. Robinson later boasted that the Boston collection rivaled all other museums in the country, and was second only to the famous collection at the Royal Museum in Berlin in both size and scope.[28]

However impressive the Boston museum's new cast collection, it was the Slater Museum in Norwich that ultimately sparked the fashion for educational collections of casts in the 1890s, and it catapulted Robinson's career. Robinson's catalogue and his reorganization of the Boston collection had convinced William Slater to build a similar educational collection for Norwich. In 1887, Robinson began buying casts from fabricators in Europe. He arranged for their shipment to Norwich, he negotiated customs obstacles, and he supervised the installation. Like the collections in Boston and Berlin, the Slater Museum presented examples of classical Greek, Roman, and Egyptian, as well as Renaissance, sculpture that could be used both to illustrate history and to introduce artistic masterpieces.[29] At their core, collections of casts represented democratic educational exhibitions, which reformers hoped would reach a broad museum public.

In an influential essay in the *Nation* that was reproduced through the 1890s, Robinson urged other small cities throughout the United States to

build similar museums. He stressed the "importance of collections of casts and other art reproductions as factors in popular education," and he insisted that museums were just as necessary as public libraries. In fact, Robinson argued that only through collections of reproductions, like those the Slater Museum had just installed, could "the body of our people . . . hope to become familiar with the great masterpieces of European galleries." Rather than restricting art galleries to "those who have plenty of leisure," Robinson believed that every small city should provide "a gallery in which children would grow up familiar with the noblest productions of Greece and Italy, in which the laborer could pass some of his holiday hours, and in which the mechanic could find the stimulus to make his own work beautiful as well as good." Robinson used language strikingly similar to that used during debates about opening the Metropolitan on Sundays. "For the benefit of the mill-operatives and other laborers who form the largest portion of the population of Norwich and the adjoining towns, to whom the Museum might do a world of good," Robinson campaigned, "we sincerely hope the day is not far distant when the building will be open at least a couple of hours each Sunday."[30]

Introducing the kind of practical advice he would advocate throughout his museum career, Robinson stepped beyond the lofty sentiments about art's uplifting qualities that most advocates of museums in the nineteenth century repeated, and he instead offered clear steps that could be followed to build democratic art galleries. Robinson presented the Slater Museum as a model or case study to dispel the impression that such museums were necessarily expensive, and to show what other small cities might do with minimal investment. Slater built the museum in Norwich, Robinson reported, "to stimulate others who had the means to follow his example in other parts of the country." Therefore, Robinson broke down the process of selecting and installing a collection of casts, and he offered suggestions to cut expenses. Despite the high quality of materials used in the Slater Museum's installation, it cost only $27,112.97. "Is there any city or college in the Union," Robinson asked, "in which this sum could not be raised for a similar purpose?" Since few museum visitors would be familiar with the works on display, Robinson also suggested that museums include lecture halls, where "regular courses of instruction or occasional lectures upon topics connected with the theory or history of art" could be presented to the public. "To open a gallery like this to the public, and then leave people to float about in it aimlessly, without a notion of its meaning or its purposes," Robinson counseled, "is to do but half the work."[31]

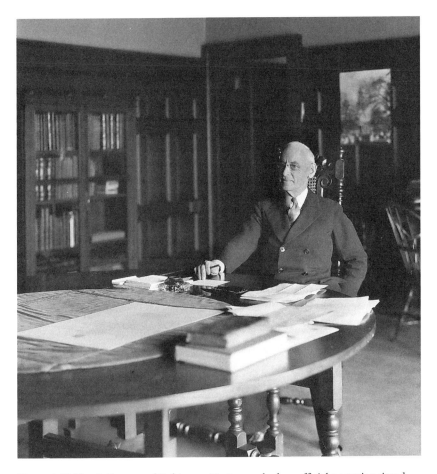

Figure 6. Unlike de Forest and Robinson, Kent never had an official portrait painted and certainly possessed no images of himself suitable to be accessioned into the Metropolitan's art collection, as their portraits had been. Here we see Kent in his office, surrounded by many of the old American things he loved and promoted at the Met. Henry Watson Kent. The Metropolitan Museum of Art. Image © The Metropolitan Museum of Art.

While William Slater financially supported the Slater Museum and Robinson laid its intellectual groundwork with his installation, the person most responsible for the museum's reputation for educational innovation in the 1890s was its twenty-two-year-old curator and librarian, Henry Watson Kent. Kent constructed his education as a museum professional on the job, combining training in library science with sponsored study trips abroad and association

with local collectors. Drawing upon models like London's South Kensington Museum, Kent allied the museum with its local industrial community, and he developed practical education programs that would themselves become models for how museums could do the other half of their work—the half that Robinson thought most art museums neglected.

Though Kent had no training (either formal or informal) in museums or art history, he nonetheless single-handedly ran the Slater Museum and the adjacent Peck Library as academic arms of the Norwich Academy. Kent maintained galleries, provided tours and classes for students and public visitors, generated publicity, and coordinated loan exhibitions to supplement the museum's collections of casts. Kent took great pride in his status as a self-made museum professional, and he later boasted that during his years at the Slater, he had performed all of the curatorial and administrative work of the museum: generating exhibition ideas and coordinating with local collectors, assembling and installing, labeling, making and printing catalogues, handling publicity, keeping records and returning loans, and personally explaining collections to visitors. "A museum man," Kent assured readers of his autobiography, "did not have many holidays—in those early days if the Museum was open, the Curator was there."[32]

As Robinson's article promoting collections of casts circulated, and news of Kent's educational innovations spread, the Slater Museum attracted visitors interested both in the educational value of the collections and the novelty of its offerings. From Boston, Robinson regularly checked in with Kent to learn about the museum's progress, to ask for press clippings, and to offer advice. At one point Robinson gloated, "among the people whose good opinion is worth having," the Slater Museum "is always known as one of *the* museums of the country."[33] As the museum's reputation increased, so did Kent's responsibilities. "At whatever hour one of these out-of-town visitors came," Kent remembered, "it was the custom to show them around, and this too fell to my lot."[34] Since the museum's opening, Kent had developed his own appreciation of art and particular skills of personal diplomacy. He recalled with humor the time President Benjamin Harrison asked him whether a cast reproduction of Donatello's Saint John the Baptist was a good likeness and if, on that account, "you have here any portraits of Jehovah?"[35] Accompanying one "prominent citizen of Norwich," through an exhibition, Kent deflected questions about the collection's monetary value by instead explaining its educational value, and he eventually succeeded in securing a new building for the academy's Art School.[36] Kent so successfully implemented the Slater Museum's educational

goals that when outside museums sought to use the Slater as an institutional model, they looked to Robinson and Kent as a professional package.

In the spring of 1891, while the Metropolitan Museum's board bitterly negotiated its decision to open its galleries on Sundays, new trustee Robert de Forest assembled a special committee to build a collection of plaster casts that the museum promised would rival not only other collections in the United States but even those in Europe. New York papers lamented that their city had fallen behind other cities that had opened galleries of reproduction sculpture. The *New York Times* complained that the Metropolitan was "behind similar museums abroad and even in this country"—not only Boston and Chicago, but even the Slater Museum and the Corcoran in Washington, D.C. had more casts.[37] De Forest and his committee set their sights on the world-famous collections of the Royal Museum in Berlin and the Trocadéro in Paris. The Metropolitan Museum promised to purchase copies of "all the masterpieces in the different collections of the world, and bring them together under such an arrangement as would best exemplify the progress of the plastic arts at all epochs."[38] The Metropolitan already had a small collection of sculpture casts, and it had recently purchased a large number of architectural casts that had yet to be installed.[39] De Forest hoped that a committee of older trustees and younger men—both on the board and as outside advisors—could raise sufficient funds and offer professional or expert art-historical perspective.[40] While Robinson had claimed in his well-circulated article in the *Nation* that a small city could obtain a representative collection for $27,000, the Metropolitan set its sites much higher and vowed to raise $100,000.[41] Although the Metropolitan's bravado clearly represented cultural rivalry, de Forest and his committee also saw an enlarged collection of casts as an important educational reform— aligned to the same democratic goals they hoped to achieve by opening the museum to the public on Sundays.

As a new trustee on the Metropolitan's board, de Forest saw modernization and expansion of the museum's collection of casts as a way to introduce new educational experiments, and to carve out a position of cultural and political authority for himself in the museum's hierarchy. Toward the end of his first year as a trustee, de Forest made his move by proposing his committee on casts to new Metropolitan president Henry Marquand. "It looks as if I should have more time this winter to indulge my interest in Museum affairs," de Forest demurred, "and there is one particular department in which, for several years past, I have been anxious to see a move started, that is, the de-

partment of casts." "I have had this in mind during my last trips in Europe and have been able to gather information, which, in connection with advice I have had from several familiar with the subject, makes me feel to suggest definite action." Mindful of museum politics, and playing the role of a junior trustee with precision, de Forest promised that he had consulted with museum director Louis di Cesnola and confirmed that Cesnola was on board. De Forest also offered to take full responsibility for all work as a vice chairman, if only Marquand would officially chair the special committee—to give it authoritative weight.[42]

The committee on casts reflected de Forest's corporate style of rationalized management: he recruited trained experts in various fields, and he secured funds through his own institutional and personal affiliations. Museum reform, though, also required attention to museum politics. De Forest suggested a special committee of experts, "partly with the view to get efficient workers and partly with the view to interest desirable people in the Museum." "The younger artistic element is not represented at all in the Museum," de Forest cautioned, "and I have sometimes thought feels lukewarm because this is the fact." De Forest believed the Metropolitan should take advantage of the cultural capital that New York's celebrated artists and architects could offer the museum. "Stanford White and Louis C. Tiffany are both very much interested and have even suggested getting up an entirely outside committee for this purpose."[43] For the cast committee, De Forest also suggested men "on the business and money side," such as Singer sewing machine founder Alfred Clark, financier Edward D. Adams, and banker George Baker. Finally, de Forest made a case for bringing in new museum professionals. "A new generation has come up far more widely and intelligently interested in art matters than the old generation, and eager to do something." De Forest feared that unless tapped, these young museum professionals would take their talent and expertise elsewhere. "Unless they do something in connection with the Museum, there is real danger that they will do something in other directions." As a businessman and institutional philanthropist, de Forest saw the market for well-trained professionals as one more arena for sound economic pragmatism, and he warned Marquand, "men give most largely to that for which they [the young professionals] are doing." De Forest suggested that after revising the museum's collection of casts, this new generation of museum workers might eventually move into other departments in the Metropolitan. But for the time being, he promised, "I had nothing in my mind at the moment but a committee on casts."[44]

De Forest's emergence on the Metropolitan's board as a leader in the educational (and organizational) reform of museums, however, challenged many older trustees, because he called into question not only the way they had previously run the museum, but also their philosophical vision of art and cultural uplift. The Metropolitan's director Louis di Cesnola, in particular, resisted almost everything de Forest tried to do with his new committee on casts. Cesnola bristled at the notion that the Metropolitan risked losing the services of a new generation of professionals. "I am sure that we Trustees of the old generation," Cesnola huffed in a letter to Marquand, "though not considered so 'intelligently interested in art matters', are surely as patriotic as the young generation." Cesnola remained lukewarm about bringing in outside members to the advisory committee, but he agreed it was "at least worth trying as an experiment, though I do not believe it will prove satisfactory."[45]

Marquand and other pragmatic trustees, however, recognized that a new collection of plaster casts would also give the Metropolitan a new public image by promising to extend its educational benefits to a broader public. Still mired in public controversy over the museum's Sunday access policies, they hoped that an extravagant collection of casts would represent the coming of a new age of museum reform to a public that seemed underwhelmed by the museum's return on municipal investment. Increasingly, plaster-cast reproductions offered the most practical way of making museums educationally useful in the 1890s. When Ripley Hitchcock criticized the Metropolitan's management and educational effectiveness in 1889, he targeted inadequate labels, a paucity of catalogues, a lack of knowledgeable guides, and the infrequency of public lectures. But for Hitchcock, the lack of a good collection of plaster casts represented the museum's most glaring deficiency. "The Museum needs large and well-chosen collections of antique and Renaissance casts," Hitchcock urged. "This department should be intrusted to an expert and made one of its most important."[46]

During the last month of deliberations over opening the Metropolitan on Sundays, de Forest took his new cast committee by private railroad car to visit the Slater Museum's collection in Norwich. The *New York Times* and local Connecticut papers covered the trip because they recognized its significance, but we can also detect in their coverage de Forest's emerging leadership style. "If the trip were carefully arranged with a special parlor car or cars on which lunch could be served," de Forest had suggested to Marquand in planning, "it should be an enjoyable one, and if we invited, in addition to the trustees, some 10 or 15 possible subscribers of large amounts, I doubt not it would pay,

though of course nothing should be said on the trip about contributions."[47] The *Times* confirmed that "the hospitality of the drawing-room car was widened" to include notable New Yorkers who were not on the cast committee but who might make financial contributions. "Some of these [dignitaries] have already contributed roundly to the fund," lauded the paper, but they all proved "interested in its success."[48] Presented as an opportunity "to inspect the good work" at the Slater Museum, the trip actually helped consolidate de Forest's plans. The committee had already drawn up a tentative list of casts that it wanted to buy.[49] Rather than scrutinize Slater Museum galleries, de Forest's carefully selected New Yorkers spent most of the day dining with William Slater at his home, touring "the old-time residences and elm-bordered streets of that inland seaport" and meeting with local dignitaries.[50] De Forest's tourist excursion assured completion of his goal to build an educational gallery of casts, and it secured enough funds to make the collection sufficiently impressive to placate many of its critics—the Metropolitan would rival not only small, local collections like the Slater's, but also bigger collections in cities such as Boston and Chicago, and maybe even those in Europe.[51]

While the committee was securing funds, de Forest assembled his team to build the collection, and he turned to the recognized experts in the field, Robinson and Kent. De Forest used his connections to ensure cooperation from the Museum of Fine Arts and the Slater Museum, both of which agreed to lend the services of their professional experts on plaster cast collections. "We could not have had better assistance," enthused de Forest when he announced his professional coup to Marquand. "His [Robinson's] position and ability are universally recognized for so young a man." De Forest said that it was "a courtesy for the Boston Museum to let us use him, which we ought to recognize." To thank the MFA, de Forest commissioned two models of the Acropolis at Athens, and he gave one to the Boston Museum. While long since removed from Metropolitan galleries, the Acropolis model still holds a prominent place in the classical galleries at the Museum of Fine Arts. "The more comity between Museums the better," insisted de Forest. "We are too big to be jealous and we have no business to be jealous even if we are likely."[52]

Over the summer of 1891, while elite New Yorkers escaped the city and working New Yorkers began exploring the Metropolitan for the first time on Sundays, Robinson and Kent worked to assemble the Metropolitan's collection of casts. Experts in various historical and art-historical fields prepared lists of sculpture for reproduction, and the committee distributed them for final review to additional experts. Robinson prepared lists for most of the ancient casts

and the Italian and German Renaissance casts; Professor A. L. Frothingham at Princeton prepared lists for early Christian, medieval, and French Renaissance art; and Allan Marquand, also at Princeton, prepared the Egyptian lists.[53] Once final lists had been approved, Robinson acted as a purchasing agent through dealers in Europe. Kent later recalled that he frequently traveled during the summer of 1891 to Robinson's summer house in Manchester, Massachusetts to discuss plans for the Metropolitan's collection.[54] While Robinson "edited" Kent's ideas, Kent nonetheless oversaw the arrangement of casts in Metropolitan galleries by country and by school of art.[55]

De Forest's method of recruiting experts and delegating authority to efficiently build a world-class collection of casts for the Metropolitan personified his leadership style, but it also differed sharply from the way the Metropolitan had been managed previously, and it raised alarm among many of the museum's older trustees. The professional credentials of the men de Forest recruited, and the systematic application of their mission, contrasted with the organizational style of Cesnola. A former military commander and son of an Italian count, Cesnola maintained domineering control over all museum activities, strolling corridors and galleries in his military boots to supervise minute details. Many members of his staff—and an increasing number of trustees—found his leadership style autocratic and unprofessional. The museum's bookkeeper assembled an extensive dossier alleging financial mismanagement, which ultimately proved inconclusive, but it revealed the rudimentary accounting system Cesnola used to manage museum transactions.[56] Cesnola was also frequently attacked by the press and art journals as unscholarly. Journalist and museum historian Calvin Tomkins writes that from 1890, Cesnola increasingly lashed out at trustees he felt were undermining his authority. "The chairmen of our important committees," he charged, "do not do their own work but delegate it . . . to irresponsible parties of their own choice."[57]

The introduction of young men with more experience in professional museum management, like Robinson and Kent, likely threatened Cesnola, and threatened the authority he enjoyed wielding. Cesnola's criticism, however, also indicates the perception among older trustees of de Forest's leadership style: they saw delegation to professionals as shirking personal responsibility (perhaps an example of their Victorian-influenced ideas of laziness), rather than as efficient management. Fearing the obsolescence of his own curatorial staff, Cesnola objected to Robinson's position in the museum, and to the advice de Forest sought from outside experts when they compiled the list of

casts. "It seems hardly worth while to slight our Curator of Casts," Cesnola insisted to Marquand, "by applying to the Curator of Casts at the Boston Museum, to prepare and select, such an incomplete list of them."[58] De Forest defended the process of delegating preliminary lists out to experts in selected fields for ultimate selection, and he explained that the process was one democratically agreed upon at meetings of the special committee. "Of course," de Forest snapped back, "the General cannot keep track of all that is going on without attending meetings of the committee."[59] Further fueling Cesnola's ire, de Forest's cast committee retained control of the $79,000 it raised, rather than turning it over to Cesnola and the museum treasurer. With his committee of casts, de Forest planted the seeds for change at the Metropolitan, but he also anticipated future conflicts between the younger generation of museum reformers like himself and older trustees who resisted their new ideas, and their own loss of power.

De Forest used public sentiment in favor of opening the Metropolitan Museum on Sundays to challenge the management style of many of the museum's founding trustees, and he saw collections of casts as the kind of democratic programming that he hoped to implement on a grander scale at the museum. In one heated exchange with Cesnola over allocation of donor funds, de Forest articulated his ideas of cultural democracy. "Some look upon the Museum from the standpoint of a collector," he suggested with pointed reference to the Met's collector-director, "others from the standpoint of an educator." "For myself, my taste is very catholic, but perhaps the thirst for art education which I see developing in so many quarters appeals to me more than my own personal delight in a rare and beautiful work of art."[60] These early confrontations over museum management and the educational value of objects represented the initial skirmishes in a larger battle for cultural democracy in the 1890s that pitted questions of educational utility against traditional ideas of connoisseurship.

The Metropolitan's collection of casts debuted in 1894, when the museum opened a second new wing to the north of the first 1880 building. Further obscuring its original red-brick façade, the new Metropolitan also altered many of the ideas about museums that its founding leaders had originally presented. Rather than focusing on moral uplift, the new generation of museum leaders assembled by de Forest tried to make the museum useful. They arranged galleries that could teach the public, even if the objects within those galleries were reproductions. This new generation of progressive connoisseurs placed the educational value of museum collections above their monetary,

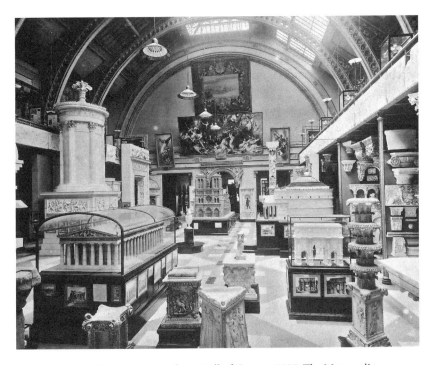

Figure 7. Metropolitan Museum of Art, Hall of Casts, c. 1907. The Metropolitan Museum of Art. Image © The Metropolitan Museum of Art.

aesthetic, and uplifting values. *The American Architect and Building News*, reflecting democratic goals of expanding the usefulness of museum galleries for a broader public, also recognized the practical value of casts. Its editorial review pronounced the Metropolitan's new architectural and sculptural casts "rich indeed in a most instructive sort of artistic wealth."[61]

Art and Industry

Just as collections of plaster-cast reproductions of sculpture offered educational possibilities that progressive connoisseurs like Robinson, Kent and de Forest believed justified their place in art museums, industrial arts—everyday household things—were seen as having educational value to teach taste and improve the quality of goods available to American consumers. Modeled on the British design reform movement and education programs at London's South Kensington Museum, the alliance of art and industry became one of

the central movements for museum reform in the late nineteenth and early twentieth centuries. Industrial arts also served the goals of democratizing museums by breaking down distinctions between high culture and industrial production, and by expanding opportunities to teach and learn appreciation of beauty and principles of design—the cultivation of taste—which traditional notions of connoisseurship had previously restricted by social privilege.

While the Slater Museum's collection of plaster casts made the museum famous and helped launch the careers of Robinson and Kent, its innovative outreach programs and special exhibitions of industrial arts had an even greater long-term impact on education reform in American museums. Through the 1890s, Kent mounted temporary loan exhibitions of decorative arts at the Slater Museum to promote American arts and crafts and to influence the quality of local industrial production in Norwich. Unlike trustees and curators such as de Forest, Robinson, and even Cesnola, Kent received his training as a museum professional and he developed his taste on the job. Kent used the Slater Museum's collection of plaster casts to teach himself classical art history, so he could in turn teach students at the academy with the museum's collection. Kent supplemented this on-the-job learning with institutionally sponsored study trips abroad, and through acquaintance with local collectors. Unlike connoisseurs who legitimated their taste through traditional education and travel, Kent literally developed his eye in the museum, which likely contributed to his great success as a museum educator.

When Kent started his job at the Slater Museum, like most Americans, he had neither training in art history nor extended exposure to art. Born in Boston in 1866 and initially educated at the Boston Latin School, Kent had attended the Norwich Academy as a sponsored student long before Slater built a museum for the school.[62] Whereas curators could obtain scholarly expertise in art history at universities like Harvard or through study abroad, especially in modern German universities and museums, the general field of "museum work" was then in its infancy. "There were no schools to teach us who were interested in such training in those days, when this 'profession' was not recognized, by colleges or anybody else," Kent later recalled. "There were no books or magazines devoted to this interest for us to read."[63] Kent would construct his self-made history by explaining in his autobiography that the "museum man" had to apply nineteenth-century New England-style bootstrap self-sufficiency: "If we were in earnest we had to depend upon ourselves to get whatever we thought would make us desired and useful."[64]

In contrast to museum curators and directors with unambiguous backgrounds in connoisseurship, Kent had trained primarily as a public servant, and he later complained that too few curators and directors had been "imbibed with" a relationship to the public.[65] Following his preparatory training and a year of "boy's work" at the Boston Public Library in 1884, Kent trained under Melvil Dewey at Columbia's School of Library Economy.[66] "Librarians, following Dewey's lead," Kent proudly explained, were "trained first of all as pubic servants." Kent was among the first group of men and women to enter the new field of library science when he helped Dewey prepare for the first academic program in that field at Columbia. Dewey's goal of "economy" required the "administration of a library in a business-like, efficient manner." The School of Library Economy established new standardized methods of cataloguing, accessioning, and classifying. Kent participated in weekly discussions "on all manner of subject," he said, "calculated to bring home to the students the philosophy of the new library ideas, correct administration, and efficient methods of work."[67] "What the Columbia School taught me," Kent continued, "were the things that Dewey himself stood for . . . the dignity of his profession, librarianship, and for the importance of the public library as second only to the public school as a source for the education of the people."[68]

This philosophy of public service and "economy" paralleled the approach taken by settlement-house and other emerging social-service movements in the 1890s, and like those movements, library science also provided access to professional occupations for both women and men like Kent who were otherwise restricted by social class and gender.[69] Though Kent studied under Dewey, he was not a matriculated student at Columbia. Rather, he was an assistant who helped Dewey prepare for the first academic class. Kent's professional training therefore approximated older models of informal apprenticeship instead of formal accredited education. Kent learned the skills of this new profession by working under its master, as he worked out later academic curricula.

The Slater Museum's opening in November 1888 provided Kent his first exposure to museum interpretation and to the social differentiation and the requisite deference to donors and social dignitaries expected of nineteenth-century public servants. When guests streamed into Norwich from Boston and New York, they were escorted through the new galleries by Edward Robinson, William Slater, and the academy's director, Robert Porter Keep. But Kent, "elegantly dressed in a new black frock coat and striped trousers," remembered that he simply helped the guests to their seats, and he later

admitted that he was "overawed by their superiority and their condescension."[70] While Kent knew the names of many of the university professors, museum presidents and celebrated artists whom he sat, he had never before seen their faces. Though overwhelmed by his new position and the audience attending its ceremonial beginnings, Kent nevertheless took away from the afternoon a clue about the diverging philosophies regarding public art museums at the end of the nineteenth century.

Kent credited Daniel Coit Gilman's dedication speech with providing specific suggestions for using the Slater collection of classical casts in classrooms. Like Kent, Gilman had also studied at the Norwich Academy as a boy, and he also remembered reading classics without any illustrations of their heroes.[71] Gilman encouraged using the museum's reproductions to illustrate Greek history as "a guide to the monuments of past civilization."[72] "Here light is thrown upon the art, the architecture, the decorations, the coinage, the biography, the mythology, the religion of the most interesting epochs of the past."[73] But Gilman also drew parallels between classical and vocational education, he linked appreciation of beauty to training in design and its application in manufacturing, and he called for "the influence of art upon industry."[74]

Neatly summarizing his autobiographical education, Kent later claimed that while he listened to Gilman's address, he thought it seemed as though Gilman was "walking with the young Curator and Librarian from the Slater Museum hall to the beautiful Peck Library a few steps down the corridor, throwing out helpful suggestions as they went." Kent assured that he "pricked up his ears and took these words down in his mental notebook."[75] While in reality Kent likely left the dedication ceremony as confused as he had come to it, as a museum professional he nevertheless followed the path Gilman outlined.

After the ceremonial pomp and pronouncements by donors and the cultural elite, the practical job of running the museum as an educational arm of the academy fell to Kent. Or, as Kent observed, "The fanfare over, my job began."[76] Following Gilman's advice, Kent sought "practical ways of making the Museum do its work" in order to see that it was "used and became an educational agent." Kent established a classification system to catalogue the museum's cast collection based on Dewey's library classification system. Using galleries and photographs, Kent instructed academy seniors in art history, and he staged student plays like the *Iliad* in the Slater Museum's lecture hall.[77] To "promote the application of art to industry," Kent also opened an art school at the Academy in 1890 that stressed "design and its application to the

training of designers for textile and jewelry factories."[78] Perhaps Kent's early commitment to practical education came from his own experience of learning about art from the museum's collections.

To learn practical exhibition and management techniques specific to museums, and to develop his art-historical connoisseurship, Kent traveled in 1893 to Europe to study its museums. Thus far, Kent had only worked in a museum of casts; in contrast to patrons like Slater and Gilman and curators like Robinson, Kent had never made the Grand Tour, so he had never seen the original works of art from which the Slater's collection had been cast. But armed with letters of introduction from Robinson and Gilman, and his expenses paid by Slater, Kent gained access to every museum on the continent, where he made sketches and took notes emphasizing methods of exhibition, details of display, and presentation of collections.[79] His first notebook entries reveal the awe of a young man overwhelmed by the quantity and quality of southern European museums, but his later entries show the acquired criticism of a man who has seen a lot and had access to more.[80] By the time Kent made it to museums in northern Europe, little impressed him; instead, his eye was trained to detect problems with display and interpretation. In Munich, he tersely reported that the walls and decoration of the Glyptothek Konig Ludwig I were "elaborate & gaudy."[81] By this point in his journey, Kent paid keen attention to details that he could export home for use in his own museum, but the Glyptothek was "without value for reproduction." His notes, therefore, became increasingly sharp: "Labels. None . . . No help of any sort."[82] Kent's disappointment continued in Berlin; he found "little to be learned as worth copying" at the Koniglichen Museum. "The Italian sculptures," he sniffed, were "mounted with rich stuffs but in poor taste."[83] Increasingly, he criticized museums as old-fashioned and ineffective. Kent determined that the Koniglich Bayerische National Museum had "no points of special interest" because "there are no modernisms."[84]

Kent discovered that the only museums to address problems of access and display—museums that implemented what he called "modernisms"— were those influenced by Wilhelm Bode. "I was fortunate enough," Kent explained regarding Bode's German museum management, "to see what was really a development of what we may call the modern museum idea."[85] Wilhelm Bode eventually directed all of Berlin's museums, though at the time of Kent's visit he was still in the process of consolidating power and innovating their collections. Bode established the first "friends of the museum" program, soliciting funds and collections from Germany's banking

and industrial establishment (which was enjoying financial prosperity af-
ter the Franco-Prussian War). Bode's innovations eventually required art
dealers like Joseph Duveen and Jacques Seligman to include Berlin on their
regular itinerary.[86] As he expanded collections, Bode implemented special-
ized classification systems and recruited a corps of academically trained
art historians. Decorative art curator Wilhelm Valentiner explained that he
went through a two-year "museum training course of almost spartan char-
acter" after joining Bode's staff.[87] Perhaps what most influenced Kent were
Bode's innovations in display and interpretation of art. Bode detested the
"wallpaper" method of display that most nineteenth-century museums de-
ployed, arranging paintings floor-to-ceiling; Bode thought they looked "like
herrings one above another."[88] Instead, he arranged paintings and sculpture
according to art-historical chronologies of schools and artistic progress, in
rooms appropriately decorated to reflect their historical context.[89]

However impressed he was with Bode's modernisms, Kent reserved his
strongest praise for the South Kensington Museum's teaching methods of dis-
play and its incorporation of decorative arts. As Gilman had first suggested
to Kent, the South Kensington emphasized decorative arts as models for in-
dustrial design. Founded by Henry Cole to improve British manufactures by
providing examples of good design, in conjunction with art schools for both
craftsmen and the general public, the Victoria and Albert Museum within the
South Kensington complex in London displayed decorative art to the pub-
lic.[90] Kent found this educational museum philosophy "way ahead of such
efforts in other countries."[91]

Inspired by the museum modernisms he saw in Europe, Kent came back
to the United States armed with notes aimed at improving museum account-
ability. Back at work at the Norwich Academy, Kent began implementing
modernisms at the Slater Museum, using what he had learned to bring it up
to speed with the best of the European institutions. He designed cases based
on his notebook sketches, he improved labels, and he developed more edu-
cational programs. Hoping to experiment with the aesthetic innovations and
different artistic media that he had also discovered in Europe, Kent integrated
loan exhibitions into the Slater Museum's programming.

As Henry Cole at the South Kensington Museum looked to traditional
British design to improve national industrial production, Kent exhibited
American craft traditions at the Slater Museum. But without a network of
producers or design reformers, Kent turned instead to local businessmen and
collectors in Norwich. To encourage cooperation from Norwich industrialists,

Kent put forth economic arguments he had learned from Daniel Coit Gilman. Norwich was an early center of New England's textile production, and later a leading manufacturer of firearms. Thanks to Civil War contracts, Norwich industry had prospered in the second half of the nineteenth century. Gilman often reminded local dignitaries that Norwich prospered only because of the skill it exhibited in manufacturing materials brought from a distance. Gilman cautioned that competition elsewhere meant that "in the future, beauty must be added to utility; to solidity, grace must be given; art must be allied to craft." Paris, Berlin, and Vienna distributed manufactures throughout the world because they produced attractive things. Unless local American manufacturers improved the aesthetic quality of their production, they could never stand up to international competition.[92] Kent used economic arguments like these to ally the Slater Museum with local manufacturers, and he staged exhibitions of arts and crafts while he continued to experiment with other museum modernisms.

Kent found that once the initial publicity and novelty of the cast collection had worn off, he had to work to maintain public interest in the museum. Therefore, he assembled loan exhibitions of art and other collectibles drawn from the collections of local patrons to the museum. Kent borrowed from museum benefactor William Slater's collection of paintings for many of the museum's loan exhibitions, but his exhibitions of decorative arts are most remembered today.[93] In 1895, Kent arranged a special loan exhibition of chairs to demonstrate "their historical and artistic development." He hoped to influence the students in the academy's art school, and Norwich's larger industrial community, by showing examples of eighteenth-century crafts.[94] Kent borrowed the furniture collection of local coverlet manufacturer George Palmer, and displayed his chairs chronologically to present their artistic development.[95]

Kent tapped into an emerging movement of collecting early American antiques to stock his galleries with examples of American craft. The collectors with whom Kent associated represented a relatively new approach to the field of collecting in the United States. These early collectors are often celebrated for their visionary ability to see value in old American things, but they were unique in the history of collecting not only because of their interests.[96] The popular image of the legendary Gilded Age collector usually focused on wealthy industrialists who accumulated vast treasure houses of (mostly) European art that had been authenticated and valorized by arbiters like the dealers Henry Duveen and Jacques Seligman. Their collections have therefore often been identified

as symbols of social and cultural status. The antique collectors Kent came to know, however, were middle-class professionals for whom the hunt entailed rummaging through New England farmsteads instead of Parisian salons. George Palmer, for example, was among the first group of collectors of American antiques who used to roam the local Connecticut countryside banging on farmhouse doors inquiring about old things. Palmer and his fellow collectors came from the first generation of middle-class Americans who had the leisure to engage in the pursuit of antiques, and the accumulation of knowledge necessary to construct a field of collecting.

Kent developed his own taste for American craft by combining his love of local history with a love for the objects associated with it. Kent's fascination with Norwich—a colonial town within an industrial city—began when he attended the Free Academy as a youth in 1881.[97] "Everything about the place recalled the old times," Kent enthused. His recollections include childhood memories of the Huntington sisters, spinster descendants of Revolutionary heroes, who used to dazzle him with their hoop skirts and diamond rings and invite him to peek at historical "treasures" they kept locked in a block-front desk.[98] Later, through friendships with local collectors like George Palmer, Kent learned about early craft forms, production techniques, and the local craftsmen who created them. Perhaps the anachronism of a colonial town within a teeming industrial city, and ideological inspiration from the South Kensington Museum and from men like Daniel Coit Gilman, encouraged Kent to fuse his love of the past with the present by presenting old things as industrial models for new things.

The loan exhibitions of industrial arts that Kent organized in the 1890s contributed to the Slater Museum's reputation for educational innovation. Kent used these temporary exhibits to encourage repeat visits to the museum and to reach out to Norwich's industrial community. In contrast to traditional arguments about cultural diffusion that see trends emanating from metropolitan centers out to the periphery, Kent was able to use his self-made museum education to make a provincial museum like the Slater a model that would influence major cultural institutions like the Metropolitan Museum. By reaching out to a new kind of collector and exhibiting American crafts alongside plaster-cast reproductions, Kent experimented with the most prominent educational models of the late nineteenth century, and he helped to set the stage for the democratization of cultural categories in museums, and for the introduction of modern museum strategies.

Figure 8. In 1902, Richard Morris Hunt designed this iconic new façade for the Metropolitan Museum, fronting on Fifth Avenue. The wing opened in 1904. Over the next twenty years, McKim, Mead and White would design additional wings for the museum that grew out from its core cluster of nineteenth-century buildings. Metropolitan Museum of Art, 1904. The Metropolitan Museum of Art. Image © The Metropolitan Museum of Art.

The De Forest Faction

During the late 1890s and the first years of the twentieth century, art museums in the United States accumulated record donations of both money and recognized masterpieces, which allowed them to build world-class fine art collections and to endow newer, more impressive building projects. In 1902, the Metropolitan Museum built an even more impressive neoclassical façade facing Fifth Avenue. To many New Yorkers the new building represented the wealth and opulence of the era, and its image still reinforces historical myths about the Gilded Age museum. However, many people within museums also recognized their democratic potential. Like their peers in social reform, they borrowed from European institutional models and experimented with education programs that they believed could produce practical results. The

progressive connoisseurs in American art museums like de Forest, Kent and Robinson, however, needed to wait for the right moment when they could move into positions of power and implement the kind of large-scale change they envisioned.

Through the 1890s, Robinson and Kent built professional networks by forging relationships with private collectors. Robinson developed a relationship with a group of collectors and scholars of classical art, concentrated around aesthetes Ned Warren and John Marshall at Lewes House, their gentlemen's colony in rural England. Ned Warren's brother Sam was president of the MFA in Boston, so Lewes House served as a sort of buying agent for Robinson in the 1890s. Relationships between private collectors and early museum professionals like Robinson and Kent represented a professional departure from the previous generation of museum leaders in the United States. Many museum founders were themselves collectors who stocked galleries. For example, Cesnola had donated the Metropolitan's extensive collection of Cypriot art after amassing it while serving as U.S. consul to Cyprus earlier in the nineteenth century—Cesnola's generosity led immediately to his positions on the museum's board and as its first director. Kent and Robinson, however, became institutional collectors—they fostered relationships with individual collectors that would eventually develop into professional networks that they could use to build museum collections as they implemented the modernisms they envisioned. In Norwich, Americana collectors such as George Palmer and his cousin Eugene Bolles had sought Kent out for his knowledge of Norwich history, and Kent in turn relied on them for periodic exhibitions. By relying on networks of collectors, these progressive connoisseurs also introduced professional standards that protect institutional interests by keeping individual museum curators from competing in the market for art.

In 1900, Kent moved from Norwich to New York to become the assistant librarian of the Grolier Club, a position that he credits with adding connoisseurship to his taste and practical museum education.[99] The Grolier Club, founded in 1884 as a private club for book and print collectors and named after a French bibliophile, housed an impressive collection of rare books, from which it mounted exhibitions of the "book arts" in its clubhouse space. To illustrate the evolution of his taste, Kent distinguished his professional education under Melvil Dewey from the refined education he received at the Grolier Club. Kent claimed that Dewey was neither a "great student or scholar, nor a great bibliographer, but he was [rather] what may be called a great mechanician."[100] But at the Grolier Club, Kent developed more critical

tastes. Drawing on the resources of the club, Kent learned the art of elegant book making through acquaintance with master printers who still practiced that artisanal craft. His introduction to New York collectors further informed his connoisseurship and his knowledge of craft traditions.

The informal nature of the Grolier Club, and the friendships he established there, also provided Kent access to a new social landscape of connoisseurship and epicurean taste, which he entered on a less deferential level than he had previously experienced. New York was emerging as a modern industrial metropolis when he arrived at the turn of the century, but the Grolier Club offered a comfortable, buffered atmosphere for its antiquarian members. "It was a different New York in those days," Kent recalled: "much more quiet and sedate."[101] As a bachelor new to New York, Kent took as much advantage of the club's sociability as an employee could, and he became an eager student of the members' antiquarian knowledge and their social pretensions. Members of the Grolier Club introduced Kent to the fashionable world of *fin de siècle* dandies, where topics of conversation at Delmonico's varied from debate about Benjamin Franklin's romantic reputation to competition over who had the closest friendship with aesthetes like James McNeill Whistler.[102] Kent recalled his admiration for the salad-making skill exhibited by member Hopkinson Smith, "whose ability to make various combinations of greens and a remarkable variety of dressings required a grand array of pots and kettles around his plate and the attention of everyone at table."[103] Likewise, Kent appreciated the domestic taste exhibited in members' homes. Kent found William Loring Andrews's house on Thirty-Eighth Street "a delightful place, filled with illustrations of his interests, engravings of New York, and, I remember, a silver teapot by Paul Revere." Curiously, despite the American provenance of Andrews's collections, Kent swooned, "It was such a room as would have been used by a French bibliophile."[104] Joining Grolier Club librarian Richard Hoe for breakfast meetings, Kent marveled that he often found Hoe "with Lamerie dishes in front of him and a French poodle on a chair on either side of him."[105]

The personal and professional skills Kent learned at the Grolier Club, and the relationships he fostered with New York collectors and connoisseurs, further enhanced his reputation as museum man. Through professional and personal experiences that combined an ethos for public service and practical education with cultivation of taste, Kent established a professional reputation for himself as a progressive connoisseur. Robert de Forest was eager to tap professional talents like Kent and Robinson, but museum politics at the

Metropolitan forced him to hold his plans for implementing democratic museum modernisms.

As early as 1895, the de Forest faction had tried to exert influence on the Metropolitan's board and advocate dramatic change, but for the moment, older trustees held onto power and continued to determine the museum's agenda. Frustrated by Cesnola's intransigence, de Forest and other members of his committee on casts orchestrated a coup in 1895 to remove Cesnola from his position as both director and secretary of the board of trustees. De Forest summoned a large group of trustees by cablegram to John Kennedy's Fifty-Seventh Street house to discuss removing Cesnola from the board. Trustee Hiram Hitchcock, Cesnola's only defender at the meeting, reported that de Forest organized the gathering where several trustees, including founding trustee Joseph Choate, argued that Cesnola "was not the right man for the place, hindered progress, prevented gifts, was deceptive, brusque, insulting, domineering, unjust to subordinates, not a good manager, not in touch with art here or in Europe, does not fairly represent us, is a martinet, owns the museum," and perhaps most inflammatory, "controlled Mr. Johnston and now controls Mr. Marquand."[106] The assembled trustees drafted a letter to Marquand recommending Cesnola be released from his services and from all connections with the Metropolitan Museum. Apparently shocked by their letter, Marquand accused de Forest and Kennedy of timing their request to occur while older, conservative trustees like Frederick Rhinelander and William Dodge were in Europe. The younger trustees nonetheless insisted on presenting their proposal for an immediate vote at the pending annual meeting of the board. "I am sorry to say," Marquand wrote another trustee, "that it looks like a contest is coming on Monday at the Museum." "The plan is an adroit one," he continued, "by the youngest of the trustees to put Cesnola out. If they succeed the conservative force will go and the Museum will be run by the impressionists."[107]

The younger trustees centered their argument on Cesnola's intransigence and his inability to fulfill the museum's mission of usefully educating the public. "The Museum cannot, so long as his official relations to it continue," de Forest insisted in a public statement to the press, "maintain those relations with other museums at home and abroad, and with the art and scientific, not to speak of the general, public, which are important to its growth and influence."[108] The de Forest faction specifically objected to Cesnola's resistance to new ideas and the damage he caused the Metropolitan's reputation. Referring to the directors of other museums, one trustee complained, "no one of

such officials speaks of him with respect as a well-equipped, erudite archeologist."[109] In fact, Cesnola's scholarship had been criticized so roundly—both Clarence Cook and Edward Robinson had denounced his collection of Cypriot art—that many critics questioned the Metropolitan's value as an educational institution.[110]

Ultimately, the conservative force on the Metropolitan's board held out, but the *New York Times* made it clear that their vote saving Cesnola' position represented resistance to "young blood" among trustees, rather than a vote of confidence.[111] Museum president Marquand threatened resignation if the measure carried and he presented a supporting letter from J. P. Morgan, a trustee since 1888 who promised significant future gifts to the museum. His position saved, Cesnola wrote to conservative trustee William Dodge (president of the Young Men's Christian Association and former head of the New York City Chamber of Commerce), "With our presently divided Board it will be impossible to continue to run the Museum as successfully as before." The new generation of trustees on the board had very different ideas about running a public art museum, and they were not willing to back down. "To bring back harmony to the Board is impossible," Cesnola continued, "to get rid all at once of the de Forest faction is also impossible, because none will resign, and the terms of some extend to 1901." "What will happen to the Museum between now and then," Cesnola warned, "God only knows!"[112]

While nothing dramatic happened at the Metropolitan Museum between 1895 and 1901, the institutional changes the de Forest faction envisioned had been introduced and only needed time to develop. Progressive connoisseurs such as de Forest, Kent and Robinson spent the last years of the nineteenth and first years of the twentieth century working out their own professional strategies, and preparing for the moment when they could move into positions of leadership and make museums the kind of useful public institutions they had studied. Robinson and Kent continued to build collections of plaster casts for museums and schools throughout the country while they also pursued their own individual interests. While promoting the educational value of casts, Robinson had also spent the 1890s expanding and refining the collection of classical antiquities at the Museum of Fine Arts—in 1902 Boston recognized Robinson's scholarly reorganization of the collection by appointing him director of the museum. At the Grolier Club, Kent continued to develop his professional skills and cultivate friendships with gentlemen collectors. De Forest further consolidated authority in the city's social reform movements by chairing housing, public art and preservation commissions, and by financ-

ing savings and loan institutions like the Provident Loan Association, which he founded during the economic depression of 1893. By the early twentieth century, de Forest had accumulated sufficient political and cultural capital that he became popularly known as New York's "first citizen."

Between 1899 and 1904 Cesnola and nine other older trustees at the Metropolitan Museum died, allowing the progressive connoisseurs to move into positions of leadership and implement their plans for a more democratic and publicly accountable modern museum. During the 1890s they had experimented with education reforms in American museums to overturn the image of Gilded Age museums as elite temples of art that would both lift up the poor and improve moral behavior. Instead, museum leaders like Robert de Forest, curators like Edward Robinson, and managerial professionals like Henry Watson Kent tried to make museums useful public institutions. When they moved into positions of cultural authority in the early twentieth century, the American museums they ran finally achieved the international status their founders had envisioned. Despite arguments that art museums abandoned their education goals once they shifted from exhibiting casts and running art schools to focusing on fine art, the men and women who assumed positions of leadership in these art museums used their cultural capital to present a progressive museum agenda for education reform.

CHAPTER TWO

═════

The De Forest Faction's Progressive Museum Agenda

In 1905, the Metropolitan Museum underwent an institutional revolution that reverberated throughout American museums. A new generation of trustees and museum professionals—Henry Watson Kent, Edward Robinson, Robert de Forest, and other likeminded progressive connoisseurs—replaced the old guard of museum leaders who believed that simply providing access to art could lift up the poor and improve society. This new guard believed museums should instead introduce practical education reforms that could effect social change, like other Progressive Era institutions. Progressives expanded upon earlier nineteenth-century philanthropic reform, which had focused on ameliorating individual circumstances through moral uplift, by implementing broad programs to restructure the urban environment. Twentieth-century reformers believed that they could implement political and social reforms that emphasized order, rationality and efficiency. They used new social science techniques of investigation (surveys, statistics and models) and the behavioral theories of environmental determinism and social engineering to manage cities and regulate social tensions. Combining philanthropy with governmental power, and starting with individual families and working out through the local community to the larger city and nation, progressive reformers tried to improve the built environment in order to influence individual, community and national civic character.[1]

At the Met, Robert de Forest integrated modern principles of bureaucratic management and standardized tools of social research into museums to develop efficient education programs that could produce practical results.

Popularly known as New York's "first citizen" by the early twentieth century, de Forest fused cultural institutions like museums with the larger social reform movement. By the end of the first decade of the twentieth century, de Forest had staked a place for the museum within an institutional network of educational and social reform institutions, through education work with schools and industrial designers. Museums in the nineteenth century had always purported to educate the public, but policies of access restricted galleries to elite and middle-class visitors, while art schools physically segregated working-class craftsmen from the museum. After 1905, the Metropolitan Museum led the movement to make museums educational institutions dedicated to public service. Because de Forest believed that the entire city constituted the museum's membership, making the galleries work required extensive outreach. Coordination with schools and settlement workers would foster appreciation of beauty among future citizens, and coordination with manufacturers and trade associations would improve the quality of finished products available to citizen-consumers.

The Metropolitan announced in its 1905 annual report that the museum had just entered a new epoch in its history. "The generation that had watched over its birth and directed its early development has almost passed away," the museum observed. "The new generation of trustees now enter upon their labors, and into opportunities which these labors have created."[2] The day after former museum director Louis di Cesnola's funeral, J. P. Morgan was elected president of the museum's board and Robert de Forest its secretary and first vice president. While Morgan stacked board vacancies with fellow millionaires like Henry Clay Frick and George Blumenthal, de Forest recruited like-minded trustees who shared his vision of museum reform, including three members of de Forest's 1891 plaster-cast advisory committee, whom older trustees had once referred to as the de Forest faction.[3] Instead of relying on personal stewardship, the new trustees ran the museum like a business. Robert de Forest immediately hired the young museum professionals Henry Watson Kent and Edward Robinson to help him modernize the museum's professional infrastructure, restore its art-historical credibility and expand its educational accountability. The progressive connoisseurs de Forest recruited to the Metropolitan Museum after 1905 developed a new agenda for the education of civic taste. Museum reformers insisted that the museum had a civic responsibility to improve public taste because the ordered beauty of home environments—and the everyday things that surrounded people—contributed to good citizenship. Through professional associations and phil-

anthropic foundations, Kent and de Forest later disseminated their ideas of cultural democracy and the relationship between art and labor to museums and libraries across the nation.[4]

Like many Progressive Era reformers, the new leaders of the Metropolitan Museum looked for usable pasts to inform the present. Rather than bury their heads in the past, the new generation of progressive connoisseurs embraced industrial and social modernization, but they argued that the past could be used to inform the industrial present and future. Reformers suggested that the museum, as a repository of art, had the best public resources in the city to teach the public principles of good design. Curators selected what they considered the best examples of tasteful historical objects like Chippendale chairs and federal-style tables, and they presented them as models for public taste. While trying to make art museums democratically accessible through outreach to a new urban public of working New Yorkers, cultural leaders nonetheless reinforced traditional hierarchies of education and status by giving museum curators and other recognized connoisseurs the authority to distinguish good taste from bad. The subjective nature of selecting objects from the past as models for good design in the present represents one of the many paradoxes of turn-of-the century cultural reform. Social and cultural modernists searched for a usable past, but their judgment was frequently clouded by the nineteenth-century conventions they tried to overturn.

New York's First Citizen

Robert de Forest illustrates the sometimes contradictory impulses of progressive reform, and the ambiguities of programs for the democratic cultivation of civic taste. De Forest was very proud of his taste, and he likely believed that careful attention to the details of his own homes contributed to his commitment to civic engagement. However, few New Yorkers had the cultural and economic resources to cultivate his version of domesticity. De Forest lived in a Greek Revival-style townhouse mansion on Washington Square North with his wife Emily. Once the most fashionable district in the city, by the early twentieth century Greenwich Village represented "old New York." In her 1906 novel *Custom of the Country*, Edith Wharton placed representatives of that old Knickerbocker tradition on the block she herself had once shared with de Forest to contrast the city's older gentility to the crass, modern industrialists living farther uptown.[5] But the de Forests filled their home with furnishings and art that bridged those older traditions and the modern century.

Figure 9. Home of Robert de Forest, 1934, Washington Square North, Greenwich Village, New York, N.Y. Historical American Buildings Survey, Library of Congress.

When they received the townhouse as a wedding present in 1873, the de Forests moved in with the furniture that Emily de Forest's grandfather had originally commissioned in 1832 from New York cabinet maker Duncan Phyfe. Phyfe had been New York's premiere furniture maker in the early nineteenth century because his neo-classical designs seemed to mark the high point of American craft development. By the early twentieth century, they also represented to taste and design critics the swansong of American taste before the advent of industrial production. Emily de Forest's inherited furniture therefore gave the young couple a solid, respectable aesthetic foundation upon which to build their domestic taste.

The de Forests decorated their home in a cosmopolitan style that mixed classic antiques with cutting-edge design, and American tradition with exotic flourishes. Upon moving in, they added Egyptian collectibles acquired during their wedding trip. In the 1890s, the de Forests built a modern library addition in their back garden, and they hired friend and distant relative Louis Comfort Tiffany to decorate it in the modern, fashionable style of Aesthetic exoticism. Tiffany filled the library with designs of his own, with East Asian treasures the couple picked up during their world travels, and with teakwood furnishings made in the colonial Indian workshops of Robert de Forest's brother, Lockwood de Forest.[6] In 1898, de Forest hired architect Grosvenor Atterbury to build a sprawling country estate called Wawapek in Cold Springs Harbor, Long Island, which the de Forests filled with Emily de Forest's American antique and ceramic collections.[7] Atterbury himself was known as a pioneering professional architect for his ability to combine aesthetic elements from the past with technical innovations like poured concrete and skeletal steel construction.[8] When the de Forests decided to combine old American antiques with modern furnishings, and when they segregated high-style pieces like their Duncan Phyfes from more humble American antiques in their city and country homes, they also revealed how selective the search for a usable past could be.

De Forest was a paradoxical figure: on the one hand, he represented a new model of twentieth-century reformers who applied social-science theories and principles of business management to older nineteenth-century ideas of charitable uplift, but he was also a member of New York's cultural and economic elite. Descended from seventeenth-century shipping magnates, and a board member of multiple railroads, de Forest represented both old New York and the modern, industrial era. He used older patriarchal methods and personal connections to accomplish his modern social agenda. But de For-

est was also an old-world aristocrat, and his philosophy was at least in part influenced by noblesse oblige. He believed in assisting people in their own improvement, rather than handing out blank-check assistance. As a man committed to shaping the modern corporate world, but bound by older conceptions of social relations, Robert de Forest represented the contradictions of his period. [9]

De Forest's aristocratic worldview also influenced his relationships with his subordinates, and their interaction often mixed professional managerial delegation with patriarchal deference. Though de Forest and Kent worked together to shape the built environment by improving public taste, they were not equals in the modern institutions through which they worked. While de Forest was a first citizen, socially and economically connected to New York's cultural and political elite, Kent was a member of the new managerial professional class, who maintained a position of respectful deference to the man to whom he owed both his livelihood and his professional opportunities. In his autobiography, Kent recalled morning meetings with de Forest in his Washington Square townhouse, at which they discussed the museum modernisms they planned for the Metropolitan while de Forest ate his breakfast. Kent recalled that de Forest was always "complaisant and willing to let me try out new ideas."[10] Nevertheless, their morning interactions reflect the social divide that separated these two progressive connoisseurs. Kent lived across Washington Square Park in a bachelor's apartment house called the Benedick, whereas de Forest lived on the Row, nestled among his wife's inherited Duncan Phyfes, their exotic collectibles, and the modern improvements they made to the house.[11] Kent never mentions in his memoir that de Forest walked across the park to see him, nor that they ever met socially, or that Kent even joined his boss for breakfast. After their morning meetings, Kent likely traveled uptown to the museum on elevated trains, and perhaps later on the new subway lines, while de Forest doubtless motored to the museum after conducting business at his Wall Street office and supervising his various institutional reforms.[12] Their different approaches to progressive connoisseurship represent the sometimes constrained social and professional interaction that "modernity," brought on by industrial capitalism, demanded of institutional leaders and their subordinates in the early twentieth century.

In many ways, de Forest's social background and his economic commitments shaped his social and aesthetic reform philosophies. Progressive reformers on both the sides of the Atlantic shared de Forest's philosophical vision of the city as a collective household, and they worked to improve modern society

through programs of social engineering and manipulation of the built environment.[13] But when de Forest sent his professional subordinates to museums and international conferences to study and bring back European approaches to reform, he only selectively used their ideas and programs. Whereas more radical social intellectuals responded to the social problems of industrial cities by experimenting with urban collectivism or public control of housing and infrastructure, American Progressives like de Forest used cross-Atlantic ideas to enable the development of industrial capitalist society. A cultural critic like Lewis Mumford shared de Forest's imperative of aesthetic and social reform, and of clearing away the clutter of nineteenth-century homes and cities, but he formed very different conceptions of how to respond to industrialization. Like de Forest, Mumford also looked for usable pasts, but he departed from the direction of de Forest's reforms by using ideas from the past to radically reconstruct the social and political landscape.[14] De Forest, in contrast, searched for usable pasts that could guide industrial modernization, rather than eradicate it. After all, de Forest's institutional influence came out of his business, social, and family relations—whose members all had a stake in the successful transition to a modern twentieth century industrial capitalist society.

After 1905, de Forest integrated the Metropolitan Museum into his larger network of cultural and social-welfare institutions by developing an agenda for the education of civic taste. Hoping to use the museum to effect social change, de Forest introduced education reforms at the Metropolitan that focused on the home, and he reached outside the museum's walls to influence a broader museum public. Kent implemented the museum's new social agenda by rationalizing its organizational management and developing education programs that reached out to schools and local industry. By improving consumer taste and the quality of manufactures available to consumers, the Metropolitan Museum hoped finally to fulfill its founding mission of educating the people. As New York's "first citizen," Robert de Forest integrated museums into a larger social agenda: to refashion the aesthetics of American cities by carefully selecting elements from the past to shape the modern built environment of homes, neighborhoods and cities.

The Civic Household

The 1900 Tenement House Exhibition provided a model for de Forest of the social impact that exhibitions could have on the public. The Tenement House Exhibition awoke middle-class New Yorkers to the horrors of living

conditions in working-class neighborhoods, and it pushed leaders like Theodore Roosevelt to improve housing regulations. It also suggested to de Forest the power of exhibitions to educate the public. Through the first decade of the twentieth century, de Forest consolidated cultural authority as he built model communities, oversaw historic preservation, and disseminated progressive ideas about art and democracy through philanthropic institutions like the Sage Foundation. Social exhibitions like the Tenement House Exhibition exemplified the Progressive commitment to civic housekeeping in the early twentieth century. Reformers believed the city represented a collective household that could be managed, so they applied principles of professional management and tools of social research to their project of engineering the city. The social exhibition emerged as a powerful tool to illustrate social problems in industrial cities by presenting to the public vivid images of poverty and social exclusion, and offering solutions through models of good government and city planning. For civic leaders like de Forest, the social exhibition itself became a model for bringing together experts from various fields to efficiently educate the public.

Just as museum reformers had looked to European models in the 1890s and stepped beyond uplift ideas to develop education programs that could produce practical results, social reformers looked for models that could make real changes in the social and living conditions of American cities. The social exhibition both educated the public about unhealthy, dangerous living conditions and advocated change. The 1900 Tenement House Exhibition, sponsored by de Forest, so successfully opened public eyes to the problems of urban housing that state and municipal commissions established new housing laws to improve living conditions. Convinced that exhibitions of art could similarly effect social change in the early twentieth century, after 1905 de Forest positioned the Metropolitan Museum within a larger network of civic institutions committed to shaping the modern American city.

Housing reformer Lawrence Veiller claimed to have invented the social exhibition as a mechanism that he hoped would generate public interest and demand for social improvements. Veiller worked with de Forest to organize the Tenement House Exhibition of 1900 to argue for legislation to improve housing conditions in New York's immigrant slums. Despite improvements in housing codes over the previous several decades, the majority of the city's working population continued to live in unsanitary, dangerous tenement buildings because the "Building Ring"—a collusion of property owners,

their lobbyists and corrupt politicians—prevented better housing regulations and enforcement of existing laws. Veiller was a fierce critic of New York's dumbbell-style "old law" tenements with their narrow air shafts and inadequate sanitary and fire provisions. He believed strongly in environmental determinism, and he argued that better housing was the key to providing better opportunities for New York's immigrant poor. When the Tenement House Exhibition opened, Veiller wrote that he had been "convinced that no real progress was to be made unless the whole community was aroused to a knowledge of existing conditions." Therefore, he gave "the public such a statement of tenement-house needs that no one concerned could longer neglect taking action toward the amelioration of the living conditions of the working people of New York."[15] The Tenement House Exhibition itself became a model for the social exhibition in the twentieth century, which progressive reformers used to publicize social problems and propose solutions.

The Tenement House Exhibition also represents one of de Forest's first successful attempts at reforming the built environment by bringing together experts and collaborating with other institutions. At Veiller's urging, de Forest organized a housing conference under the auspices of the Charity Organization Society to advocate for a permanent city organization with the authority to revise and enforce housing standards.[16] Just before de Forest joined the Metropolitan Museum's board in 1889, he became president of the Charity Organization Society (COS) through his friendship with its philanthropic founder, Josephine Shaw Lowell. A longtime welfare activist and widow of Civil War hero Robert Gould Shaw, Lowell had encouraged the city to form the Charity Organization Society in 1882 to coordinate independent charities and eliminate redundancy. COS advocated improvement of social conditions rather than charitable moral correction, and it kept extensive records of living conditions through site visits by its "friendly visitor" staff.[17] This documentary information eventually contributed to the extensive block-by-block surveys and statistical records that Lawrence Veiller compiled for the Tenement House Exhibition.

Like de Forest's other assistants in his various philanthropic affiliations, Veiller brought to the organization professional expertise as a housing reformer. He coordinated all aspects of COS research and advocacy, and he implemented its policy. Veiller traveled frequently to Europe to study housing reform, and he was a faithful attendee at international housing conferences.[18] Throughout the 1890s, housing conferences and city-planning exhibits circulated ideas about model housing, urban layout, and zoning restrictions.

Veiller used many of these models to begin what he called "a wide education of the people of New York City as to the serious evils that existed and the necessity for effective remedies."[19]

The COS tenement commission represented an alliance of New York's new generation of reform activists and a new generation of voluntary civic leaders like de Forest. The commission included Veiller, de Forest, muck-raking journalist (and Teddy Roosevelt's vice-busting associate) Jacob Riis, architectural historian and philanthropist Phelps Stokes and COS reformer Edward Devine, as well as settlement house veterans Lillian Wald (Nurses Settlement), James Reynolds (University Settlement), and Mary Simkovitch (Friendly Aid Society). Nevertheless, the commission's proposal to amend existing housing law and enforce its subsequent application by both build-ers and owners languished in Albany under fierce opposition until Veiller's 1900 Tenement House Exhibition generated widespread public attention and enthusiasm.[20]

When the Tenement House Exhibition opened at the Sherry building on Fifth Avenue, it marked a significant shift in attempts to reform American cities by publicizing the social impact of unregulated housing markets. The exhibition presented over one thousand photographs, as well as charts and maps, which illustrated to middle-class and wealthy New Yorkers the living conditions of most of their working fellow citizens, and it linked those condi-tions to the civic health of the city. But the exhibition not only forced its visi-tors to confront existing conditions; it proposed solutions to the problems of tenement housing by providing models of affordable, well-made apartment buildings.

The Tenement House Exhibition offered solutions to the tenement house problem by suggesting restrictive legislation, by presenting model buildings as commercial enterprises, and by proposing improvements to existing build-ings. Veiller claimed that he worked sixteen hours a day for months—"almost killing myself in preparing this work."[21] In addition to the building models and thousands of photographs that documented existing conditions in tenement districts, Veiller compiled statistical data from COS case workers that corre-lated reports of infectious disease and applications for poverty assistance with block-by-block maps.[22] By comparing data, Veiller's maps showed that pov-erty and disease predominated in immigrant neighborhoods because of their physical conditions, and thereby demonstrated the environmental causes of poverty.[23] Veiller challenged what he called "the old-fashion idea that work-ing people did not wish to bath" and he hoped the exhibit would expose as

"foolish fallacy" arguments that they were responsible for their situation.[24] Combined with displays of model tenement apartment plans, the exhibition articulated the message that housing reform needed to be implemented in response to the city's industrial and demographic growth.

As Veiller hoped, the Tenement House Exhibition drew huge crowds and generated strong public support for housing reform. After the opening, the *New York Times* reported that the Sherry building's ballroom was "crowded beyond the doors, and a large number of the visitors were unable to gain admittance."[25] At the opening, de Forest told the political and social dignitaries who did get in the door that the pictures and plans in the exhibition told more in five minutes than could be obtained in a library in five weeks. "The highroad to the Ladysmith of tenement reform," de Forest enthused, could be seen in the practical models presented in the exhibit, which proved that good housing could be produced as a business enterprise.[26] De Forest's analogy to breaking news of British relief forces in South Africa during the Boer War likely also struck chords of immediacy and strategic importance with his audience. As a new model for social reform, the tenement exhibit moved beyond tugging at public heartstrings, and instead presented practical proposals for a broad constituency of power brokers in political and financial circles who could implement de Forest's goals for improved housing.

Veiller's Tenement House Exhibition succeeded in encouraging state intervention in the housing market: New York Governor Theodore Roosevelt changed housing laws and established a state tenement house commission under de Forest after he saw the exhibition. At the opening of the exhibit, Roosevelt said, "if we succeed in upbuilding the material and therefore moral side of what is the foundation of the real life of the Greater New York we shall have taken a longer stride than is possible in any other way toward a solution of great civic problems." "Go and look through the charts downstairs," Roosevelt urged, "which show the centers of disease and poverty, and remember that it is there that the greatest number of votes are cast."[27] In a speech a few weeks later to the state legislature, Roosevelt explained that the proportional relationship between social disorder and inadequate living conditions presented in the exhibit proved that certain "decencies of life" were "indispensable if good citizenship is to be made possible."[28] Roosevelt was reportedly so moved by the exhibit that he asked Veiller to tell him what needed to be done, and said he would help him do it.[29] It did not hurt that tenement reform was both politically expedient and in line with his own agenda. In his speech to the state legislature, Roosevelt asserted that

Figure 10. Poverty and Disease maps showed block-by-block conditions in tenement districts—stacked above and below so viewers could compare conditions. Dots on buildings indicated families who had either applied for assistance or been reported by the Health Department for various diseases (coded by color). Veiller claims that few buildings had no dots, and many had several. These maps show conditions on blocks bounded by 17th and 23rd Streets, and Third Avenue and Avenue A. Lawrence Veiller, Disease Map, Tenement House Exhibit, 1900. Collection of the New-York Historical Society, L7.2.17.

Figure 11. Lawrence Veiller, Poverty Map, Tenement House Exhibit, 1900. Collection of the New-York Historical Society, L7.3.17.

immediate new tenement laws were "in the interest of the State whose standard of citizenship in the future is partly dependent upon the housing of children in the tenement house districts of the present."[30]

The exhibit's success catapulted de Forest's reputation as a civic leader, and it fired his enthusiasm for reforming the built environment. De Forest became commissioner of the New York State Tenement House Commission, with Veiller as his executive deputy, and with the authority to enforce state law to improve housing conditions. The new housing law of 1901 required generous courtyards between and behind buildings, it set minimum room dimensions, and it established an enforcement department to ensure compliance.[31] De Forest explained the environmental influence of homes in *The Tenement House Problem*, a 1903 report for his new tenement house commission. "It is only by providing homes for the working people, to protect life and health and to make family life possible, free from surroundings which tend to immorality," he argued, "that the evils of crowded city life can be mitigated and overcome." This was de Forest's first step toward improving civic capacity by improving the built environment. "Homes are quite as much needed to make good citizens as to make good men," he insisted. "According as the working people are provided with better or poorer homes will the government, morals, and health of a city be better or worse."[32]

After closing in New York, the Tenement House Exhibition toured American cities like Chicago and Boston before it went to the 1900 international exposition in Paris. The Palace of Social Economy at the Paris Exposition presented a social-economy pavilion that included labor protection, agricultural reform, cooperative organizations, savings and insurance institutions, and public health and housing reform.[33] The Paris Exposition provided a forum for progressive reformers from Europe and the United States to share information and publicize reform models, and it sparked a transatlantic exchange of ideas through the first decades of the twentieth century.[34] Progressive connoisseurs also flocked to the exposition's stalls to study international models, and to determine what they could borrow and adapt for local conditions in American cities.

Tapping into public enthusiasm for social exhibitions and urban reform, de Forest joined social reformer Jane Addams for a joint forum on urban housing conditions. When Addams opened Hull House in 1889, she was first among many of her generation to transplant the settlement house idea from European social-reform models like Toynbee Hall in London. The settlement house movement of the 1890s focused on improving living conditions for

Figure 12. Tenement House Exhibit, Palace of Social Economy, Paris, 1900. Courtesy of Smithsonian Institution Libraries, Washington, D.C.

working-class immigrants by working directly with local communities to assess conditions and implement change. Settlement house workers, mostly young college-educated middle-class women, moved into tenement neighborhoods to teach working-class families homemaking skills that included food preparation, ironing, sanitary improvement and general healthcare, as well as providing English language instruction and classes in American civics. Combining civics and homemaking made perfect sense to settlement workers because of their belief in the wider social benefit of good, orderly homes. Settlement leaders in New York worked with de Forest on tenement house commissions, and they frequently collaborated with leaders like Addams at international housing conferences.

"A Housing Conference, it seems to me," Addams insisted, "ought first of all to look at industrial conditions as they confront the workingman to-day, not as conditions existed fifteen or twenty years ago, nor as they existed

for our fathers." Dismissing what many among her generation of reformers considered a nostalgic earlier image of cities that uplift ideas seemed to cling to, Addams continued: "A conference should not consider the workingman of its imagination, nor yet the workingman as he ought to be, but the workingman of to-day as he finds himself."[35] As chair of the Chicago City Homes Association, Addams oversaw Chicago's contribution to New York's Tenement House Exhibition, and she hosted the show when it traveled to Chicago later in 1900. To make clear to local visitors the conditions in Chicago's slum districts, the Chicago exhibition augmented Veiller's poverty and disease maps with local displays that represented Chicago's typical dilapidated frame houses. "These old frame houses, below grade, every room filled to overflowing," the *Chicago Daily Tribune* reported, "constitute a veritable culture of contagion."[36]

Throughout the Progressive Era, reformers used the social exhibition as a model for educating the public. In 1909, for example, a social exhibition of the Pittsburgh Survey, documenting living and working conditions in the center of steel manufacturing with statistics and photographs by Lewis Hine, grabbed the attention of reform-minded publics in cities throughout the U.S.[37] Today, these social exhibitions filled with statistical data, charts and architectural models seem rather dry, and unlikely either to attract large audiences or to influence art museums. However, the public-policy success of the Tenement House Exhibition, and its popular appeal to an emerging civic-minded middle class, made it a useful tool for presenting social problems through detailed statistics, and offering solutions to those problems through models for better accommodations. After sending the Tenement House Exhibition on multiple tours, Veiller and de Forest repackaged some of its public health data and developed traveling tuberculosis exhibitions that similarly charted rates of infectious disease and offered models for sanitary living conditions. In 1902, one TB exhibit featured the reproduction of a dark interior bedroom to show what Veiller called "indescribable filth and disorder."[38] Copies of the social exhibition format often included before-and-after model apartments to illustrate the advantages of healthy, well-maintained home environments. These exhibits proved to museum reformers like de Forest that exhibitions focused on the home had the power to improve household taste, and to fulfill their goals of making their galleries work for the people. After visiting the tenement exhibit in Chicago, the *American Architect and Building News* recognized the practical promises of fusing social reform with cultural institutions when it mused,

"perhaps, the best art of the twentieth century will have such questions in its code of ethics."[39]

Robert de Forest heeded that call, and he found additional ways beyond the social exhibition to integrate museums and other cultural institutions into a larger reform movement focused on improving the built environment of cities. Programs for the cultivation of civic taste aimed to enhance the individual's capacity to participate in civil society. Reformers saw the city as a collective household, and they insisted that public institutions like museums had a civic responsibility to improve the aesthetics of the built environment. Through his leadership position in philanthropic social reform institutions like the Sage Foundation, Robert de Forest focused on improving the condition of physical surroundings in order to provide people with the ability to help themselves. Like other Progressive Era reformers, de Forest believed that improving living conditions insured that people would have opportunities to participate in democratic society.

The Russell Sage Foundation became de Forest's most important institutional source for funding taste education and for financing the many social-engineering, built-environment and aesthetic reforms he oversaw as the leader of various institutions. According to some historians the foundation was a financial mainstay of social welfare because it seemingly stood behind almost every important reform project of the early twentieth century.[40] After financier Russell Sage died in 1906, de Forest helped his widow, Margaret Olivia Sage, establish a foundation for "social betterment." De Forest drafted a mission statement that allowed the foundation to respond to various social problems by hiring specialized research experts to study them, and policy advocates to propose remedies; the foundation's considerable endowment let de Forest carry through those policies.[41] Ultimately, the Sage Foundation became de Forest's most successful funding apparatus, which he used to purchase museum collections and finance exhibitions at the Metropolitan Museum, to build model homes and communities, to preserve historic civic buildings, and to finance city planning.

Reformers like de Forest saw city planning, beautification, and zoning as ways to regulate the built environment of cities because they believed that ordered cities—like ordered homes—contributed to the development of civic character. While progressive reformers recognized industrial change and urbanization as progress, they believed that industrial cities should be tamed, and maintained. Progressive reform of the urban landscape often entailed

clearing slum neighborhoods of dilapidated buildings, and replacing symbols of urban vice and corruption with parks and civic monuments. By eliminating from the landscape the physical embodiments of the worst excesses of industrial capitalism, reformers hoped to foster better-run cities. Planning and beautification, therefore, had both political and social implications. More efficient, better-looking cities, it was hoped, would ease social tensions, just as sanitary tenement housing would improve public health.

The Sage Foundation's Forest Hills project represents de Forest's ambitious reach, in this case a plan for building attractive model homes to improve civic capacity. In 1908, the foundation purchased 200 acres of land in central Queens to develop a model community with mixed, multiple-class garden-style cottages. Modeled in part on British reformers' working-class garden communities, but consistent with the commercial imperatives of tenement reform, Forest Hills was both a philanthropic project to provide affordable and aesthetic housing, and an example for developers of using good design as a business proposition.[42] De Forest hired his personal architect Grosvenor Atterbury to design the houses, and Frederick Law Olmsted, Jr. to lay out the community. Located outside Manhattan's tenement house districts, Forest Hills offered working New Yorkers a pastoral, aesthetically pleasing environment. The community featured a paved town square, tree-lined narrow winding roads, and cottage-style garden homes and apartments. Unfortunately, the high cost of land and the project's high design standards meant that the community was too expensive for the poor, so Forest Hills ultimately became a middle-class suburb.[43]

The failure to bring good design to the people echoed British efforts by reformers like William Morris, who never managed to reconcile the high cost of hand production with broad availability. Whereas British social reform models like Ebenezer Howard's garden city in Letchworth (designed by Raymond Unwin) relied on a single-tax structure, and whereas other European municipalities experimented with legal and administrative measures to limit urban land speculation, Forest Hills was always a private development, which served precisely as a model for other private developers. At the end of the day, British garden cities mostly provided an aesthetic model for American reformers, rather than political, economic or social models. Historians argue that American reformers in general, and de Forest in particular, resisted state investment, so their European-inspired reforms always failed to work out in the same way.[44]

The City Beautiful movement of building civic monuments and ordering

industrial cities also represented many of the Progressive goals of shaping the built environment in the early twentieth century, as well as many of the limitations of city planning in the United States. As part of de Forest's interest in reforming the collective household of the city, he looked to civic spaces that could serve as sites for informing his vision of democratic virtue. To regulate the appearance of the city—from new construction of municipal buildings and public art to drinking fountains and letter boxes—de Forest sat on the boards of most of New York's art and planning commissions.[45] Through the Municipal Art Society and the city's Art Commission, he advocated City Beautiful features like monuments and grand civic centers, modeled on those recently constructed in Baron Haussmann's Paris and Daniel Burnham's Chicago.[46] These urban plans featured ordered landscapes of broad avenues laid out in geometric patterns, classically inspired civic buildings, and open vistas of parks and monuments. For many planners, they represented the antithesis of the disordered, chaotic industrial city. Large-scale building projects, however, required government intervention into private real estate—a violation of American traditions of property that proved difficult for many American reformers to stomach.

Comprehensive plans to refashion civic landscapes also required selective decisions about what elements of the city to save and what to discard.[47] The restoration of New York's City Hall, and its installation of tasteful, patriotic interiors, represented the kind of usable past de Forest and other reform leaders sought to promote. In fact, finding a suitable usable past at City Hall—the seat of government in the nation's largest city and notoriously the seat of numerous Tammany Hall administrations—seemed fundamental to civic reform. City beautification thus entailed the careful preservation of symbols of good government and the destruction of bad. In 1858, the 1803 building by Joseph Mangin and John McComb had suffered from a fire that destroyed its cupola, much of the interior rotunda and its public halls. De Forest again hired his architect Grosvenor Atterbury, who was simultaneously at work on Forest Hills housing plans, to professionally restore the building. Atterbury's restoration is often seen as an early example of professional, scientific preservation. Columbia School of Architecture curator Richard Bach wrote in the *Architectural Record* that the restored City Hall "may be said more nearly to approximate the dream of old John McComb than the completed structure as he left it."[48] Nevertheless, City Hall's preservation team made very selective decisions about what represented the right usable past. They removed historically significant structures in the park, such as the old martyr's prison,

to make way for a new subway entrance, in part because it did not fit in with
aesthetic ideas of park design in the early twentieth century. They also advo-
cated removing other buildings that represented the wrong histories, such as
the old post office and the Tweed courthouse, both of which symbolized mu-
nicipal graft and bad government.[49] Perhaps nothing better illustrates what
was at stake for aesthetic and social reformers like Robert de Forest than the
decision to literally whitewash the unfinished north side of City Hall to make
it more attractive. Just as slum clearance erased poor neighborhoods from
the city's landscape, selective preservation frequently painted over inglorious
histories while preserving useful pasts.

The cultural politics of reforming cities in the early twentieth century en-
tailed a curious combination of democratic impulses to expand access to at-
tractive, healthy environments, and restrictive ideas about cultural authority.
Who had the right to define beauty and determine the proper use of public
spaces? Progressive connoisseurs like de Forest and his many associates in
various arts and social-reform organizations believed that they had a civic
responsibility to improve public taste, but they often made unilateral deci-
sions for the public. For example, de Forest frequently used the Sage Founda-
tion to circumvent municipal intervention in aesthetic decisions about civic
spaces like City Hall. Whereas public appropriations required approval from
the city's board of estimate and various city agencies, de Forest could draw
liberally from Sage money to shape the urban environment to his vision of
civic taste.[50] The Washington Square Association in Greenwich Village like-
wise represented the conflict between private interests and public spaces.
Wealthy residents who lived on de Forest's block, facing the park, formed the
association to regulate the appearance of neighborhood streets, lobbying to
rid sidewalks of vendors and policing park conduct. But local residents and
settlement workers from adjacent tenement neighborhoods rejected elite def-
initions of taste, and frequently clashed with the Association.[51] Mayor George
McClellan—at once a Tammany Democrat and a member of elite New York
society, who lived next door to Robert de Forest—carefully negotiated the
contradictions of urban beautification and ideals for cultural democracy. Mc-
Clellan once referred to de Forest sarcastically as only "a sort of first citizen,"
but he cooperated with de Forest in his many institutional positions to help
shape the urban landscape and influence public taste.

After 1905, de Forest positioned the Metropolitan Museum within this
larger reform network of New York institutions committed to civic house-

keeping. Social exhibitions like the Tenement House Exhibition proved to de Forest that exhibitions could produce educational results, and that the public had a keen interest in reforming homes. While de Forest never thought an art museum like the Metropolitan could lead to government regulation, like the Tenement House Exhibition had, he did think it could provide models of good taste, as the 1900 exhibit had provided models for better housing. Just as model communities and historic preservation drew from the right historical precedents to meet the needs of the modern century, de Forest believed the modernized museum could serve the needs of the present and future.

A New Era at the Met

When Robert de Forest assumed a position of leadership at the Metropolitan Museum of Art in 1905, he seized the opportunity to implement the practical education reforms he and other progressive connoisseurs had imagined since the 1890s. The new board of trustees hired Henry Watson Kent as de Forest's assistant to oversee the museum's management; they expanded museum collections from three over-arching curatorial departments to nine specialized departments staffed by experts in their respective fields; and they appointed a director and assistant director with bona fide art-historical museum credentials to oversee them.[52] To ensure the new direction of the museum, de Forest looked to the recognized leaders of museum innovation: he recruited Sir Casper Purdon Clarke from the South Kensington Museum in London and Edward Robinson from the Museum of Fine Arts in Boston. To promote the modernized museum as a public service, the Metropolitan published monthly bulletins to update its members on the changes to the institution's management and the new direction of its educational philosophy.[53] The first *Bulletin* explicitly stated that its conception of museum members to whom trustees would now be accountable included, "not only the corporate membership of the Museum, but all the citizens of New York."[54] Democratizing public access and expanding collections lay at the heart of the museum's modernization—just as they had in the 1890s when the de Forest faction advocated opening galleries on Sundays and building collections of plaster-cast reproduction sculpture.

De Forest put a progressive civic taste agenda at the center of the Metropolitan Museum's institutional revolution. Rather than relying on what they considered old ideas that "mere examination" of art provided social uplift, de Forest and Kent promised to turn the Metropolitan Museum into a "public

Figure 13. These offices illustrate the infrastructural improvements Kent made to the
Metropolitan's "machinery." Confined mostly to the museum's expanding basement
quarters, Kent's managerial machinery made the Metropolitan a self-sustaining
institution. Metropolitan Museum of Art, Printing Office, 1926. The Metropolitan
Museum of Art. Image © The Metropolitan Museum of Art.

institution of art [that] was, in the last analysis, a public servant."[55] Kent ar-
gued that "the old idea of the museum as a storehouse of art" subjected the
Metropolitan to "criticism that it would become a mausoleum in fact unless
it was made actively serviceable." To make the museum work for the public
welfare, Kent later claimed that he incorporated rational business methods to
"improve the machinery, the business system, of the Museum's own organi-
zation." Kent's machinery included in-house printing and photographic de-
partments, modern cataloguing and archival systems based on recent library
science, public programs and lectures, cooperation with public schools, and
expansion of collections and curatorial departments to include decorative
arts alongside the fine arts.[56]

Figure 14. Metropolitan Museum of Art, Lettering Shop, 1922. The Metropolitan Museum of Art. Image © The Metropolitan Museum of Art.

The Metropolitan's organizational makeover was part of a larger movement of professionalization at the turn of the twentieth century, which drew from bureaucratic rationalization and scientific principles of corporate management.[57] As a leader of modern civic institutions, de Forest also insisted on the efficient, systematic management of the organizations he ran, and he turned to professional managers like Kent to make them work. Indeed, professionalization of museums represented one of the central reforms that progressive connoisseurs advocated in the early twentieth century. The skills of

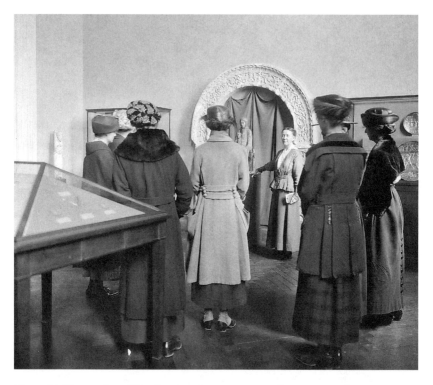

Figure 15. Kent made public education the cornerstone of museum modernization in the first decades of the twentieth century. Gallery lectures like the one depicted in this image and classes and gallery visits for children as illustrated in accompanying photographs helped fulfill the goal of making the museum work for the people. Metropolitan Museum of Art, Gallery Lecture, 1920. The Metropolitan Museum of Art. Image © The Metropolitan Museum of Art.

library science that Kent learned while studying with Melvil Dewey, and the museum modernisms he copied from European museums in the 1890s, contributed to the professional standards he later implemented at the Metropolitan. In 1906, Kent helped to found the American Association of Museums as a professional organization to disseminate these standardized museum practices, and he tried to make the Metropolitan a model of institutional management and educational progress.

Kent used all of the museum's new machinery to enhance its educational efficiency. He coordinated the museum's educational programs by creating relationships with New York's public school system, hiring museum instructors

Figure 16. Metropolitan Museum of Art, group of school children in the Great Hall, 1910. The Metropolitan Museum of Art. Image © The Metropolitan Museum of Art.

and information agents, and organizing special lecture series, geared both to the general public and to teachers, to encourage their use of the museum in classrooms. Within the first year of the museum's reorganization, over one thousand teachers had applied for free tickets of admission. In 1907, Kent was made Supervisor of Museum Education to facilitate outreach to teachers in public and private schools in New York.[58] In 1908, Kent hired the Metropolitan's first instructor to provide guided tours and to coordinate courses for school teachers to use museum reproductions in their classrooms.[59] But Kent complained that cooperation with public schools was "an uphill battle" because few teachers themselves knew much about art history, and because they already had heavy curricula to incorporate into their lesson plans.[60] As late as 1911, the *Bulletin* criticized the Board of Education for making no requirements for its teachers to work with art museums, in contrast with cooperative relationships encouraged with science museums in the city.[61] Therefore, in 1912, the Metropolitan's board of trustees established a committee for educa-

Figure 17. Metropolitan Museum of Art, children's art class, 1924. The Metropolitan Museum of Art. Image © The Metropolitan Museum of Art.

tional work, to more forcefully advocate city cooperation. Within a year, the Board of Education appointed James Haney as Supervisor of Art in the High Schools.[62] Under the auspices of the School Art League, Florence Levy helped set up a pilot museum program at Washington Irving High School. By 1916, museum education programs had been incorporated by history departments at De Witt Clinton, Stuyvesant, and the Ethical Culture high schools in New York City.

In many ways, Kent's education department within the museum replicated the professional practices of library science. Drawing on his own training in the field, and the role of public servant that Melvil Dewey encouraged for young women, Kent recruited young unmarried women to staff the majority of his education positions. Kent tapped Winifred Howe from the Norwich Academy to work directly with him as an editorial assistant, and he brought

Juliet Robinson from Norwich to answer visitor questions at a new informa-
tion and sales desk.[63] In 1909, Marion Fenton joined the museum staff as its
instructor. Kent's corps of dedicated professionals worked behind the scenes
in the museum's basement classrooms to fulfill their boss's goal of implement-
ing the Metropolitan's democratic educational mission.

In its 1911 annual report, the Metropolitan Museum proudly announced
to the public that its education work had successfully shifted the museum from
the old idea of a mausoleum of things into Kent's vision of a public-service
institution. "First and foremost," the Metropolitan declared, "our Museum
no longer appeals merely to the 'upper classes'—the educated, the cultured,
the rich." "It has entered into the life of the people." Kent's outreach programs
promised to extend the Metropolitan's benefits to the entire city. "The poorest
child of the public school is welcomed as cordially as the wealthiest amateur
and accepts our invitation as eagerly." "The Museum has become an integral
part of our city's education system."[64]

The progressive civic taste agenda that Robert de Forest initiated at the
Metropolitan Museum after 1905 so revolutionized the museum's manage-
ment and programming that in 1913 de Forest commissioned an official his-
tory to document its historical accomplishments. To set up the Metropolitan's
institutional revolution, and distinguish the modernized museum from its
nineteenth-century roots, Kent and Winifred Howe combed through mu-
seum archives, which Kent had only recently organized by modern principles
of library science, to identify the museum's original educational mission as
they highlighted its halting early efforts at educating the public. "The keynote
of the present era in the history of the Metropolitan Museum of Art," trium-
phantly asserted Howe, "is educational efficiency."[65]

When de Forest ascended to a position of leadership at the Metropolitan in
1905, he directed his immediate attention to the museum's collection of casts,
on behalf of which he had fought his first institutional battle in the 1890s. De
Forest understandably had great interest in the status of what was popularly
considered the most up-to-date department in the Metropolitan Museum.
To former director Louis di Cesnola the collection had represented a chal-
lenge to the management style of the museum's founding trustees; therefore
Cesnola had all but locked de Forest out from any institutional oversight after
the collection opened in 1894, when de Forest's special committee of advisors
and museum professionals had been disbanded. De Forest's interaction with
then curator of casts John Paine in 1905 provides a window into a fascinat-

ing moment of institutional change at the Metropolitan, and it illustrates the links between ideas of professional management and education reform that lay at the heart of de Forest's vision of a modern museum agenda.

In 1905, confusion about the chain of command at the Metropolitan Museum caused some embarrassment to de Forest, when he was forced to rescind a promise to the director of the Carnegie Institute in Pittsburgh. De Forest had understood that an architectural cast—a portal of St. Gilles— would not be needed by the Metropolitan for two years, so he had agreed to send it to Pittsburgh and await a new copy that the Carnegie museum had ordered. Such agreements with other museums represented exactly the kind of institutional collaboration that de Forest envisioned. It also signified his commitment to the common educational mission of museums over any sense of competition. Unfortunately, the Met's curator of casts, John Paine, told de Forest that the new museum director, Casper Purdon Clarke, had recently installed the object in the Metropolitan's great hall before traveling to London. Being caught unaware was not the kind of public face de Forest had in mind for the Metropolitan Museum's institutional revolution.

De Forest fired off an angry letter to the museum's acting director, George Story. How, de Forest demanded, could he have been unaware of the museum's plan? "It does seem very strange that in my relation to the cast collection, as present chairman of the Committee of Casts, and as practically past Chairman of the Committee that bought these casts," de Forest fumed, "no inkling should have reached me of any intention to put the portal in place."[66] De Forest ordered Paine to provide a list of all important casts not currently installed in the Metropolitan. After Paine supplied the list and asked about object installation, de Forest realized how isolated Cesnola had kept the cast collection from other departments in the museum. And of course he realized the extent to which Cesnola had created an atmosphere of mistrust and skittishness among the staff.

Paine revealed that Cesnola had kept different collections of casts in the museum separate, in order to distinguish his own authority from de Forest's special committee of the 1890s—what Paine called "special committee territory." Paine told de Forest that even objects from different collections that shared similar characteristics and historical context had always been kept in different galleries, and he wondered whether they could ever be brought together. Exasperated, de Forest replied that labels could certainly explain distinctions between collections within the museum. "My fundamental thought," de Forest ordered, "would be that particular collections, so-called, should not be kept together to the disadvantage of scientific distribution."[67]

At the same time, Paine's curatorial decisions raised questions about his judgment and his taste. While looking into the management of the department of casts, de Forest and Story found that Paine had reinstalled parts of the collection in what they considered an illogical fashion. They found architectural pieces, originally built to be seen at ground level, installed far above visitor sight lines. "I have not seriously interested myself in the work of the Curator of Casts," Story admitted to de Forest, "assuming as a matter of course that a man who had occupied the position of Curator for a long series of years must know his business; but the proposition to put the 'St. Gilles' up where the large picture by Markart now hangs seems to me to be so preposterous that I feel that something should be done to change this program." Story also felt that one of Paine's decisions to install a portico "up in the air over the arches at the other end of the Architectural Hall is equally absurd and will surely bring a feeling of contempt upon the judgment of those in authority if it is allowed to become an accomplished feat."[68]

The embarrassment over the mistake with Andrew Carnegie's museum, the questions about following a proper professional chain of command, and the alarming issue of improper installation techniques raised significant concerns for de Forest about the professional and educational management of the Metropolitan Museum. Not only had he been left out of the loop regarding questions of installation for a department over which he presided as a chairman, but it seemed that his new director had failed both to catch these organizational problems and to keep him abreast of curatorial decisions. When de Forest fumed to Story that he had had no inkling that the St. Gilles portal was installed, he wondered how Clarke had failed to mention it to him—especially since he had been living in de Forest's house on Washington Square while making permanent housing accommodations. However, with Clarke in London wrapping up affairs, de Forest tried to get to the bottom of things by meeting with Paine. He asked Paine whether he had made the questionable decisions, or if Clarke had. "I should like to know whether it is an arrangement which you, as a matter of judgment and taste, favor." "I should also like to know how far Sir Purdon Clarke has expressed his judgment on this arrangement, and what, if any, instructions you have from him."[69] Paine's answers failed to assuage de Forest, so he asked Paine for all of the monthly reports he had sent to Cesnola over the past four years.

Paine's reports, however, even further shocked de Forest, and they suggested just how far the Metropolitan lagged behind his own standards of institutional management and professional conduct. All of Paine's monthly

reports had been hand-written and docketed in the nineteenth century fashion—folded in quarters and labeled at the top edge. De Forest found Paine's method of communication with the former director, and the degree of authority Cesnola had maintained over minute details, staggeringly inefficient. "All these reports," de Forest complained in a hastily written report, "seem to be in the handwriting of Dr. Paine." "From the fact that most trivial matters, which would naturally be taken up conversationally, are mentioned in these reports, I should infer that all communications between Cesnola and Dr. Paine were in written form." "Is this so?" he asked. "It would also seem that Dr. Paine did not have power to decide any questions of arrangement of pedestals." In fact, it did not seem to de Forest that Paine retained any institutional authority over his department. "In only one instance does he affirmatively recommend in his reports any particular arrangement of rooms or corridors." "Did he submit a general plan for arranging the entire collection?" "If not," de Forest asked, "by whom was such a general plan made?"[70]

In the 1890s, most of the de Forest faction's criticism of Louis di Cesnola had focused on his unprofessional management, his lack of scholarly qualifications, and his autocratic control of museum collections. When de Forest hired Henry Kent to take over Cesnola's responsibilities managing the administrative aspects of the museum, Kent too reported that he was shocked by what he described as the Metropolitan's old fashioned and unprofessional organization. He complained that the museum had only one telephone in the library, to which he had to run when called, and that even "a typewriter was come by with difficulty." Kent likewise disdained Cesnola's staff: he called them "men of middle age" with no museum training. Kent described the museum's registrar as an Irishman who "carried a Latin bible in his pocket, from which he would ask you to read passages, to test your scholarship," and the original three curators, among whom he assured there was "no love lost," as more inclined to chase one another through galleries than to pursue museum work. Because Kent had first been brought in by the de Forest faction in the 1890s to build the collection of casts, Cesnola's former assistant still regarded Kent as an "interloper" in 1905. When instructed to hand over museum files, he appalled Kent by dumping all of the records and letters "docketed in the old-fashioned way and bound up with red tape" into a vault "helter-skelter."[71]

Charged with cleaning up the clutter of nineteenth-century inefficiency, de Forest and his team of museum professionals set to work to systematically reform the museum's educational infrastructure. In response to what he considered unacceptable standards of professionalism, de Forest called an

emergency meeting of the cast committee. They unanimously voted to order the curator of casts to suspend all actions pending further decision by the trustees and the director. By the end of the year, de Forest had hired Edward Robinson away from Boston's Museum of Fine Arts as a new assistant director to work with Clarke. Robinson, of course, had established his professional career as a classical art historian in the 1890s by building collections of plaster casts. Robinson helped de Forest whip the Metropolitan Museum's department of casts into shape by reinstalling them into educational series, and by building collaborative relationships with other art museums. By 1907, a newly professionalized committee of casts was able to issue a glowing report. "The museum has the most important collection of casts," declared the Metropolitan, "both architectural and sculptural, in the country."[72] Plaster casts had represented a hallmark of museum modernisms in the 1890s, and the de Forest faction made sure that they would also illustrate the educational reforms at the center of the Metropolitan's progressive agenda.

In 1911, Robert de Forest asserted the new democratic imperatives of the Metropolitan Museum's civic taste-education agenda at the opening of the Child Welfare Exhibition. "Knowledge and appreciation of art is by no means all that our Museum teaches the child," declared de Forest. "It illuminates history. It inspires patriotism."[73] De Forest promised to extend the benefits of his privileged education to all children of New York City, and he stepped beyond the refining influences of art by recognizing the practical relationship between art and labor in the early twentieth century. The Metropolitan provided children the opportunity "to appreciate the beautiful not only for the joy that appreciation of the beautiful brings," de Forest insisted, "but to utilize the beautiful on the practical side of earning their living." "I am fortunate enough myself," he admitted, "to have acquired a very keen appreciation of the beautiful, and I think if it became necessary for me to earn my living by practicing any of the arts or crafts I could turn that appreciation to good account." Though de Forest learned about art and beauty while traveling in Europe as a child, he expressed his commitment to the museum's democratic reform goals by assuring, "I could have acquired that same appreciation of beauty in art here in New York if as a child I had had the treasures of our Metropolitan Museum at hand."[74]

The 1911 Child Welfare Exhibition brought together most of the city's cultural and educational institutions to demonstrate the social contribution that museums and libraries made to civil society. The Metropolitan teamed

up with librarians and settlement workers to illustrate the influence museums had recently begun to have in educating the children of New York City. The Met announced in its *Bulletin* that the exhibition presented "a picture of child life in New York" and it demonstrated "the economy of concentrating effort for human betterment upon the children of to-day, and so lessen the social waste and financial burden of the charities and reformatories of to-morrow."[75] The exhibit displayed charts, models and photographs of homes, schools and recreational facilities in New York to illustrate the civic importance of advocating for improvement in child services.[76] "This exhibition aims to give the boys and girls of the city a better chance," announced its organizers in the exhibition handbook, "and so to give a better chance to the city itself."[77] It also allowed the Metropolitan to show how it had become a public-service institution.

The Child Welfare Exhibition represented the work of hundreds of social workers, investigators and social-policy experts committed to improving the well-being of children. "The work of the various committees," announced the reformers who planned the 1911 exhibition, "gives a many-sided survey of what is after all one problem." The child welfare committee borrowed from the education philosophy of John Dewey to insist, "The indefinite improvement of humanity and the cause of the little child are inseparably bound together." The Exhibition broke the city down into constituent parts to show to middle-class audiences the social importance of improving physical conditions. Institutions throughout the city contributed statistical data, photographs, and models that made the point that playgrounds offered advantages over streets for children's play; that specialized libraries could introduce children to history and civic ideals; and that museums could benefit public taste by teaching appreciation of art to children at an early age. "To-day, there are few of us who have followed the great educational movements of the country and the progress of museums," wrote Metropolitan Museum instructor Marion Fenton, "who do not recognize that museums stand second only to schools and libraries as the future great educational institutions of the country, and that 'today is the age of the child.'"[78] The exhibition catalog argued that museums, like libraries, provided the public with access to history that could serve as a "first great lesson in civics."[79]

Museum educators also positioned the Metropolitan Museum within a network of institutions that promoted civic education and Americanization. Libraries, schools and settlement houses recognized a need to teach the na-

tion's new immigrants skills of citizenship in order to ensure their successful transition into American society. Beginning in the 1890s, immigration in the United States had increased dramatically as significant numbers of new immigrants from eastern and southern Europe arrived at American shores. The new generation of progressive reformers used modern tools of social science investigation to determine the needs of these new groups of Americans and proposed educational models to integrate them into the nation. Progressive reformers of all stripes looked to the home—and institutions that could influence the home—as the foundation of civic development. From the home, out to the community, the city and the nation, the new generation of progressive connoisseurs committed to improving the built environment and shaping American society in the twentieth century.

To illustrate its commitment to improving American homes and American taste, the Metropolitan Museum presented to the public a new "educational credo" in 1918 that linked the education of taste with civic engagement. The museum's new progressive agenda had turned away from traditional attitudes that restricted the appreciation of art and the cultivation of taste to culturally privileged audiences. "We believe that every human being is born with a potential love of beauty," announced Winifred Howe, "and whether this capacity lies dormant or springs into activity depends largely upon his education."[80] Taste advocates at the museum argued that access to art education through museum galleries contributed to good citizenship. "Eyes that know how to see beauty and a mind that can appreciate its spirit are genuine assets to the individual," Howe enthused, "of greater value now than ever before, and through the individual to the community, the state, and the nation." The Metropolitan promised to fulfill its civic duty of fostering good taste and improving citizenship by elevating both consumer demand and the quality of manufactured goods. "We believe that the Museum may perform a two-fold service in the community," the *Bulletin* explained, "cultivating good taste in home decoration, dress, etc., on the one hand; and giving to salespeople, designers, and manufacturers, on the other hand, every facility for the study of the collections of decorative arts, for copying or adapting objects therein or gaining inspiration for new designs, thus helping to meet the demand that the Museum itself helped to create."[81]

The Metropolitan recruited design experts to help articulate its twentieth-century education agenda, to show museum members how aggressively the Met worked to make its galleries useful. "The chief asset of a designer," insisted architect and world's fair consultant Charles Howard Walker in 1917,

"is Good Taste."[82] "Good Taste can be inculcated by words, can be imparted by traditions," Walker acknowledged. But, "the surest method by which it can be obtained," he said, "is by constant association with objects in which it already exists."[83] Walker's logic echoed Charles Eastlake's 1871 argument that everyday objects influence taste, but Walker took his argument one step further. "Training in good taste," he asserted, "is therefore essential." Walker saw art museums as logical places to provide such training for museum visitors who did not otherwise have everyday access to objects of beauty. "For the designer the wealth of material in the Metropolitan Museum is a treasure trove." But what made the Metropolitan particularly useful was guidance of taste experts like him. Curators had selected "work which has been sifted through the centuries until the dross is no longer in it, and which has been assembled with appreciative care, with the experience and good taste of skilled men."[84] Like preservationists and city planners who selected out the "right" histories to save, museum curators collected objects of what they considered good taste, and they carefully presented only those they deemed most useful to educate untrained designers and craftsmen.

The Metropolitan also worked to improve consumer taste in order to help individuals make informed decisions in their household acquisitions. Museum tastemakers argued that standards needed to be established and taught "in schools if possible" to allow "full enjoyment of objects of art by the people at large."[85] *Antiques* magazine editor Homer Eaton Keyes lamented that the most important "educative forces" were institutions motivated only by margins of profit: magazines, movies and department stores. While manufacturers recognized demand and catered to it, Keyes argued, "the education of taste which produces those demands ought not to be left to them."[86] Instead, museums and schools needed to teach taste. Standards, Keyes thought, were essential. "When all else fails," Keyes wrote, "we fall back on public education . . . to develop high standards of aesthetic taste." Keyes argued that aesthetic standards could be taught through "the corrective stimulant of intellectual contact with the best of what has been done."[87] Art museums, of course, could provide such contact.

Settlement workers and museum educators teamed up to use museum collections to reach a broad public of new Americans. Educator and Boston settlement veteran Laura Scales argued that immigrants had a "natural" inclination for art. "Appreciation and taste," she wrote, "are [the immigrant's] long inheritance."[88] Jane Addams had long argued that the artistic traditions of immigrant groups would enrich the cultural fabric of America, and she insisted

that immigrant crafts represented a great Americanizing force. Scales also claimed that immigrants found pride in the art of their homelands because it "knit for them their past with their present." The Metropolitan frequently sent traveling exhibitions into immigrant neighborhoods that presented traditional art from immigrants' homelands. The museum sent Italian art to Chatham Square's Little Italy libraries, while it displayed Czech and Slovak art and gave lectures on Bohemian design in eastern European neighborhoods.[89]

But just as settlement workers sometimes misunderstood the needs of working-class families, education reformers in museums could be quite patronizing. Attempting to illustrate to American audiences the socially constructed nature of concepts like high and low art, Scales inadvertently marred the intellectual capital of immigrants as a group, and relegated them as a class for manual labor. Because the immigrant, "ignorant and unlettered man that he is," had "not yet learned the American way of spelling Art with a capital letter and setting it apart for women's clubs and moneyed connoisseurs," Scales argued that his natural inclinations for art could be fostered through aesthetic standards to beautify the built environment. "America has need," she thought, "of the man who comes to make beautiful her paths as well as to dig her streets and lay her sewers." By providing access to examples of taste, the museum claimed to serve both the community and the individual immigrant by giving him a civic role. Scales believed "the museum can bring home to the immigrant his chance to help enrich the head and heart of his new country as well as her pockets." Education, Scales promised, would "serve the public and not merely the taskmaster on the job." Museums, she argued, could offer the immigrant "an inducement toward loyal citizenship to which he is eager to respond."[90]

The movement for the civic education of taste in museums transformed the relationships between art, labor and democracy in the United States. Advocates of aesthetic education saw fostering taste as beneficial for everyone involved in Americanization projects. By teaching taste, museums contributed to better built environments, they gave immigrants a civic role in such beautification, and they improved their material conditions by giving immigrants more marketable skills. Scales acknowledged that many immigrants studying museum collections would take up commercial design because of its "quick financial returns" and she hoped that proper training would result in the right "mark upon our everyday surroundings."[91] Museum educator Agnes L. Vaughan hoped that exposure to "the most highly developed expression of

art or of mechanical genius" in museum collections would instill "a sense of the dignity of labor as well as the glory of creative achievement, the satisfaction of work in spite of the drudgery of modern industry."[92]

Similarly, educator Anna Slocum identified the interlocking benefits of using museums to aid in Americanization. "Besides the better preparation for work, the museum by giving more vitality to the sense of sight, opens happy ways to the enjoyment of leisure hours, and gives refreshment and rebound to the mind deadened by routine."[93] "But of equal importance with the better workmanship, the more attractive environment, the greater enjoyment of leisure," Slocum insisted, "is the deeper insight into history that may be obtained by study in the museum. For the spirit of a nation, created by its citizens, is revealed by its artists." Slocum also echoed Jane Addams's arguments for encouraging immigrant contributions to American identity.[94] "Many are the objects that our museums contain to bring back distant lands to our homesick immigrants. To train these immigrants for their future duties as citizens of our republic the most vivid teaching of history is necessary. Our public schools need the help of those who have gone into the depths of past civilizations."[95] "Are our political ideas of unity of government, liberty, and law to be overwhelmed by our great size, our material possessions, our wealth of immigrants," she urgently asked, "or shall we be able to enlist these forces on the side of law, order, and progress?"[96]

Such were the pressing social questions of the early twentieth century. Contrary to historical arguments that museums in this period responded to these questions by burying themselves in the past, by transforming themselves into agents of social control, or by focusing only on the sacred status of art, the Metropolitan Museum used its collections and its new methods of communicating with its publics to help inform the kind of modern society its leaders embraced. By helping the museum community (recently defined to include all people in the city) improve individual taste and beautify their homes, the Metropolitan Museum hoped to contribute to modern society and expanded democracy, providing the aesthetic building blocks of good citizenship.

On Robert de Forest's eightieth birthday in 1928, New York threw its "first citizen" a gala pageant. Two hundred fifty arts and social service philanthropic leaders packed the Vanderbilt Gallery on Fifty-Seventh Street to pay tribute to "the captain of philanthropy." Befitting the stature of the city's first citizen, the New York Times described the event's proceedings on its front page: "Mr.

de Forest surveyed the pageant from a throne to which he had been escorted with Oriental pomp." He was there enthroned as the "Abou-ben Adhem of New York" while a group of museum attendants and members of the Metropolitan Museum Employee's Glee Club serenaded their leader. Then, New York dignitaries dressed as a "caravan of the three Arabs" unrolled a "magic carpet" below his feet and presented to de Forest the symbols of his public service: a casket with the jewels of charity and kindness, a spray of flowers representing the "flowering of art," a toy house representing his housing reforms, and a map of the metropolitan region representing his contributions to municipal improvement.[97]

Robert de Forest's various reform projects intersected with the widespread preoccupation with improving American homes physically and aesthetically in the early twentieth century. For de Forest, reform started with individuals and their interior settings, then moved to the quality of housing stock, and out to the larger built environment of cities and the nation. This movement corresponds with de Forest's belief in the potential for individual actors to contribute to democracy, and with his commitment to provide them necessary assistance in improving their environments, to enhance their capacity to perform their roles as good citizens. The Metropolitan Museum remained de Forest's primary commitment and was at the center of his institutional affiliations, all of which he used to make things happen at the museum or to extend its influence. De Forest often reminded his friends and professional subordinates that he had always been intimately tied to the fate of the Metropolitan because he and Emily Johnston de Forest became engaged on the day the Met was officially founded. With his father-in-law serving as the first president of the board, de Forest's marriage linked him to the "worries and pleasures" of the museum, so he followed its growth and developed a personal commitment to seeing it expand into a modern public-service institution.[98] His overlapping affiliations gave him the institutional power to set a progressive agenda at the Metropolitan Museum, and to see it through.

Progressive civic leaders like de Forest ran their institutions like businesses, and they turned to professional managers like Henry Kent to make them work. Just as Progressive reformers like housing advocate Lawrence Veiller and settlement leader Jane Addams borrowed the tools of corporate capitalism to reform its institutions, Kent implemented what he called museum modernisms and principles of bureaucratic rationalism to make the Metropolitan an educational institution. In 1914, American Association of Museums secretary Paul Rea conducted a survey of educational work done

by museums, compiling statistics for over six hundred museums. The United States Bureau of Education commissioned the report so it could quantify recent advances in museum outreach and insure continued accountability of public cultural institutions. Rea concluded that American museums "are now democratic in the highest sense, responsible directly to the people and developing in proportion as they satisfy the needs of the people."[99]

"The most distinctively modern educational activity of museums," Paul Rea advised in his 1914 report to the Bureau of Education, "is to be found in cooperation with public schools."[100] In its *Bulletin* of the same year the Metropolitan Museum announced that it too had surveyed cooperative programs that linked museums with local schools, and it suggested that its own outreach to New York City schools proved that the Metropolitan had shifted its focus from the founders' idea of an elite temple of art into a modern public-service institution.[101] Reformers saw the city as a collective household and they insisted that public institutions like museums had a civic responsibility to improve the aesthetics of the built environment. De Forest and Kent borrowed from models like social exhibitions, which both educated the public about social problems and provided models for better cities, and they tried to develop similar educational exhibitions to effect change in art museums.

When New York's cultural elite chose to honor Robert de Forest as the "Abou-ben Adhem of New York," they revealed more about de Forest's leadership style and their own cultural background than they probably intended. Abou-ben Adhem was an eighth-century Sufi saint known for his asceticism, but he had been made famous in the nineteenth century by popular poet James Henry Leigh Hunt. Hunt portrayed Abou-ben Adhem as a selfless man whose name had been written in a golden book among others whom God loved, because he had instead preferred to be known as "one who loves his fellow men." At de Forest's party, the *New York Times* reported: "After the display of the caravan's treasure, an angel appeared who wrote in a golden book Mr. de Forest's name and his new title." In oriental capes and headdresses, representatives from de Forest's institutional affiliations formed a procession to pay tribute and sign their names to his golden book. After multiple toasts and formal resolutions, "a group of school children closed the program with a dance and two little negro boys in red turbans entered with a huge birthday cake bearing eighty candles."[102] Needless to say, the names in de Forest's golden book formed a who's who of Progressive Era social and arts reform leaders, but their curious tribute to the model of modern institutional reform illustrates the contradictions that modernity represented in the early twen-

tieth century. De Forest, at the same time scion of old New York wealth and society and innovator of modern social philanthropy, bridged the ethos of the nineteenth and twentieth centuries. He used his social connections and worked with professional task-oriented experts in multiple fields of reform— most of them dressed in costume and positioned below his feet in deferential gratitude—to select and preserve symbols of the past as he shaped the built environment of the future.

CHAPTER THREE

=====

The Educational Value of American Things

Balancing Usefulness and Connoisseurship

Just as Robert de Forest placed the Metropolitan Museum of Art within broader Progressive Era social reform circles, Henry Watson Kent brought the museum into a network of educational institutions that aligned arts and industry. Instead of thinking about art museums as temples of spiritual uplift, progressive connoisseurs at the Metropolitan Museum, the Newark Museum, and the Brooklyn Museum all embarked upon programs that used examples of what they considered good American design to teach American craftsmen and manufacturers alike. At the Met, Kent and de Forest hoped that decorative art galleries would teach appreciation of beauty to an expanded museum public. Education reformers saw American decorative arts as the cornerstone of museum modernization in the early twentieth century because they believed such objects provided the opportunity to make museum galleries useful. By selecting and presenting examples of good design as models for emulation, art museums sought to influence both consumer choice and the quality of modern industrial production.

Decorative arts were central to the Metropolitan's institutional revolution because they also served the museum's goals of teaching civic taste. Kent's interest in illustrating principles of art to industrial designers aligned with Robert de Forest's belief in environmental determinism, so they implemented a two-pronged taste education program that focused simultaneously on reaching out to public schools to teach future generations, and cooperating with trade groups and industry to improve the quality of American manufactured goods available to consumers. In both cases, decorative arts became part of the museum's new policy of increased democratic access. Reformers hoped

galleries filled with decorative arts would also appeal to a broader museum public because their familiarity made them seem more accessible to many museum visitors than paintings and sculpture.

Perhaps Kent's greatest ally—and fiercest critic—was Newark Museum director John Cotton Dana. Friends and colleagues since their early professional years working in New England libraries, Kent and Dana shared a commitment to making museums democratic educational institutions, and they both believed in expanding cultural categories beyond the fine arts of painting and sculpture, to make art museums useful and accessible to a broad urban public. Cultural politics within their respective museums, however, determined the extent to which they could each expand collecting practices and the art museum canon. Whereas the Newark Museum often presented quotidian objects as examples of everyday design, the Met justified inclusion of decorative arts by collecting almost exclusively craft masterpieces. As a consequence, Dana frequently claimed that the Newark Museum represented a more democratic cultural space. Because Dana had established the Newark Museum as an auxiliary of the city library, he often had more autonomy than Kent, who always had to justify his education programs to both curators and board members at the Metropolitan. But Kent's personal experiences in some of the most exclusive cultural institutions in the United States influenced his tactics as much as strategic pragmatism. Kent had established his professional credentials by working in institutions that wielded considerable cultural authority. The Slater Museum had become, as Robinson once reminded Kent, an influential cultural destination in the 1890s; when Kent started working at the Grolier Club in 1900 it represented a bastion of old New York social conventions that combined connoisseurship of the "book arts" with the intellectual capital of bibliophiles. And of course, the Metropolitan Museum stood out for many people as a model of high culture. Throughout Kent's career, he maintained great pride in his association with such prominent institutions, and his own relative position as an outsider within these institutions likely also influenced his use of masterpieces to test and secure the place of American things in an art museum.

The shift toward using teaching collections of decorative arts in art museums raised difficult questions about the cultural hierarchy of objects in a museum. The introduction of decorative arts recalled debates about the relationship between art and labor and the role of museums in training designers, issues that reformers had grappled with in the nineteenth century. Like other art museums in Philadelphia and Boston during the nineteenth

century, the Met had opened an art school for craftsmen in 1880, but its location remote from the museum's galleries, the absence of a teaching collection of objects, and the general misunderstanding of the needs of working-class students prevented the school from successfully linking art and industry.[1] While recognizing the need for practical education, museums clung to older nineteenth-century ideas and usually maintained a sharp division between connoisseurship and industrial-education programs. Just as museum policies of access had limited real democratic opportunities for taking advantage of whatever uplifting qualities art could provide the public, art schools in museums had reinforced the separation of different museum publics. In 1894, the Met finally closed its art school, and most of these debates seemed to have been put to rest. Historians argue that museums abandoned their commitment to popular education when they closed their industrial art schools, and instead focused on the accumulation of masterpieces and cultivation of art galleries as sacred temples. The persistence of this image of art museums through the twentieth century has reinforced such arguments. However, closer examination of collaborative art museum programs to reach out to industry in the early twentieth century reveals a much more complicated relationship between connoisseurship and educational utility. Museums invited manufacturers to study museum collections, they distributed photographs and illustrations to trade magazines, and they organized programs and talks to bring designers into museums. The kind of decorative art collected and displayed by museums, however, depended significantly upon traditional notions of connoisseurship. Trustees and curators wrestled over distinctions between fine and applied art, they reconsidered traditional criteria for evaluating the cultural and educational value of objects, and they turned once again to the relationship between authenticity and reproduction—genuine and fake.

Decorative Arts Ascendant

Whereas plaster-cast reproductions of classical antiquity had represented an innovative commitment to education reform in the 1890s, when few American museums hoped to acquire collections of original masterpieces, by the early twentieth century collections of decorative arts moved to the cutting edge of museum education. By 1905, the Metropolitan Museum boasted a world-class collection of art worthy of its impressive new neo-classical façade on Fifth Avenue. With the professional expansion of curatorial departments

under the direction of Edward Robinson (as acting director), the Met began a systematic program of acquisition. Young curators Bryson Burroughs and Bashford Dean built impressive collections of European paintings and Medieval arms and armor, Albert Lythgoe oversaw the Met's rapidly expanding collection of Egyptian antiquities as objects poured into the museum from expeditions funded by J. P. Morgan, and of course, Robinson and his team of private collectors and young scholars like Gisella Richter assembled the Met's stellar collections of classical antiquities. In this new environment, where masterpieces of fine-arts were increasingly available to the public, reproductions no longer had the same educational value as they had in the 1890s.

Essentially, the Metropolitan shifted its curatorial emphasis to original artworks once it had the fine art collections necessary to ensure the museum's position in the international hierarchy of art museums. The Met's new international reputation enabled progressive connoisseurs like de Forest, Kent and Robinson to take risks by opening up the art museum canon to include decorative art. During the first quarter of the twentieth century, the museum phased out its collection of plaster cast reproductions, and shifted its educational programs from using copies to teach the appreciation and history of art, to using authenticated decorative arts to teach principles of design. Because the museum built its decorative art collections with craft masterpieces, reformers at the Metropolitan were able to anchor their new education programs around original artworks that could be attributed to master craftsmen, who followed in traditions of art-historical connoisseurship.

At first glance it may seem ironic that the Metropolitan democratized its collections and disrupted the museum's cultural hierarchy of things at the very moment when it was securing its international reputation by building encyclopedic collections of masterpieces like those in the European palaces of art. When we look at the way connoisseurship and the museum's educational programs intersected, however, it actually makes perfect sense. Because American decorative arts so challenged the cultural status of art museums like the Metropolitan, curatorial decisions about what to collect swung toward things that could be recognized as masterpieces, rather than toward vernacular or modern industrial production, such as the Newark Museum collected. When the Met first decided to collect and display decorative arts, it actually chose classical French furnishings, which could more easily be legitimized as tasteful and educationally valuable. Kent advocated adding American decorative arts to the museum's permanent collection of fine art to improve the quality, appreciation, and availability of modern American things, but he also hoped

to elevate the cultural status of old American things by moving them into art museum galleries. He believed that well-made furnishings of everyday life had aesthetic and historic value that warranted their placement in an art museum, and he wanted to use those collections because he believed they had educational value, and could inform modern design.

Since the mid-nineteenth-century founding of the South Kensington Museum, educators had seen the utility of opening teaching collections of decorative arts, but aesthetes and cultural arbiters still questioned the legitimacy of including everyday objects of utility in an art museum. To assuage those concerns, and to bridge the ethos of connoisseurship and the usefulness of museums, the Metropolitan tested the cultural waters by first opening a collection of recognized masterpieces of French decorative arts. In 1907, after J. P. Morgan put his extensive Hoentschel collection of French Renaissance decorative arts on loan, and promised to build a new museum wing for its display, the Metropolitan Museum created its first department of decorative arts. Morgan's collection of almost nineteen hundred pieces of French furniture and decorative accessories, and his promise of future gifts of fine art and endowment funds, encouraged otherwise recalcitrant members of the museum's board to expand the Metropolitan's canon.

To legitimate the new department, Robinson conducted an extensive search to find a curator for the Met's new decorative art department, canvassing his multiple professional contacts in European and American museums. His correspondence with museum leaders like Berlin Museum director Wilhelm Bode illustrates the imperative of maintaining the Metropolitan's cultural distinction while expanding its canon. Robinson ultimately chose Wilhelm Valentiner from the Kaiser Friedrich Museum in Berlin. Valentiner's professional and academic pedigree helped ease the Metropolitan's expansion into decorative arts. A former private assistant to Bode, Valentiner held art history degrees from Heidelberg. Bode called Valentiner a *kenner*—a good expert—who was both "finely equipped in the history and philosophy of art," and "quick at distinguishing good from bad, master from pupil, genuine from false."[2] The *Bulletin* boasted to museum members that Valentiner was "regarded as one of the ablest of the younger generation of scholars who make a specialty of the history of art from the expert point of view." Consistent with the Metropolitan's recent interest in recruiting young progressive connoisseurs, the *Bulletin* further assured that its new decorative art curator "has had thorough training in various branches of museum

work, which has given him exceptional preparation for the duties of his new position here."[3]

The Metropolitan opened its new decorative art galleries to industrial manufacturers and craftsmen for study, and it encouraged trade journals to publish the illustrations of good design that Kent's photo department made available. When Morgan built a new wing for the museum in 1909 to house his collection, the *Bulletin* reported to members that the wing was "primarily for the benefit of craftsmen and designers of our country."[4] Morgan himself explained the links between the museum's modernization, its education mission, and its expansion into decorative arts in a 1909 *Bulletin*. Morgan pointed out "the steady and orderly progress which has been made in rounding out and developing its collections, notably on the side of industrial art, and in the improvement of their arrangement both from a scientific and an esthetic viewpoint." These developments, Morgan insisted, illustrated "the steady increase in the extent and use of its educational opportunities."[5] "Many prominent firms of decorators and manufacturers of tapestries, jewelry, silverware, furniture, metalwork, lace, and textiles, not only New York houses but several out-of-town firms have sent their designers to the Museum," noted a 1912 *Bulletin*, "and have purchased large numbers of photographs for use in studios and factories." This policy of outreach to industry also let the museum present itself as accountable to the public. "We count it especially significant of the recognition of the Museum's desire to make its collections practically useful to those whose work lies in the making of designs for objects of the decorative arts that so many individual designers have looked to us for help." Incorporation of the decorative arts into museum collections was specifically tied to the Met's educational goals of assisting craftsmen and manufacturers. "The number of these individual workers in textiles, woodwork, pottery, and metals," the museum told members, "has been increased greatly since the opening of the collections of the decorative arts given by Mr. Morgan and arranged with earlier accessions in the Wing of Decorative Arts in 1910."[6]

Hoping to expand the decorative arts collections further, Kent began advocating collecting the American furniture he had become acquainted with in Norwich, but his initial attempts were thwarted by board members who had only reluctantly agreed to open up the museum canon beyond traditional fine arts by accepting Morgan's loan of classical French Renaissance furnishings. Neither Morgan nor the taste arbiters and connoisseurs he hired—like art dealer and occasional Metropolitan curator Roger Fry or even Robinson— and certainly not most members of the board were willing to go so far as to

incorporate old American things into the museum. Though a small "craze" for collecting Americana had grown in the United States, the museum was not quite ready to acknowledge its legitimacy by putting these things in its galleries.

Early New England collectors had first recognized the cultural value of colonial American furniture in the last decades of the nineteenth century. While many early collectors valued these objects for their historical and ancestral associations, like other taste and design critics they also recognized their aesthetic qualities of simplicity and fine craftsmanship, which they felt had been lost in machine-made modern design. For most Americans, however, these old New England pieces had little value. In fact, most American collectors, as well as the general public, considered American antiques old-fashioned, uncomfortable, and useless.

Kent and many Americana collectors, however, saw aesthetic virtue in American decorative arts, which they believed could serve as a corrective to the decline in taste that critics attributed to machine-made nineteenth-century design. They argued that, in contrast to ornate Victorian furniture covered in superfluous decoration, colonial American furniture represented restraint, and harmony of material, scale, and line. Collector R. T. H. Halsey told a radio audience that "colonial art held simplicity as its chief tenet."[7] Taste critics Clarence Cook and Edward Bok advocated simplicity in their advice columns, and Cook wrote specifically that "the furniture of the Revolutionary period is evidently the outcome of [a] refined and cultured time."[8] Even Elsie de Wolfe, America's first professional decorator, advocated the simplicity of American antiques. De Wolfe advised using seventeenth- and eighteenth-century French antiques in the Fifth Avenue and Newport mansions she decorated for Vanderbilts and Fricks, but in the advice columns she wrote for the *Delineator*, de Wolfe urged modest homemakers "just beginning housekeeping" to use old American furniture, all the while repeating her design mantra: "Suitability, Suitability, Suitability."[9]

American decorative arts, however, challenged the cultural hierarchy of objects in art museums by expanding the art-historical canon, which had previously been restricted to European fine art. In the 1870s the founders of American art museums like the Metropolitan favored European paintings and classical antiquities because they wanted their museums to establish their own cultural legitimacy in a rivalry with European cities and museums. While they could have focused on American art as a means of promoting cultural nationalism, they instead emulated European museums by building

their own palaces of European culture in cities like New York and Boston. Rather than position American art within an art-historical narrative of western civilization, they chose to appropriate a European art tradition. In the early twentieth century, advocates of Americana in art museums complained that directors and boards of trustees still had very little interest in decorative arts, and even less in Americana. Halsey charged that most museum directors "seemed unwilling to see it" because "they didn't know it."[10] Kent even admitted that the Met's acting director Edward Robinson "was not interested in, certainly not enthusiastic about, the showing of these American things."[11] Kent assumed that Robinson, a scholar of classical art, simply did not think Americana was "in the class with Greek and Egyptian art."[12] Both Kent and Halsey complained that the Boston Museum of Fine Arts likewise "scoffed at us" because its director felt that "American arts and crafts were not worthy of exhibition."[13]

When the Metropolitan purchased a small collection of English furniture in 1908 to complement Morgan's French collection, Americana advocates like Kent, Halsey and fellow collector Luke Vincent Lockwood seized on its aesthetic links to American antiques.[14] Most colonial-era American craftsmen had emigrated from England, and they brought English craft traditions with them. The first collectors of American antiques traced aesthetic forms and craft techniques from English precedents to regional centers in New England, New York, or Philadelphia. When the Metropolitan acquired English antiques, it seemed to open the door for American decorative arts. Therefore, Kent recruited the collectors who had written the history of American craft development to make the case to trustees and the museum public.

Lockwood, an American furniture collector and published expert on colonial antiques, wrote in the museum *Bulletin* that the educational value of the new English collection "can hardly be over-estimated, for there is no branch of art which more clearly depicts the manners and customs of the human race, the study of which will do more to awakening a sense of the beautiful in every day life, with its accompanying direct effect upon the individual."[15] Hoping to encourage the acquisition of American furniture by museums to enhance that value for individual visitors, Lockwood further explained, "the evolution of style and decoration in furniture is one of the most fascinating and instructive of studies, and America is especially rich in specimens showing the various transition stages."[16] By presenting the "evolution of style" to museum members, Lockwood put craft development into an art-historical tradition of linear progress, and he staked a claim for the position of American

antiques within the tradition of connoisseurship and museum placement. Applying an argument of American exceptionalism, Lockwood continued: "In no other country has a style been so completely worked out as it has here, because the colonies being so far removed from the centers of fashion were not tempted to forsake an older for newer style before it had been fully perfected, and having once acquired the style, the colonial workmen adapting it to the needs of the people, developing it until it had reached a perfection not attained in Europe."[17]

The Metropolitan Museum first presented American decorative arts in a loan exhibition for the 1909 Hudson-Fulton Celebration. Commemorating both Heinrich Hudson's 1609 river navigation and Robert Fulton's 1809 steam voyage up the Hudson with parades, fireworks, theatrical water battles, and coordinated museum exhibitions, the Hudson-Fulton Celebration represented the quintessential Progressive Era event: it simultaneously commemorated the city's founding and its entrepreneurial spirit of progress. The celebration also struck chords of civic pride and local patriotism by placing New York's history within the larger historical narrative of the United States, alongside Jamestown and Plymouth Rock. As part of the celebration, the Metropolitan mounted complementary loan exhibitions of Dutch masterpieces and American antiques. The Old Masters represented the city's Dutch heritage (and many of the Knickerbocker families on the museum's board), while colonial and early republic antiques brought the art-historical narrative up to Fulton's time. The Hudson-Fulton Celebration paralleled the approach of many of the city's Progressive Era leaders, in their efforts through institutional collaboration to disseminate taste education programs throughout the city and nation. As chairman of the Hudson-Fulton Commission's Art Committee, Robert de Forest coordinated the contributions of various cultural and educational institutions to the city-wide event, and he used its high profile to test public reception of old American things in an art museum. In much the same way as preserving City Hall served to ground the city's civic expansion in the "right" past, including examples of early American home life in the museum offered the possibility of influencing homes and individual taste through American historical traditions.

To stake a place for American antiques in the Metropolitan Museum, Kent had built a network of collectors and experts in American craft traditions. Kent marshaled his personal and professional associations from his days at the Slater Museum in Norwich, Connecticut and at the Grolier Club in New York to assemble a collection of masterpieces of American craftsman-

Figure 18. The Hudson-Fulton Exhibition presented over 200 pieces of early American decorative arts in the museum's new decorative art galleries, which J. P. Morgan had recently built for the Met. Note the small scale of the old American things on display, juxtaposed with the grand scale of the Beaux-Arts galleries and looking like—in the words of trustee Elihu Root—"fish out of water." The furniture seemed to many progressive connoisseurs to call for a new method of display when permanent galleries would be built at the museum. Metropolitan Museum of Art, Hudson-Fulton Exhibition, 1909. The Metropolitan Museum of Art. Image © The Metropolitan Museum of Art.

ship for the museum's temporary exhibition. The Hudson-Fulton Exhibition presented over two hundred examples of early American antiques, from the seventeenth century to the 1830s, which illustrated the development of American design. Tables and chairs, chests of drawers and upholstered beds, silver and ceramics were all arranged chronologically in linear rows along gallery walls to present a narrative of artistic progress, which aligned with the new scientific classifications of art historical arrangement that Robinson had recently implemented in the Metropolitan's fine art galleries. The museum further legitimized American decorative arts by presenting them alongside the paintings by Dutch masters that were also part of the Hudson-Fulton Exhibition.

John Cotton Dana and the Newark Museum

On the opposite side of New York harbor, John Cotton Dana waged his own cultural battle for American industrial art and the democratization of museums. Today, historians and museum professionals frequently cite Dana as the father of museum innovation in the United States.[18] From 1909, when Dana opened the Newark Museum as an educational affiliate of his public library, until his death in 1929, Dana aggressively promoted the usefulness of museums and the alliance of art and industry. Dana's withering critiques of American art museums, and his pointed attacks against the Metropolitan Museum in particular as a model for what he considered "dead museums," captured early twentieth-century debates about the cultural hierarchy of things within museums. Dana criticized the "gloom of the old-fashioned museum temple" filled with old masterpieces, claiming that it was useful only for elevating the perceived cultural status of museum benefactors. Instead, he advocated a "museum with brains" that served both the people and American industry by displaying objects of modern American production.[19] Like Kent, Dana also saw the advantages of aligning art and industry, and he used his position as librarian and museum director in Newark to push larger cultural institutions like the Metropolitan to democratize their collections for greater public use. The public rivalry, however, between the Newark Museum and the Metropolitan Museum over conflicts of connoisseurship and public usefulness, masked the professional and personal collaboration that Dana and Kent pursued throughout their careers.

Dana and Kent were long-time friends and colleagues who shared a commitment to public service and an interest in using museums to teach taste,

but they sometimes differed in their approaches to museum usefulness. Like Kent, Dana's professional experience as a librarian had instilled values of efficiency, bureaucratic management and community outreach. But Dana came to museums much later in his career than Kent, and when he did his museums were always under the umbrella of public libraries. Therefore, Dana usually had much more professional autonomy than Kent to pursue explicitly educational programs. Because Dana had graduated from Dartmouth, trained as a lawyer earlier in his career, and passed the New York bar, he also likely wielded greater social authority with museum trustees when he challenged the cultural hierarchy of things. In his first position as a librarian in Denver in 1889, Dana pioneered such democratic innovations as open stacks and children's rooms. Dana first encountered museum work when he moved to the industrial city of Springfield, Massachusetts in 1898. As head of the city library, Dana also oversaw management of the city's museums: Springfield had recently completed a small cultural complex that included art and natural history museums. Aside from select objects from a few local benefactors, however, his museums' limited collections offered scant educational opportunities for Springfield's local public of industrial workers.

Dana recruited Kent from the nearby Slater Museum in Norwich, Connecticut to build an educational collection of plaster-cast reproductions of classical sculpture. Kent's reputation as an innovative museum educator during the 1890s had led to several other collaborations with local museums. In addition to his early work for the Metropolitan in the 1890s, Kent had also helped the Rhode Island School of Design select casts and photographs for its study collections, and he built cast collections for the Buffalo Fine Arts Academy and the Carnegie Institute in Pittsburgh. Kent later wrote that in 1899 he and Dana began a life-long friendship that gave them both "many amusing and lively hours." "Dana," Kent said with admiration, "was full of schemes for making his library useful. In this matter we saw eye to eye."[20] Dana commissioned Kent to design settees, swinging photograph cases, and photo storage cases for the Springfield Library based on sketches from Kent's European notebook.[21] "The installation," Kent boasted, "was one of real beauty."[22] Together, they made pamphlets on Greek mythology for school children to use in the exhibits, and Kent frequently traveled to Springfield to give lectures. Fusing common goals, Kent and Dana used the Springfield Museum's collection of plaster casts to teach classical history and appreciation of art.[23]

Kent and Dana's correspondence after Kent moved to New York in 1900 to become librarian of the Grolier Club illustrate Kent's increasing professional

stature.[24] In 1901, Kent had sufficient institutional authority to offer his own sage professional advice to Dana. In a personal note commenting on changes in the structure of the Springfield Library's board, Kent declared, "Directors and Trustees with unfailing good manners are rare," and he congratulated Dana on his "windfall" after the resignation of one of its (apparently ill-mannered) officers.[25] Trustee relations, in fact, represented the biggest obstacle for both men throughout their careers. Though Kent said that he and Dana always saw eye to eye with their schemes to make their institutions useful, "in later years," he recalled, "the methods by which we tried to work out this principle differed somewhat because of the different materials and trustees we had to work with."[26] While Kent became a respected museum professional known for institutional innovations, Dana maintained an undisputed reputation as the father of museum pragmatism and community outreach.

Dana's reputation comes as much from what he said in the public sphere about the social role of museums as from what he did at the Newark Museum. During Dana's twenty years as a museum leader he wrote proficiently about his ideas for cultural democracy, criticizing traditional art museums. Dana tapped into the emergent progressive discourse about museum education, environmental determinism, and the relation between art and industry that museum professionals like Kent and American Association of Museums president Paul Rea had long advocated, and he selectively borrowed arguments from social theorists like Thorstein Veblen and John Dewey to promote his own plans for the Newark Museum. Like Kent and de Forest at the Metropolitan, Dana wanted to improve public taste because he too thought it represented a civic imperative: democratizing access to art, teaching appreciation of beauty, and improving modern industrial design offered these social progressives practical solutions to the problems that industrial capitalism posed for American democracy. But like many progressive reformers, Dana cherry-picked social arguments from multiple reform models to suit his own cultural politics.

Throughout Dana's writing, the Metropolitan Museum served as a foil against which he could frame more democratic museum strategies. Dana mounted a publicity campaign to win public support for his vision of museum usefulness, because many of Newark's museum trustees wanted an art museum like the Met, modeled on European palaces.[27] Therefore, Dana ignored many of the Met's own democratic reforms, such as outreach to schools and craftsmen, and traveling exhibitions in working-class neighborhoods. Instead, Dana focused on the Metropolitan's elitist pretensions (which

he certainly had no trouble identifying). Dana excoriated temples of art as self-indulgent reflections of the egos of rich men, whose primary purpose was distinguishing visitors by social class, rather than bringing museum publics together. Most municipal art museums, Dana argued, were merely storehouses for rich stuffs, rather than educational institutions. "Probably no more useless public institution . . . was ever devised," Dana charged, "than that popular ideal: the classical building of a museum of art, filled with rare and costly objects."[28]

Dana's 1913 essay "The Gloom of the Museum" pitted traditions of connoisseurship against educational utility, and it introduced the arguments he would repeat throughout his career. "Art museum objects were not chosen for their beauty or for the help they might give in developing good taste in the community," he insisted, "but for their rarity, their likeness to objects found in European museums, and for their cost."[29] Dana pronounced traditional "mausoleums of curios" failures because they were "filled with objects not closely associated with the life of the people."[30] Attacking what he considered the "undue reverence for oil paint," Dana proposed, "oil painting has no such close relation to the development of good taste and refinement as have countless objects of daily use."[31] Dana followed the same arguments that Kent used at the Metropolitan to introduce a department of decorative art, insisting that museums could best serve the public by presenting objects of American production. "Art in America does not flourish," Dana complained, because "most of our great museums look with open scorn on the products of American artists and artisans."[32] For Dana, a museum with brains was a museum that allied art and industry, according to the model of the South Kensington Museum, to improve public taste and make local manufactures more competitive through better design.

Indeed, Dana pioneered the exhibition of modern industrial arts in the United States, which he delighted in pointing out to Kent at the Metropolitan— and anyone else who would listen. Dana presented exhibitions of various New Jersey industrial products, from textiles to ceramics and pottery. "A museum is supposed to be of help," Dana maintained, "in improving the taste of its constituents and in increasing their interest in, and their powers of discrimination concerning, the objects they daily see and use."[33] Exhibits like the Newark's 1913 exhibition, New Jersey Clay Products, presented hundreds of examples of both modern and historic pottery and brick pieces to illustrate manufacturing techniques and decorative motifs. Dana argued that European nations had long appreciated the value of single-industry exhibits, and he hoped that more

collaborative exhibitions could likewise promote local production. "We believe that under modern advertising conditions it would not take much work of this kind to link the name of Trenton," Dana suggested, "with the idea of chinas and porcelains in the minds of both the wholesale and the reading public as thoroughly as Limoges has become linked with the same idea."[34]

One year earlier, Dana had presented an influential exhibition of modern German applied art, in collaboration with the Deutcher Werkbund, that is often identified as a defining moment in the history of modern design in the United States.[35] Founded in 1907, the Werkbund was a craft school that sought to ally art and industry by moving away from historicist imitative design. Its importance in design history is thus linked to the idea of a progressive evolution of aesthetic modernism.[36] Dana's interest in presenting the exhibition at the Newark Museum, however, stemmed from the Werkbund's track record of mounting traveling exhibitions that promoted local industry. The exhibition featured both objects of industrial design, and their photographic reproductions. "It would be well to emphasize the part the manufacturers have taken in this progressive movement in Germany," wrote American Federation of Arts editor Leila Mechlin, "not only to commend their action, but to urge that American manufactures follow their example."[37] Dana had asked the Metropolitan Museum to host the traveling Werkbund exhibit, but Edward Robinson said that that the Metropolitan's policy against "what might be called trade exhibitions" prevented the museum from participating in the traveling show. Robinson further explained that the Met had recently turned down applications from silversmiths and jewelers, among other trade representatives.[38] Long after the exhibition's success, Dana frequently referred to Robinson's refusal as evidence of the Metropolitan's elitism in his own campaign to promote the Newark Museum. "The thought I am developing of making our public museums of definite useful value," Dana wrote eight years later, "was still alien to our most important museum."[39]

While Dana publicly criticized the Metropolitan, he privately assured Kent of his personal respect and reminded him of their mutual goals of practical education and democratizing museums. Clearly, Dana saw his role as one of gently prodding Kent to move the Metropolitan Museum further toward the alliance of art and industry, and he assumed that their friendship could weather any disruptions his public criticism may generate. One notorious 1922 editorial in the *Nation* tested such limitations. Dana mocked the Metropolitan's education programs to improve public taste, and he sarcastically accused the Met of arrogantly making decisions about what constituted

examples of good taste for improving American design. "The Metropolitan management," Dana charged, "seems to hold that the only real, true, and holy art is found in the objects it has gathered."[40] In direct, public response to Dana, Kent wrote a letter to the editor of a Newark newspaper agreeing that "the development of public taste in such products of the industries is a continuously forward movement not utterly dependent upon what the past has to offer," but he defended the Metropolitan's role of presenting the past in its galleries, and he called instead on schools to teach design.[41]

Privately, Dana assured Kent that his "notes on the Metropolitan" "were designed in part to aid you in your long fight for reason in Museum management." Dana even insisted to Kent that he had intended for his editorial to "amuse you a little!" "What I wished to do, though this with the faintest hope," Dana teased, "was to induce one or two of your brass-bound trustees and even of your contented officials, to look at their museum as 'A Thing in the Whole World', and so look at it as to be led to say, 'I wonder if we are doing merely what conventions says, and not even trying to do what a study of the museum in this day's American life may suggest?'"[42]

"A good idea?" Dana closed with familiar joviality, "even though its hope is quite forlorn?"[43] Kent maintained remarkable composure in all his correspondence, so it is difficult to measure his response, but the personal and professional dynamics that Kent and Dana shared throughout their careers suggests that he certainly had reason to hit back. By 1922, Dana was still mounting exhibitions at the Newark Library, rather than an independent museum, because he continued to spar with museum trustees over the kind of museum Newark should build. Indeed, all of Dana's writing served the primary purpose of keeping his vision of cultural democracy in the public eye, and forcing the hands of his own brassbound officials. Moreover, Dana frequently deferred to Kent's professional expertise, asking for practical advice about running an efficient museum. Most of Dana's letters, in fact, consist of questions about professional and constitutional matters for incorporation, references to individuals and firms that could make reproductions for educational galleries of industrial arts, and questions about provenance of objects. Kent always sent his friend prompt and detailed responses.[44]

In response to Dana's clumsy mea culpa in 1922, Kent replied with good humor that he had written elsewhere about his own hopes for greater institutional collaboration, and he reminded his friend of the multiple publications where he had expressed such views. But no doubt exquisitely aware of his own institutional restrictions and the careful negotiation between trustees and

curators that his job at the Metropolitan required, Kent suggested to Dana, "don't write your criticism for the newspaper; send it to me!"[45] Kent's irritation must have stemmed in part from his own quiet success at the Metropolitan over the past ten years in obtaining the support of trustees and other "contented officials" for expanding the museum canon to include American industrial art and promoting museum usefulness. Dana, Kent also knew, was very aware of just how well he could "induce" Met leaders toward his own educational objectives.

The same year that Dana had opened the Newark Museum, Kent began advocating American decorative arts at the Metropolitan Museum, and he started to consolidate his own strategies of institutional politics. Faced with internal constraints from many of the so-called brassbound trustees on the museum's board, Kent marshaled his professional and personal resources to introduce American antiques to museum audiences with a test-case exhibition. If he could present American things in the museum as part of the Hudson-Fulton celebration, Kent believed public appeal would compel museum leaders to commit to an eventual permanent collection. But unlike Dana, who could mount a publicity campaign to maneuver public support for his vision of cultural democracy over the traditional ideas about art museums held by many of Newark's trustees, Kent needed to work within the institutional parameters of the Metropolitan's cultural position, and he had to more explicitly use art-historical arguments to make his case. Kent also tapped into emergent interest in colonial revival aesthetics and patriotic historical associations to legitimize his proposal for an exhibition of American things.

The Colonial Revival

During the Progressive Era, the colonial revival offered a specific construction of the American past for its advocates to frame modern American social relations. Social and aesthetic reformers alike drew selective elements from America's colonial and early republic past as models for Americanization. They celebrated romanticized ideals of Puritan thrift, republican virtue, and egalitarian communities of New England households as antidotes to the seeming social incoherence of modern industrial cities. Settlement workers and progressive educators recreated colonial kitchens and demonstrated preindustrial household labor, they served Yankee dinners to immigrant children, and they used U.S. history to teach American civics. Ancestral societies and historic preservationists also looked to the colonial and early republic

American past to define the present, and many teamed up with antique collectors to preserve specific examples of American design and architecture.

In 1909, Robert de Forest used the Hudson-Fulton Exhibition to promote
colonial revival aesthetics as models of civic taste, linking the Metropolitan
Museum's loan exhibition of American antiques with the restoration of New
York's City Hall. While Kent planned the Met's exhibition of American things,
de Forest added to the exterior preservation of City Hall by opening newly restored public interiors in coordination with the Hudson-Fulton Celebration.
The progressive interest in searching for a usable past to inform progress in
the modern century certainly influenced the way de Forest and Kent recovered artifacts from the American past for their educational programs, but so
too did the cultural politics of collecting and preservation. Balancing socially
progressive goals like inclusive programs for Americanization with the arthistorical prerogatives of collectors was often difficult. At the Metropolitan
Museum, Kent advocated expanding the canon to include American decorative arts because he believed they could be used to improve modern American design, but he also wanted to increase the status of old American things.
The network of collectors he developed to assemble the Hudson-Fulton Exhibition also wanted to increase the value of their collections and legitimate
their role as experts. Robert de Forest tapped into the same networks of collectors to restore the interiors of City Hall because he believed that tasteful
civic landscapes could have as powerful an influence on ideals of citizenship
as tasteful homes.

Kent saw the Metropolitan's 1909 Hudson-Fulton Exhibition as his own
opportunity to test public reception of American things in an art museum.
Once de Forest secured the approval of the Metropolitan's board of trustees
for Kent's exhibition of Americana, the task of assembling a collection of museum-worthy American things fell upon Kent. One of the most curious—and
perhaps impressive—details in the history of the Hudson-Fulton Exhibition
is the fact that Kent (a museum administrator) fulfilled almost all of the curatorial obligations for the American portion of the loan exhibit. The Metropolitan's cultural authorities frankly paid much more attention to the upcoming
exhibition of Dutch master paintings, which they deemed the more important
aspect of the Hudson-Fulton Exhibition. For example, Edward Robinson and
J. P. Morgan chased down collectors like department store magnate Benjamin
Altman, whom they successfully persuaded to overlook his usual policy of
not lending his art by offering to give Altman a personal tour of Morgan's
house in London. After art dealer Henry Duveen escorted Altman through

Morgan's highly coveted (though rarely seen) collection, Altman wrote Robinson: "It was a great pleasure to see the beautiful paintings and objects of art and the arrangement of the house."[46] Altman promptly instructed his agents at Duveen Brothers to ship three Rembrandts and a Ruysdale that he had recently purchased in London to the Metropolitan for the Hudson-Fulton loan exhibit.[47] While curators and prominent members of the museum's board focused on securing old masterpieces, Kent and his staff assumed the responsibility for creating lists of American objects, locating appropriate pieces, and securing their loans from a broad base of private collectors.

Lacking the cultural influence of the museum's institutional authorities, Kent used his personal connections with the collectors he had met in Norwich at the Slater Museum, and in New York through the Grolier Club. Kent recruited New York collectors R. T. H. Halsey and Luke Vincent Lockwood as advisory members of the museum's committee to assemble the American loan collection, and they in turn helped Kent recruit local liaisons in Boston and Hartford to scout out individual collectors.[48] Over the course of a year of very busy coordination, Kent and his friends built an institutional network that brought together informal associations early collectors had begun during the 1880s and '90s.

To secure approval from fellow museum board members, de Forest promised that the American furniture galleries in the Hudson-Fulton exhibit would be arranged "according to the German National Museum' system."[49] For museum professionals like Kent and Robinson, as well as for anxious trustees, this terminology assured that the Met's experimental exhibition of American things would comply with academic art-historical methodology. Kent later explained this modern museological jargon to Lockwood, one of the recognized experts in the field but nonetheless an amateur collector. "It would be our plan to arrange our collection of furniture," Kent explained, "according to the 'room' method of the German museums, which would of course, mean a chronological showing of evolution of styles."[50] Collectors like Lockwood had previously used similar methodology to organize their collections and to begin systematic promotion of American antiques. Lockwood's 1901 catalogue of American furniture, along with collector Irving W. Lyons's 1891 book, in fact served as guides for Kent and his advisory committee as they worked to identify desirable pieces and to track down owners willing to lend their things.

Relying on word-of-mouth contacts and informal tips, Kent canvassed the Northeast for cooperative allies to whom he could delegate the task of

garnering local support. In early 1909, Kent wrote to collectors like Francis Bigelow in Cambridge, asking whether the Metropolitan could borrow objects that had been depicted in the recently published illustrated histories of American antiques, and also whether the collectors knew of others with similar objects. For example, Kent asked Bigelow if the museum could borrow his "tall Chippendale clock, which appears as figure 268 in Miss Morse's book on 'Furniture of Olden Times,'" and he provided a list of other things the Metropolitan desired. "I would be glad to have you indicate any other objects that you would be willing to lend." In a postscript, Kent added, "We should appreciate the names of other owners of large pieces of American silver."[51] Bigelow replied that he was reluctant to lend pieces for fear they may be damaged during transport, but he suggested a willingness to change his mind since he was also quite interested in selling some of his things. Bigelow seemed to vacillate between wanting to display them and fearing that they would be locked in exhibition if he found new buyers.[52] Hoping to head off Bigelow's hesitation, Kent and assistant Florence Levy traveled to Boston that Spring to meet with him and other local collectors. After their reconnaissance trip, Bigelow jumped on board to assist securing loans from other collectors of silver he knew throughout New England—probably many from his informal commercial transactions. Ultimately, Bigelow helped Kent secure loans from several prominent Boston collectors. By late April, Bigelow suggested that his objects, along with those owned by collectors Eugene Bolles and Dwight Blaney, could all be sent together in "a special car so they can be put in place here in Boston and removed by careful teamsters in New York—so as to prevent handling." He also reported that Blaney had recently purchased a Japanned clock from his collection that he knew Kent wanted for the Metropolitan's exhibit. While he reported that Blaney seemed reluctant to lend it so soon, Bigelow recommended, "You better include it in your list to him & I will try to persuade him." Whatever Bigelow's personal motivations, he quickly joined Kent's team. "It has been a pleasure to do what I have," Bigelow beamed, "& I only hope you can have the pieces you want."[53]

Halsey helped to bring together collections of silver and furniture, and Lockwood helped secure pieces from collector-friends in Hartford like Wadsworth Athenaeum curator Albert Pitkin—who would himself serve as a local contact and chase down other recalcitrant collectors. Tapping into Pitkin's identity as a public servant, Kent posed an alternate approach to the more pecuniary motivations he floated to Bigelow. Kent asked for Pitkin's assistance with introductions to local collectors like venerable Hartford banker Henry

Wood Erving, who maintained seeming indifferent reluctance, by striking chords of educational virtue. "I would not be so insistent in this matter," Kent apologized, "if it did not seem to me an exceptional opportunity to secure examples which will show the development of our American manufactures in a logical manner." "This is the first time such an exhibition has been made," Kent continued, "and it seems to me that its educational value would be great and that the people who are interested in such matters might be induced to lend objects in their possession for the sake of this result." While neither Pitkin, Kent, nor Lockwood persuaded Erving to part with his things, Pitkin did secure alternate pieces from other Connecticut collectors for Kent's exhibit at the Metropolitan. Explaining his motivations to Florence Levy, Pitkin said, "I believe in good museums, and their good work."[54]

Perhaps the biggest contributor to the Hudson-Fulton exhibit was Boston lawyer Eugene Bolles.[55] One of the early collectors of American antiques who had scoured the countryside in horse and buggy looking for old things, Bolles owned perhaps the most highly esteemed collections of seventeenth- and early eighteenth-century furniture. Bolles loaned the Metropolitan Museum so many objects that, rather than combine his collection with Blaney's and Bigelow's, he sent his pieces in two separate shipments. The personal attention Bolles gave to packing and shipping his collection illustrates the strong proprietary relationship many of the early collectors had with their things. Though Bolles complained that his legal cases kept him "tied up as tight as the petrified bones of a prehistoric man in some ancient quarry," he nonetheless oversaw minute details of the collection's preliminary cleaning, repair and packing.[56] Bolles sent all of the things he lent the Metropolitan to one of his favorite local cabinet makers, Davenport & Company. "Their place is in the center of the city, not far from my office, so that I can handily go there every day, if necessary."[57] In May, Bolles reported, "the removal of the things has developed into quite an undertaking, and as I see them in a row on the floor at Davenport's, they make I think a very good showing."[58] Bolles's collection of early furniture ultimately complemented later high-style pieces in the exhibition that Norwich collector George Palmer loaned, and the early nineteenth-century Duncan Phyfe pieces that Halsey and the de Forests contributed.

Kent's authoritative role as intellectual and organizational leader of the American contribution to the Hudson-Fulton Exhibition reveals both how successfully he could pull strings to see his proposals through at the Metropolitan in his first five years as its administrator, and the breadth of his own informal education as a progressive connoisseur. To generate public enthusi-

asm, Kent undertook a publicity campaign to blitz local and national press, decorating magazines and trade journals, as well as craft, design, and vocational schools, with a barrage of press releases, announcements, and offers to reproduce photographs of objects in the exhibition.[59] Here we see his interest in broad outreach to diverse museum publics. But Kent also used the exhibition to express his personal taste, and to pursue his interest in fine binding and the book arts that he had developed at the Grolier Club.

While Kent remained focused on the educational value of his exhibit and its possible links to modern industry, he also took great delight in his role as the creative authority of the exhibit. Kent hired master printer Walter Gillis to produce all of the exhibition's catalogues, as well as selective promotional materials for museum members. Of course, every detail passed Kent's desk. In July, Kent offered suggestions for the exhibit invitation: "It seems to me desirable that it should be printed in the type of the period of Hudson, 1620." "I found in the Grolier Club several types copied from manuscripts," Kent delighted, "which would seem to me to lend themselves admirably for that purpose." "My judgment would be that the paper should be Dutch and that the whole scheme of the invitation should be as simple as possible—no decoration, only borders."[60] At another point Kent relied on Gillis to exert his own professional influence and knowledge of the book arts to veto what he considered objectionable images that had been proposed for the catalogue. "I am forwarding to you herewith, a photograph of the Hudson-Fulton seal which to my mind is hideous, and which I hope you will not find possible to use on the title page."[61] Despite Kent's democratic commitments, his aesthetic sensibility sometimes led him to make curiously elitist suggestions. "With regard to the binding of the Hudson Fulton catalogue, would it be well to put the cheap editions in paper similar to that used on the unbound Cast Catalogue, but of a dark blue or dark grey color?" "For the more expensive editions," however, Kent hoped for something more refined. "Could we not use the boards covered with charcoal paper, with either a skiver [leather] or velum back?"[62] The promotional and educational materials he produced for the Hudson-Fulton Exhibition illustrate both the limits and the sometimes paradoxical nature of cultural democracy in the early twentieth century.

The Hudson-Fulton Exhibition opened to great fanfare and public spectacle. As part of a city- and state-wide celebration, Kent could not have asked for a better forum to present American things in the art museum—nor could he have asked for a more topical event to fuse ideas of progress with history. The celebration included parades up and down Fifth Avenue,

as well as along the water route of the Hudson River, historical pageants, concerts, and exhibitions in all of the city's cultural and educational institutions. At the Metropolitan, the Hudson-Fulton Exhibition brought in record numbers of visitors: by the eve of its closing in November 1909 over 180,000 people had visited museum galleries.[63] To Kent's delight, museum visitors confounded elite critics by flocking to the furniture galleries instead of the Dutch masters.

By the time the Hudson-Fulton Exhibition closed, the Metropolitan's *Bulletin* had announced that Kent's experiment had succeeded: "The collection of American furniture and other decorative arts has found an interest which has already begun to have practical results, and our trade journals, schools, and craftsmen in the lines represented have clearly indicated their appreciation of the exposition of art of this country in earlier times."[64] During the exhibition, Florence Levy gave public lectures to schoolteachers on "Two Centuries of Industrial Art in America," Lockwood talked to small groups of teachers of manual training in elementary schools, and Halsey presented illustrated lectures of "American Silversmiths of the Seventeenth and Eighteenth Centuries and their Work" to the Jewelers' Board of Trade.[65] The Art League of the Public Education Association later organized meetings for public school teachers to instruct them in the educational use of pieces within the loan exhibition.[66]

J. P. Rome, secretary of the industrial art advocacy group the Art in Trades Club, described the impact the Hudson-Fulton Exhibition had on industrial design. "When Chippendale furniture was coming into vogue less than a decade ago," he recalled in 1918, "a certain manufacturer went into a certain museum and saw therein a certain collection of Georgian furniture." The unwitting manufacturer remarked, "It is wonderful how quickly they brought this collection together since the starting of the vogue." "'Yes,' replied a friend who was with him and who knew better, 'it is wonderful, since they had only a century and half to do it in.'"[67] Clearly in on the joke, Rome worked with Kent to make museum objects like the American things in the Hudson-Fulton exhibit available to manufacturers for study. As editor of *The Decorative Furnisher*, Rome published reproductions of museum pieces to influence more manufacturers to study historical designs. Rome argued that traditional museum visitors admired and praised art objects, but he suggested that industry would not only praise good design, but also "produce goods for everyday and continual consumption."[68]

Just as Kent used his acquired museum skills and his association with collectors and donors to make the Slater Museum in Norwich a cultural destina-

tion in the 1890s, he used his professional improvements at the Metropolitan and his connections with collectors and with de Forest to make American decorative arts acceptable in art museums. Emphasizing the educational role of vernacular decorative art at the South Kensington Museum to influence British manufactures, he argued that local traditions could play an equally progressive role for American industrial arts. While Kent set out to democratize the collections, he also succeeded in democratizing the museum experience. Visitors seemed to find household arts more accessible than painting and sculpture; perhaps because household arts—the objects of everyday use that Eastlake identified as integral to good taste—were less intimidating and required less cultural capital and art-historical education to appreciate. Thus, American decorative arts offered yet another advantage for taste education at the Metropolitan Museum.

Popular legend among historians of Americana collectors and the decorative arts positions the Hudson-Fulton exhibit as a watershed moment in the history of collecting, and Henry Kent's role in its formation has itself taken on mythic symbolism. Kent is frequently cited as the figure most responsible for legitimizing American decorative arts in art museums. Following the exhibition, Kent encouraged de Forest to secure the Bolles collection of American furniture for the Metropolitan Museum. Kent invited Robert de Forest and his wife Emily, along with R. T. H. Halsey, on a motoring trip through New England to introduce them to old New England houses, as well as to the collectors who both maintained the buildings and stripped them of their furnishings. Kent carefully orchestrated both the trip and his guest list. Both Halsey and Emily de Forest were collectors of Americana with significant Duncan Phyfe collections, while Robert de Forest had recently recruited Halsey to restore interiors at City Hall. Kent scripted these relationships into the more touristic details of his motoring trip to reinforce his guests' common interests in Americana, and to make his case for their place in an art museum. But Kent also later claimed with humility that it was actually the impression of the old houses, things and collectors—not to mention the proper fish chowder that "these New Yorkers had never tasted"—that ultimately encouraged de Forest to rally support among fellow members on the Metropolitan's board.[69] However Kent pulled the strings, de Forest's support ensured Kent's proposal to build a permanent collection of American things in the art museum. In 1910, de Forest advised Sage Foundation founder Margaret Olivia Sage to buy Eugene Bolles's collection of early American antiques, previously loaned to the Hudson-Fulton exhibit, for the Metropolitan Museum.

Robert de Forest tapped into the popularity of American antiques and the colonial revival by pledging to build a permanent collection of American decorative art at the Metropolitan Museum, and by restoring the interior rooms of New York's City Hall. Both projects illustrate the constructed nature of colonial revival interpretations of the past. Viewed as part of a larger movement to define American identity, they also illustrate the changing uses of colonial revival ideas and aesthetics through the First World War. De Forest linked restoration of the Governor's Room at City Hall to the progressive 1909 Hudson-Fulton Celebration because he believed New York's seat of government should present a public image of civic taste. Coordinating the reinterpretation of the Governor's Room with the 1909 Hudson-Fulton Celebration further tied historic preservation and the search for an American aesthetic to de Forest's larger program to improve civic taste.

The Governor's Room had been renovated by the city as recently as 1905, but de Forest and his team of architects and collectors remade the space into an idealized interpretation of federal-style architecture and furnishings that served the symbolic needs of the city's Protestant establishment, over the political machinations and spurious taste of Tammany Hall.[70] To progressive connoisseurs like Robert de Forest, the just-completed 1905 restoration of the Governor's Room at City Hall illustrated exactly what was at stake in controlling the physical appearance of civic spaces. Oversight authorities like de Forest's Art Commission had been unable to reign in city-contracted decorators because municipal appropriations required broad discretionary input. The room's redecoration confirmed to many critics the corrupting influence of political machines—in this case the machine produced a vulgar misrepresentation of civic taste. The large paintings gallery at the south end of City Hall had been finished with red walls and garish fixtures in silver and gilt. De Forest used his leadership of the city's Art Commission and his access to private resources to reinterpret the decoration of the Governor's Room and circumvent any future municipal objections. By relying on private funding through the Sage Foundation, de Forest and his team retained complete control over the appearance of public space.

De Forest's overlapping leadership of regulatory and philanthropic cultural institutions allowed him to shape the city's civic landscape by restoring landmarks as he deemed appropriate. In 1907, Mayor George McClellan had given the Art Commission advisory authority over all city building projects. Just as the tenement commission gave de Forest authority over health and safety specifications for buildings, the Art Commission gave him oversight

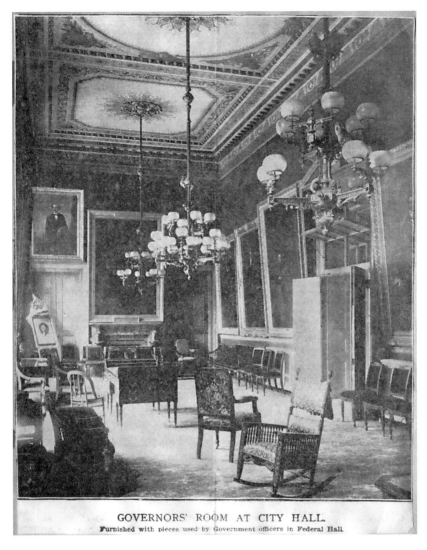

GOVERNORS' ROOM AT CITY HALL.
Furnished with pieces used by Government officers in Federal Hall.

Figure 19. This newspaper photograph of the Governor's Room in 1905 shows the exuberant style of decoration that many progressive connoisseurs found objectionable. The walls were reportedly finished in red with silver and gilt details. Governor's Room, New York City Hall, undated scrapbook clipping. Courtesy New York City Municipal Archives.

of aesthetic matters in the city, including monuments and historic preservation.[71] Historians argue that historic preservation in New York, much of which de Forest oversaw, served the function of setting aside certain spaces representative of a civic past that were necessary counterpoints for the city's capitalist development.[72] De Forest coordinated the redecoration of the Governor's Room to coincide with the city's Hudson-Fulton Celebration, which highlighted New York's Anglo-Dutch heritage, but he also linked civic taste with New York's history and its industrial progress.

Seizing control of the Governor's Room at City Hall and reinterpreting its appearance to represent the civic taste of early republic statesmen seemed to provide a progressive counterpoint to nineteenth-century municipal corruption (and tasteless vulgarity). De Forest called on his personal architect Grosvenor Atterbury and the collector R. T. H. Halsey to ensure the right aesthetic imprimatur. Atterbury and Halsey made a great team, whom de Forest could rely on both for their expertise and their cultural capital. The Sage Foundation provided $25,000 to allow de Forest's team to exert sufficient authority and autonomy to push through their vision of American taste. In 1908, Atterbury began to carefully remove restorations made to the Governor's Room in 1905, and reinterpret its interior architecture in the federal style. Atterbury had built de Forest's country estate, Wawapek, on Long Island's north shore and he was presently at work with Frederick Law Olmsted, Jr. designing the Sage Foundation's garden community of social housing in Forest Hills, Queens. City Hall historian Mary Beth Betts makes clear that Atterbury took creative license with the interior restoration at City Hall. Most of the original details of the Governor's Room had been lost over the previous decade, so Atterbury "restored" the interior based on careful study of historic style books. He opened windows that had never existed, and he stripped the interior of its late nineteenth-century embellishments to meet the colonial-revival tastes of the early twentieth century.[73] Like other contemporary architects and designers who worked in the colonial revival style, Atterbury romanticized historical architecture and edited his restorations to fit an idealized version of the past.

Early professionals in the field of historic preservation like Atterbury frequently played with history to fit certain architectural details into their ideas about usable pasts. Boston's Paul Revere House, for example, served as a test case for preservationist William Sumner Appleton, and set the stage for the awkward balance between colonial revival imagination and professional documentation that Appleton's Society for the Preservation of New England Antiquities (SPNEA) would later navigate. By the early twentieth century,

Figure 20. Atterbury stripped the Governor's Room of its recent decoration, as
well as many original architectural fragments, to redesign the building according
to the colonial-revival ideas of an early-republic public interior that he considered
appropriate. Governor's Room, New York City Hall renovation, undated. Courtesy
New York City Municipal Archives.

Figure 21. The newly designed Governor's Room featured reserved green walls, stately yet constrained drapery, and Duncan Phyfe furniture drawn from the collections of R. T. H. Halsey and Robert and Emily de Forest. Governor's Room, New York City Hall, 1909. Art Commission of New York City. Courtesy New York City Municipal Archives.

preservationists looked with alarm at the physical and social transformation of Revere's historic eighteenth-century residence. Like many old buildings, the Revere House had been modified over the years to meet the needs of successive residents. Nestled within what had become an Italian immigrant neighborhood, the North End, the Revere House had been converted into multi-use functions as an Italian bank, storefront, and tenement apartments. Through the Sons of the Revolution, Appleton created a private organization of concerned Bostonians to purchase the house, restore it, and turn it into a civic museum for the education of local immigrant communities. In 1907, architectural historian Joseph Chandler reinvented the house to fit antiquarian ideas of early Boston architecture. Chandler removed a third story, original to Revere's occupancy, to emphasize the building's overhanging façade and turned pendants, and he installed casement windows that suggested an Anglo-Saxon aesthetic.[74] In New York, the Sons of the Revolution similarly reconstructed Fraunces Tavern, site of patriotic meetings of the Sons of Liberty during the Revolution and celebratory speeches by George Washington at its conclusion. The restoration, however, was based largely on the historical imagination of architect William Mesereau. Without original drawings, Mesereau pieced together a colonial-revival suggestion of how he thought a colonial tavern would have appeared. In 1907, the Sons of the Revolution also turned Fraunces Tavern into a museum that taught patriotic values, like the Revere House.[75]

In response to renewed interest in colonial-revival aesthetics after 1909, Columbia University curator of architecture Richard Bach wrote a series of reviews of colonial architectural history for the *Architectural Record*. Bach had great respect for early American architecture, but very little patience for sloppy architectural history and preservation. Bach spared few arrows for architectural histories that he regarded as misinformed or simplistic, and he was particularly distressed by conflation of the terms *colonial* and *Georgian*, and by flattening of regional differences. Bach explicitly rejected arguments that American architectural forms were the result of environmental characteristics exceptional to the New World, and New World artisans. He agreed that American architecture developed from European models, but he argued that American styles were adapted by specific "manipulation of forms that belong to time and accidents," rather than from any "race or place or period."[76] Bach likewise discounted histories that focused exclusively on "the whole life story of American dwellings of pretentious character from the dignified homes" of elite families that were increasingly in vogue. Bach dismissed such histories

as only "of particular value to that much maligned stratum of society known as the dilettante."[77]

To counter the historicized fantasies that colonial revival enthusiasm unleashed, Bach called for professional standards of accuracy and scientific precision. Like SPNEA leader William Sumner Appleton, Bach also disapproved of the "vandalism" of old houses. Therefore, Bach made a plea in 1915 for the compilation of detailed histories and descriptions of every American building style while the buildings still stood. "The buildings disappear monthly," he complained, "and many are repeatedly altered, converted into taverns and museums or turned to other purposes, which almost invariably involve important structural changes."[78] Bach identified architectural historians with scientific training. He congratulated Norman Isham and coauthor Albert Brown "upon the excellent manner in which they have availed themselves of their opportunity to contribute an important chapter to the history of Colonial architecture."[79] Bach likewise thought Joseph Chandler was "one of the most serious and understanding students of the Colonial style."[80] In particular, Bach agreed with Chandler's derision of colonial-revival-style architecture. Bach ridiculed "the many hybrid varieties of alleged Colonial derivatives that belong properly in the category of what [Chandler] calls Kickapoo Colonial." "If its precepts are taken to heart," Bach warned, "such a self castigation among practitioners will result that the tasteless reproductions so casually foisted upon a public only too eager to live in Colonial houses will be forever consigned to the limbo of the architecturally unfit."[81] Yet Chandler had overseen the creative restoration of the Paul Revere House, and Bach himself had praised de Forest's and Halsey's restoration of City Hall. In particular, Bach cheered the removal of "quasi artistic embellishments at the hands of party henchmen" that had "accumulated [by] a number of Early Tweed and Mid-Tammany accretions." In fact, Bach thought the new "chaste decorative scheme" of the redecorated Governor's Room at City Hall probably looked as good as it had when McComb designed it in 1803.[82] Like de Forest and Halsey, and most preservationists in the early twentieth century, Bach also preferred saving the "right" histories and white-washing the rest: in fact, he particularly delighted that the unfinished brownstone north side of the building was "now fortunately painted over."[83]

In combination, the projects to build a permanent collection of American antiques at the Met and to restore City Hall interiors to a tasteful early republic aesthetic helped popularize the colonial revival movement. After the success of the Hudson-Fulton exhibit, Kent further consolidated his collect-

ing associations to build the Met's permanent collection of American things, and he carved out a privileged place for himself within the ranks of the newly legitimized art-historical field of Americana. Kent founded the Walpole Society in 1910 as an institutional base of collectors and experts that he could tap into for the Metropolitan's new American Wing. The Walpole Society was an exclusive gentlemen's club for his collecting friends, which ensured that the network he had already built could be used as a formal resource for institutional collecting. As a combined professional and social institution, the Walpole Society advocated increasing the status of old American things through promotion in museums and by publication, and it also protected individual members' status as erudite gentlemen-scholars by restricting membership and access to privileged information. During the restoration of City Hall, Halsey became a member of the Metropolitan's board of trustees to oversee construction of period room galleries for the new American Wing, which Atterbury would build. Kent made the Walpole Society an institutional arm of the Metropolitan Museum, and de Forest made Atterbury and Halsey once again his personal design team, as they all worked together to further legitimize American decorative arts and use them to make Metropolitan Museum galleries work for the public.

During the first two decades of the twentieth century, progressive connoisseurs like Henry Watson Kent, Robert de Forest and Edward Robinson revolutionized the Metropolitan Museum's institutional culture by introducing new ideas about cultural democracy. They rejected what they considered to be old-fashioned ideas about museums as exclusive temples of art, and instead tried to make museums democratic educational institutions, in line with schools, libraries, and settlement houses. While neither alone in the field nor even first in the United States to implement what cultural reformers were calling museum modernisms, the Metropolitan nonetheless stood out for its influential position among art museums, and for the undisputed cultural capital of its curators, trustees, and administrative professionals. Metropolitan trustee—and museum president after 1913—Robert de Forest integrated the Metropolitan into a larger network of progressive institutions that were committed to shaping the built environment of cities in order to enhance American democracy. After 1905, de Forest recruited a new generation of reform-minded trustees and museum professionals like Kent and Robinson— who had established their own professional reputations for education reform

in the 1890s—to help him usher in a progressive museum agenda dedicated to the improvement of public taste.

At the heart of progressive ideas about cultural democracy lay a belief in the utility of allying art and industry. The Metropolitan Museum, like other institutions committed to the education of civic taste, placed decorative arts at the center of education reform because museum leaders believed they could be used to teach the public principles of good design. American things served both Kent's and de Forest's democratic education goals because they served as tasteful examples of the everyday things that surrounded people, and because they proved to be so popular with the public. However, decorative arts also challenged the hierarchy of things in museums, and disrupted the cultural interests of many museum benefactors. It is no surprise that the Metropolitan's first collection of decorative art, after all, was a collection of French Renaissance things. After the popular success of the 1909 Hudson-Fulton Exhibition, Kent was able to bring American things into the Metropolitan in part because his collector friends had categorized them by art historical methodology, which helped stake their claim for art museum placement.

Debates about the relationship between educational utility and connoisseurship, however, framed this period of cultural innovation in museums during the early twentieth century. Newark Museum director John Cotton Dana denounced "mere gazing museums" that focused only on expensive things and thus "failed to be of definite educational value," and he frequently criticized the Metropolitan Museum for shying away from what he implied was "the taint of commercialism."[84] In contrast to his own "quite frankly commercial" exhibits of local industrial production that tried to teach taste with "the pots and pans of everyday life," Dana complained that most art museums were content to merely "secure and expensively install an old, rare, and costly chest, which attracts the gaze and evokes the wonder of the casual visitor and the envy of the occasional expert."[85] Acknowledging Kent's recent successes at the Metropolitan after the Hudson-Fulton exhibit, Dana nonetheless questioned whether the taint of commercialism represented an insurmountable obstacle separating traditions of connoisseurship and ideals of educational utility in art museums.[86] More accustomed to compromise and increasingly more at home in the paradoxical role of progressive connoisseur, Kent tried to reassure his old friend that their educational goals and the cultural prerogatives of art museums were not, in fact, mutually exclusive:

As I see it the question is "How can you tell when something is tainted with commercialism and t'aint?" I have an underhanded conviction that very few objects of art were ever made without recompense of some sort. If it was not money, it surely was patronage, pension or something that could be bargained with and, hence, was commercial. If we must, in the case of all objects of art to be shown in the Museum, ask the question 'Has this ever been bought or sold or otherwise used to bargain with?' before admitting it to the galleries, we might well turn over the building to an athletic club or to some other purpose as worthy.[87]

The Metropolitan Museum shifted its curatorial emphasis from plaster casts to original artworks after 1905 because it had the fine-art collections necessary to ensure the museum's position in the international hierarchy of art museums; and that reputation was precisely what enabled the Met to take risks by opening up the canon to include decorative art. The museum phased out its collection of plaster casts and shifted its educational programs to focus on using decorative arts to teach design. But those decorative art collections at the Metropolitan were built with originals, thus orienting its new education programs around original artworks that could be attributed to master craftsmen who followed in traditions of art-historical connoisseurship.

CHAPTER FOUR

The Arts of Peace

World War I and Cultural Nationalism

World War I had a profound impact on the progressive museum agenda and on the way art museums used American things to improve public taste. Robert de Forest seized on the war as an opportunity to disseminate his notions of cultural democracy, and he used his leadership positions at the Metropolitan Museum, the Sage Foundation and the American Federation of Arts to increase public access to art and improve the aesthetics of American cultural production. Shortly after the United States entered the war in 1917, the American Federation of Arts (AFA) met for its annual convention in the nation's capital, where de Forest called on cultural institutions to maintain vigilance against calls to shift their attention to seemingly more immediate matters of wartime. Rather than focus only on national security, de Forest urged art museums to further expand their programs of outreach because he believed that the social value of art was particularly crucial at times of war. "If we decide that these things are of secondary importance," de Forest argued, "we admit that art is not a necessity but a luxury." "No," he insisted, "I believe it is our duty to hold the torch of art aloft before the darkness that is ahead of us and to keep that light burning through all that darkness to the glory of our country and the glory of the cause we serve."[1]

The Great War shifted the way Americans thought about the relation between art and democracy. Progressive cultural leaders in museums, art commissions and educational institutions in the early twentieth century had come to aesthetic reform and art education with diverse social and political objectives, they had studied catholic reform models, and they had worked together through collaborative association to improve the built environment

of cities and improve public taste. Like their peers who had tried to solve the social and political problems of the Gilded Age, progressive connoisseurs collected data, compiled statistics, and turned to experts for solutions that could democratize opportunity and enhance American citizenship. Enthusiasm for multiple points of view and the encouragement of cultural debate represented one of the great strengths of the progressive movement. But fierce disagreement about the role of the United States in the First World War also revealed the weaknesses in the loose coalitions that made up the progressive reform movement. The war split progressive reformers into oppositional camps over American intervention, while patriotic sentiments and fears of radicalism narrowed the debate about art and democracy for those progressives who saw the war as an opportunity to expand public appreciation and encourage government support of the arts.[2] The question for progressive connoisseurs like Robert de Forest, Henry Watson Kent and Edward Robinson was where they stood in the polarized cultural landscape that emerged during the war.

Progressive connoisseurs like Robert de Forest saw the war as an opportunity to promote the civic value of art by linking it to progressive civilization. Under de Forest's leadership, the American Federation of Arts provided a platform for promoting cultural nationalism and defining American taste by articulating a common message and disseminating it through member institutions. A national federation of museums, art commissions and civic planning committees, the AFA suggested cultural policies and coordinated the activities of its constituent members to present a unified progressive agenda for the education of civic taste. But nationalist rhetoric that celebrated the virtues of American civilization narrowed debates about American cultural production. Before the war, progressive cultural reformers had promoted industrial arts, based in part on the perceived material and cultural benefits of education for industrial workers. By war's end, the rationale for industrial education rested on discussions about the relative costs to cultural consumers of imported labor and international competition. In the process, the war transformed the way the progressive connoisseurs in the American Federation of Arts thought about the relationship between art, labor, and democracy.

Progressive connoisseurs also used the war as an opportunity to define the aesthetics of American modernism. At the end of the war, no one was certain what a modern American style would look like, nor what role cultural modernists who made up what historians now call the left wing of the progressive movement would play. The AFA and its constituent institutions, like the Metropolitan Museum, expanded cultural outreach to industry by

presenting annual exhibitions of modern industrial production through the twenties, but curators and trustees in art museums remained leery of modern paintings. Cultural conservatives mounted attacks in the pages of newspapers and professional journals that equated modernism in painting and sculpture with socialism and anarchism. Rhetoric celebrating progressive western civilization and the virtues of art combined with increasing fears of political and social unrest to define American taste in a classical aesthetic tradition. While progressive connoisseurs like Kent promoted modern industrial arts, and embraced what Newark Museum critic John Cotton Dana called the taint of commercialism, they carefully negotiated modern art, to avoid any possible taint of radicalism it might hold.

Progressive connoisseurs searched for a modern American aesthetic and a distinctly American style because they wanted to move away from the eclectic designs and excessive ornamentation of industrial products, toward better designs that could compete with European cultural production in postwar markets. Taste critics lampooned American production for its eclectic style and misuse of ornament, its barbarity and its vulgar pretensions. The key for design reformers and home economists alike during the progressive era had been to clear away the clutter of nineteenth-century homes. Taste experts who advocated simple lines and harmonious use of ornament found models in the various popular artistic traditions of the early twentieth century. Arts and crafts societies and artisanal producers of handicrafts had experimented with simple forms and careful choice of material and ornament over the past few decades, but the high costs and limited output of hand production restricted these objects to elite consumers. To make good design available to the man in the street, cultural authorities in museums offered to select appropriate models for machine-made industrial production. Rather than emulating Victorian oddities that drew seemingly at random from various sources, progressive connoisseurs argued, better American products should be based on more careful selection of styles from the past. Robert de Forest and Henry Watson Kent believed that experts with art-historical training, who had cultivated what they all agreed designated good taste, could assist manufacturers and industrial designers in making tasteful modern American things.

Economic rivalry and patriotic fervor during the war combined to fuel intense cultural nationalism in the United States. The war offered social and political progressives the opportunity to promote democracy abroad, and to expand their domestic reform programs through a centralized regulatory state. Advocates for wartime preparedness hoped that the progressive tactics

of gathering statistical information and turning to experts for solutions to social problems could be expanded to the national level through the government's sophisticated new communication networks. The American Federation of Arts followed a similar course of action, consolidating its member institutions to propose regulation of the built environment, as well as the promotion of art and national taste. Responding to the increasing climate of cultural nationalism, cultural leaders like de Forest also recognized an opportunity in the war to legitimize industrial arts education in art museums. Statistical surveys that scrutinized art education in the nation, and the introduction of industrial arts classes in New York schools, offered encouraging signs, but progressive cultural leaders called for specialized programs for the education of skilled craftsmen and designers. Focusing on patriotic rivalry and pride in American production, museums and other cultural institutions promised to share the burdens of war. The Metropolitan Museum announced in 1918, for example, that by diligently working with industrial manufacturers to improve American design, the museum was "helping to '*win the war after the war now.*'"[3] Taking the progressive commitment to public service to the national level, the museum aligned art with the democratic promises many progressives saw in the war.

Art, Democracy, and War

After the United States entered the war, Robert de Forest mobilized the many cultural institutions he led under the American Federation of Arts to seize the moment and take advantage of opportunities to promote a progressive agenda for the arts. Modernization of industrial infrastructure for wartime production in the United States, and suspension of art production in Europe, offered the chance to improve American industrial design in anticipation of a postwar market for well-made decorative home furnishings. The AFA served as a national outlet for the promotion of a progressive arts agenda in the United States. It consolidated arts and civic organizations throughout the nation, and systematically disseminated de Forest's arguments for cultural democracy through editorial articles, statistical data and traveling exhibitions.

Founded in 1909, the AFA brought together art museums, municipal and state art commissions, city planners and private clubs, all dedicated to City Beautiful ideals of reforming the way industrial cities looked through gleaming civic centers and the elimination of commercial images. A coalition of representative institutions organized in chapters throughout the nation, the

AFA set the national cultural agenda while it simultaneously took the temperature of shifting definitions of American taste and identity. A first citizen like de Forest exemplified the kind of institutional cooperation the AFA promoted, and his institutional affiliations in New York paralleled its ideological aims of shaping the built environment by improving civic taste and democratizing access to art.

The AFA ultimately became the central institution for the promotion of civic taste education in the early twentieth century, and its aptly named journal *Art and Progress* served as its "official organ" for disseminating that message.[4] Contributors wrote articles about art exhibits, they shared city planning ideas, and they listed upcoming events and issues of interest to readers. "Today in America there is a great onward movement of which all must be conscious," declared the federation in the journal's first issue, "we are marching to double quick time—but whither?" "Within the next few years towns will be built, cities enlarged, waterways improved, roads constructed, monuments erected, which, if art is employed, will materially enrich the nation and the people."[5] Believing that beautiful domestic and urban environments were crucial to democratic progress, the AFA used its publications to create a forum for progressive connoisseurs. During the early years of the war, the AFA also used its journals to identify opportunities for expanding cultural democracy, and for making American homes and cities more attractive. While Europeans were preoccupied by war, American artists and designers, architects and city planners, and museum professionals and art educators could seize the moment and catch up with European cultural production.

To make crowded cities more attractive for city dwellers, and to establish civic spaces, the AFA encouraged municipal leaders to erect monuments, open parks, and regulate building and development with zoning codes. Just as de Forest oversaw collaboration between the Municipal Art Society and the Art Commission in New York to preserve City Hall and build a new civic district to its immediate north, the AFA vigorously supported U.S. Park Commission plans to build a public Mall in Washington, D.C. that would link the U.S. Capitol to new Lincoln and Jefferson memorials. Reinforcing the relationship between art and civic virtue, the national Mall would be lined with classical white marble museums, memorials, statues and government buildings.[6] The federation also distributed pamphlets documenting successful City Beautiful projects to promote smaller civic campaigns.[7] Linking its City Beautiful policy with its democratic art mission to a national agenda, the AFA also cooperated with the Smithsonian Institute to build the National Gallery of Art

on the Mall in Washington, D.C.[8] "One of the simplest and directest ways of cultivating a taste for beauty is by making cities beautiful," proclaimed British ambassador to the U.S. James Bryce. Surveying the progress of Washington's civic landscape in 1911, Bryce marveled to AFA members, "you [Americans] have been setting an example to the world, and making Europeans hopeful for art in this country." "No city that I know in Europe or elsewhere has employed tree planting so skillfully and generally; and in none have the results been so good." In contrast to the muddy paths that had previously passed for streets in the Capitol district, Bryce delighted that "most of the streets of Washington look like glades and vistas in a noble forest."[9]

When war broke out in 1914, however, cultural leaders circulated reports from Europe of stalled civic projects and abandonment of the arts—paired with accounts of the human devastation of the war—to remind the American public of the importance of art and cultural production to the progress of democracies. These cautionary tales illustrated the urgency of implementing long-planned American projects lest the progressive moment disappear. "There never has been such a favorable—such a colossal opportunity since the dawn of History for the cultivation and practice of artistic taste by a nation as there is now," advised diplomat Henry White. White, who attended meetings of the American Federation of Arts and sat on the boards of the Corcoran and the Smithsonian, urged fellow citizens to enlist design and planning experts to beautify American cities and homes. Art education, White believed was "a potent factor in the moral and mental uplift of a nation."[10]

During the winter of 1916, as American progressives debated the morality and the pragmatism of military and economic preparedness for war, the American Federation of Arts published an open letter from the prominent English design reformer Charles Robert Ashbee about the state of British art and civic projects. A leader in the English arts and crafts movement, Ashbee's Guild and School of Handicraft built upon the philosophic foundation of William Morris and John Ruskin to link art and morality through the dignity of labor.[11] Describing the state of art production in England, Ashbee reported that most art and civic construction projects had been suspended due to the war. The English arts and crafts movement had also stagnated because of national preoccupation with agriculture and factory production. "Our Garden Cities and developments in town and country are for the time being," Ashbee concluded, "things of the past." "We look at our plans, and models and reports, and wonder if we shall ever touch such things again."[12] Ashbee's report from the European front reinforced the fears of many progressive reformers

in the United States that the war might stall long-planned projects to improve the civic environment, but it also revealed a lapse in British production that other progressive connoisseurs hoped the United States could use to its advantage.

When cultural and civic leaders from around the country met in Washington for the 1917 AFA convention, they found the nation's capital steeled for the impending conflict. Construction of monuments and museums along the national Mall, and the ceremonial parks along the Potomac River, had all been temporarily stopped. To many AFA delegates who had vigorously promoted Washington's beautification, the half-finished civic landscape seemed to illustrate the pervasive mood of stalled progress and uncertainty, mingled with optimism for cultural democracy. AFA leaders told member institutions that the convention maintained "a seriousness of purpose and cheerfulness of faith." "The war and its great significance were not forgotten," promised the AFA. "When a distinguished army officer in khaki uniform stepped upon the platform to make an address its reality was poignant."[13] Stirred by such poignancy and patriotism, de Forest's call to hold forth the torch of art at the convention promised a nobler civilization born from the sacrifice and sorrow of the present. During the convention's business meeting, Robert de Forest identified the opportunities the war presented, and he demanded, "more man-power, more women-power and more money-power."[14] The American Federation of Arts responded by committing its institutional resources to raise the national profile of art museums and to link aesthetic considerations with patriotism in the call to improve American industrial production.

Robert de Forest used the imperatives of patriotism and cultural nationalism to promote industrial arts, and he linked good taste in objects of industrial production to the economic strength of the nation. The mobilization of industries and the temporary reduction of European imports, the American Federation of Arts argued, offered American manufacturers the chance to establish a position of dominance in the market for home furnishings. Through the AFA, experts and long-time promoters of the alliance between art and industry came together to make the case for improving American design to the public and to the federation's constituent partners. These experts in museums, craft societies, and vocational schools used the pages of the federation's monthly journals to link wartime opportunities to the goals of improving American production, to debate philosophies of craft and industrial produc-

tion, and to illustrate the cultural and economic benefits of industrial arts education.

The divisiveness of the war and the horrors of its destruction, however, changed the way artists, critics, museum directors and intellectuals thought about the purpose of art in a democracy. For many Americans, the war represented a crisis of civilization, and they sought cultural restoration instead of practical opportunities. Traditional ideals of spiritual uplift and the inspirational power of art began to overshadow progressive values of educational utility, as well as arguments for making museums useful. Architect Ralph Adams Cram believed that Americans had lost the power to produce great art because they lost sight of values and standards.[15] Cultural critics at the American Federation of Arts agreed, and some started to question the relationship between industrial society and cultural progress. "Ours is the age of the machine with its standards of efficiency," cautioned an AFA editorial, "and we are witnessing today the most cruel and inhuman war that has ever been waged."[16] The artist Birge Harrison also asked how "such titanic cataclysms as the present European struggle, involving the slaughter of thousands of men and the ruthless destruction of a large part of the stored-up treasures of the ages" could suggest democratic progress.[17] Progressive connoisseurs responded to cultural pessimism born of wartime disillusionment by presenting the practical opportunities they saw for promoting American industrial arts in patriotic terms, which promised both to improve American design and restore the body politic. While progressive connoisseurs always had civic intentions for taste education, the patriotic manifestation of these goals during the war focused more on protecting narrow constructions of American democracy than on making better citizens.

Americanization meant many things to many people before the First World War, and its goals were just as broad as the constituency of its advocates. Progressive connoisseurs like Robert de Forest and Henry Watson Kent had introduced decorative arts into art museums to improve the quality of American industrial arts because they believed better homes made better citizens. Training in industrial arts not only offered the promise of better things in the marketplace, but it also provided the ability to improve the material circumstances of working Americans—especially the foreign born who lived and worked in industrial cities. "We are a great industrial people living in an industrial age," explained industrial arts educator James Haney. "Nine out of every ten boys who enter the elementary schools must later earn a living with their hands; these boys, therefore, must be trained toward their future

work." Haney teamed up with Kent in 1908 to bring future craftsmen in New York City's public schools into the Metropolitan Museum. "Not only does manual training give knowledge of plans and processes to the would-be artisan," Haney justified, "but it early gives him respect for the skilled workman and pride in honest construction." Educators like Haney saw benefits to all Americans in the alliance between art and labor. "If in addition, the workers are taught not merely to make things but to make them beautiful, to apply art in a practical way, to manufactures, it will add much to the commerce and to the material wealth of the nation."[18]

Progressive connoisseurs combined older ideas of the uplift value of art with more practical advantages of democratizing appreciation and knowledge of art through hands-on training courses. "The principal asset of a worker in the industrial arts," argued industrial arts advocate and world's fair promoter C. Howard Walker, "is that of an appreciation of beauty." Walker saw personal gratification and individual achievement as the principal reasons for teaching industrial arts. The "opportunity for creative work," Walker argued, "stimulates the mind as well as the hand."[19] But Walker also identified the economic benefits to workers trained in the industrial arts. He used statistics from the real estate exchange to show that skilled craftsmen with broad training in various fields of industrial arts production had greater opportunities, and earned higher wages, than almost any comparable category of manual laborers.[20] Committed to assisting industrial artisans, organizations like the Alliance Employment Bureau in New York teamed up with schools and developed classification systems to more efficiently place students trained in commercial art trades with appropriate firms and trades.[21]

Advocates from remarkably diverse cultural positions recognized the practical benefits of training in the industrial arts. Brahmin aesthete Ralph Adams Cram wanted greater American investment in industrial and craft education to see his own architectural projects through, but he also knew the value of good craftsmen. "Without the craftsman an architectural design is worth little more than the paper on which it is drawn," Cram acknowledged, "it is an ephemera; a simulacrum, of glory."[22] Cram could cite numerous examples when a paucity of skilled artisans in the United States had hindered the ability of architects like himself to complete their designs, and he hated the persistent practice of importing skilled workmen from Europe at high wages, while consistently neglecting to train a native work force of skilled artisans. "Nearly all our expert labor in the artistic trades is imported from Europe," he complained. "We pay large wages to foreign workmen, but refuse

to educate our own people so that this financial benefit may accrue to them."[23] "We do not hesitate to say," Cram concluded, "that the present state of things is barbarous, uneconomical, and in the last degree discreditable to the architectural profession."[24]

The needs of the architectural profession, however, differed from those of industrial workers—whether foreign born or native—as well as from a larger democratic public of consumers. The democratic necessity for machine production, combined with recognition of the interests of industrial capitalism, marked a significant distinction in the way design reform played out in the United States as opposed to Europe. Whereas the British arts and crafts movement held tighter to Morris's ideals of handicraft, and frequently tended toward socialism, progressive connoisseurs in America like de Forest and Kent advocated *industrial* arts education. For de Forest and Kent, acceptance of machine production framed their ideas about cultural Americanization. Like other social reformers, de Forest believed citizenship began in the home, and he insisted upon making tasteful products of home furnishing and decoration available to as broad a public as possible. Collaboration between institutions in the American Federation of Arts took this belief in environmental determinism to the national level by linking art museum programs with city planning in order to beautify civic and private landscapes alike.

The American Federation of Arts also provided a forum for philosophical debates between advocates of hand and machine production in the design reform movement. The highly skilled craftsmanship that Cram sought for his architectural projects had no need for the machine, so he looked back to the Middle Ages to find a time when artist and craftsman were united. Like William Morris and John Ruskin before him, Cram wanted to restore an ancient ideal of guilds, workshops and master artisans. Advocates for handicraft production hoped that taste arbiters such as architects, and the wealthy clients who hired them, would seek out talented craftsmen, and they believed that this demand would ultimately fuel emergent communal craft workshops.[25] This trickle-down theory of taste emulation had predominated cultural discussion since the advent of industrialization in the mid-nineteenth century, but progressive connoisseurs in the early twentieth century started to open up the debate by incorporating more democratic ideas about the relationship between art and labor.

Carnegie Institute educator C. Russell Hewlett thought that any process that could produce multiples, and thus democratize access to beautiful and useful things, should be embraced. "There has been a tendency during the last

twenty-five years to exaggerate the value of hand labor," Hewlett observed, "while condemning the use of machinery." "Taking the cue from William Morris and his associates," he continued, "there has been much talk about the dignity of labor, and the disgrace that thinking man should become the slave of the machine which he has made." "Yet surely from the use of labor-saving devices, with the resultant increase in the number and lowering of the cost of beautiful surroundings," Hewlett argued, "we may confidently look for a general improvement in the popular attitude toward all that is best in the applied arts."[26]

To counter arguments "that the finest standard will always be taken from the hand-made article," Hewlett dismissed the "fetish of hand-craftsmanship." "For many operations," Hewlett argued, "the inflexible and scientific precision of machinery is better than the hands of erratic mankind." Hewlett agreed that the chief benefit of learning a trade for many amateur craftsmen came from observation of master craftsmen, and he acknowledged that handmade things would likely "lead the way in the matter of artistic perfection." But he argued that machines should be used by craftsmen as "mechanical helpers." Hewlett advocated teaching students of design the skills of hand production, alongside theory, so that they might use machines to their full potential. "While man remains the master of the machine it is a labor-saving tool of the nth power of efficiency."[27]

Hewlett thought the greatest advantages of machines were the "great educational and elevating stimulus exerted by the increasing use of machines." He marveled at the possibilities of bringing things of "the finest artistic achievement into the homes of all classes, and thus exerting an educational influence deeper and more direct than pedagogic instruction possibly ever could." The industrial arts, Hewlett argued, had been aristocratic, but "machinery has made them essentially democratic."[28] "Even though its mission is yet only begun, we can not be too grateful for the machinery which makes it possible for everyone to possess practical objects of beauty!"[29]

Ideas about the arts and Americanization, however, shifted as the war got closer—news from the front, like Ashbee's report on the state of the arts in Britain, increasingly generated questions among progressive connoisseurs about the possibilities for democratic reform, and the contours of opportunities presented by the war. "Shall we in this day when civilization has been shaken to its foundation," *Art and Progress* asked in the winter of 1915, "stand firm for the higher aspirations of man, or shall we permit ourselves to be

swept into the devastating current?"[30] Arguments for improving the aesthetics of American art and design became increasingly nationalist through the war. In 1916, the American Federation of Arts began to shift its editorial perspective away from using art and training craftsmen for the benefit of a democratic public of producers and consumers alike, to promoting more specifically the spiritual and patriotic values of art and celebrating the place of America in progressive civilization.

"If our Nation is to become one of the great Nations of the world," declared the federation in an editorial in its newly renamed journal, *The American Magazine of Art*, "it must be through a general realization on the part of the people that material prosperity is not the goal of existence." The AFA maintained its commitment to democratizing opportunity, but its goals moved away from securing the material and social benefits of arts education to more abstract ideas about civilization and progress. "There must be a recognition of the fact that art is not only the interpretation of beauty but a measure of civilization, and should be valued not simply on account of its rarity and marketable worth, but because of its inherent loveliness and inspirational qualities."[31]

At the opening of the Cleveland Institute of Art in 1916, the museum's progressive leader Charles Hutchinson reflected the nationalist intellectual shift in museum circles by carefully redefining cultural democracy and progress around ideas of civilization and beauty, instead of ideas about practical utility and civic purpose. Like earlier progressives, Hutchinson placed his progressive ideas about art in opposition to traditional notions that privileged the fine arts and recognized old masters. "This limited use of the word [art] is unfortunate," Hutchinson insisted, "since it has in large measure led unthinking men to look upon Art as something apart from daily life. Nothing is more untrue than this notion. Art is not destined for a small and privileged class. Art is democratic. It is of the people and for the people."[32] And like fellow progressive connoisseurs, Hutchinson also considered the introduction of education programs the most significant aspect of progress in recent years. "The Art Museum," he said, "has been transformed from a cemetery of bric-a-brac to a museum of living thought."[33]

However, Hutchinson broke from earlier progressive notions of art and democracy that had promised to secure both the cultural and material benefits of citizenship. "Art has had its mission in the life [of] every people. Indeed in many cases the Art of a nation is its only surviving record." Hutchinson redefined the progressive mission of museums as repositories of civilization,

rather than laboratories for cultural production, and in the process he rede-fined the concept of the right to happiness guaranteed all Americans from economic independence to spiritual uplift. "The sense of beauty," Hutchinson announced at the dedication of Cleveland's new art museum, "is a means of happiness." "There is nothing more closely allied than beauty and Art." "It is not [the] sole mission of Art to amuse or to furnish moral instincts," Hutchinson insured Cleveland's cultural patrons. "The true mission of Art, as Hegel says, is to discover the present ideal." Therefore, Hutchinson called for "exalting the value of our morals" in the face of dramatic social, political and economic changes. "In the light of all that has occurred in the past two years, what shall we say of our pride in the civilization of the nineteenth century? What shall we say of our so-called Christian nations?" Hutchinson promised a revised interpretation of progress, of art and democracy, for a nation at the brink of war. "Art for art's sake is a selfish and erroneous doctrine," he insisted. "Art for humanity and a service of Art for those who live and work and strive in a humdrum world is the true doctrine and the one that every Art Museum should cherish."[34]

Cultural arbiters like Hutchinson increasingly ascribed spiritual qualities to art that promised national uplift in the face of uncertainty and tragedy. "When so much is at stake and innumerable lives are being lost it may seem idle to even talk of art," the AFA admitted in its first editorial since U.S. dec-laration of war, "but in such stern times as these we must not forget that art is a factor in civilization—that very civilization for which this war is being waged—and that right living and higher ideals will go far toward preventing a repetition of this fearful world tragedy." The war turned art into an abstract ideal that could restore nostalgic notions of a sylvan moment before greed and alien influences changed American culture. "When peace comes the bat-tle of civilization will only be partly won—we shall still be threatened by the danger of materialism, the danger of industrialism, the danger of caring more for ourselves than for our neighbors, the danger of disintegration through an indifferent absorption of immigration." "Art is one of the weapons with which these enemies can be fought and it will prove effective in proportion to the extent and manner of its use."[35]

The rubric of civilization and patriotic sentiment dominated discussions about the value of art during the war, and these discussions moved definitions of cultural democracy among progressives away from the notion of making better citizens through practical applications to industry. During the war, cul-tural leaders shifted their discourse instead toward ideas about the nobility of

art. On the eve of the American entrance into the war, *American Art Annual* editor and frequent Metropolitan Museum educator Florence Levy articulated a new wartime relationship between art and democracy. Levy's revised progressive vision emphasized abstract notions of the nobility of art over the practical benefits of art education. "The year of upheaval in Europe," Levy argued, had made "the United States realize that there is something more worth while in life than mere physical well-being." Levy probably used the language of higher ideals when she talked about the cultural opportunities presented by the war as a way of distancing her ideas from those of the advocates for war who sought individual economic gain. But her dismissal of *all* material considerations also dropped the practical benefits for working Americans and craftsmen out of the progressives' equations for cultural democracy. In 1917 Levy, a long-time advocate for training industrial artists, argued that art could help Americans lead a higher, nobler life. "Not Art for arts sake, but art for life's sake; not art for a few individuals, but the arts for the community as a whole."[36]

In 1919, the Metropolitan Museum hosted the AFA's annual convention, where de Forest explained the imperative of making "art free for democracy." Fifty years earlier, de Forest remembered, access to art had been "confined to a privileged few," but since 1905 museums like the Metropolitan had greatly expanded access to the people of New York City. However, de Forest worried that in most regions of the nation, "art still remains a closed book."[37] To remedy that problem, the AFA sponsored traveling art exhibits from leading museums in America and Europe to its two hundred chapters. Emphasizing the civic importance of art and taste, de Forest explained that the AFA also provided accompanying photographic reproductions "of the highest type of art." Thus the American public had "the opportunity to decorate their walls at low cost with what is really best in art."[38] In the previous year alone, de Forest announced, the federation had sent thirty-one exhibitions to 106 places throughout the country. "Every man, woman, and child, particularly every child, soon to be a man or woman," de Forest insisted, "has an inherent right to be able to see, at least occasionally good works of art, for the same reason that every dweller in a crowded city should sometimes have the opportunity of seeing the green of the country." "It is part of the 'pursuit of happiness,'" he explained, "which our Declaration of Independence declared to be our American birthright."[39]

Progressive connoisseurs in art museums followed this ideological shift by using the language of patriotism—rather than civic improvement—as

their rationale for strengthening programs of cultural democracy. To justify the importance of promoting art during war, cultural leaders increasingly used inspirational language about keeping art's sacred flame burning.[40] "To help keep alight the flame of art and add more fuel," trumpeted *The American Magazine of Art*, "is distinctly the duty and privilege of the AFA."[41] In cities throughout the country, museums draped their galleries in bunting, they raised money for the war effort, they exhibited war posters and paintings from the front lines, and they proclaimed their allegiance to the national cause. By framing their commitment to public service around patriotism and military glory, they joined institutions like libraries and colleges, which were dedicating their services to training camps and schools for officers.

Patriotic rhetoric and ambiguous messages about the sacred quality of art, however, allowed more culturally conservative critics to reclaim the museum as an exclusive space, and pull back from a progressive museum agenda. Artist William Meritt Chase challenged the progressive museum reforms of the previous decade by blustering that he would like to carve above the doors of museums: "These works are for your pleasure and not your criticism."[42] Editorials within the journals of the American Federation of Arts repeated Chase's position, and they cautioned the public against dogmatically praising what they called the New Museum by reminding readers that the Old Museum, while stuffy, boring, aristocratic and even autocratic, had nonetheless been "delightful."[43] Lydia Van Rensselaer cautioned museums to "temper their devotion to the cult of 'practical efficiency,'" and return to the uplift value of art.[44] Amidst the horrors of war, increasing numbers of cultural leaders reconsidered their commitment to practical education reforms, along with their critical opposition to the idea of the museum as a temple of art and civilization.

Mobilization at the Met

The Metropolitan Museum fully embraced the war effort by presenting to the public a patriotic image of shared sacrifice. Located in the most important industrial city in the nation and one of the central ports of service for U.S. warships and soldiers, the Metropolitan faced specific threats to its security while it recognized its extraordinary civic responsibilities. Robert de Forest committed the museum to the war by offering the services of its staff, collections and facilities; and Director Edward Robinson promised to keep the Metropolitan Museum open as a haven against the relentlessness of war.

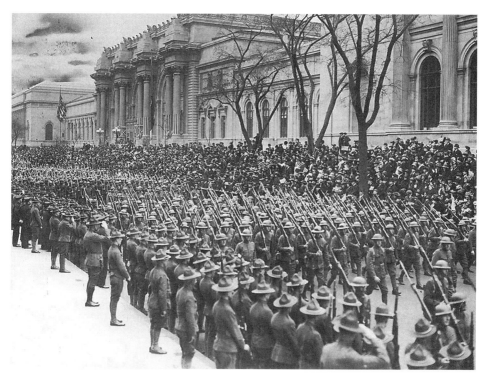

Figure 22. Governor Smith and Mayor Hylan review troops from New York's 69th regiment in front of the Metropolitan Museum, April 28, 1919. *New York Times.*

Robinson often told people that while in Belgium during the early days of the European war, he had been moved by the sight of a group of poor Belgian women looking at paintings in a small picture gallery near the line of battle. Robinson claimed that he vowed at that moment to provide the same inspiration for Americans by keeping the Metropolitan open if the United States entered the war.[45]

War conditions froze international trade, cutting the Metropolitan Museum off from fabrics and materials needed to make display cases and mount exhibitions. Once the necessity of increased war production demanded longer hours of working Americans, the museum also suffered from plummeting attendance.[46] In addition, the Metropolitan Museum temporarily lost thirty-seven members of its staff to wartime service—decorative arts curator Wilhelm Valentiner even served in the German army.[47] "The workmen and

attendants who leave we can hope to replace," the museum promised in 1917, but it warned that the curators and progressive connoisseurs it had recently hired "were trained especially for the work upon which they have been engaged, some of them being experts of high standing in the profession." The Metropolitan feared, "their places will be difficult, if not impossible, to fill, independently of war conditions."[48]

The Metropolitan Museum also responded to the hardships of war by raising the salaries of its employees to meet increased costs of living, by opening galleries free of charge on Mondays when businesses closed due to shortages of coal, and by making special arrangements for access to the museum for soldiers and sailors. The museum's staff responded by raising $24,300 as part of its Liberty Loan drive, and women on the museum staff sewed surgical dressings.[49] "In addition to the original fund," the museum declared over the summer of 1917, "gifts of money, material, and sewing machines have been received from interested friends, and the work will go forward, although more slowly during the vacation season."[50] Like the American Federation of Arts, the Metropolitan announced in 1918 that it had become "something of an annex to the War Department."[51] The museum's basement workshop became a laboratory for the development of military armor when arms and armor curator Bashford Dean consulted with the U.S. Army's ordnance department to develop body armor for soldiers engaged in modern combat. Dean produced models for helmets at the museum, and he went to France to supervise their installation in combat.[52] Boasting of its patriotic service, the Metropolitan compared Dean's helmet workshop to converted war colleges like Columbia University's.

The Metropolitan's proud association with Columbia during the war also reveals the particular stamp of progressivism de Forest chose for the museum. Robert de Forest positioned the Metropolitan Museum within a conservative constellation of cultural and educational institutions that had committed to the war effort's program of preparedness and ideological unity. Libraries and community organizations offered their services to the war department's training camps, and colleges like Columbia turned their campuses into military colleges for young officers.[53] Whether to combat vice or suppress dissent, they all drew examples from classical history to present a unified narrative of civic progress that extended from classical Greek and Roman republics through the American Revolution, and culminated in the current war for democracy. History, literature, painting and sculpture—all combined to illustrate the intellectual and creative achievements of a nation's cultural production.

The Metropolitan's collecting and exhibiting strategies during the war clearly reflected the intellectual messages of cultural nationalism that saturated American public culture. Cut off from a world art market, the Metropolitan Museum vigorously sought out and bought American antiques and architectural elements of old houses to build a permanent collection of period rooms for a future American museum wing. After the success of the Hudson-Fulton Exhibition of 1909 and the Metropolitan's own purchase of Eugene Bolles's collection of furniture, the market for old American things exploded, and private collectors as well as other museums scrambled to outfox and outbid one another. During the war, collector and preservation consultant R. T. H. Halsey joined the Metropolitan's board to supervise the hunt and acquisition of what he considered museum-quality antiques—his scouts covered the eastern seaboard looking for old houses and things. The Metropolitan simultaneously reported its wartime activities and its Americana acquisitions in its *Bulletins*. These overlapping reports updating the public about the museum's contributions to the war and individual staff members' status on the European front, read alongside enthusiastic reports of increasing collections of old American things and houses, combined to create a new sense of civic engagement centered in patriotism.

Seizing upon the national atmosphere of patriotism and the mobilization of industries, the Metropolitan Museum also ramped up its calls for the alliance of art and industry. "In time of war," the Metropolitan announced in its 1918 *Bulletin*, "prepare for peace." The Metropolitan Museum used its monthly *Bulletin* to mount an intensive information campaign to align art and industry. Columbia University architectural curator Richard Bach argued in a flurry of editorials that the use of museum resources to improve the quality of industrial production represented the Metropolitan's most important wartime contribution. Bach used wartime rhetoric of "preparedness" and "mobilization" to advocate strengthening American manufacturing to compete with international consumer products in the rush for domestic goods that would occur after peace. "Difficult as it is amidst the turmoil of conflict," Bach promised in one of his first statements on behalf of the Metropolitan's wartime commitment, "the Museum is cherishing the arts of peace." "That is its patriotic duty."[54]

For museum secretary Henry Watson Kent, the war offered the opportunity to silence critics who had resisted using museum resources to reach out to industry. The museum took that opportunity by linking the nation's

economic strength to the production of well-made decorative arts. Kent re-
cruited Bach to the Metropolitan's education committee in 1918 as associate
for industrial relations precisely because of Bach's economic arguments for
improving American design. Bach, in addition to being a curator of architec-
ture, was an editor of the trade journal *Good Furniture*, and had established a
reputation for himself as a sharp architectural and taste critic. He joined Kent
to advocate industrial cooperation with the museum because he shared Kent's
commitment to improve modern design. Rather than shying away from what
critics had called the taint of commercialism, the Metropolitan now empha-
sized the economic value of good design. Before the war, Bach argued, Amer-
ican furnishings had been a "near barbaric curiosity" because manufacturers
had rarely seen the value of "taste as an asset."[55]

But emphasizing taste as an asset had a profound impact on the Metro-
politan's education programs and its definitions of Americanization. Whereas
earlier arguments about making the museum a public service institution had
focused on individual outreach and connecting the museum to communi-
ties, wartime language committed the museum to industrial service. When
the Metropolitan played up the economic value of taste, it focused on larger
benefits to the national economy instead of the material benefits to crafts-
men, which progressives in museums had highlighted before the war. By
forging a partnership with manufacturers through industrial outreach, the
museum moved away from its commitment to improving the homes of work-
ing Americans and making better citizens. Patriotic language during the war
instead focused on consumer democracy, and establishing what Bach called
Americanism in Design. The museum vowed to make good design available
to the man in the street, but it did so by focusing its institutional resources
on educating consumers, rather than teaching individual craftsmen.[56] Ameri-
canism in design tapped into the national mood of patriotism, international
rivalry, and economic competition, but it also narrowed the definition of a
museum public to whom the Metropolitan committed its service.

Bach promised a partnership with industry that redefined the Metropoli-
tan's conception of public service. Bach argued that art museums had "one
of the finest opportunities that has ever been offered to public institutions
to render public service." Like Kent, Bach criticized old-fashioned museums
because he believed museums had a public duty to provide practical instruc-
tion. By "meeting manufacturers and designers halfway," he insisted, art mu-
seums could "escape the usual criticism that they are but fossil collections."[57]
"It is an imperative necessity that something be done at once," Bach empha-

sized when he pitched his services to Kent in 1918. Bach proposed, "to bring the industrial art producing branches in the United States to a full realization of the problem which post-bellum reconstruction will force upon them." "No greater opportunity has yet appeared for the Museum to take the leadership, to become the patron of American industrial art, to make itself the work-bench of a national taste."[58] "To my mind," Kent recommended to de Forest, "nothing the Museum could do at the present moment would be productive of so great good as to permit this active cooperation."[59]

Bach's primary objective at the Metropolitan Museum was to convince industrial manufacturers of the importance of taste as an asset in their business calculations. Bach invited manufacturers to study museum collections, he disseminated information about museum resources to trade journals and newspapers, and he mounted annual design exhibitions at the Metropolitan Museum that presented what he considered the best in American production. Bach borrowed tactics of wartime propaganda, developed through the Office of War Information, and used the museum's modernized professional infra-structure to turn his office into a "machinery of publicity."[60] Bach promised Kent that he would maintain a careful balance between the museum's position of cultural authority and manufacturers' sense of autonomy and partnership. To send the right messages to industry, Bach proposed what he called "direct assistance:" he regularly visited factories and salesrooms to assuage concerns among the industries that "something is being forced on them from without." Bach compiled data, he prepared illustrations and photographs and he wrote "leads," under which trade journals ran their own copy. These tactics, Bach told Kent, would help the decorative and furnishing trades formulate a better concept of taste, by providing examples of good design and explaining their utility, because, he said, "the business appeal remains fundamental."[61]

To make his case to American manufacturers and to the museum public, Bach used the familiar rhetoric of shared sacrifice and patriotic opportunities. Bach urged Americans to "maintain morale in the face of almost impossible conditions, not only as to labor and materials, but as to design and taste." To appeal to industrial manufacturers, Bach advocated "mobilizing" art industries and placing them on "a war footing."[62] "The war isolated the United States," he explained, "and we counted among our resources machines galore, fine raw materials, excellent technical ability, but no designers and no schools to produce others to make good the shortage due to the occupation of Europeans in higher duties."[63] "The greatest industrial nation," Bach taunted, "without an industrial art!" But Bach argued that the war also provided a

chance to improve American domestic manufactures, and he promised that the Metropolitan Museum "stands ready to help them to a better understanding, not as a patron, not as a big brother, but as a partner in progress."[64]

The Americanism in Design that Bach promised by emphasizing taste as an asset and partnership with industry, however, represented a departure from the democratic education goals that progressive connoisseurs had advocated before the war. Rather than promoting a democratization of opportunity that emphasized competency and civic improvement, the Metropolitan Museum's wartime program of industrial outreach encouraged economic competition, and suggested a kind of consumer democracy. Arguments for improving industrial arts no longer focused on civic beauty, or de Forest's belief in environmental determinism, but rather upon business calculations and consumer demand. Bach's outreach to factories and salespeople also necessarily cut out considerations of industrial labor and the material benefits of industrial education.

The consumer democracy suggested by Bach's ideas about Americanism in Design maintained the conviction among design reformers that good design could be made available to all people. Bach insisted that true democracy, especially during times of war, "had to imply the extending of the greatest benefits to all equally." To make things of good design available to the man in the street, the Metropolitan Museum came down on the side of machine production in debates about cultural production. Bach picked up calls by reformers like British arts and crafts leader C. R. Ashbee to combine Morris's commitment to handicraft and the dignity of labor with the democratic possibilities of machine production.[65] Echoing arguments being made in the journals of the American Federation of Arts, Bach argued that machines made it just as easy to produce good design as bad design, but "the machine," he insisted, "must be harnessed to the mind; not the hand to the machine."[66]

Acceptance of the machine also offered the opportunity for expanded industrial production to international markets. In the throes of wartime exuberance, the Metropolitan challenged, "let the American designer become a power, as he is in France." Most early twentieth-century aesthetes in the United States regretted that France dominated cultural production. By 1918, however, the Met argued, "no designer in France or anywhere else has at his command a greater field for inspiration than may be found in New York." "The Metropolitan Museum of Art is enabled to place at the disposal of the designer and the manufacturer an illimitable power of suggestion." The Metropolitan's wealth and its collection of world-class masterpieces finally put

New York in a competitive position. "The time has come," the museum defiantly announced, "when the designers and the manufacturers will see this as clearly as the museums do, and by working together, American workmanship will attain such a standard that the old labels, 'Made Somewhere-else,' may be taken off our goods."[67]

In 1918, the *New York Times* picked up Bach's call to "mobilize" industry for postwar competition. "After the war," a *Times* editorial announced, "no matter how international the world becomes in politics or in the higher arts, in the handicrafts it will still remain nationalist." The *Times* echoed the arguments Robert de Forest had been making about the centrality of tasteful homes to good citizenship, but like much of the new wartime rhetoric around taste, the editorial shied away from earlier arguments of inclusive Americanization. "Furniture and dishes and wallpaper make a home only when they have a certain harmony of character." Like Bach and other taste critics before him, *Times* critics objected to eclectic styles and misuse of ornament. "That is why so many American homes are disturbing," the paper complained, "and why a succession of American homes produces a kaleidoscope weariness." Echoing the Metropolitan's educational message of the past decade, the *Times* concluded, "the character of its national setting must be felt in a home's equipment."[68]

By claiming for the Metropolitan Museum a patriotic duty to create a new craftsmanship, and calling on manufacturers to meet their patriotic duty and join in artistic progress, Bach and Kent forged a program of partnership with industry to develop Americanism in design. Neither Kent nor Bach knew exactly what that nationalist design would ultimately look like, but they believed that use of museum collections could produce well-designed, modern objects that could compete with high-quality production from European manufacturers. Bach hoped that well-informed production of modern decorative arts could create a "new craftsmanship which shall form part of the cultural heritage of the United States when its duties on the soil of France have been gloriously accomplished." To encourage manufacturers to join in the collaboration between art and industry, Bach insisted, "It is the patriotic duty of manufacturers to provide the best design on earth for America." "In this," he pledged, "the Museum stands ready to help."[69]

Many cultural critics in the popular press still held onto nineteenth-century ideas about the sacred qualities of art, and they likely considered such partnership with industry blasphemy, but few museum professionals objected any longer to what John Cotton Dana mockingly referred to as the taint of

commercialism. Allying art and industry had represented a central tenet of museum modernism since the mid-nineteenth-century founding of the South Kensington Museum. And implementing practical programs to teach taste and improve industrial arts had been one of Kent's primary goals since he began working at the Metropolitan in 1905. World War I provided the opportunity to promote museum usefulness at an unprecedented scale, but the patriotic sentiments that made promotion of American industrial arts possible also flattened discussion of its democratic possibilities. "The nations whose skilled artisans, guided by gifted and trained artists turn [raw] materials into forms of grace adorned with lines of beauty," the Metropolitan promised, "will receive fame and fortune, and set their children's feet on those broad plateaus where knowledge and power and enjoyment are to be had."[70] Nationalist rhetoric moved the criteria for improving industrial arts away from material benefits to individual workers, or helping workers become better citizens. Instead of committing to the economic and social betterment of working Americans, the Metropolitan Museum—and many other art museums—now justified investment in industrial arts education with arguments for international economic competition. Kent and Bach anticipated postwar demand for household consumer products, so despite the deprivations of war, they determined to focus on the future. "And in that future," the museum assured, "there will be emulation, if not rivalry, among the peoples of the earth . . . [to] produce most cunningly the things that peaceful people desire—such as chairs, tables, beds, clothing, utensils, adornments, jewelry, and all things of use and ornament that make men comfortable and tend to make them joyous."[71]

World War I represented a significant moment of change for the Progressive movement in the United States. At the Metropolitan, the Great War shifted the rationale of democratic education programs that focused on American things from making better citizens into two distinct new directions that both responded to, and helped to shape, the cultural geography of the 1920s. On the one hand, the Metropolitan built colonial-revival period rooms that displayed American antiques; while on the other, it presented annual exhibitions of modern industrial arts to improve the quality of American design, aligning with industrial manufacturers and shifting the focus of its education programs to consumers. Both directions signified a shift away from inclusive Americanization programs, which had aimed to enhance citizenship, to more exclusive, restricted ideas about American identity, and more conservative ideas about labor and production.

It is one of the great ironies of United States history that the war that had been fought, in part, to expand progressive ideas about cultural democracy, and to strengthen the role of a regulatory state, ultimately soured many Americans against the progressive impulse. During the war, the federal government under Woodrow Wilson exerted unprecedented influence over the lives of ordinary Americans. Growing resentful of conscription, loyalty campaigns, and economic controls that dictated production, labor relations and prices, many Americans lost interest in progressive ideas. The war's devastation, and the unanticipated economic and social crises that immediately followed the war, only further contributed to a collective sense of profound postwar disillusionment. Progressive connoisseurs, who had hoped the war would open up opportunities for implementing long-planned projects to improve American taste through the democratization of art, also found decreased public support. Patriotic rhetoric and abstract ideas about the relationship between art and civilization constrained postwar programs for cultural democracy in increasingly narrow definitions of American identity and cultural nationalism.

Changes in the way art museums promoted industrial arts education represented only one example of the impact the war had on progressive ideas about art, labor and democracy. Whereas earlier arguments for teaching industrial arts to craftsmen had emphasized the potential rewards to a democratic public of manufacturers, consumers and artisans alike, postwar rationale focused on the economic benefits to industry and the possibility of an enhanced marketplace for consumers. This shift followed larger social trends in the United States away from protecting the rights of workers, toward the embrace of consumer culture in the 1920s. The labor and social disruptions that immediately followed the war recalled earlier nineteenth-century fears of working-class radicalism and spurred distrust of workers and labor unions. Industrial producers of domestic furnishings tapped into social insecurities brought on by inflation, strikes, and race riots. In response, American manufacturers promised domestic comforts and a nostalgic return to normalcy. The factors that allowed for the rise of consumerism, however, came directly out of wartime economic shifts, related in no small part to the calls to preparedness that museums like the Metropolitan Museum had made during the war. Expanded industrial production, combined with the advent of sophisticated advertising campaigns, lured more and more Americans into what social critic Sinclair Lewis called "the goods life." The sudden availability of easy credit in the 1920s gave Americans access to an expanded world of consumer goods and obviated the need to worry about the rights of labor or

the ability of people to afford such things. As a result of reactive isolationism, arguments for improving American cultural production by the end of the war became increasingly nationalist.

Throughout the war, design reformers used patriotic arguments and economic rationales to improve American design, but nobody knew what Americanism in design would ultimately look like. Today it is easy to read artistic development in the teens and twenties through the narrative lens of abstract modernism. The history of art and design in the twentieth century is often told as a linear progression moving from imitative historical motifs to functional abstracted forms, but artists and designers at the time struggled to define a modern aesthetic. Modernism really meant many things to different Americans in the early twentieth century. Most aesthetic reformers, in fact, looked for inspiration in historical artistic traditions—whether idealized American pasts like the frontier style or the colonial revival, or eastern traditions coming out of more recent American colonialism, or even medieval and classical European traditions. Patriotic language and nationalist sentiment through the war, however, motivated cultural arbiters to more systematically define a singular American style that would be appropriate for American social progress in the modern century. In the cultural and political atmosphere of wartime restrictions and postwar retrenchment, cultural critics and much of the general public carefully distinguished "good" art produced by contemporary artists from avant-garde modern art.

In a period of acute attention to intellectual constructions of civilization and progress, conservative cultural critics, and many progressive connoisseurs, associated avant-garde art with the horrors of war and the decline of civilization. Critics lambasted modern art, and frequently associated it with socialism and anarchism. One critic bemoaned "all the ists and isms which have astonished the world during the past fifty years."[72] In contrast to art produced in the classical tradition, modern art came to represent ugliness, disorder, and the rejection of standards of taste and decency. In 1915, *Art and Progress* grounded its definition of beauty in "Platonic-Aristotelian theory [that] holds that 'beauty' resides in order and in the elements of order—unity and multiplicity (harmony, measure, proportion)." In short, "beauty is identical with good.'" Whereas beauty reflected "lawfulness, refinement, higher and better living," ugliness represented "chaos in judgment," and "lawlessness, brutality, immorality." The choice between beauty and ugliness seemed to the editors of *Art and Progress* to have profound social consequences. "If we choose wrong the path leads us wither we know not, but surely downward

rather than upward, to the lower levels from which our progenitors by toil and sweat and prayer have enabled us to climb."[73] Contrasted with ambitious claims about classical art's uplifting qualities and keeping the sacred flame alight, experimental abstraction and social realism in painting and sculpture became mimetic substitutes for the dramatic social and political upheavals of the late teens and nineteen twenties.

On the eve of the American entrance into the war, *The American Magazine of Art* associated the modernist art movement with the cultural disintegration of Europe. "A few years ago the world of art was startled by the strange antics of a group of mad men." AFA editors complained that these mad men called themselves artists yet "willfully and deliberately chose to interpret ugliness rather than loveliness, deformity instead of perfection."[74] The American Federation of Arts hoped that the war had led this modernist vogue in Paris to a natural death, but the critics in the federation feared that modernism had gained a foothold in America. The 1913 Armory Show that introduced European modern art to American audiences and scandalized many New York art critics still represented a cultural watershed. Cultural critics continued to write about the impact of the exhibition, which included post-Impressionist paintings by Cezanne and the new cubist style of Picasso and Duchamp. "The new art is pulling down, not a building up," insisted *The American Magazine of Art*. "Those who are destroying the ideals of the past have nothing so fine to offer in their place." "The art which has survived the centuries is an art which uplifts and, if we in this century hope to carry on the torch and keep alight the flame, it can only be by holding fast to old ideals of purity and nobility in thought, in form, and expression."[75]

For a first citizen like Robert de Forest, framing the discourse of modernism had great significance because he believed so strongly in the link between aesthetics and social progress. De Forest's Greenwich Village neighborhood—indeed his block on Washington Square—became a testing ground for definitions of modernism and patriotism. An emerging group of young artists had established studios in the old carriage houses on the path behind de Forest's house. Artists like John Sloane, Robert Henri, and George Bellows self-consciously described themselves as radicals who challenged the standards and conventions of classical, academic paintings by choosing everyday urban scenes as their subject matter. Critics who objected to the banality and ugliness depicted in their paintings derisively labeled them worthy only of being thrown in the ashcan. Taking on the name as a badge of pride, the Ashcan artists would become the first group of modern American artists—many had

also played a significant role organizing the 1913 Armory show that brought European modernism to a larger American public.

Robert de Forest apparently objected to the social and aesthetic experimentation that was going on in his backyard. It is easy to see how a social modernist like de Forest would be reluctant to embrace social-realist themes of Ashcan artists. De Forest, after all, used his political capital to transform the way industrial cities looked, and much of his social reform intervened specifically in New York's tenement neighborhoods. The gritty scenes of washer-women, prize fights, and bleak waterfront districts represented the kinds of social problems that he believed art and beautification projects could alleviate. But the Ashcan artists also represented a more fundamental threat to de Forest's ideas of civic integrity. In 1917, artists John Sloane and Marcel Duchamp led a group of local bohemians in a protest, occupying Washington Square Arch. Drinking wine and reciting poetry, they declared themselves the New and Independent Republic of Washington Square—or New Bohemia—to assert their opposition to American involvement in the World War.[76] Such protests represented the literal confluence of modern art and anti-patriotism for a first citizen like de Forest, and it emerged seemingly in his front and back yards.

Museums like the Metropolitan Museum of Art, and most of the institutions influenced by the American Federation of Arts, remained leery of modern art through the 1920s. In 1921, the Metropolitan tested the cultural waters by mounting a loan exhibition of French Impressionist and post-Impressionist paintings, but was met with such vociferous criticism, associating the art with Bolshevism, that museum leaders would not again attempt to display modern art for several years.[77] As late as 1929, the Metropolitan Museum refused to accept a donation of Gertrude Vanderbilt Whitney's collection of modern art, most of which was the work of Ashcan artists, on the grounds that it had not yet stood the test of time. It would be easy to dismiss Robert de Forest's reticence toward modern art as reactive anti-modernism, but in fact de Forest was a man deeply committed to social and cultural modernism. He spent his professional and philanthropic career implementing bureaucratic and intellectual modernizations in the institutions he ran because he believed in the power of civil society to influence the modern American nation. Rather, de Forest's reluctance to embrace modern art in his cultural institutions, or to welcome its creators in his neighborhood, represented the divisions within the progressive movement that emerged during World War I.

During these years of institutional modernization, the Metropolitan in-

stead used decorative arts to test public response to modern aesthetics. By focusing on decorative arts as the one area of experimentation, the Metropolitan safely negotiated the waters of aesthetic modernism. The relative cultural value of decorative art in the museum's hierarchy ensured that any adverse public reaction posed a less significant threat. Specifically because they were arts applied to daily modern living, modern decorative arts could logically be presented to an art museum public without risking public reaction, unlike endorsements of experimental fine art like post-Impressionist, social-realist, or cubist paintings, which were considered shocking and dangerous by many of the museum's traditional patrons. While the museum public might not understand modern paintings, trustees gambled, people could understand modern household objects. Besides, improvement and modernization of consumer goods fit right in with de Forest's progressive agenda. Modernizing the aesthetics of consumer products did not threaten the capitalist system, but rather strengthened it. Modernizing individual homes and improving their aesthetics also strengthened the Metropolitan's larger social agenda of helping to build better homes, better families and better communities.

The Art of Living

The American Wing and Public History

The Metropolitan Museum of Art unveiled the American Wing of period room galleries in November 1924 with a lavish dedication ceremony, where museum trustees, architects and curators spoke about the patriotic and educational value of American decorative arts. "Our Museum," Robert de Forest proudly enthused, "is sounding a patriotic note." "We are honoring our fathers and our mothers, our grandfathers and our grandmothers," he proclaimed, "because for the first time an American museum is giving a prominent place to American domestic art."[1] To encourage other institutions to follow the Metropolitan's example and build similar collections of American decorative arts, de Forest invited one hundred cultural and educational leaders to an elaborate six-course dinner at the University Club after the opening exercises. Henry Watson Kent and Richard Bach also orchestrated an unprecedented blitz of newspapers and the trade press to generate reviews and encourage the general public and manufacturers to visit the American Wing. The progressive connoisseurs who had come to power in American museums in the past twenty years saw the American Wing as the culmination of their goals for cultural democracy and the cultivation of an American style. Museum leaders like de Forest and Kent hoped the American Wing would legitimate American decorative arts by establishing their art-historical credibility while illustrating the educational value of everyday objects.

By the 1920s, museum openings had rarely received this kind of attention, but the American Wing had been a very personal endeavor for Metropolitan leaders. Robert de Forest and his wife Emily gave the American Wing to the Metropolitan as a gift, and they supervised most of the details

of its completion. Henry Watson Kent considered the American Wing one of the greatest achievements of his career. Since coming to the Metropolitan in 1905, Kent had worked to build a permanent collection of American things. Immediately after the Hudson-Fulton Exhibition closed in 1909, Kent had arranged the Metropolitan's purchase of Boston collector Eugene Bolles's early American furniture. With the Bolles acquisition, the Metropolitan Museum initiated an unprecedented collecting and museum-building campaign to establish an American Wing. In just fifteen years, the museum's new generation of professionals built an entire wing from the ground up. They accumulated objects, enlisted experts, and secured funds; they established a new field of collecting and introduced novel display techniques; and they promoted new educational programs of museum outreach. As Kent had done for the Hudson-Fulton Exhibition, he marshaled his professional and personal resources to implement his goal of presenting American industrial arts to inform modern design; and as de Forest had done in all of his institution building, he brought together his personal and social-reform networks to fund the new wing and use it as a model for improved American homes.

Building on the popularity of the Hudson-Fulton Exhibition, the Met and other art museums seized upon the period room idea as a venue for exhibiting American decorative arts. Thus, wartime buying among museums and private collectors drove up the market for American things. Restricted from European art markets during the war, and responding to calls for cultural nationalism, museums recruited Americana collectors, and they sent scouts out to locate old American things and houses. Though one among many institutions competing for old things and houses, the Metropolitan Museum dominated the field. The museum's wealth and the network of collectors Kent had built gave the Metropolitan distinct advantages, and assured its position as a cultural leader in the period room movement of the 1920s. Shortly after the American Wing opened in 1924, art museums in Brooklyn, Philadelphia, Boston, Baltimore, and St. Louis opened their own galleries of American period rooms.

The Metropolitan Museum pioneered the use of material culture to tell the history of the United States, but by focusing on masterpieces, the story of American history told at the American Wing privileged elite social life, and the refined taste and patriotism of "great men." Whereas an earlier generation of preservationists had furnished historic houses like Mount Vernon with objects that had personal and patriotic associations, Met curator R. T. H. Halsey broke new ground by using old American things as primary evidence to tell a specific story of American home life. Halsey called his

interpretation "The Art of Living" because he believed that America's forefathers built elegant homes as reflections of their cultivated taste and superior education, which, he argued, contributed to their civic ideals. Progressive connoisseurs at the Met like de Forest, Kent and Bach wanted to present a usable past with American things that could be used to both explain artistic development in design to craftsmen, and present models of tasteful homes to new American citizens. Therefore, the Met's period room galleries told overlapping stories of the development of craftsmanship and American home life. However, art-historical imperatives that privileged the linear development of craft technique and attribution of master artisans led to galleries filled with only the finest examples of craft masterpieces. To stake a claim for American things in the Metropolitan Museum's hierarchy of cultural production, the American Wing displayed high-style American antiques that very few families—either in the past or in the 1920s—could have afforded. Stories of American home life like those told in the American Wing ultimately had profound consequences for telling public history throughout the twentieth century. Over the next three decades, junior curators and consultants at the American Wing moved on to institutions throughout the country and built similar period room galleries that interpreted exclusive histories of the United States.

The Metropolitan's interpretation of American history also had far-reaching consequences for the progressive museum agenda. Historic houses and public history museums, which flowered in the decades after the American Wing's completion, picked up the narrative of American history told there. The professionalization of museums and the preservation movement privileged the expertise of art and architectural historians, whose focus on accuracy of design and craft details further restricted historic narratives to the homes of the elite. The focus on aesthetics in historic houses also tended to flatten social conflict, directing attention to the fruits of wealth rather than the labor that created it. Historical villages like John D. Rockefeller's Colonial Williamsburg and Henry Ford's Greenfield Village, and house museums like Francis du Pont's Winterthur, all reinforced narratives of progress while they justified the social relations that preserved their founders' positions of power.[2] Until very recently, exclusive narratives of American history like these dominated public history institutions—reinforcing social exclusion and alienating large segments of the American public. Today, a new generation of art museum professionals have teamed up with academic historians and revised once-exclusive historical interpretations by more critically examining

the past, and by transparently presenting period rooms as social constructions of the 1920s.

Period rooms emerged in response to a cultural landscape of profound social transformation following World War I. But they meant very different things to the various people who built them. The museum leaders and professionals who modernized cultural institutions and ushered in a progressive museum agenda hoped period rooms would fulfill their goals for cultural democracy and public service. Museum educators thought period room settings had the potential to reach a broader museum public than traditional art galleries, and believing in the power of attractive homes to make better citizens, they hoped that examples of good American design would influence manufacturers and consumers alike. But many collectors and architectural historians, on whom museum professionals like Kent relied, saw period rooms as a way to promote a new field of collecting and to secure their own positions of authority and expertise. Many of the collectors also tapped into colonial revival notions of nostalgia and Anglocentric traditions. Though museum educators, professionals and private collectors came to period room projects in art museums with divergent goals, they all agreed on the need for a suitable usable past to frame the social landscape of the 1920s.

Period Rooms and the American Wing

Period rooms first appeared in European museums in the late nineteenth century as innovations that put objects into historical context. Kent admired them among the modernisms he found when he visited European museums in 1893. Stockholm's Nordika Museet had opened period rooms in 1873, and in 1891, its director, Arthur Hazelius, opened Skansen, an outdoor park that included vernacular buildings filled with historically appropriate objects to illustrate folk traditions. By the turn of the century, several museums in northern Europe had installed period rooms, including the Swiss National Museum in Zurich and the Bavarian National Museum in Munich.[3] In 1904, the Rhode Island School of Design (RISD) built a Georgian-style house to display collector Charles Pendleton's extensive collection of American antiques. The architectural details of the Pendleton House rooms were all reproduction, but connoisseurs and collectors so admired their historical accuracy that Americana expert Luke Vincent Lockwood wrote the house's catalogue, and the Walpole Society of collector-scholars flocked to Providence in 1912 to see it.[4] In 1907, George Francis Dow installed three authentic period rooms

at the Essex Institute in Salem, Massachusetts. Dow exhibited a vernacular colonial kitchen, bedroom and parlor with salvaged interior woodwork from local houses.[5] Though Dow presented these vernacular rooms with relatively humble furniture, Kent showed them to the de Forests and Halsey when he drove them through New England in 1909 to sell them on his plans for the American Wing. They all later claimed that the period room idea stuck from this point.

In the United States, one of the most impressive aspects of the period room movement was the scale of private investment and personal initiative, which led to such rapid collecting and institution building. Curiously, the progressive connoisseurs who transformed American museums in the early twentieth century from paternalist institutions into modern bureaucratic organizations now recruited private collectors and antiquaries, who heralded many of the elitist attributes the progressives had so vigorously fought to reform in the 1890s. Therefore, the process of building and installing American period room galleries recalled nineteenth-century patronage and private philanthropy: museums relied on autocratic collectors to assemble their collections, they sought out personal loans of objects, and they finessed private funding sources to finance their projects.

The American Wing, for example, represented a peculiar combination of public spirit and private initiative. Despite the progressive insistence upon ideals of public accountability and civic engagement during the early twentieth century, the Metropolitan Museum built the American Wing as an entirely private project—unprecedented at the Metropolitan. Whereas all previous museum additions had been funded in large part by municipal appropriation, Robert de Forest secured only private funding to build the American Wing, and he recruited a team with professional and personal autonomy to construct it. Most museum exhibits had been assembled by curators from existing collections (either within a museum or those previously assembled by a donor), but Robert de Forest, Henry Kent and R. T. H. Halsey built the American Wing almost entirely on their own. They determined the type of story they wanted to tell, and they located all of the pieces to do it. They also decided on the wing's architecture, hired its architect, and oversaw its construction. Because they had composed a plan to present their story in a series of period rooms, their task of finding and assembling was that much more difficult. Kent used the Walpole Society of American antique collectors to help find the right objects, and Halsey negotiated with other individual collectors to coax them to sell their pieces. At the same time, Halsey sent

scouts out to roam the countryside looking for desirable colonial houses from which the museum could purchase interior woodwork. While Halsey and fellow collectors searched New England and the South for furniture and interior paneling, de Forest raised the money to build the American Wing.

Period room galleries in other art museums followed similar approaches, turning to voluntary gentlemen-collectors in an age of otherwise professional institution building. Collector Luke Vincent Lockwood single-handedly built the Brooklyn Museum's period rooms, personally selecting objects and interior paneling, and laying out the financial capital to secure pieces when they hit the market. Like de Forest at the Metropolitan Museum, Lockwood used his position on the Brooklyn Museum's board of trustees to tap into appropriation funds to reimburse his personal investment. At the Museum of Fine Arts in Boston, collector Edwin Hipkiss personally located old New England objects and houses, and he negotiated with fellow collectors and the descendants of old Boston families to secure a representative collection of period rooms that commemorated Boston's social and political elite. Fiske Kimball similarly orchestrated collection building at the Pennsylvania Museum in Philadelphia, and Lockwood later offered his expertise and personal wealth to build period rooms at the Museum of the City of New York. Public memory and institutional narratives frequently explain this anachronistic phenomenon of private philanthropy and cultural paternalism as the response to cultural hierarchies in museums, which continued to marginalize American things. But by positioning period room initiatives as the work of cultural pioneers who opened up the canon, these institutions—and many of their historians—have crafted the public record to cloak a process of anti-democratic private control of public institutions under the mantle of public-spirited cultural stewardship.

De Forest and Kent often told people that when they first suggested a permanent collection of American antiques they were met with wary opposition. Critics as well as friends of the museum worried that the Metropolitan Museum's position of cultural authority and international prestige could slip away. "It was almost with fear and trembling," remembered Halsey, "that some of the trustees at the Metropolitan Museum under the leadership of Mr. Robert W. de Forest pursued their evil course." "We firmly believed that a demonstration of the history of American art would meet with popular approval," Halsey said, "but sometimes jokingly were told it would be our funeral."[6] De Forest recalled that his friend John Cadwalader had expressed dismay when he first heard about the museum's plans for a

permanent exhibition of American antiques. "What do you mean, de Forest," Cadwalader insisted. "There is nothing American worth notice."[7]

Nearly unlimited funds, however, gave de Forest and his team at the Met the means to make American things worthy of notice. The Sage Foundation provided de Forest unrestricted financial resources to interpret American Wing galleries without public interference. In many ways, the 1908 restoration of interiors at City Hall provided de Forest the template for a successful, independently financed project to define civic taste. In response to what many considered the tasteless 1905 restoration of the Governor's Room that the city had financed, de Forest used the Sage Foundation's flexible funding policy to redecorate the public rooms—without public input. For the American Wing, de Forest used the same funding approach, and he even relied on the same team of experts to build it, recruiting Atterbury and Halsey. When the Metropolitan Museum purchased the Bolles collection in 1909, de Forest persuaded Margaret Olivia Sage to provide the funds. "It is to Mrs. Sage's wise liberality," Kent wrote in the 1910 *Bulletin*, "that we, in New York, are enabled to save the evidences of our forefathers' appreciation of art."[8] In 1916, de Forest donated an additional twenty-five thousand dollars of Sage Foundation funds to the museum for the permanent installation of the museum's Americana collection.[9] In 1922, Robert and Emily de Forest announced that they would personally pay for the completion of the American Wing.[10]

Financial independence gave the American Wing team the freedom to experiment with period room displays and the autonomy to determine their content. After Kent acquired the Bolles collection, and once de Forest secured Sage money to install it, Halsey's committee started to explore methods of display. Despite the Hudson-Fulton Exhibition's popular success, everyone at the museum seemed to agree that traditional museum galleries failed to complement the scale and proportion of old American things. The furniture in the 1909 Hudson-Fulton exhibit, for example, had been arranged in linear rows against gallery walls in the Metropolitan's new Beaux-Arts-style McKim, Mead, and White building. Museum trustee Elihu Root said the American pieces in that exhibit looked "like fish out of water."[11] He felt that "the homely productions of American household art quarreled with the great rooms of the Museum" because they "could not be appraised under this strange and inappropriate environment."[12] Complete period-room settings, on the other hand, offered the opportunity both to place the museum's old American things in their historical context and to interpret idealized American home life.

Period room builders at the Metropolitan, the Museum of Fine Arts

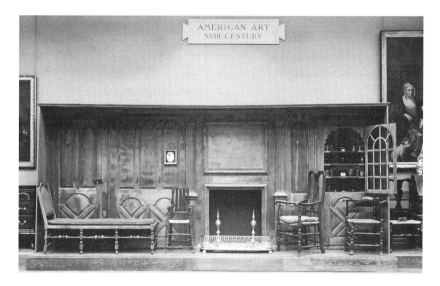

Figure 23. Unlike most of the furniture and accessories on display at the Hudson-Fulton Exhibition, this small vignette of pieces was presented in front of eighteenth-century paneling, loaned by collector George Palmer. In contrast to those pieces that Elihu Root felt looked like "fish out of water," here the paneling seemed to draw the museum visitor's eyes down to the objects, presenting them on a domestic scale. Metropolitan Museum of Art, Hudson-Fulton Exhibition, 1909. The Metropolitan Museum of Art. Image © The Metropolitan Museum of Art.

and the Brooklyn Museum tapped into their personal networks of friends and fellow collectors to accumulate representative collections of American craft masterpieces, and they faced off in a rapidly accelerating market for old things. Kent and Halsey relied on the Walpole Society of collectors to help build the Metropolitan's collection, while Hipkiss turned to Boston's Trestle Board Club of antiquaries and collectors to build the MFA's period rooms. Lockwood turned to a private network of dealers and buying agents to assemble his collection of Americana in Brooklyn. All three institutions competed for old things and old houses, but they ultimately narrowed their interpretive approaches to accommodate the collections they had and their relative financial resources, as they competed in the hot market for Americana in the teens and twenties. As the wealthiest institution with the greatest buying power, the Metropolitan staked out its intellectual and art-historical territory, and determined to build a representative collection of the history of the entire nation's craftsmanship. The Metropolitan Museum felt confident enough

to call its period room galleries "The American Wing" because the museum had a sufficient collection of objects and interiors to present what its curators considered a full chronology of American craft, through rooms filled with American masterpieces—however narrow and selective the American Wing's ultimate colonial-revival narrative of U.S. history actually was.

The American Wing essentially left other art museums to carve out interpretive exhibitions that could supplement rather than compete with the Metropolitan's collection. Hipkiss focused on the local history of Boston and surrounding seaports, turning to old Boston families—his rooms were arguably the most "authentic" historical interpretations because he was able to furnish rooms with original things still in the hands of Brahmin families. Local pride and regional rivalry also helped the Museum of Fine Arts hang onto objects and houses even when the Metropolitan's deeper pockets threatened their removal to New York. Lockwood, however, had fewer resources. Always at a disadvantage when seeking benefactors among New York's elite, who frequently preferred association with the Metropolitan Museum, the Brooklyn Museum turned to a more creative interpretive approach to give its American collection an edge. Lockwood installed series of several rooms (sometimes entire floors) from a single house to distinguish Brooklyn's period rooms from the chronological series of unrelated rooms telling an art-historical narrative at the Metropolitan. It also helped to buy house interiors from the South—where prices were cheaper and rooms easier to pinch.

The decision by art museums to strip interior molding and paneling from old houses might seem strange given their institutional missions to preserve cultural patrimony. Many of the collectors and museum professionals who built period rooms were even members of preservation societies, and had themselves played active roles preserving civic landscapes. Halsey and the American Wing's architect Grosvenor Atterbury, in fact, had first impressed de Forest when they collaborated to preserve New York's City Hall. The preservation ideals of early twentieth century preservationists, however, were always selective. Early preservationists were most interested in saving examples of a usable past that could serve their interpretive agenda. Just as de Forest saved the "right" history in City Hall Park, Halsey, Hipkiss and Lockwood focused on saving the parts of houses that corresponded to their colonial-revival visions of American domestic life. Most museum professionals actually justified tearing rooms out of old houses by emphasizing the social advantage of public ownership of old relics in a museum. If houses were being stripped for profit, they argued, museums had a responsibility to make

sure they did not end up in private hands. No one, however, seems to have explored the role played by the period room movement in creating a market for interior woodwork in the first place.

At the Metropolitan Museum, Halsey wanted only the best examples of American antiques to tell a complete narrative of the development of American craftsmanship. When he joined the Metropolitan's board, the museum owned a few pieces of paneling that corresponded in period and style with the pieces of furniture it already owned.[13] The six hundred pieces in the Bolles collection represented perhaps the best examples of early colonial furniture, but Halsey needed to acquire later pieces to present his story. The museum had to acquire excellent quality later eighteenth-century and early republic furniture, as well as correlating examples of silver and ceramics.[14] Kent turned to the Walpole Society to secure collections, either asking members to loan or donate their objects, or taking advantage of their expertise to locate and appraise antiques in the hands of other collectors and dealers. As a fellow collector and member of the Met's board of trustees, Halsey negotiated with collectors on the one hand, and fellow trustees on the other hand, to authorize purchases and to tap into secured endowment funds.

At the Met, Halsey and de Forest found sufficient funds to make the museum's most significant purchases during the war, in order to follow through with their interpretation of artistic excellence in period rooms. In 1917, Halsey admitted to silver expert Alfred Jones that the hardships of war distracted him. "My boy is over in France driving an ammunition cart," he explained, "and naturally my thoughts are more in that part of the world than on what happened here in America in the 18th century."[15] Nevertheless, Halsey continued to correspond with his assistant Durr Friedley even while Friedley trained at Kelly Field in San Antonio; Halsey asked him about plans for the wing and discussed the rooms Friedley had found.[16] The previous year, Halsey had told Friedley, "I am more and more impressed with the idea that we only put beautiful rooms in the new wing."[17] Halsey also revealed the direct role he hoped the museum would play in increasing the market for colonial revival things. "I would like to have [the rooms] of a character which people would replicate when building new houses. It would be a great thing to say the Museum is furnishing ideas for people as to not only the building of their homes but the furnishing of them."[18]

As the market value of American things increased and other museums began to compete for private collections, Halsey and Kent finessed fellow collectors. To court Ulster County judge and silver collector Alphonso Clear-

water, the museum made him an Honorary Fellow for Life in 1912.[19] Clear-water had lent pieces from his collection for the Hudson-Fulton exhibit and a later Colonial Dames exhibit in 1911, but after 1912 he sent almost all of his new silver to the Metropolitan.[20] When Halsey became chair of the American Wing's planning committee, he started negotiating to limit Clearwater's loans to the best pieces.[21] In 1915, Halsey wrote Durr Friedley that he had corre-sponded with Clearwater and successfully pared down his suggested loans to the five pieces Halsey wanted. "I also intimated to him, in a diplomatic way," Halsey explained, "that the others [additional silver] would not add to the value of his collection, as what he needed was quality, not quantity."[22] Of course, Halsey meant the Met preferred quality over quantity. "I feel that in the future," Halsey triumphantly concluded, "only fine pieces will be sent down."[23] In 1916, Halsey installed Judge Clearwater's fine pieces in a special exhibition, and he prepared a catalogue for the public—and of course for Clearwater's pleasure. In 1923, Halsey wrote a complimentary description of a Clearwater loan in the *Bulletin,* and he used Hollis French's Walpole Society publication *A List of Early American Silversmiths and their Makers* as a vetting guide.[24] Halsey's attention and flattery ultimately secured the Metropolitan the bequest of the Clearwater collection in 1933.

George Palmer's collection of eighteenth-century furniture, however, called for more careful diplomacy and institutional cunning. In 1913 the Metropolitan purchased a collection of silver from Palmer, but Halsey and Kent had their eyes on his furniture, and they were anxious lest someone else, or some other institution, get their hands on it before them. Palmer's late eighteenth-century high-style American antiques provided just the right complement to the museum's Bolles collection. However, the Hudson-Fulton exhibition's success and the Walpole Society's promotion of American things had increased both the status and prices of American antiques. News that the Metropolitan planned to open an American wing further elevated their value, so wealthy collectors and other museums entered the field and competed for encyclopedic collections like Palmer's.

Palmer claimed that when he and his cousin Eugene Bolles began col-lecting together in the 1880s, they avoided competing with one another by instead focusing on different periods because they hoped their collections would one day end up in an art museum.[25] Kent knew Palmer and his collec-tion very well from his Norwich years working at the Slater Museum. In fact, Kent first tapped Palmer's collection in the 1890s when he assembled a loan exhibition of chairs at the Slater. Palmer eventually purchased most of the im-

portant pieces that remained in old Norwich families, including a block-front chest that the Huntington sisters had showed off to Kent in the early 1880s when he was a young student at the Norwich Academy.[26] By the time Palmer loaned his pieces again to Kent for the 1909 Hudson-Fulton Exhibition, his collection rivaled all others in the field for the quality of its workmanship and its comprehensive arrangement. Kent and Halsey certainly kept their eyes on the prize, and they worked hard to ensure that the Metropolitan would supplement the Bolles collection with Palmer's collection.

In 1918, the Metropolitan negotiated buying a selection of Palmer's collection. Halsey selected forty-three specific pieces that would illustrate the narrative of artistic excellence he intended to present in the American Wing, but Palmer itemized those pieces at well over one hundred thousand dollars.[27] In less than a decade, since Sage had bought the six-hundred-piece Bolles collection for the Met, prices had skyrocketed. Whereas Bolles had appraised his most valuable pieces at two thousand dollars and his average pieces in the modest hundreds, Palmer appraised his American Chippendale pieces alone at seventy-one thousand dollars.[28] Kent recruited Walpole Society members Luke Vincent Lockwood and Henry Wood Erving to appraise the Palmer pieces, and they confirmed the furniture's staggering appraised value.[29]

The elevated antiques market required Halsey to negotiate delicately with both his collecting friend and the museum board. In an uncomfortable confidential letter, Halsey asked Palmer to reduce his prices by explaining his difficulty securing an appropriation for this purchase from the Metropolitan's board. Though the Met was a wealthy institution by 1918, most of its assets were locked into endowments or restricted for particular purposes by the legal demands of benefactors. Halsey explained that he had found leftover funds in an old bequest to purchase English Chippendale furniture and porcelain that he could use to secure Palmer's American and English furniture, but he asked Palmer to remove later pieces to meet the restrictive criteria. Halsey also explained that the "seeming indifference of Trustees" to buying American things threatened to thwart the entire purchase.[30] Clearly uncomfortable bargaining with a fellow collector and Walpole Society member, Halsey insisted that he only "chats" with him in order to express his "anxiety to have the collection in the museum." "I realize what I am up against," he continued, "hence the wish to make absolutely sure of the completion of this transaction."[31] Halsey insisted that he could not even present the proposal to the board unless Palmer brought his price down to an even one hundred thousand dollars. "This has been a hard letter to write," Halsey finished, "but

I know you will understand what I am driving at."[32] Ultimately, de Forest and Halsey were able to use funds from a 1909 bequest from trustee and former de Forest faction member John Stewart Kennedy to buy Palmer's collection, and they made Palmer an Honorary Fellow.[33]

At the same time, Kent and Halsey were hunting along the Atlantic seaboard for old houses from which they could buy interior woodwork for their period rooms. While news spread very quickly that the Metropolitan Museum was in the market for old houses, reaction to that news differed dramatically by region. For many collectors, New England houses and their interior furnishings represented the pinnacle of American taste, so the region around Boston became the most contested and heated market during the colonial revival. Halsey sent his scouts throughout New England looking for houses with good quality interiors that the Metropolitan could purchase, but local preservationists resisted the demolition of historic houses, and they resented the implications of having a New York museum strip local homes.

William Sumner Appleton founded the Society for the Preservation of New England Antiquities (SPNEA) in 1910, the same year Kent founded the Walpole Society. The Walpole Society and SPNEA shared overlapping membership because both worked to promote old American things (whether furniture or houses), but Kent's and Halsey's period-room proposals to present furniture collections in relocated interiors conflicted with SPNEA's goals of saving old houses *in situ*. Bostonians had been among the first Americans to think seriously about preserving historic structures from demolition, and they introduced many of the tactics of public information campaigns and grassroots organizing that would come to characterize the profession of preservation and sustain the movement well into the twentieth century. SPNEA is frequently seen as the organization that transformed preservation from sentimental crusades to save places with patriotic historic association into a professionalized movement with standardized practices. Like the cultural leaders who modernized museums, the preservation societies of the early twentieth century integrated principles of professional bureaucracy and the civic spirit of progressivism into their efforts to save selective elements of the built environment. Kent initially asked Appleton for advice finding good New England interiors for the Met's period rooms, but Appleton refused.[34]

In 1918, the Metropolitan Museum and the Society for the Preservation of New England Antiquities faced off over a New England house. When colonial revival businessman Wallace Nutting put the Portsmouth, New Hamp-

shire Wentworth-Gardner house on the market, the effects of wartime buying and the popularity of the colonial revival movement had pushed prices so high that SPNEA could no longer prevent what Appleton frequently called the museum's vandalism, because the society could not raise sufficient funds to purchase the house at its inflated value. Appleton complained that the war had halted preservation efforts by diverting the public's attention; at the same time, of course, museums eagerly snapped up vulnerable properties.[35] Nutting had purchased the elegant Georgian-style Wentworth-Gardner house in 1915 as part of a chain of five historic houses that he intended to restore to attract tourists, but the venture ultimately failed. Nutting offered the chain of houses and their furnishings to both the Metropolitan and SPNEA for $125,000. In New York, Kent and Halsey called upon their experts and started negotiating with museum trustees, while Appleton rallied his allies in Boston to raise the necessary funds. In the end, Nutting needed money more quickly so he broke up the chain and offered his houses individually; the Met had the money, but SPNEA could not compete, so the museum bought the Wentworth-Gardner house in August, 1918. Halsey later claimed that the museum had acted in defense of the public good: on the one hand, he explained that the Met saved the house from a wealthy New Yorker who was competing with the museum for it, and who planned to float it to Long Island for use as a private residence; and on the other hand, he assured New Englanders, probably with little success, that the house would give their region solid representation in the American Wing's galleries.[36]

Preservation groups like SPNEA consistently marshaled opposition to the stripping of interior details from old houses, but when faced with imminent extraction, Appleton usually favored pragmatic politics over outright resistance. For example, Appleton had originally encouraged Nutting to buy most of the historic properties in his chain despite widespread concern within preservation circles about Nutting's idiosyncratic, unprofessional and frequently inaccurate restorations.[37] Appleton was gambling that Nutting represented the lesser of the evils as long as his ownership of old houses kept them intact and in their original landscapes. Appleton miscalculated, but he also recognized the advantages of working with museums once their dominance in the market for old houses became apparent. When in 1920 another Portsmouth house went on the market, Appleton reluctantly worked with Edwin Hipkiss at the Museum of Fine Arts to keep it in New England, even if doing so entailed stripping its interiors for the MFA. The Jaffrey house offered many of the same attractive Georgian features as the Wentworth-Gardner house, and

local dealers hoped the Metropolitan's recent purchase would generate interest. "I must confess a keenest regret," Appleton pleaded with Hipkiss, "that it should be necessary, from the Museum's point of view, to strip so interesting a house, which I would gladly see preserved entire." "Still," Appleton accepted, "I must admit that I have no counter to advance." Appleton offered Hipkiss extensive notes about what he considered the important features of the house, and he pointed out details for museum interpretation—at the same time, he also staked a claim to any fragments the museum decided to leave behind.[38] Ultimately, SPNEA and local antiquary societies like the Trestle Club recognized the importance of preserving Brahmin patrimony, and committed themselves to helping Hipkiss keep old New England houses and things in Boston.

Restricted, for the most part, from the market for old houses in New England, Halsey and Kent turned to the South, where preservationists had only limited resources to protect local properties. To present his interpretation of the Art of Living at the Metropolitan, Halsey sought out homes originally built by the elite, but most elite families in the North passed on sufficient wealth so that their descendents could maintain their homes and protect them from demolition. If not, local preservationists usually rallied to remove threatened houses from the market. In fact, many of the colonial revival collectors and genealogists who supported organizations like SPNEA came from old elite New England families. The most common preservation threat to old homes in New England had to do with urban transformations that had placed some houses in socially undesirable neighborhoods.[39] In the South, however, older elite families had not maintained their wealth, so houses built by the slave economy were often heavily mortgaged and in alarming states of disrepair by the early twentieth century. By the end of the nineteenth century, early preservation societies in the South, like the Mount Vernon Ladies Association, had turned from large-scale mobilization campaigns to save historic houses to more localized efforts at erecting monuments and preserving ideals of the Lost Cause. For many individual families, selling a room from an old plantation house provided descendents the possibility of saving a house from foreclosure. Ironically, the Old Dominion, birthplace of the preservation movement, ultimately served as the Metropolitan's best resource for elite period rooms.[40]

Durr Friedley spent the winter of 1916–17 traveling through Virginia looking for eighteenth-century houses and reporting to Halsey. Their correspondence reveals an organized network of informants and experts, and

significantly less local resistance than they encountered in New England. In many cases, Halsey passed along tips from local architects and antiquaries, who knew the Metropolitan was looking for old houses. His scouts would then take photographs and measurements and feel out property owners.[41] In November 1916, Halsey instructed Friedley to contact Miss Rebecca Irwin, the owner of a house that had a room he thought would "make a stunning big exhibition room for the portraits, furniture, etc."[42] Halsey was sure Friedley could directly approach Irwin, "a gentlewoman in every sense of the word in much reduced circumstances," and bargain with her because she was "of the old fashioned type" and "reduced" to boarding with friends.[43] Southerners were used to having northern businessmen come south and "pillage" their relics, but reduced circumstances, as Halsey knew, made resistance difficult. Halsey wrote that he wished he could be "hunting through the country" with Friedley because the hunt in Virginia likely reminded him of early informal collecting, before big museums like his own snapped up collections and houses, and drove up their prices.[44] Nevertheless, Halsey stayed in New York and passed Friedley's discoveries on to Kent, de Forest, and architecture experts Norman Isham and Francis Dow; in turn, Halsey passed their judgments back to his scout. In the spring, Halsey instructed Friedley to contact the "ladies" who owned an Alexandria ballroom that Washington had visited and make an offer, because he had recently heard that they too were "in a very receptive condition" and "may be willing to sell."[45]

Between 1916 and 1918, the Metropolitan acquired eight more rooms that Halsey believed represented the Art of Living. Like the Kennedy bequest that secured the Palmer collection, the Metropolitan's Rogers Fund provided flexible income that de Forest could use to purchase houses and room interiors as they became available. In 1895, locomotive manufacturer Jacob Rogers left the museum its largest endowment to that point; when de Forest and Elihu Root had negotiated terms with the Rogers estate, they netted the museum a five-million-dollar endowment without restrictions on its income.[46] The Rogers Fund allowed the museum to both act quickly and buy liberally. With its buying power and its consolidated network of informants, scouts, and experts, the Met usually got its house, even when Halsey and Kent were competing with fellow collectors. When the Metropolitan bought a room from "Marmion," a plantation house in Fredericksburg, Virginia in 1916, Pennsylvania Museum director Edwin Barber congratulated Kent, and admitted that he had also tried to buy the room, but his museum could not afford its price.[47] In 1917, Luke Vincent Lockwood also went up against Halsey for a

house he had his eye on for period rooms at the Brooklyn Museum. They ultimately agreed to split the rooms, but Lockwood went away with upstairs rooms while Halsey hung on to the choice parlor-floor rooms. After agreeing to their terms, Halsey wrote Lockwood that he was pleased they were "working along the same lines," but he explained that the Met had been "after this house for 10 years."[48] As collectors, dealers, and preservationists increasingly became aware, when the Metropolitan went after something for the American Wing, it usually got it.

Perhaps it is fitting that museums made their most significant purchases for their period rooms during World War I. Wartime experiences altered many aspects of American life, but museum purchases also affected the colonial revival movement. When art museums entered the market for old American things, their prices increased, and wealthy new collectors entered the field. In combination, museums and millionaires like Du Pont and Ford priced out many of the early collectors who had helped the Metropolitan first elevate the status of their collections in 1909. At the same time, entrepreneurs like Wallace Nutting tapped into an emerging middle-class desire for old things by marketing reproduction colonial furnishings.[49] During the nineteen twenties, the colonial revival movement also influenced definitions of what it meant for things and people to be American. The American Wing's interpretation would be both a reflection of and a catalyst for more restricted definitions. The Wentworth-Gardner house, which highlighted this shift in values, stayed in Portsmouth through the war. Halsey, de Forest and Kent negotiated with SPNEA and local preservationists, Hipkiss worked with local Boston collectors and preservationists, and Lockwood scrambled to buy the best furnishings and house interiors his budget could maintain. At the Metropolitan, de Forest ramped up fund-raising and his team worked out their plans for the American Wing's installation, all the while waiting for workmen and curators to return from wartime service.[50]

Presenting History in the American Wing

After the war, Halsey and his committee went to work finalizing their plans for the American Wing. The Metropolitan Museum now had most of the furniture, accessories and interior woodwork needed to present a visual illustration of Halsey's interpretation of American history, focused on the lives and homes of colonial and early republic elite Americans. Halsey had more traditional ideas about popular education and cultural democracy than the pro-

gressive connoisseurs who had transformed American museums in the past two decades. Unlike de Forest and Kent, Halsey focused on bringing American things to the Metropolitan to increase their art historical value through museum placement and recall their associations to a selective American past. In speeches promoting the American Wing, Halsey referred to the exemplary moral values of colonial American craftsmen and their patrons, as much as he referred to the artistic merits of American things.[51] Halsey championed the Art of Living—cultivated taste among the early American elite—because he believed its ideals could be used as a model for privileged Americans in the 1920s to counter the social transformations of the twentieth century.

"Traditions," Halsey insisted at the opening of the American Wing, "are one of the integral assets of a country." "Much of the America of today has lost sight of its traditions." Halsey hoped the Metropolitan's period room galleries would be "invaluable in the Americanization of many of our people, to whom much of our history has been hidden in a fog of unenlightenment." Halsey believed the founding fathers could provide inspiration to counter the dangers he saw in unchecked immigration. "The tremendous changes in the character of our nation, and the influx of foreign ideas utterly at variance, with those held by the men who gave us the Republic, threaten, and unless checked, may shake the foundation of our Republic."[52]

Halsey's alarmist interpretation of American society in 1924 and his narrow interpretation of traditional American character in the American Wing marked a significant shift in the Metropolitan's program of Americanization. Following World War I, such narrow interpretations of model American home life, centered on a distant past, became increasingly popular as American institutions turned away from more inclusive definitions of what it meant to be "American." In contrast to the museum educators before the war who advocated incorporating immigrants into society by teaching them art and encouraging them to help beautify America's streets by tapping into their "natural" love of beauty, Halsey insisted on restricting the museum's educational message to Anglo-Saxon models. While de Forest and Kent probably had more comprehensive reasons for interpreting the American Wing's galleries as models of civic home life, they ultimately yielded interpretive power to Halsey. Their decision to yield their more fluid interpretation of Americanization to Halsey's more conservative position coincided with the concurrent shifts in public attitudes in the 1920s to tighten American borders and redefine patriotism; and that shift had repercussions in multiple quarters, from housing reform and settlement work to public education programs, and

in the increasing insularity of hereditary groups like the Sons and Daughters of the American Revolution.[53]

The Metropolitan's position of cultural authority helped disseminate Halsey's ideas of American identity and the selective interpretation of history to museums large and small across America. The Met's financial advantages and the strength of Kent's network of collectors and architectural historians allowed Halsey to finish the American Wing years ahead of his peers in other art museums. Because de Forest paid for the construction of the American Wing with private funding, he was able to circumvent public debate about municipal appropriation and further push the building's completion ahead of the Metropolitan's period-room rivals. Therefore, the American Wing had a disproportionate cultural influence on the way its sister museums interpreted American things. Despite the collaborative nature of much colonial revival collecting, the American Wing set the agenda for telling history with things in the twentieth century. Halsey's dominant position in building the American Wing, coupled with the cultural landscape of the 1920s, changed the museum's interpretation of the relation of past, present and future.

In 1915, de Forest bought the 1824 façade of the former Assay Office on Wall Street as it was being dismantled, stored it on a vacant lot, and hired his long-time architect Grosvenor Atterbury to design a building behind it to house Halsey's high-style American interiors.[54] Atterbury built the new wing as a freestanding building in Central Park. It stood next to the museum's McKim, Mead, and White building, which housed J. P. Morgan's collection of French decorative arts, with a colonial-style garden in front of it.[55] Halsey hoped that museum visitors would enter the American Wing after touring the European furniture galleries, which displayed models on which American craftsmen had based their designs, before adapting them for wealthy American patrons.[56] "The primary purpose of the American Wing," Halsey announced in a speech shortly after its opening, "is to give an ocular demonstration to our people in particular, and to the world in general for the first time, that our American industrial arts unconsciously developed a style which may be called their own."[57]

The story told by the American Wing of how that style developed, however, was anything but unconscious. Halsey and his team of curators, expert collectors and architectural historians carefully constructed the building and its period rooms, and they scripted the wing's narrative interpretation. They selected pieces that represented an evolving development of American styles

Figure 24. Robert de Forest salvaged the façade of the former Assay Office building (c. 1823) on Wall Street, stored its stones in a lot in Central Park, and had it reconstructed as a new façade for the Metropolitan Museum's American Wing. American Wing, Metropolitan Museum of Art, 1925. The Metropolitan Museum of Art. Image © The Metropolitan Museum of Art.

and craftsmanship, as well as artistic excellence, and they determined which rooms corresponded with that story and which specific objects would tell it. Kent worked with Atterbury to fit the rooms into the new building and line them up with the fenestration of the Assay Office façade.[58] Atterbury later compared the process of arranging the American Wing's old rooms within one modern building to tell a story to "the most diabolical cross-word puzzle ever concocted." The careful selection of objects and architectural relics, and their slight adjustments with regard to placement, scale and architectural integrity illustrate exactly what was at stake in constructing a story of American history and craft development during the colonial revival. "It is the evil habit of such puzzles," Atterbury recalled, "to read both up and down and crosswise."

"But the American Wing must be so arranged," he insisted, "that you can read it also diagonally and 'every-which-way,' and yet always spell the same words, 'The Spirit of Colonial Art.'"[59]

For much of the American Wing's organization and management, Halsey combined traditional museum paternalism with professionalization. On the one hand, Halsey's detailed, hands-on commitment to the American Wing recalled the proprietary devotion to the museum shown by the Met's founding trustees in the nineteenth century. In 1923, Halsey sold his seat on the stock exchange, retired from business, and devoted his full-time attention to supervising the final details of the American Wing's installation. Halsey loaned pieces from his own collection to extend the museum's narrative to include early nineteenth-century (primarily Duncan Phyfe) furniture, and he loaned decorative accessories to give the rooms an air of domestic authenticity.[60] Halsey personally managed the details of installation, yet he also delegated responsibilities to a staff of experts, who applied the professional methodology of archival research and historical documentation to their installation.

The American Wing's application of professional standards, historical accuracy and professional expertise reflected the concurrent professionalization of the colonial revival movement in the1920s. After all, promotion of American things by professional organizations like the Walpole Society and SPNEA, not to mention museum placement, encouraged the revival of colonial styles. Halsey's team consulted inventories, wills and other primary sources to ensure historical accuracy of its period rooms. Like the first Americana collectors, who combed archives to determine provenance and trace craft traditions through emigration documents, Halsey's staff worked to ensure the same kind of accuracy in their representation of home life and their architectural backdrops for those well-researched American decorative arts and artifacts. Nonetheless, prevailing colonial revival interests dictated the way they presented their "historically correct" colonial and early republic homes in the American Wing. They privileged a certain past, they simplified it, in some cases literally whitewashing paneling, and they altered it to suit their needs. Kent and Halsey moved inconvenient doors and windows that didn't "fit" and they relocated mantelpieces to provide the best vantage point for museum visitors.[61] These architectural alterations mirror the way Halsey and other colonial revival enthusiasts likewise tweaked history to suit their needs and present it in the best light.

The increasing professionalization, reliance on experts, and focus on his-

torical accuracy also gendered museum work, collecting, preservation, and the colonial revival movement in general. When amateurs became distinguished from professionals, women who had previously worked alongside men buying and preserving Americana became marginalized as men established the standards and professional criteria that controlled access. Similarly, when collectors privileged colonial furniture and silver, and when museums and dealers raised their dollar value, they also privileged trained craftsmen over domestic homespun producers. The art museum's emphasis on authorship further marginalized the unattributed and undocumented handiwork of women.[62]

By telling the history of craft through American homes, the American Wing also privileged a particular definition of family. When the American Wing opened in 1924, domestic space was considered the female realm, but male curators established their authority over home design by displaying domestic space in the public realm of the museum. They also determined the way ideal domestic space would be interpreted. The emphasis on colonial interior settings focused the museum's curatorial connoisseurship on masculine artisanal craft production and the patriarchal domestic authority of heads of colonial households. By freezing the wing's narrative chronology at 1830, the museum also stopped it before industrial capitalism had created a middle class and the gendered ideology of separate spheres that "feminized" domestic space. Thus, the wing's educational message linked preindustrial masculinized colonial households and patriarchal authority to civic virtue.

After being excluded from positions of authority in the increasingly standardized colonial revival movement, women who had previously hunted for old things and campaigned to save buildings alongside men continued to work through their "traditional" voluntary organizations. Unable to acquire professional credentials, many women used their hereditary authority to participate in the colonial revival campaign to define American identity and style.[63] For example, Emily de Forest continued to collect American antiques for her country house and for the museum, and she wrote genealogical histories of her family.[64] Similarly, patriotic women's groups used old American furnishings and silver to celebrate their historic and family associations, and to stake a claim for themselves as serious collectors. As early as 1892, the Daughters of the American Revolution had mounted an exhibition of "relics of olden times" drawn from their personal collections. The exhibition featured five rooms packed with over one thousand objects, and was later criticized by professional collectors and museum curators for its disorganization and its focus on the historical association of objects, rather than their artistic merit.[65]

Nevertheless, museums like the Metropolitan never refrained from calling on women's groups to borrow their objects or their money. In 1911, for example, the Met cooperated with the Colonial Dames of New York to mount Halsey's exhibition of colonial silver and portraits. And in preparation for opening the American Wing in 1922, Halsey presented a Duncan Phyfe exhibition at the Metropolitan that drew heavily from collections of the Colonial Dames and prominent New York collectors like Emily de Forest.[66]

Even major institutional lenders like Emily de Forest and Margaret Olivia Sage took a back seat to men like Robert de Forest—who represented both women as an institutional leader. In addition to providing large financial contributions through her foundation, Margaret Sage personally gave the museum individual objects for the new wing, as well as for other museum departments. Like other friends of the museum who donated a piece of lace here and a spoon there, Sage gave the museum a seventeenth-century American wainscot chair, eleven Navajo textiles, a Bennington coffee pot, candlesticks, and a painting in 1910; a collection of two thousand Japanese ivories in 1911; two pieces of lace in 1913; and another Bennington ware piece in 1914.[67] While Sage's large financial endowments represent Robert de Forest's institutional efficiency in funding various social reform agendas, her personal gifts to the museum represent an older, traditional form of gendered gifting. Emily de Forest similarly gifted smaller objects to the museum in addition to her large financial donations, which she usually made with her husband. When she gave the museum its first period room in 1910, she did it anonymously, but she publicly donated linen and needlework and, with her husband, she donated a fifteenth-century Arabic window.[68] Margaret Olivia Sage, Emily de Forest, and many other women collectors gifted objects to the Metropolitan again and again throughout its years of institution building, and their donations helped to sustain colonial revival interpretations.

Yet the men who built the American Wing presented their venture both as a rational business enterprise and a nostalgic homage to simpler times. When the American Wing opened, Edward Robinson marveled that it represented "the finest piece of team-work the Museum has yet seen." Elihu Root mused that de Forest, Halsey, Kent, and Atterbury so embodied the ideals of the colonial era that they had "formed an old-fashioned American community."[69] However, the final hectic stages of construction, the difficulties coordinating various contractors, and the crossed wires between the collectors who volunteered their expertise and the museum professionals

who oversaw installation belie such simplified characterizations. Hardly a colonial enterprise from olden times, the American Wing required the careful management of bureaucratic logistics and personal diplomacy. Building leaks, disagreements about finishing details, and questions about insurance delayed the wing's construction. But so too did conflicting work requirements of the various teams of laborers who built the wing. The private funding de Forest secured for the American Wing allowed the museum to circumvent city contractors and political interference, but the museum's cabinet makers, who pieced together the historic architectural fragments, felt the private contractors de Forest hired to erect the building threatened their work and their autonomy to make decisions.[70] The museum's curatorial staff likewise bristled at amateur collectors like Halsey who overstepped their authority.[71] Of course, no institution wants to air its dirty laundry, but the American Wing in particular needed to put forward an idealized façade because its interpretive messages relied on the very careful selection of evidence to construct its narrative of progress.

Grosvenor Atterbury promised that the tight architecture of his "crossword puzzle" would allow the works of art in the American Wing to "tell their own stories." Indeed, for the men who built the American Wing, the illusion of authenticity in their period rooms held paramount importance. The Met's period rooms, Atterbury explained, had been constructed behind the façade of the Assay Building and separated from the Metropolitan's main buildings to maintain a simulacrum of the past. Atterbury said the project would be successful if "we have managed to eliminate, or at least conceal, the institutional quality of the American Wing." He hoped the period rooms' "ghostly owners of Colonial times" would "flock back home like homing pigeons to their old nests." Atterbury certainly did not speak for everyone at the Metropolitan Museum, but his fantastic musings suggest the shortcomings of colonial revival interpretations of history. By using objects to tell stories, the Metropolitan created new meanings for American things that stepped away from the educational values that progressive connoisseurs like Robert de Forest and Henry Kent had promoted. Instead of serving as models for industrial manufacturers and civic taste, the American Wing's recreated rooms, filled with carefully selected furniture and decorative objects, provided a background for museum visitors to enact their own fantasies of the past. "Nothing could please me better," Atterbury said, "than if, when you go into the American Wing this morning, you were to run into John Alden kissing Priscilla on the top floor."[72]

Telling Public History

The American Wing set the stage for the way the public history of the United States would be told during the twentieth century. The Metropolitan Museum's period rooms influenced the way other art museums presented American decorative arts, and it introduced the practice of using material culture to tell social history. R. T. H. Halsey and his team of curators, architects, architectural historians and fellow collectors carefully reproduced historic details and followed the latest standards of professional accuracy. But the combination of art-historical preferences for showing craft masterpieces, and cultural insecurities of the 1920s that favored nostalgic fantasies like Atterbury's ghost stories, focused the story of American domesticity on lives of the elite, and simplified American history by presenting a conflict-free narrative of progress. When the American Wing opened in 1924, it raised the bar for art museums across the country, encouraging them to finish their own period rooms, and to furnish galleries with the best American things they could obtain. The high-style things and architectural details that filled art museums and historic houses became the primary evidence public historians used to tell American history.

Ultimately, Halsey's interpretation of the Art of Living in the American Wing was a colonial-revival interpretation. He used elite homes as models for his version of Americanization, focused on the lives of civic leaders. Halsey argued that the statesmen who had owned the houses that he stripped of their furnishings and architectural detailing, and then reconstructed in the American Wing, "would not have been willing to spend big money to build these beautiful houses unless they, their families and their friends had the education to appreciate them."[73] Because they had beautiful things, Halsey determined that they had "acquired the Art of Living."[74] Halsey's particular agenda for improving civic capacity represented traditional notions of elite stewards governing the many, but his simplification of social history most clearly aligned with the imperatives of the postwar colonial revival movement. By simplifying narratives and removing conflict, Halsey fit into a larger contemporary movement to create a singular definition of American identity and style that could likewise simplify diversity and complex social relations, and thus reduce conflict in the present.

Halsey flattened regional difference to present a unified Art of Living, combining New England merchant houses, Philadelphia townhouses, and Southern plantations, all removed from their context and fitted into a neat

building behind a neoclassical façade. Perhaps his own regional elasticity as a refined New Yorker with revolutionary New Jersey roots, who grew up in New Orleans with carpetbagger parents and later taught at schools in Annapolis, also made Halsey a model for the Art of Living. When Halsey linked the civic achievements of eighteenth-century Chesapeake planters to their elegant homes, he never mentioned that their Art of Living depended on slave labor. In fact, he sometimes presented examples of refined planter "culture" that relied specifically on slave participation. In a speech to members of the University Club in Annapolis, Halsey explained that the "intellectual life" of the region was "along cultural lines," and he supported this conclusion by listing Maryland planters' leisure activities such as staged boxing matches among slaves and water races with "gaily painted barges manned by uniformed crews of slaves."[75] Trivializing slave labor in his speeches and freezing the American Wing's narrative before the Civil War also let Halsey ignore regional conflict and at the same time facilitate reconciliation—also an important component of the colonial revival movement.[76] By flattening social relations and simplifying regional difference, Halsey presented "eighteenth century gentlemen [as] a well rounded lot of men."[77]

The American Wing's overlapping art-historical and social history narratives reinforced Halsey's model of the Art of Living. First, the American Wing presented American antiques as art objects in the art-historical tradition of connoisseurship. Halsey wrote the exhibition's accompanying *Handbook* with his assistant curator Charles Over Cornelius, and they insisted that the "history of arts of North America" dictated the exhibition's arrangement.[78] What they left out was the fact that Halsey and his collector friends had only recently written that history. Museum visitors descended from the earliest rooms on the third floor, with solid seventeenth-century oak joinery and paneling, down to elegant and refined late eighteenth-century mahogany craftsmanship, and finally finished on the American Wing's first floor, dedicated to early nineteenth-century neoclassicism. This art historical interpretation was necessary to justify American objects' place within an art museum, and the cultural legitimacy of the collectors who had worked so hard to get them there. At the same time, the American Wing presented a "visual personification of homelife in this country" as part of the museum's civic education program.[79] Coinciding with the opening, Halsey and his romantic partner Elizabeth Tower published *The Homes of Our Ancestors* to complement the art historical narrative in the Wing's *Handbook*. Halsey and Tower wrote their complementary social history to emphasize the lives of

great men who epitomized elite values of the Art of Living. The period rooms, they argued, represented "the homes of men—pastors, planters, mariners, merchants, and tradesmen—by whose efforts and sacrifices the Republic was made possible."[80]

The earliest rooms in the American Wing represented the spartan existence of frontier life and settlers' perseverance. Because preservationists like Appleton at SPNEA would not allow Halsey and Kent to get their hands on seventeenth-century houses, however, the museum reproduced three rooms. Nevertheless, Halsey justified their place in an art museum by assuring that "strict historical precedent has been followed for [their] treatment."[81] Museum visitors entered the third-floor galleries through a reproduction of a 1681 meeting house in Hingham, Massachusetts, which featured trusses designed like the interior of a ship's hull, and then walked through copies of the "best-known rooms" in Massachusetts: from the Hart house in Ipswich and the Parson Capen house in Topsfield.[82] Using the simple kitchen from the Parson Capen house, Halsey described the early settler as a "marvel to all people" because, he said, "there was hardly a man who had ever been called upon to supply shelter without ready materials, food by hunting or to protect himself and family from attack by animals or redmen."[83] Halsey's interpretation of the homes of early settlers reinforced his social history narrative of patriarchal home life, and it set the stage for progressive American civilization. However, the Parson Capen house was in fact built for Priscilla Allen by her wealthy father, after her marriage, because she was appalled by the "tumble-down cottage her poor parson wanted her to live in."[84] Nevertheless, Halsey described settler home life around the kitchen's huge fireplace, where, he argued, patriarchal authority ensured domestic harmony: the "good housewife performed her innumerable tasks of cooking, baking, soap-making and candle-molding," he began. "It was here that the children learned to knit, sew and told their ghost stories; and here that men discussed witchcraft, taxes and government."[85]

As museum visitors progressed through the period room galleries, the interpretation of colonial American life also progressed toward greater civilization. Halsey explained, "as the struggle for existence became less intense, the colonists, with their greater leisure and assurance of success in the New World, began to settle down permanently and were able to devote more time and care to making the interiors of their homes attractive."[86] The detailed 1750 room from Newington, Connecticut that George Palmer originally loaned the museum for the Hudson-Fulton exhibit, and later sold to the Met in 1918, was presented as a "typical provincial Connecticut interior." The original early

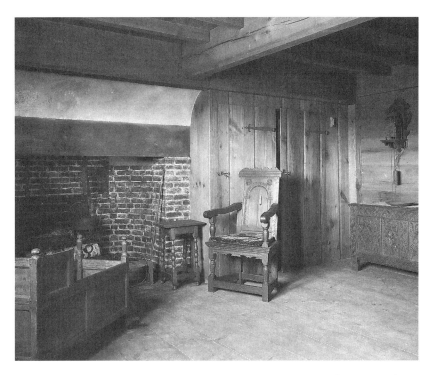

Figure 25. Because the Met could not persuade property owners to sell seventeenth-century interiors from old New England houses, the American Wing team carefully copied architectural details of the Hart house in Ipswich, Massachusetts, and the Parson Capen house (pictured here) in Topsfield, Massachusetts, and reproduced them for the American Wing. In 1937, the owner of the Hart house agreed to sell interior elements to the Met, so these reproductions were retired from display and replaced with the newly acquired original architectural relics. Parson Capen Kitchen, American Wing, Metropolitan Museum of Art, 1924. The Metropolitan Museum of Art. Image © The Metropolitan Museum of Art.

eighteenth-century room had been upgraded around 1750 with new panel-ing, probably modeled on Boston fashion, and thus represented the home of socially conscious homeowners who paid a great deal of money to ape cos-mopolitan fashions.[87] As in the case of most rooms in the American Wing, this room was hardly typical of provincial interiors, or even urban ones. In fact, George Palmer included it in his collection, which was recognized as the finest collection of high-style eighteenth-century masterpieces, precisely because it represented such elegant workmanship.

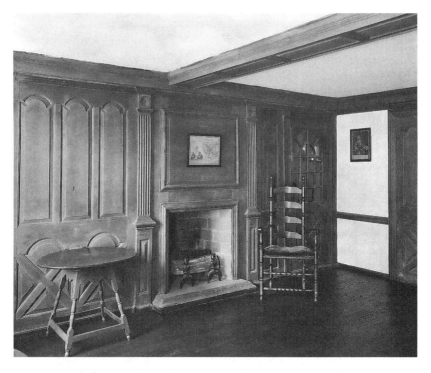

Figure 26. Part of the paneling in this room had first been presented at the
Metropolitan during the 1909 Hudson-Fulton Exhibition. Room from Newington,
Connecticut, American Wing, Metropolitan Museum of Art, 1924. The Metropolitan
Museum of Art. Image © The Metropolitan Museum of Art.

Within these increasingly civilized eighteenth-century households, Halsey
presented his ideal domestic interpretation. "Colonial women were never
idle," he assured. "When the daily tasks were done," Halsey said, "they em-
ployed themselves in beautifying their homes."[88] In a fractured construction,
Halsey painted a picture of republican motherhood in which women could
contribute to the civic character of their homes by beautifying them. Though
he took pains to limit women's domestic authority in colonial homes, he nev-
ertheless reinterpreted colonial life to incorporate early twentieth-century
consumer capitalism. Halsey explained that colonial women, "made needle-
work covers for the chairs," but he would have been happy if modern women
purchased good needlework covers from department stores.[89]

Typical of the colonial revival's creative application of history, Halsey used
preindustrial households to present his ideal version of gender relations, but

he applied industrial concepts like separate spheres that articulated nine-teenth-century restrictions on women. "While boys were sent to an Ameri-can college," for example, "to complete their education," girls, he explained, "were taught mostly at home by American or foreign tutors."[90] Further ignor-ing the regional and class differences that affected choices for both men and women in the eighteenth and early nineteenth centuries, Halsey continued, "They [girls] married at an early age and never dreamt of higher education."[91] Perhaps this simplified interpretation of domestic colonial life appealed to anxious patriarchs in the 1920s, who were uncomfortable with the recent po-litical and economic opportunities of the New Woman.

By flattening history, the American Wing presented similarly simplified interpretations of social interaction and class structure. The 1768 Samuel Powel house from Philadelphia provided Halsey the opportunity to distin-guish colonial society from the complex structures of industrial cities in the early twentieth century. The Powel house had been among the most elegant homes in late eighteenth-century Philadelphia, and—an important part of the pedigree of any historic house—it boasted George Washington as one of its many distinguished historical guests. However, by the early twentieth century the once elegant Georgian-style townhouse was in serious disre-pair, and it occupied a block in an increasingly undesirable neighborhood in Philadelphia's old central city. Therefore, the Metropolitan Museum had no trouble acquiring its upstairs back parlor in 1917.[92] Halsey decorated the Powel House with elaborate painted Chinese wallpaper that was from the period, but not from the house; nor is there any evidence that the house ever had papered walls. The wallpaper, and the room's decorative plaster ceiling, "borrowed" from another room in the original building, reflect the colonial revival embellishments that curators like Halsey made to present a specific version of colonial life in the American Wing's period rooms.[93]

Halsey used this fabricated room to present a likewise fabricated his-tory of social interaction in *The Homes of Our Ancestors*. "The inhabitants of Philadelphia," he wrote, "were divided into three distinct classes—the 'worldly folk,' one of whom owned the room illustrated; the common people, among whom we find the famous cabinetmakers; and the Quakers, founders of the city, whose quaint habits and religious customs are very well known."[94] Distinguishing Quakers, definitely members of Philadelphia's colonial elite, from the "worldly sort" and reducing their religious practices to quaint hab-its, maintained the American Wing's emphasis on Calvinist values, and fa-vored New England's civic traditions over others. But ignoring Philadelphia's

Figure 27. Samuel Powel House, American Wing, Metropolitan Museum of Art, photographed 1950. The Metropolitan Museum of Art. Image © The Metropolitan Museum of Art.

laboring classes more profoundly simplified the narrative interpretation of American life that the Wing promoted.

The famous cabinetmakers Halsey identified as the "common people" represented the foundation upon which he and other reformers built the American Wing. The narrative of artistic development required collectors to identify and attribute skilled master craftsmen who could produce masterpieces worthy of museum placement. Unlike the colonial laboring poor, these craftsmen operated within an artisanal system that organized both their production and their social and political lives. Apprenticeship served not only to teach skills of a trade, but as a phase in the education of young men. Mastery of a craft in the eighteenth century also ensured citizenship in a society that restricted franchise by property. Thus, limiting his definition of the "common people" to cabinetmakers had political implications for Halsey and the civic

education goals of the Metropolitan Museum. The American Wing simultaneously erased the laboring poor—and class-based social conflict—from the story and highlighted craftsmen as models of civic taste and character because they produced the goods that allowed the elite to enjoy the Art of Living.

The masculine world of the artisanal craft tradition represented, therefore, both an artistic and a civic ideal that the American Wing promoted. This is where Halsey's two narratives came together. On the one hand, the American Wing certainly represented a world lost to industrialization. The American Wing froze its interpretation at 1830, when machine production started to dismantle craft traditions, and critics began lamenting the decline of American design and taste. By stopping its interpretation at 1830, the museum also ended its story of American home life before the concomitant industrial transformations of urbanization, immigration and the introduction of capitalist class structures. The feminized domestic interior of the nineteenth century, therefore, also dropped out of the interpretation. However, viewing the American Wing only as an example of nostalgia for a culturally homogenous, patriarchal past ignores the pragmatic role that connoisseurship played in de Forest, Halsey and Kent's social agenda for the American Wing.

Progressive connoisseurs developed and used their knowledge about American decorative art to present a narrative of the artistic progress of colonial craftsmen, and they argued that refined taste could reinvigorate Americans' abilities to order their homes and their social landscape. Halsey wrote, "The old American arts and crafts, in their simple elegance, are in rich harmony with the mental attitude of our people."[95] He continued, "There was an appreciation of beauty here, which was not confined to our craftsmen." Rather than restricting aesthetic appreciation and refinement of taste to elite audiences, as Halsey would have preferred, de Forest and Kent believed that everyone could attain these skills, and thus shape their own environments. By emulating the ordered simplicity of early American homes, they believed, Americans in the twentieth century could clear away the clutter of late nineteenth-century indulgence and promote ordered home life, just as contemporary home economists hoped to remove the "dust dangers" of Victorian drawing rooms and promote healthy families, and tenement reformers hoped to build model housing and promote better cities.

Decorative arts in period room settings were popular among museum visitors, precisely because they did not require previous art historical education. "Art in craftsmanship," even Halsey recognized, was "in reality much

more important in the cultivation of the love for the beautiful among our people than the great gallery paintings and pieces of statuary."[96] Further, by concentrating on the artistic achievements of individual producers, and the dignity and honesty of labor, the museum demonstrated that ordinary people could do extraordinary things. Halsey told an audience of college students, "Our early craftsmen were a splendid lot of men [and] some of them filled important civic positions."[97] To illustrate his point, he asked, "Can any foreign piece of silver have greater human interest to an American than that possessed by a piece of silver hammered by that picturesque American rider, Paul Revere?"[98] As social and aesthetic reformers, de Forest, Kent and even Halsey equated the civic virtues of Paul Revere with ordinary working-class New Yorkers in the 1920s, to demonstrate the civic capacity of all (American) citizens to create beauty and to shape their own environment.

The American Wing had a profound influence on the way the history of the United States was told during the twentieth century. Art museums throughout the nation adopted the period room idea and built their own American wings, which presented high-end decorative arts in domestic environments. The Museum of Fine Arts in Boston and the Pennsylvania Museum in Philadelphia opened period room galleries in 1928, followed by the Brooklyn Museum in 1929, and museums in Baltimore and St. Louis in 1930. Historic house museums and recreated historic villages like Colonial Williamsburg similarly interpreted elite American home life in idealized settings. The networks of collectors and museum professionals on whom Halsey and Kent relied all collaborated on period room projects, and many later moved on to interpret museum collections throughout the nation. After building the American Wing, Halsey taught courses in colonial art and culture at St. John's college in Annapolis (and later at Yale), where he focused on teaching young men the Art of Living. Rather than concentrating on a particular regional definition of American homes, Halsey liberally cited a variety of elite homes to link cultivated taste to character development. Borrowing perhaps more from John Ruskin than John Dewey, Halsey used the founding fathers' grand homes in Annapolis (as well as Mount Vernon and elite houses in New England and Philadelphia) to teach his students that the extravagance of great houses proved that educated taste built civic character. Whereas de Forest spoke about the poorest child in the city, and about educating future citizens through museum pieces and installations (as well as through American Federation of Arts programs, City Beautiful, and tenement reform), Halsey focused on the Art of Living and the cultivated taste of elite men.

Whatever the American Wing's ultimate influence on public history, Henry Watson Kent and Robert de Forest built the American Wing primarily to influence public taste and the industrial production of American things. To promote the American Wing and make its galleries work for designers, Kent insisted that Halsey provide a handbook that would describe its furniture and architectural details, emphasizing their artistic innovations.[99] Kent's protégé Richard Bach blanketed trade journals and newspapers with press releases and promotional literature to insure publicity for the American Wing. "Many of us have written and preached about art in America, both past and present," Bach wrote in an early press release, "but few have seen that our progress in art as a nation depends upon the gradual formulation of a style of our own." "The Wing of American Art," he promised, "will state the case as to our history."[100] The Metropolitan Museum's progressive connoisseurs saw the American Wing as a necessary vehicle for their program to promote Americanism in Design. The old American things in the museum's new period rooms served as models of well designed industrial art for manufacturers and consumers alike.

American things in art museum galleries also served de Forest and Kent's educational goals of democratic outreach, because they served as tasteful examples of the everyday things people surround themselves with, and because they proved to be so popular with the public. The popular appeal of decorative arts had very much to do with the fact that they were, in fact, everyday things rather than fine art. Museum visitors who did not have art-historical training, and who might feel uncomfortable in fine art galleries that they perhaps did not understand, could relate more personally to chairs and tables and tureens. One need only spend time hanging around decorative art galleries like those in the American Wing to see that visitors still interact with those objects differently than they do with the pieces in fine art galleries. In many ways, and for many museum visitors, galleries of decorative arts seem less like traditional art galleries and more like antique shops or other consumer sites. One is far more likely to hear someone say they would love to have this highboy or that gate-leg table in their home than that Turner landscape over their mantle. Tapping into the museum public's acquisitiveness ultimately served de Forest and Kent's education agenda because they hoped their galleries would encourage the public to model their own homes on the tasteful things the Metropolitan presented.

Progressive connoisseurs saw the American Wing as a constituent part of their museum agenda to promote cultural democracy. Period room arrangements were among the museum modernisms Kent discovered on his

first European study trip in 1893, and he was impressed by their ability to contextualize art objects within their larger cultural milieu. Museums of all types modernized their display techniques in the early twentieth century to make their interpretations more accessible and educationally effective. Period room arrangements coincided with the dioramas of natural habitats and ethnographic pastiches that were being installed in the 1920s in natural history museums. Like the dioramas installed across New York's Central Park at the American Museum of Natural History, the American Wing's period rooms also focused on family settings and emphasized domestic home life.[101] At the Metropolitan, period rooms helped democratize accessibility and they promoted de Forest's focus on improving American taste and home life.

CHAPTER SIX

―――――

Americanism in Design

Industrial Arts and Museums

In 1925 the *New Yorker* called Richard Bach "the man who 'sold' Art to the United States without the United States ever knowing it." Since teaming up with Henry Watson Kent at the Metropolitan Museum in 1918, Bach had expanded the museum's educational outreach by building an extensive network of industrial manufacturers and retailers. The Metropolitan Museum's annual design exhibitions brought manufacturers into the museum because Bach sold them on the cash value of design. "The businessman has not gone cuckoo," assured the *New Yorker*, "he has merely been convinced by trials, graphs and charts that an article will sell better if it looks better." Portrayed as a hero, a trickster, a proselytizer, and a suave salesman, Bach had spread his gospel of design and convinced producers of decorative objects that museum study—and placement of their things in Metropolitan galleries—made good business sense. "To-day," marveled the *New Yorker*, "he has a thousand satisfied customers, covering all the important manufacturing fields from talcum powder cans, on through neckties and collars to wallpapers and soap."[1] Unlike the nineteenth-century founders of art museums who had been leery of opening museums up to a broad public, Richard Bach expanded the Metropolitan's audience and made its galleries a destination for the furnishing industries. "His bureau," applauded the *New Yorker*, "reaches millions of tradesmen through the trade papers." "The out of town buyer making his yearly trip," remarked the magazine with only a hint of elitism, "finds a visit to the Museum as necessary as his visit to the girl shows." While perhaps not exactly in line with Robert de Forest's ideals of cultural democracy, Bach's program of industrial outreach impressed the magazine because it moved

the art museum beyond what Kent had called the old-fashioned conception of museums as high-brow places of spiritual uplift. "A great man is this Mr. Bach," proclaimed the *New Yorker*, "influencing more lives than he, or anyone else knows about."[2]

By forging a partnership with industry, Kent and Bach tried to improve the design quality of American things. Like all of Robert de Forest's reform programs, the Metropolitan's industrial arts reform in the 1920s focused on collaboration with multiple institutions to efficiently reach the largest possible audience. Rather than commit funds to a single industrial art school as the Metropolitan had in the nineteenth century, the museum instead worked with manufacturers and trade groups to disseminate museum resources. Kent worked with schools to train teachers to use Met collections and bring their classes to museum galleries in order to teach taste and appreciation of beauty to future citizens. To improve American consumer products, Bach focused both on production, through outreach to manufacturers, and on availability, through outreach to retailers. At the same time, de Forest used the American Federation of Arts to further disseminate information through traveling exhibits. Asking manufacturers to team up with the museum and commit their own resources to the partnership corresponded with de Forest's commitment in his other social-reform work to providing resources to help individuals help themselves. The Metropolitan used its dominant cultural position to influence the production of American manufactures, and to encourage other museums to sponsor their own exhibitions for industrial outreach. Instead of reaching a few dozen craftsmen in New York City through an art school, the Met used its modernized institutional machinery to reach a much larger audience that could potentially contribute to what Bach and Kent called "Americanism in Design."

Richard Bach's outreach to industrial manufacturers raised a number of old questions about the cultural function of museums. Should they be places of public service, or should they reify cultural capital by encouraging the cultivation of taste and the pursuit of traditions of connoisseurship? Bach's annual design exhibitions challenged both the cultural hierarchy of museum objects and the jurisdiction of professional art historians and their authority over the museum's production of knowledge. Curatorial staff under the direction of Edward Robinson always met Bach's design exhibits with cautious hesitation. Since Robinson had overseen the professionalization of the Met's curatorial departments, the curator's job had been standardized, using historical scholarship to choose objects for museum display. It was the curator's

expertise that determined what objects had stood the test of time. Authenticity and the singularity of masterpieces influenced decisions about what to collect and present to the public. But Bach and Kent showed objects that had come right out of the factory. In fact, the criteria for their design exhibits explicitly overturned central tenets of the curatorial profession, by specifically requiring objects to be made in multiples. Kent and Bach insisted on mass production because they wanted to insure that good design could be made available to the man in the street; but Robinson, other curators, and taste and design critics frequently questioned the quality of modern American industrial production on display in the Met's annual design exhibits.

The 1925 international exposition of decorative arts in Paris made it clear to everyone that American design—despite urgent calls since the war and aggressive promotion at prominent museums like the Met—still lagged behind European design. The Paris exhibition popularized the style known as art deco, and it pushed department stores and consumers toward acceptance of modernized aesthetics. Anticipating the gulf separating American and European aesthetics, American firms pulled out of the exposition; Bach went to Paris instead as part of a delegation sent by the U.S. government to assess international production. The Met's decorative art curator Joseph Breck, however, went to buy objects for the museum. Once high-end French objects designed in the new style went on exhibit in Metropolitan Museum galleries, Bach was forced to reevaluate his program of industrial relations, and the annual exhibitions of colonial-style things that manufacturers had copied from Met collections.

The prerogatives of manufacturers and their demands to control labor and silence their designers had ultimately shackled Bach's outreach program to the will of industry. By directing his attention toward manufacturing firms and committing the Metropolitan's resources to their service, Bach shifted attention away from meeting the needs of craftsmen and designers. Art schools like the Deutcher Werkbund and the Bauhaus focused on training artisans, whereas Bach focused on working with industrial producers, many of whom aggressively restricted the ability of their employees to maneuver and market their skills. The objects that Breck was buying for the museum, on the other hand, had all been produced by artisans, and all came into the Metropolitan with attributions to the artists who made them. By responding to the desires of manufacturers and tapping into the cultural environment of the 1920s, Bach inadvertently took the Metropolitan's progressive agenda to improve American things in a curious direction, which turned away not only from

the traditions of connoisseurship and attribution of artists, but also from the progressive goals of improving the interests of individual producers and respecting the rights of labor. When the *New Yorker* applauded Bach's efforts at democratizing use of the Metropolitan Museum yet questioned his tactics of salesmanship, it must have concerned the progressive connoisseurs who had spent more than a quarter of a century trying to reform the relationship between art, labor and democracy in American art museums.

Nevertheless, the Metropolitan Museum made its most significant contribution to American design and the promotion of American things in the last half of the 1920s. Confronted by the quality and design of decorative arts in the Paris exhibition, and legitimately committed to cultural democracy, Bach shifted direction. To make good design available to a wide public of consumers, he brought in prominent designers and architects to work with firms that produced decorative furnishings. Rather than stage his customary annual exhibit, in 1929 Bach and his team of designers and manufacturers worked to present a grand exhibition of high-style yet machine-made objects in a series of functional room settings. While they planned their exhibition, Bach coordinated with department stores and the American Federation of Arts to make examples of good design (whether American or not) available to as broad an audience of potential consumers as possible. The Metropolitan Museum's 1929 exhibition, The Architect and the Industrial Arts, popularized modernized geometric American design, and it legitimated the role of art museums as places for the exhibition and promotion of modern design.

Museum Cooperation and Industrial Relations

"Miss Modernity," announced the *Evening Telegraph* with a wink in 1921, "walks forth to take the air in a costume whose smartness proclaims itself to be the style of the day after tomorrow." Thanks to Richard Bach's aggressive publicity campaigns, newspapers and magazines as diverse as the *Evening Telegraph*, the *New York Times* and *McCall's Magazine*, and trade journals from *Good Furniture* to *Carpet and Rug News* and *Industrial Arts Magazine*, ran stories through the 1920s celebrating the links between new design and historic models in art museums, while they simultaneously promoted the Metropolitan Museum's industrial design exhibits. "She does not know," continued the *Telegraph* with a knowing nod, "that although her gown may not be 'old-fashioned,' it is redolent of antiquity, and authentic antiquity such as vouched for by no less an authority than the Metropolitan Museum." The

secrets to Bach's success that the *New Yorker* let its readers in on were really part of the larger campaign to make the Metropolitan useful, and to disseminate de Forest and Kent's agenda by getting the message out that the Met offered services to a broad constituency, to meet a wide range of public needs. "She does not know," continued the article-cum-press-release, "that those who designed that lovely border on her dress or the material of which her hat is fashioned spent hours of careful copying and adapting of ancient Persian or Egyptian or perhaps Chinese motives as found on articles thousands of years old and now in the museum." "She does not know that when she steps out with her best young man, he may be wearing a tie whose design was copied line for line from tracery on ancient armor." "She does not know that in his home and hers, and in the one they may some day have together, the furniture and hangings and china and wall paper and lamps and other accessories may be copies of antiquities in the museum's galleries or adaptations from them." "To state it briefly," concluded the *Telegraph,* parroting almost word-for-word Henry Kent's mantra of museum usefulness, "she is not aware that the Metropolitan Museum of Art has gone to work."[3]

The Metropolitan Museum's annual industrial art exhibitions encouraged manufacturers to cooperate with museum educators by offering them the chance to show their products in the museum's galleries. Like art and antiques dealers, manufacturers knew that museum placement, especially Metropolitan Museum placement, increased the value of objects. The museum's presence in the Americana market during the war had sharply raised prices for old things and old houses, and encouraged the popularity of colonial reproductions. Gallery placement in a Met exhibition provided further pecuniary inducement for many manufacturers to work with the museum, as firms bargained that a museum pedigree would inflate the market value of their wares. Kent and Bach set terms for their exhibits to persuade the furnishing and decorative industries to experiment with new design motifs, and to craft a new modern American aesthetic. For them, old American things represented an American tradition of aesthetic excellence, which they hoped would inspire designers to create good modern design that could meet the needs of the modern century. At the core of all their efforts at industrial outreach lay a commitment to making good design available to a broad democratic public of consumers, and therefore they made machine production the central requirement for all of their design exhibitions.

Unfortunately, the museum's pragmatic decisions to align its outreach with the needs of manufacturers rather than designers, and overlapping messages

from various departments within the Metropolitan Museum, hampered Kent and Bach from successfully breaking out of imitative colonial revival styles in most of their design exhibitions. Americana collecting among art museums in the 1920s, to build period rooms, and the popularity among consumers for objects that looked like old American things, encouraged most American manufacturing firms simply to produce new products without significant investment in design innovation. The Metropolitan's galleries provided excellent resources for manufacturers to measure objects and copy ornamentation for colonial revival reproductions. Moreover, Bach's complicity with manufacturers in removing the names of designers from object labels and exhibition catalogues further prevented the Metropolitan's design exhibits from celebrating and promoting creativity and individual artistic excellence. Instead, during the first half of the 1920s, the exhibits served primarily as salesrooms, promoting what increasingly seemed like tired copies of the historic objects in adjoining museum galleries. Ultimately, the history of Bach's department of industrial relations during the early nineteen twenties was a history of institutional reassessment and professional agility. Bach and Kent scrambled to stay one step ahead of manufacturing firms and taste and design critics, both within and outside the museum.

Bach pitched the cash value of design to manufacturing firms because his job entailed coordinating *industrial relations*, as opposed to running an art and design school. When Bach started working with Kent to improve the production of American things, he identified the primary goal to be training craftsmen and industrial designers. While he privately advocated industrial art schools as one solution, Bach thought the Metropolitan's strongest contribution to better design rested in aggressive outreach to industrial manufacturers.[4] To accomplish museum outreach, Bach encouraged trade journals to reproduce photographs of museum objects for emulation and inspiration, and he contacted individual manufactures in various industries to facilitate cooperation. Since the end of the war, Kent and Bach had succeeded in democratizing the art museum by making its galleries work for a broad public. But the *New Yorker* suggested that Bach's democratization of art could only be accomplished through the tricks of the salesman. By embracing commercial interests and encouraging businessmen to use the museum, however, Bach took a pragmatic step toward making the museum useful. Ever since Edward Robinson had declined to sponsor a German industrial design exhibit in 1912, John Cotton Dana had mocked the Metropolitan Museum for neglect-

ing the needs of industry—Dana suggested the museum feared the "taint of commercialism." Mounting annual design exhibitions countered those fears by illustrating the museum's commitment to democratizing its use and its collections.

In 1917, Kent coordinated the Metropolitan's first industrial arts exhibition.[5] Like the Hudson-Fulton Exhibition, it was both a public (and trustee) experiment and an invitation to participants (this time manufacturers) to loan their things to the museum. Kent invited manufacturers who had studied the Met's collections in the previous year to submit examples of good design. "The Designer and the Museum" opened in one of the museum's basement classrooms where designers and artists studied museum objects. The *Bulletin* explained that exhibitions of the products of such study made their placement in the classroom appropriate. But "exhibition" in a basement classroom, rather than a museum gallery, left no question about the relative cultural value these objects held in the museum's hierarchy.[6] The objects Kent gathered for the exhibition represented copies of museum pieces. Several firms had copied objects in J. P. Morgan's Hoentschel collection of French decorative arts. Trustee William Sloane Coffin's company, W. & J. Sloane, copied both French and English museum pieces, and Tiffany copied silver from the Clearwater collection of American silver, as well as sending reproductions of its own art pieces, which de Forest had recently begun to deposit in the museum from his personal collection.[7] The *Bulletin* explained that the exhibition fulfilled "the ideal of [the museum's] founders."[8] However, it clearly did not meet the ideals of many of the people Kent had hoped to impress.

John Cotton Dana's office at the Newark Museum issued a rather tepid critique of Kent's first exhibit, and suggested that the Metropolitan could push its democratic agenda further by opening the museum's industrial exhibits beyond the display of luxury goods. "I don't wonder Mr. Kent thought it a good exhibit," declared one of Dana's assistants. "It is." Dana's office acknowledged that the exhibit was both interesting and beautiful. "It is however almost entirely an exhibit of articles de luxe." To make good design available to more democratic audiences, the Newark Museum suggested reaching out to producers of ordinary things for ordinary people. The exhibit could have been more educational, Dana's staff believed, if the modern designs on exhibit had been shown with the museum objects that inspired them. But Dana's staff also questioned the utility of presenting the exhibition in the museum itself. "It ought to be exhibited down town where shoppers (ordinary shoppers) would see it. Then the ordinary shoppers might begin to want such things.

Then the manufacturer would begin to make them." Dana sent copies of his internal report to Kent, to further push his friend toward what he considered useful museum education. While the Metropolitan had made great strides in shifting its galleries in the direction Dana had long advocated, he apparently thought Kent still had lessons to learn from Newark. Kent surely must have bristled when reading the last lines of Dana's missive. Dana insisted that if Kent took his advice, "then the Metropolitan would really have something to do (perhaps)."[9]

Whatever his reaction to Dana, Kent hired Richard Bach after the first Designer and the Museum exhibit in order to reach out more forcefully to decorative industries, and strengthen the museum's program of industrial relations. Clearly, he also wanted to silence many of the Metropolitan Museum's critics. To secure funding within the museum for a new department, Kent used the rhetoric of wartime opportunities to make American products more competitive with European production, like the industrial art propaganda the American Federation of Arts had disseminated. Bach shared Kent's interests in aligning art and industry, and he brought to the Metropolitan experience as a respected architectural and design critic, as well as familiarity with trade journals and industry. Kent and Bach also shared a common identity as dedicated public servants, and a commitment to conscientious professionalism. In many ways, Bach became Kent's professional and intellectual protégé at the Metropolitan Museum. Kent counseled Bach, he provided him letters of introduction to museums and art historians throughout the nation and in Europe, and he secured funding for research projects to advance their common agenda.

Like Kent, Bach wanted to make the museum a laboratory that designers and manufacturers could use to improve modern design. He also wanted to encourage design innovation, so he made the entry requirements for his design competitions flexible. To avoid direct copies, Bach encouraged designers to use museum objects for "inspiration." The complaints of taste and design critics had always, after all, focused on misuse of ornament, and lack of harmony of line, color and proportion. To help designers properly use museum objects for inspiration, Bach hired a field worker to guide those who used the museum's classrooms. Bach also stepped up museum outreach to industry through strategic public relations. The *New York Times* reported that in five months, Bach dramatically increased manufacturers' use of museum resources.[10]

The first industrial art exhibition Bach organized opened at the Met in 1919. This exhibit was not relegated to a basement classroom—Kent and

Bach managed to get two large museum galleries on the second floor of the Metropolitan. Bach used the exhibition in legitimate museum galleries as an opportunity to illustrate the Metropolitan's service to industry, and to the museum's public. He proclaimed that the exhibited pieces proved that "design sells," because the furnishing trades alone represented expenditures of over $500,000,000.[11] "Manufacturers have found it to their advantage to use the Museum," he reported, "and this means they have found it to their business advantage."[12] The Met pitched the usefulness of the museum to future manufacturers and businessmen, claiming that manufacturers had finally realized that "taste is an asset in trade as it is in life." Using empirical evidence such as the number of local and national industries impacted by American design standards, and recording the dollars spent by consumers for industrial decorative goods, Bach justified expanded outreach by emphasizing the pragmatic benefits of putting museum galleries to work.

Bach also explained how the museum was working to encourage new aesthetic designs. The majority of the pieces on display, he announced, no longer represented copies or reproductions. Rather, Bach encouraged designers and manufacturers to use museum objects for inspiration, "wherever it may be found," and he explained, "differences of material, style, artist, period, race or purpose are not considered barriers." As example, he described "a designer of dress fabrics [who] saw possibilities in the armor collection," and "a paper soap wrapper design [that] saw its beginnings in snuff boxes."[13] Aside from museum inspiration, Bach also required that all design entries should also be "destined for the open market."[14] By focusing on everyday objects for the "man in the street," as taste critics since Charles Eastlake had encouraged, Bach brought the Metropolitan Museum one step closer to improving American taste through better American things.

The *New York Times* commended the museum for the exhibition's "dignity, beauty and comprehensiveness," and for providing a "valuable laboratory to which the everyday people come and work out their plans."[15] "It is this kind of systematic use of local materials by native designers and manufacturers," the Metropolitan announced after Bach's 1919 exhibit opened, "that will give the country a place among other countries as a producer of goods with artistic merit."[16] In truth, however, the "inspired" designs in Bach's 1919 industrial arts exhibition were hardly inspiring, or even innovative. Most designs simply borrowed decorative motifs from one object and applied them to another. For example, a rug manufacturer reproduced floral motifs from millefleurs tapestries into rug designs, and a furniture manufacturer borrowed colors

from Chinese ceramics to paint a chair.[17] While attempting to break new aesthetic ground, the museum was simply a resource library, rather than an industrial art or craft academy. Bach's field workers tried to assist designers who used the Metropolitan's study rooms, but they had been no more trained to conceptualize innovative designs than the craftsmen they guided. These clumsy first steps toward innovation proved sufficiently confusing for some museum visitors to warrant an explanation from Bach.

"Inspiration" as the criteria for exhibition eluded designers and visitors alike. In 1920, just prior to opening the museum's next industrial art exhibit, Bach felt obliged to explain to museum members that designers *loosely* interpreted objects "based on Museum study" so that "designers would not be hampered by the feeling that in order to be of good design the object they produced must be a copy of a Museum piece." The Metropolitan, Bach continued, was trying to "fully demonstrat[e] that the collections are presently useful in a thorough and (though the word may be anathema to some ears) commercial way." To help, Bach promised that the exhibition opening the following month would also include the museum objects that were used for inspiration, alongside the modern designs.[18] Finally, Bach made clear that "the art Museum has set out to prove a thesis: that an art museum is an educational institution of immediate and practical utility in the development of current manufactures in the industrial arts, and that the Metropolitan Museum has had signal success in offering the kind of assistance which these producers could most directly use."[19]

Just as the issue of copies had challenged notions of connoisseurship since the introduction of plaster casts, the traditional emphasis on authorship in an art museum raised specific questions about the identity of the craftsmen who designed the objects that had now made it into legitimate upstairs museum galleries. Whereas objects in the museum's fine and decorative art galleries were identified by the artists and craftsmen who had produced them, the attribution labels and exhibition catalogues for Bach's design exhibits provided only manufacturer names. Historians have wondered why Bach's catalogues for these exhibitions did not identify individual designers alongside manufacturers' names until 1929.[20] In part, the answer has to do with the structure de Forest established for Bach's division of industrial relations. Rather than opening a school and teaching individual craftsmen, the Metropolitan had decided to improve industrial art through institutional collaboration. Part of the museum's partnership with industry entailed acquiescing to manufacturers' demands to protect their business interests, and restrict proprietary

information about their creative assets. In short, manufacturers insisted upon keeping their designers anonymous to control their labor.

"American manufacturers," Bach reported, "fear to give due recognition for creative work to their designers because they fear that, by doing so, they would be encouraging an element in their business organization over which they cannot exercise control."[21] Immediately after the war, the United States had experienced massive labor strikes, as well as urban riots. Labor disruption, Bach wrote, "affect[ed] the industrial arts in a direct way, especially because they all require the highest kind of skilled hands."[22] In 1920 Bach explained, "the exhibition this year holds a mirror to unsettled social conditions resulting directly from the war and the turmoil of reconstruction which is the aftermath of war."[23] Bach specifically identified "the problem of social unrest, finding its outlet in the complex of labor difficulties with which we are all familiar."[24] In the 1920 *Bulletin*, Bach reported that decorative art industries had experienced several recent strikes, including metal working, jewelry, and furniture trades, which significantly reduced production. Precisely because the manufacturers who contributed to the Metropolitan exhibits required skilled craftsmen, Bach revealed, "American manufacturers scoff at the suggestion that the name of an artist [should be] affixed to their product." "The practice," he observed, "would be folly." Bach paraphrased manufacturers: "Our position in the American market is insecure and our hold on the designer precarious."[25] Manufacturers argued that if they released designers' identities to the public, competitors would "take away our designer."[26] "In this policy of suppressing talent in the industries American manufacturers seem to be of a single mind," Bach concluded. It "seems constructed purposely to keep the designer in a position where his activities can be subordinated to the commercial prestige of the concern for which he works."[27]

Ironically, the Metropolitan Museum's most successful program to align art and industry and promote its progressive agenda for cultural democracy had redefined the relationship between art and labor, moving away from extending the benefits of art education to industrial producers. Both Bach and Kent wanted to "make the galleries work" to improve industrial design, but by emphasizing the economic bottom line to manufacturers the museum moved into a new phase. When Kent escorted nineteenth-century dignitaries around the Slater Museum's galleries in the 1890s, he always deflected their inquiries about monetary value by explaining the educational value of objects in the museum. Bach probably pitched the cash value of design to manufacturers because he thought it would present his easiest argument to get them

in to the museum, but his goal and the goals of Kent and de Forest were educational; they valued good design for a number of reasons, which they could all articulate. Bach required objects in the exhibit to be planned for the "open market" because he wanted to make good design available to everyone. But by selling the economic value of taste, he inadvertently contributed to economic calculations that devalued the skilled labor that produced tasteful objects of good design. Ultimately, the museum's decision to capitulate to manufacturers' demands and erase designers' identities from exhibitions contributed to consumers' calculations that high quality and low cost justify labor exploitation. The potential for inclusive definitions of Americanism in Design—definitions that would include immigrants and their contributions as workmen—started to fade into the distance. The "man on the street" would now have to participate in consumer democracy if he wanted to be part of what Bach once optimistically called the "new craftsmanship that would influence the cultural heritage of the United States."[28]

By 1922, "Americanism in Design" at the Metropolitan ultimately meant consumer-driven design, without a focus on either the mind or hand of the craftsman. This was indeed a long journey from William Morris and his emphasis on the integrity and dignity of individual craftsmen and their labor. Despite Kent and Bach's aspirations to encourage a new aesthetic craftsmanship, most of the objects in the Metropolitan's industrial design exhibitions still reproduced period pieces in the galleries, or applied decorative motifs from one medium to another. In fact, most of them resembled colonial revival copies, which Bach sometimes called Kickapoo Colonial, but which were in part inspired by the American Wing. If consumer demand did dictate the quality of design, something had gone terribly wrong with the museum's taste education program. Bach revealed his frustration when he admitted that objects in the 1922 exhibition illustrated "the primary truth that Museum resources do not offer a panacea for the incompetent designer or an easy sale-getter for the commercially minded manufacturer or tradesman." He regretted that the exhibition represented neither "the sum total of the years' work, nor necessarily the best that the year has produced."[29]

By focusing on consumers and mass production, Bach had dropped designers and craftsmen from the Metropolitan's industrial design program. In itself, this was an odd direction for an art museum to take. Bach calculated that rising consumer taste would pressure manufacturers to give more attention to design development in their production, but the "market force" of

Figure 28. Note the colonial-revival style of many of the objects on display in these industrial art exhibits from the early 1920s. Sixth Exhibition of Industrial Design, Metropolitan Museum of Art, 1922, The Metropolitan Museum of Art. Image © The Metropolitan Museum of Art.

consumers ultimately failed to encourage better design. By further restricting entries in his exhibitions to manufactures that had been inspired by museum study, he also inadvertently encouraged *retardataire* design, as one historian has described the various revival styles that appeared in the Metropolitan's industrial design exhibits.[30] The museum's design restriction seems particularly defeatist considering the fact that the Metropolitan was deliberately not serving as a design school. Without instructors to guide craftsmen toward using historical models as examples for the study of design principles (line, form, and harmony of ornament), craftsmen ultimately resorted to merely copying the things they found in museum galleries.

Instead of teaching principles of design to craftsmen, the Metropolitan Museum started to play a more active role in marketing household consumer

Figure 29. Seventh Exhibition of Industrial Design, Metropolitan Museum of Art, 1923. The Metropolitan Museum of Art. Image © The Metropolitan Museum of Art.

goods. During the 1920s, the Metropolitan Museum developed an aggressive consumer education outreach campaign. Since 1915, the museum had offered lectures and seminars to salespeople and retail buyers to help them "recognize good color, good line, and other qualities that give value to art."[31] "The aim of these seminars," museum educators explained, was "to give practical knowledge of art" and "harmony" of design details to department store sales agents.[32] During the 1920s, however, these retail seminars became a central feature of the Metropolitan's education program. In 1921, Bach wrote, "purchases of home furnishings represent a half billion of American earnings annually."[33] But Bach argued that retail buyers had to be sufficiently trained to recognize the best quality merchandise in order to pass consumer demands on to manufacturers. "Unless the best is offered to our people, whose tastes improve with constant acceleration," he argued, "producers cannot hope to maintain their present positions."[34] Bach, like taste critics before him, agreed that the "middle men" who sold domestic

goods were not qualified to be arbiters of good taste, but he was confident that "by infinitesimal advances," salespeople were "likewise approaching the blinding light of good design." The museum's retail seminars apparently contributed to those infinitesimal advances. To assist the museum in its cultural mission, museum educator and Teacher's College professor Grace Cornell offered weekly classes to department store salespeople from Macy's, Lord & Taylor, James McCreery & Co., Bonwit Teller & Co., and Best & Co., as well as special classes for executives, buyers, and assistant buyers from Macy's and Abraham & Straus.[35]

In addition to training retailers, the Metropolitan courted consumers themselves by explicitly teaching home decoration skills. In 1921, Kent organized a series of public lectures for museum members who were "interested in studying what constitutes good design and color in the familiar things of daily living." These public lectures were "an extension of a practical use of the Museum collections that [had] been made for several years for practical workers—salespeople, designers, and manufacturers," but were now aimed also at homemakers "in order that their purchases may be made most wisely and with the greatest satisfaction."[36] Grace Cornell also gave lectures on "Design in the Home," while other lecturers presented "Homes of the Past" and "Homes of the Present."[37] As a telling example of the Metropolitan's new educational direction, in 1922 the museum rearticulated its Arthur Gillender Lectures. Originally provided through a nineteenth-century bequest for "artisans engaged in crafts demanding artistic study," the lectures had long been part of the museum's study-hours for practical workers. The first series of Gillender lectures reformatted for the general public, however, focused on interior decoration in various elite national styles.[38] The following year, Cornell presented lectures "showing the value of knowledge and guidance in the arrangement of the home."[39]

When the Met's decorative art curator Joseph Breck bought modern French furniture for the museum, however, Bach and Kent realized that the annual exhibits and decorating seminars were not having the impact on American design they sought. During Bach's 1923 exhibit, Breck presented a competing exhibition of modern French furniture. These two exhibitions at the Metropolitan represented something of a showdown between American and French modern design, and the outcome ultimately sent Bach's industrial relations division into a crisis of confidence. The comparison between the modern decorative arts in the Metropolitan's two exhibitions was striking. Bach still displayed historic museum objects alongside the modern American

Figure 30. In contrast to most of the objects on display in Bach's annual exhibits, which looked like historical reproductions of museum pieces, these new French pieces had distinctively fresh and modern aesthetics, geometric lines, and innovative application of motif and materials. Commode, Louis Süe et André Mare, c. 1918. The Metropolitan Museum of Art, Purchase, Edward C. Moore Jr. Gift, 1923 (23.175.1). Image © The Metropolitan Museum of Art.

designs they inspired, but the juxtaposition only showed how retrograde the new modern things were. In fact, the old things from the museum's collection overshadowed the new things in Bach's exhibition.

A *New York Times* critic said, the "gallery exerts itself to praise famous forerunners."[40] "In consequence," the *Times* ridiculed, "it is plain that a later movement is needed to place our arts upon a definite basis of original design." "Not that the works shown are crass in imitation," the reviewer assured, but implying just that. "There is nothing crass about them except their humility of acceptance." The *Times* joked, "a psychoanalyst might say something about the inferiority complex of the American mind." Doubtless referring to Joseph Breck's nearby galleries of modern French furnishings, it continued, "and

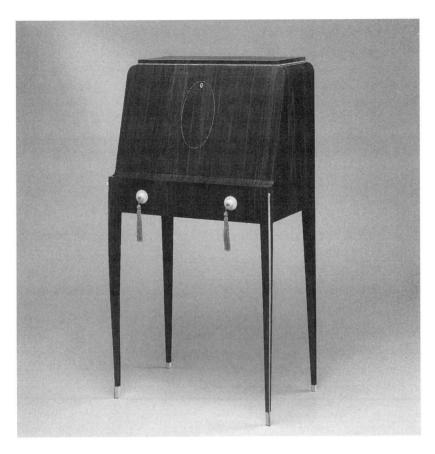

Figure 31. Writing desk, Émile-Jacques Rhulman, c. 1923, The Metropolitan Museum of Art, Purchase, Edward C. Moore Jr. Gift, 1923 (23.174). Image © The Metropolitan Museum of Art.

pinned down to it, [the analyst] would explain that he meant our perfectly obvious and not unlovable tendency to think ourselves not quite as good as the next one."[41]

Joseph Breck's modern French decorative art, on the other hand, spoke for itself. In fairness, Breck bought the best examples of art production he could find. He had neither the restrictions of museum inspiration, nor of mass production, that Bach placed on the objects in his exhibitions. Instead, Breck was a curator with a Metropolitan Museum budget to buy objects suitable for an art museum collection. In June 1922, Edward C. Moore, son of a

former Tiffany & Company executive and founder of the Metropolitan's nine-teenth-century industrial design school, had promised the museum annual gifts of ten thousand dollars to purchase what he called "only the finest qual-ity" modern decorative art.[42] To the regret of Kent and Bach, this money was not earmarked for them. The museum never accessioned the objects in Bach's industrial design exhibitions because they were not part of the museum's cu-ratorial division, and neither Bach nor Kent had jurisdiction over art acquisi-tions. Instead, Breck used the Moore funds to buy pieces of French modern ceramics and furniture, as well as Danish and American "art pieces."[43] The things he bought with the Moore funds had been produced either as one-of-a-kind pieces or in limited editions. "Today, after a decade ripe with promise," Breck wrote, "there is every indication that we are to see in our own time the triumph of a modern style," and he anticipated that it would "mark the begin-ning of a new era."[44]

Breck told the *New York Times*, "It is unthinkable that we should go on in-definitely living in dead men's shoes." Breck explained that in Europe, "there has been a great advance."[45] Rather than imitate earlier styles or mimic orna-mental motifs, the ceramics and furniture Breck brought together for the Met were, according to the *Times*, "beautiful things along strictly modern lines."[46] They displayed the originality and innovative design that the museum-in-spired copies in Bach's exhibitions never achieved, and they boasted rich fin-ishes and exotic materials like lacquer and ebony.[47] Later that year, two pieces of French furniture that Breck had recently purchased in Paris arrived at the museum, a writing desk designed by Jacques-Émile Ruhlman and a com-mode by the design team Süe et Mare. These pieces confirmed the impossibil-ity of presenting the best designs available while at the same time requiring that they result from museum inspiration, produced for the "open market." Ruhlman was perhaps the most fashionable Parisian furniture designer and decorator in the 1920s, while Louis Süe and André Mare coordinated an elite group of designers and craftsmen who produced fine and expensive house-hold furnishings. The fact that all of Breck's acquisitions were identified by their designers further distinguished them from pieces in Bach's exhibitions. The Ruhlman and Süe et Mare pieces came out of studios directed by their designers, rather than from manufacturers who subordinated their design-ers. Market factors are very complex, and comparisons between Paris and the United States in the nineteen twenties are difficult to make, but designers who controlled their production certainly had more autonomy to experiment with design. The designer furniture that Breck sent to the Metropolitan in

the summer of 1923 was both sleek and innovative. While the pieces recalled elements of historic French decorative motifs, they were undeniably new and modern. They were also exquisitely made with very rich materials. Again, in contrast to the industrial production Bach showed in his exhibition, Breck said the Met's new French desk and commode exemplified "perfection of craftsmanship."[48]

Finally recognizing the misdirection of the original program of the Metropolitan's division of industrial relations, Bach shifted his focus to individual designers to improve Americanism in Design. In the Metropolitan's 1923 *Bulletin*, Bach worked out a new relationship between designers, manufacturers and consumers for a revised plan of museum usefulness. The designer, Bach made clear for the first time, should consult "the work of the masters of past times," in museums "for study, not for imitation."[49] Still, Bach proposed, a good designer may imitate the past for himself, "believing, with the modern psychologist, that corrected practice makes perfect."[50] The designer was both "fortified and controlled by the machines and other tools that execute his design," and "commanded by his market." But Bach expanded upon his earlier definitions of the market. Multiple influences could change "the collective public expression of a desire for a design of a certain type," such as periodicals, "the politics of the moment, [or] an outstanding discovery like that in Egypt," and, of course, stores and their buyers. Bach argued that a good designer looks at all of these influences and "diagnoses" the right choice. "Design, like all other human efforts, succeeds when it masters adversity." Turning his previous arguments upside down, Bach explained that adversity for the designer represented "the process of production, the limitation of material, the idiosyncrasy of public demand, [and] the gradually waning ignorance of both middleman and consumer."[51]

In December 1923, Bach announced that the Metropolitan would lift most restrictions on entries for its industrial design exhibitions. The museum would now "solicit the best work of the year without regard to source of inspiration," as long as products had been designed and executed in the United States, and produced in quantity.[52] With this change in requirements, the Metropolitan shifted from being a guide for better design to being a showplace of better design. As a result, the objects in Bach's annual exhibitions slowly became more innovative as they moved into "the modern style," but unlike the exclusive craft masterpieces that Breck continued acquiring for museum collections, they remained within the reach of "the man on the street."

American Modern

As the *New Yorker* suggested in its 1925 profile of Bach, salesmanship represented one of the most enduring legacies of the Metropolitan Museum's progressive agenda in the 1920s. The educational tactics of recruiting experts to study problems and disseminating information through public exhibitions, which began with social exhibits in the 1890s, developed into a sophisticated network of museums and other cultural institutions. After the First World War, middle-class interest in solving the social problems of industrial capitalism waned, as more and more Americans turned their attention to securing the American Dream through the consumption of things. Museums followed these cultural trends while they concurrently tried to shape them. Education programs promoting consumer democracy, like Richard Bach's at the Metropolitan Museum, paralleled similar shifts in progressive public information. George Creel explained in his memoir *How We Advertised America* that he used progressive methods of educating the public that social workers and muckraking journalists had perfected to galvanize American support for the war.[53] Historians credit Creel's information campaign with later influencing the modern advertising industry after the war.[54] By 1925, Richard Bach used the institutional tools he had inherited from Kent, and the industrial networks he had developed since 1918, to more efficiently promote better American design. Bach also teamed up with the museum's curatorial departments to exert more cultural authority, and he used the American Association of Museums and the American Federation of Arts to send examples of good design throughout the nation to museums and department stores.

Bach realized that a new American aesthetic could not develop in a vacuum, so he took the lessons he learned from Breck's modern decorative art exhibit, and its public reception, and applied them to his goals of working with industrial trades and using machine production to democratize good design. He also kept his eyes open to concurrent developments at the Met as guides for his own outreach programs. In 1924, the American Wing opened with its focus on old American craft traditions; Joseph Breck continued to collect examples of French and other modern European craftsmanship; the museum's department of classical art—and significant public attention—turned to Egypt after the discovery of the tomb of Tut-ankh-Amen at Luxor; or it turned to the Middle Ages after John D. Rockefeller started assembling medieval relics for the Metropolitan's Cloisters installation; and Henry Kent's

education department alternately utilized all these influences to teach appreciation of art and influence public taste.

Bach and Kent accepted the fact that aesthetic change would be slow. Despite the changes Bach made to entry requirements and design restrictions, the objects in his annual exhibitions still resembled various revival periods for several years. But "one of the present certainties of American cultural development," Bach wrote in 1924, "is the steady gain of public interest in the industrial arts."[55] Acknowledging the apparent "superior artistic quality" of handcrafted decorative art, Bach conceded, "this is not the occasion to offer a defense for mass production in the industrial arts." But he made his primary goal for industrial art development in the United States clear: "quantity production is a democratic expedient for meeting the requirements of the mass." "The appearance of an isolated example of craftsmanship," he acknowledged, "must remain the concern of a limited number of fortunate persons who come into contact with it."[56] He also made clear the distinction between the museum's curatorial departments and his industrial relations department by suggesting that the things he presented in his annual exhibits may one day end up in museum galleries as examples of the highest caliber design. By continuing to show the "arts of artistic manufacture," he promised, "each season's work shows progress in design beyond that of its predecessor." "In this way," Bach hopefully boasted, "we shall have occasion to add each year a fresh chapter to the history of American industrial art."[57]

The 1925 international design exposition in Paris ultimately forced the hand of American industry to embrace a modernist design aesthetic. L'Exposition Internationale des Arts Décoratifs et Industriels Modernes, which had been organized to encourage and promote "modern" design and industrial production, introduced the new style that became known as art deco. The aesthetics of this new style emphasized clean, sleek lines and rich materials, yet recalled historicist decorative motifs influenced by classical, Egyptian, and Central American ornament. But unlike various revival styles that either borrowed or copied ornamental forms directly, the historicist references of this aesthetic were geometric and stylized. This new style represented just the kind of artistic "inspiration" Bach had hoped designers would get from museum study. Examples of this style had been among the objects bought for the Metropolitan in 1923, but their popularity after the Paris exposition convinced manufacturers that the aesthetics of the style could be simplified and easily reproduced by machines. The 1925 exposition had a profound impact on both Breck and Bach, and ultimately on the direction of

their museum departments. Both men legitimized the new style by putting it into the art museum's galleries, and they encouraged its popularity in the United States by disseminating news and images of the style to manufacturers and retailers.

After the 1925 Paris exposition, Richard Bach shifted the focus of the Metropolitan Museum's program for improving modern American things from manufacturers and design contests to a more behind-the-scenes collaborative approach. Bach used the popularity of the Paris exposition to influence American design by coordinating a 1926 traveling exhibition and disseminating photographic reproductions of objects from it to trade publications; in the process, he also shifted from the museum's earlier industrial relations premise, that consumer market forces would drive manufacturers to improve design, to a focus on celebrated designers and craftsmen as models for emulation. Finally in 1929, the Metropolitan mounted an unprecedented design exhibition that brought together high-profile industrial designers to showcase a new, modern American aesthetic in period-room settings. By changing the focus from manufacturers to designers, the Architect and the Industrial Arts exhibition brought Bach's program of industrial relations back in line with the prerogatives of the art museum, and it legitimized modern design in art museum galleries.

"This 'modern style,'" exulted Joseph Breck, "has thrown overboard the copy and the pastiche which the topsy-turvy nineteenth century in the throes of industrialism substituted for original creation." The new deco aesthetic that emerged in the 1920s seemed to fit the frenetic energy and aggressive optimism of the Jazz Age, but it also fulfilled the design requirements many cultural reformers had long sought. Breck argued that it embodied "old principles in new forms of beauty," which he believed could "meet new conditions of living with frankness and understanding."[58] Rather than copy historic motifs, the new French style referenced aesthetic elements from the past, it modified them into stylized, geometric forms, and it reconfigured them into a sleek new modern aesthetic. For the progressive connoisseurs who had searched for a useful aesthetic to influence public taste, the new modernist style offered a functionalist aesthetic that could be adapted to democratic machine production. While in Paris reporting on the exposition, Richard Bach predicted that the style would represent "the realization of another step, the turning of a phase."[59]

The Paris exposition provided Bach the opportunity to make an aesthetic

style that had previously been associated with exclusive Parisian salons available to a wide American public—and he succeeded in appropriating the new style as American design. Working together at the Metropolitan Museum, Richard Bach and Joseph Breck popularized the new style by showcasing it in museum galleries and traveling exhibits, and promoting it to manufacturers and retailers through Bach's institutional channels of industrial relations. Both Bach and Breck attended the exposition, but they went through very different professional affiliations, and with different immediate objectives. Breck attended as an official representative of the Metropolitan Museum of Art, in his capacity as curator and assistant director, with the intention of buying objects for the museum collection. Bach, on the other hand, attended as a delegate-at-large representing a commission for U.S. commerce secretary Herbert Hoover.[60] Officially, Bach was surveying the state of French industrial production, but he unofficially served as a scout for Henry Kent, who had recently assumed the role of Bach's institutional patron by securing travel funds and providing influential European contacts.

The United States did not participate in the 1925 exposition because manufacturers feared that American production could not compete with European things. Fair organizers restricted entries to "works conceived in the modern spirit," which most cultural authorities interpreted as the new French style.[61] "American manufacturers," Bach regretted, "have followed an opposite trend." "They have drawn their inspiration from the historical forms and have done this so freely and carefully that, to a large extent, the 'new inspiration and real originality' called for are conspicuously absent." Any attempt to produce "special designs and materials for this exposition," Bach cautioned to Kent before the fair, "would be inadequate and from a patriotic viewpoint unsatisfactory." If the Paris exposition represented a larger-scale international version of the annual design exhibitions Bach had been organizing at the Metropolitan Museum, the imitative objects that had been exhibited in the past few years suggested potential national embarrassment.[62] Instead of sending American things to Paris, the United States sent experts, in the fields of design and industrial art, to survey the exposition and issue a report recommending strategies to improve American production.

The Hoover Commission turned into an American publicity machine. To promote the new style, the American Association of Museums organized a traveling loan exhibition of objects and furnishings from the Paris exposition.[63] AAM director Charles Richards curated the exhibition and the American Federation of Arts took care of its expenses as it traveled from Boston to

New York and other major cities in the United States. The decorative objects in the traveling exhibition, however, did not present to Americans a representative sampling of the things shown in Paris. Rather, Richards and other curators carefully culled the exposition to select only those items they deemed innovative and suitable to a modern aesthetic. Though remembered as the exposition that introduced art deco, the 1925 Paris exhibits included a mélange of fine and decorative art in myriad styles, from historicist copies like the things in Bach's annual exhibits to the minimal functionalism of the Bauhaus school and the severe avant-garde aesthetic modernism of Le Corbusier's *Pavilion de l'Esprit Nouveau*.[64] Taste arbiters like Charles Richards, Joseph Breck and Richard Bach, however, chose only those objects they wanted to promote as the new "modern" style. Richard Bach reported to Kent that most of the Paris exposition had in fact seemed terrible to him. "The British, Italian, Belgian & Japanese buildings," Bach disdained, "are execrable." "The French official architecture of the show is worse." "In general," he complained, "the bizarre, far-fetched and truly 'expositional' is the rule."[65] Joseph Breck also considered the architecture of most national pavilions "uninspired and tawdry."[66] Art historians explain that the modern canon that is frequently associated with the influential fairs and expositions of the early twentieth century has been the result of careful historical construction by cultural authorities.[67] The popularity of the art deco style in the United States also represented very careful selection and promotion by the network of influential cultural institutions that progressive connoisseurs like Henry Kent and Robert de Forest had built in the past twenty years.

When the AFA's traveling exhibit came to New York, the Metropolitan Museum unveiled its own collection of new decorative arts and furnishings that Joseph Breck had recently bought at the exposition. These companion exhibits in adjacent museum galleries gave modern industrial art the stamp of cultural legitimacy that Bach's annual exhibits had never attained. To further promote the new style, the museum disseminated publicity that emphasized the suitability of the new aesthetic style to modern living, as well as its suitability to industrial production. Breck cautioned, however, that not all Americans would be ready for the modern style. "[As] every student of the history of art knows," he suggested, the "unfamiliar meets at first with indifference, even with hostility."[68] The *New York Times*, for example, recognized the unity of the designs and the quality of their workmanship, but the paper insisted, "most of us will not unreservedly 'like' the 'modern style.'" In fact, the reviewer argued, "the French themselves do not."[69] Breck, however, advised American consum-

ers that while the most "natural gesture in the world is to throw a stone at the stranger," the unfamiliar stranger may prove to be a "delightful person when we come to know him better." Whether the American public—or critics at the *Times*—liked the new style, taste experts promised that they had found a modern style for American things, and they determined to promote it to American consumers. The Paris exposition, Breck insisted, had been admired by the people "whose taste commands respect."[70]

In addition to traveling AFA exhibitions, Bach looked to department stores as institutions with the potential to influence public taste. Both Breck and Bach had noted the important role department stores in Paris played in disseminating the new style to French consumers. The four main department stores in Paris (les Galeries Lafayette, le Bon Marché, le Printemps, and les Grands Magasins du Louvre) had built pavilions for the exposition. Each pavilion, in fact, had been designed by leading designers and craftsmen of the new style.[71] The department stores had also established collaborative relationships with designers who opened up *ateliers* in stores. Bon Marché, for example, commissioned artist and designer Paul Follot to direct its *atelier* "Pomone" and hired a staff of draftsmen, architects and craftsmen to produce his designs. The *New York Times* described their collaboration as a "diffusing power in the market for decorative art."[72] Breck observed that the department stores played a significant role in making the new decorative style accessible to a broad public because they put "within the reach of the ordinary purse examples of furniture and other household furnishings designed by artists of the first order."[73]

Bach determined to establish the same kind of relationship between department stores in New York and American designers of decorative arts. Therefore, he expanded upon the outreach seminars the Metropolitan Museum had been providing for buyers and salespeople, and he committed the Met to unprecedented collaboration with R. H. Macy & Sons department store. The Metropolitan's 1925 annual report introduced the museum's new "cooperative effort," and explained that Macy's would "refer its supplying manufacturers to the Museum as a source of new material."[74] By "offering [manufacturers] a certain guarantee of quantities to be purchased," Macy's provided incentive to manufacturers to invest in design development. "With this certainty in his market," the museum promised, "the manufacturer can proceed with renewed assurance in his effort to improve his design."[75] In addition to providing access to museum collections for designers to study, the Metropolitan also stepped up its taste education for Macy's salespeople and

buyers. "The store, on its part, to make the purpose feasible," the museum insisted, "must undertake to train its 'buyers,' or departmental purchasing agents, to see the value of design in merchandise." By explaining the value of good design to Macy's employees, the Metropolitan hoped "to encourage their favorable attitude toward Museum-inspired designs to be offered as regular stock to their customers."[76]

In May 1927, the Metropolitan Museum opened an Exposition of Art in Trade at Macy's department store.[77] The exposition represented an alliance of New York cultural, educational, mercantile, and media institutions, with the Metropolitan Museum at the center.[78] The exposition's advisory committee announced in an advertisement in the New York Times, also one of its sponsors, that Macy's had devoted an entire floor of its new building on West Thirty-Fourth Street to an exhibition of "modern products, each chosen to illustrate the new alliance between beauty and art."[79] "Every day America grows more wisely critical of the things it buys," a press release announced. "Macy's, in contact with the millions, is keenly sensitive to this demand." "The Metropolitan Museum of Art, in accordance with its policy of extending help and advice to all American industry in the cause of the furtherance of good taste and art in modern life," committed to partnership with department stores.[80] The exposition featured displays of decorative arts "contrived in the modern spirit" by craftsmen who had used museum objects for inspiration, and it offered a series of public lectures by members of the advisory committee and other invited taste experts.[81] Illustrating the modern, functional aesthetic of the exposition, lectures, broadcast publicly on radio station WJZ, included "Modern Industrial and Decorative Art," by industrial art expert and curator of the AAM's 1926 traveling exhibition Charles Richards; "Art for All of Us," by Bach; "The Skyscraper in Decoration," by modernist decorator Paul Frankl; and "The New Architecture," by architect Harvey Wiley Corbett.[82]

When the Macy's exposition opened, Robert de Forest described the Metropolitan Museum's inspiration for collaborating with a department store. "These stores exert an even higher influence than our own art museums." "The last great Paris art exhibition," de Forest explained, "was in fact limited to industrial art." "It is notable that among the most important exhibits of this great international exhibition in the art center of the world were those of the four great department stores in Paris."[83] "People brought beautiful objects into their homes," de Forest said, because "art of this character is no longer expensive and out of the reach of people with modest incomes." "No home now need be without objects of real art," he triumphantly announced.[84]

Through institutional collaboration, New York's first citizen finally found the way to democratize taste. Though he probably would have preferred to maintain the museum's supposed cultural distance from mercantile concerns, de Forest recognized the wider influence department stores could provide. Besides, de Forest's philanthropic reforms had never dismissed business interests or discouraged profit. The Sage Foundation's 1909 Forest Hills project, for example, was a business venture and model for future real estate development as much as it was an example of housing reform. De Forest and Kent continued to try to increase attendance at the Metropolitan Museum and invite a larger representation of the city to its exhibitions, lectures and seminars, but they also believed, like taste critics before them, in the importance of improving the aesthetic quality of everyday objects. "Department stores," de Forest accepted, "in widely distributing such objects can be of quite as great an educational influence as our museums."[85]

The publicity machine that emerged from the Paris exposition popularized modern stylized aesthetics in the United States by saturating public culture with its images. Instead of competing in different museum departments, Richard Bach and Joseph Breck now worked together to use the Metropolitan Museum's position of authority to give the new style the imprimatur of good taste. Breck collected high-style European objects made by prominent craftsmen for museum galleries, while Bach worked aggressively to promote modern design to an expanded public through traveling exhibits and publicity materials. While Bach coordinated the Macy's exposition in 1927, the Metropolitan mounted an exhibition of Swedish decorative art that had been displayed in the Swedish pavilion at the 1925 Paris exposition. In 1928, the museum hosted another traveling exhibit, this time of modern-style international ceramics, which Bach coordinated through the American Federation of Arts.[86] Instead of organizing annual design exhibits, Bach and Kent worked with museum curators and a coordinating committee of manufacturers, architects and designers to seize upon American interest in modern design and plan for a dazzling museum exhibition of unprecedented scale that would make up for America's absence at the 1925 exposition.

"At last," Edward Alden Jewell rejoiced in the *New York Times*, "we have a genuinely all-American exhibition of interiors on a comprehensive scale."[87] The Metropolitan Museum's 1929 exhibition, The Architect and the Industrial Arts, showcased a bold, aggressive modern aesthetic of geometric forms and hard angles that seemed to embody the dominant strength of the American economy

Figure 32. Cooperating Committee, The Architect and the Industrial Arts Exhibition, 1929. The Metropolitan Museum of Art. Image © The Metropolitan Museum of Art. Standing: Ely Jacques Kahn, Eugene Schoen, Raymond Hood. Seated: Joseph Urban, Leon Solon, Eliel Saarinen, Armistead Fitzhugh, Ralph Walker.

and the dynamic influence of American culture in the 1920s. The exhibition featured group arrangements, reminiscent of period room settings, designed by members of Bach's cooperating committee. The designers and architects on the committee represented the leading figures in modernist American design, including Raymond Hood, Eliel Saarinen, Eugene Schoen, John Root, Ralph Walker, Joseph Urban, Leon Solon, Armistead Fitzhugh, and Ely Kahn.[88] Each designer or architect had designed a room surrounding an interior courtyard, and each had worked with American manufacturers to produce the furnishings and decorative objects they displayed. After four years of touring shows of modern French design, and magazines and department stores filled with foreign things, the Metropolitan's exhibition of all-American industrial art struck

the chords of cultural nationalism that proponents of Americanism in Design had been waiting for since the war.

"American modernism," Jewell trumpeted, "shuns excesses, the bizarre; displays a kind of robustness, a simplicity which one recognizes as the expression of a young and sturdy nation." Jewell linked the Americanism presented in the Metropolitan's American Wing to the American modernism in the 1929 exhibition by drawing continuity of character values. "The sort of American one likes to think of as occupying these modern rooms," he mused, "are Americans whose ancestors earned the right to call the country theirs." "We are a luxury-loving people," Jewell wrote, "it would be foolish to pretend that we are not." "But catering to this demand," he proudly concluded, "no longer makes importation obligatory; nor need it pursue the theory that only exotic dainties, over-refinement and breath-taking splendor are sought by people in this country who can afford luxury."[89] "Does it smack of flag-waving?" Jewell asked. His response to that question, and the response of many other Americans, was that if so, it was deserved.

Richard Bach consolidated his professional network of manufacturers and designers to orchestrate an exhibition of American industrial art that would prove that American things finally stood on their own, without emulation or inferiority. In contrast to the annual exhibitions earlier in the decade, which had attracted the attention of only limited audiences, and had disappointed many arbiters of taste with their imitative designs, this exhibition, Bach determined, would have as profound a cultural impact on American design and consumer interest as the Paris exposition had for French industrial production in 1925. To ensure that the exhibition would represent the caliber of innovative aesthetic he had in mind, Bach turned to the most prominent architects and designers in the United States.[90] The men invited to participate in Bach's design exhibition had built their professional reputations building America's skyscraper aesthetic in the 1920s. The museum invited them to conceive of completely modern spaces, and it gave them full control over design and installation. Robert de Forest promised members of the cooperating committee that they "would be free . . . to use in the exhibition any desirable materials necessary to an abstract display."[91] The museum's only stipulation was that designers work with Bach's network of industrial manufacturers to produce the materials and furnishings for their installations.

Though familiar to many curators of contemporary art and design today, this kind of artist-commissioned museum exhibition represented the cutting edge of museum practice in 1929. Discussing the exhibition plan with

de Forest, Kent called it "a new form of installation." "We are all very enthu-
siastic with regard to the project," Kent exclaimed, "including the advisory
gentlemen." Indeed, the architects and designers who agreed to work with
the Metropolitan Museum were at the top of their fields. "It was a 'feather in
our cap,'" Kent thrilled, "to be able to get Saarinen's help."[92] The participation
of celebrated designers also insured the enthusiastic support of Metropolitan
curators Edward Robinson and Joseph Breck. This modern form of museum
installation represented the culmination of the kind of professional coopera-
tion de Forest had advocated with all of his institutional reform. The Metro-
politan Museum used all of its modernized institutional resources to exert
the strongest possible influence de Forest, and the progressive connoisseurs
he had hired, could have on American design and taste.

Collaboration among so many parties, however, required at least as much
diplomacy and negotiation as had the preparation for the American Wing.
To conceptualize the plan and coordinate individual responsibilities, a co-
ordinating committee of representatives from all these groups gathered for
weekly planning meetings, punctuated with elaborate dinners at various pri-
vate dining clubs in New York to settle ruffled feathers. Big egos among all the
members of the committee led to territorial clashes. Architects and designers
needed to share ideas and respect individual differences as they divided up
the project and staked their own creative interpretations of modern design.
In turn, Kent and Bach served as liaisons with the manufacturers and crafts-
men who had agreed to produce the objects needed for each designer's in-
stallation. Negotiations between artist and producer recalled the conflicting
interests that architects like Ralph Adams Cram had identified during the
war, when Americans advocated using native industrial craftsmen. Negotiat-
ing these interests represented perhaps the biggest obstacle in the process of
planning the 1929 exhibition. Bach and Kent tried to protect the interests
of the manufacturers they had been working with since 1918, and they also
resented the sudden influence museum curators were exerting upon their de-
sign exhibition. Within the Metropolitan's professional hierarchy, however,
curators like Robinson and Breck (incidentally director and assistant director
of the museum) outranked educational administrators like Kent and Bach.

Once the Metropolitan's design exhibits started to focus on recognized
artists, the curatorial members of the staff started to exert influence on the
direction of the show. At one point, for example, Kent objected to changing
the name of the 1929 exhibit from the Eleventh Exhibition of Contempo-
rary American Industrial Art to one that would promote the exhibit's star

architects. Kent urged Robinson to keep the exhibition's name consistent with previous shows, rather than "give more effective credit to the cooperating committee." "It seems to Bach and me that by doing so, unless in a sub-title, we should confuse the real issue, namely, the progress of American design as shown in manufactures." "The architects are entitled to all credit, of course, as the designers of the stage-settings," Kent conceded, "but the credit for the performance of the play belongs to the manufacturers." "We feel that it would not be quite fair," he insisted, "if we were to swap horses in the middle of the stream, to change the title just when we are beginning to gain interest and enthusiasm for this purpose, which is what we have been doing for the past ten years." Understandably, they wanted to retain control over an enterprise they had started, and they wanted to reward their friends in industry who had cooperated over the years. "Bach and I feel," he concluded, "we should not allow the giving of [praise to architects] to interfere with the greater obligation to render praise to the manufacturers." Kent found it patently unfair of the museum to turn its back on the businessmen "who have stood by us so manfully during the earlier and formative years."[93] The exhibition, nevertheless, opened in February under the title The Architect and Industrial Arts.

As Edward Jewell's *Times* review suggests, the exhibition opened to resounding public enthusiasm. Originally scheduled to run one month—as had all of Bach's industrial design exhibits—the 1929 exhibition was extended and stayed open until the fall.[94] As with the Hudson-Fulton exhibit in 1909 and the American Wing just five years earlier, Kent once again broke museum attendance records with an experimental exhibition focused on American things.[95] The exhibition proved that the public had a keen interest in exhibitions of decorative arts, and it legitimized modern design in art museum galleries. The Architect and the Industrial Arts also appropriated the aesthetic building blocks of the French art deco style, and effectively remade them into a style that critics and consumers identified as distinctly American.

"The Metropolitan Museum," the *New Yorker* acknowledged, "has done very well by those of our architects and craftsmen who deal in the modern idiom." "From the poster on the outside of the vestibule of the entrance to the exhibition gallery," the magazine promised, visitors would be clearly guided by signposts and guides that explained the modern style. In particular, the *New Yorker* critic insisted that "a soul cannot but be thrilled" by a fountain installation designed by Ralph Walker and executed by Egmont Arens.[96] Visitors entered the galleries from one of four entrance thresholds that dramatically broke from the Metropolitan's staid but classic Beaux-Arts architectural

Figure 33. Entrance Vestibule, The Architect and the Industrial Arts Exhibition, 1929. The Metropolitan Museum of Art. Image © The Metropolitan Museum of Art.

features into frenetic Jazz Age angularity and rhythm. At one entrance, you could walk through a classical archway into a geometric alcove with sharp truncated corners and a bold black-and-white design motif of descending triangles. To provide a transition from the museum's traditional galleries, visitors walked through small vestibules with vertically striped walls resembling fluting, and stylized geometric foliage stenciled along low, flat ceilings. Upon

Figure 34. Armisted Fitzhugh, Central Garden, The Architect and the Industrial Arts Exhibition, 1929. The Metropolitan Museum of Art. Image © The Metropolitan Museum of Art.

entering the central gallery, the walls soared up to a wide wood-paneled ceiling dado of square inset fields and a flat, gridded white ceiling. The sweeping rectangular central gallery opened to large niche galleries in which the individual designers and architects had arranged their interior room settings. In the middle of the gallery, a dramatic multi-level central garden feature designed by Armistead Fitzhugh recalled the iconic stepped forms of New York's skyscraper skyline. Clad with glossy vertical tiles and surmounted

by two imposing metal sculptures resembling the skeletal structure of fish bones, the architectural garden announced to the public that modern design no longer relied on historic ornamental features.

Each of the rooms represented its designer's particular aesthetic taste, while all shared a cohesive language of bold geometry, rich materials, and close attention to finishing details. Responding to the functionalist requirements that design and taste critics frequently recommended, each room served a specific purpose, and designers justified materials, form and function in brief explanatory texts. Bach and the coordinating committee of architects, designers and manufacturers originally shied away from room settings, but the popularity of period rooms that the American Wing had introduced, and the public success of dressed rooms that department stores had recently opened, encouraged the planning committee to focus on purpose-driven rooms. Presenting specific rooms to the public offered the most effective method of reinforcing the message that Americans could incorporate machine-made modern design into their own homes. Focusing on the function of specific rooms also gave the architects a design problem they could work out from a defined set of directives. Rather than meeting the demands of clients, the Metropolitan's design committee strove to meet the general needs of modern American lives.

Architect and designer Ely Kahn designed two "room" settings—a backyard garden and a bath and dressing room—and he oversaw the final details of the larger exhibition design after Eliel Saarinen's initial conceptual development. Kahn explained that he took on the challenge of a garden as a study in going beyond what he called a conventional approach. "In a narrow lot," Kahn frankly stated, "there is not much to be done but to frame, quite simply, the activities of the person using the small garden." Assuming the needs for a hostess's seat and a few chairs for guests, Kahn designed a simple open space with slate floors and low white walls that revealed an expansive mass of solid green foliage. "The problem here," Kahn determined, "becomes one of elimination and simplification, the major interest being texture of material, the contrast of large masses of color." Therefore, he created a sweeping curved garden seat with mosaics suggestive of stylized aquatic forms and a bright orange tiled fountain. His design, he said, developed "from function and color mass rather than detail." "The constant cry of the modern," Kahn cautioned, "is for freedom of expression, independence of thought, emancipation from the fetters of the past." But like Kent and Bach and many design experts before them, he insisted that the past should inform the present. "It is obvious

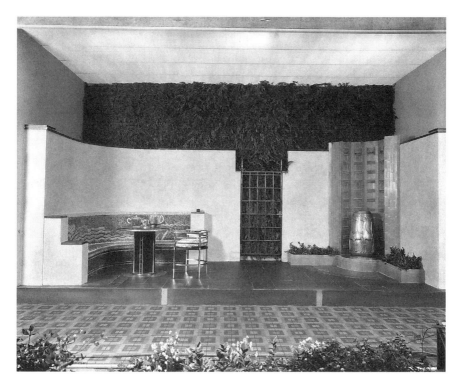

Figure 35. Ely Kahn, Backyard Garden, The Architect and the Industrial Arts Exhibition, 1929. The Metropolitan Museum of Art. Image © The Metropolitan Museum of Art.

that intelligent artists can no more discard the strong truths of their traditional education than they could willfully destroy the works of great masters." Kahn believed that careful attention to the specific problems particular to individual design projects should dictate which stylistic elements, historic or new, would be needed. "Starting from the problem and working toward a solution," he recommended, "with little aid from either European novelties or traditional recollections, the artist may approach fresh results with confidence that he has at least been honest to his work and to himself."[97]

Architect Raymond Hood insisted that as a modern designer he had better materials, newer production processes, and recent inventions at his command, "of which Michelangelo did not dream." "If I were asked if I could build a more beautiful business office than Michelangelo," Hood proposed, "I should say, 'No, but I can build a better business office.'" Like Kahn, Hood

believed that good design resulted from careful study of the problem and deliberate application of practical solutions. "Only by this road," he insisted, can the designer hope "to find the real beauty which will be the harmonious expression of modern life." Hood was considered one the most innovative and promising architects of the 1920s. His designs for the Daily News building and Rockefeller Center ultimately defined New York's art deco skyscraper architecture. Tile manufacturing executive Leon Solon, a central figure on the coordinating committee for the exhibition, called Hood the "little ray of sunshine" of their group. "Cheering discussion with the flippant quip," Solon recalled, "surprising us invariably with a sudden proposition of irrefutable practicality, hoary in worldly wisdom; his handling of aesthetic problems made one think of parallelopipoids and the absolute integrity of the geometric."[98] Indeed, Hood's geometric architectural and decorative features dazzled museum visitors. But Hood's insistence that his dramatic installations were simply the direct result of what he described as scientific study gave his designs the authority of masculine legitimacy that the *New York Times'* Edward Jewell so admired. "The layout and design of the different elements," Hood maintained, "were controlled by present-day requirements." "In general, each material has been chosen because of its fitness for the work it is to do, and with regard to economical upkeep and sanitary qualities." "Its decorative treatment, then," Hood concluded with professional certainty, "has been dictated by the capabilities of the machine or process by which it is made."[99]

One of the most eye-catching spaces in the exhibition, and one of the most reproduced images, was Hood's design for an apartment house loggia. With a fiercely stylized, geometric chromium fireplace over-mantel and ceiling, the space looked like the ballroom of an ocean liner or the smoking room of a swanky hotel. In addition to the bold metallic architectural details, Hood designed two roomy aluminum club chairs, intricate side tables, lamps and fire implements—along with a great tiered hanging pedant chandelier. Jewell surely had spaces like this in mind when he imagined the rugged American individualists who would occupy these modern rooms. Such allusions and the hard geometry of the design—paired with the dry professionalism of Hood's decorative rationale—almost obscure the fantastic luxury and decadent overabundance of the space. Hood envisioned the space as an open-air room in a tall New York City apartment building. An outdoor fireplace, he advised, could be both sociable and practical. Hood's loggia seems to embody the extreme wealth and reckless abandon of the 1920s, which in historical hindsight reads like an ironic gesture in this 1929 room. Despite the extravagance of

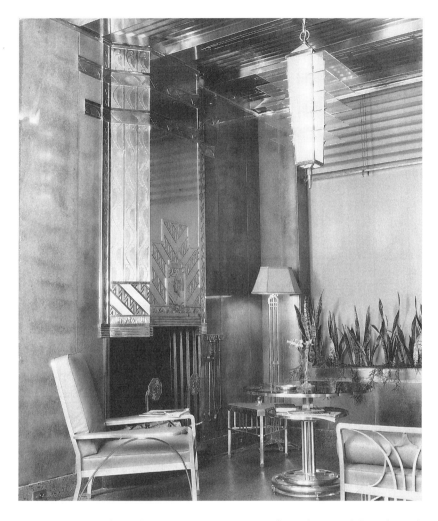

Figure 36. Raymond Hood, Apartment House Loggia, The Architect and the Industrial Arts Exhibition, 1929. The Metropolitan Museum of Art. Image © The Metropolitan Museum of Art.

the space and the hubris of its proposed use, Hood nonetheless managed to ground his design by insisting that the adaptability of his materials remained the controlling factors in his design. "The cast concrete on the walls is more solid than marble, and has a wider range of possible effects." The chromium, aluminum and fabrikoid chair coverings, Hood further pronounced, had all been chosen for their suitability to outdoor use.[100] Suitability, practicality

and efficiency, the exhibition's architects and its publicists reinforced, made luxury and extravagance in modern design acceptable for American consumers—whether they entertained swells in glitzy penthouse loggias or raised families in modest city apartments. Good design, they promised, could finally be had by everyman.

"Our industrial art in America has reached a place," Robert de Forest announced in a press release for the exhibition, "where we can now find about us beauty as well as utility in the products of this 'machine age.'" "Quality production has come to American industry," he continued triumphantly, "where quantity production originated and has been brought equal to such efficiency."[101] As they had with earlier exhibitions, Kent and Bach unleashed an aggressive publicity machine to ensure that critics like Jewell would take home the right messages from the exhibition. Kent hired a news syndicate to write promotional articles and place them in newspapers and magazines throughout the nation, while Bach saturated trade journals and professional associations with images and explanatory literature to encourage manufacturers and retailers to pick up these new designs and reproduce them for the consumer market. "Once art was deemed a thing apart from the life of the average person," de Forest concluded in his publicity article, "but today in this country no home, however humble, need be without true art in a thousand things of daily usefulness."[102]

Whether in the American Wing or in Richard Bach and Henry Kent's annual design exhibits, the promotion of American things at the Metropolitan Museum ultimately had a significant impact on American taste. The colonial revival provided a useful aesthetic for Americans in the early 1920s, but by the end of the decade and into the 1930s, machine-made functionalist modernism offered a new civic aesthetic that stood in tension with "old things." Kent and de Forest integrated decorative arts into the Metropolitan Museum to improve the quality of American consumer production because they believed that good design was a democratic right, and because they hoped that well-designed American homes would contribute to American citizenship. Richard Bach successfully implemented many of Kent's goals of converting Metropolitan galleries into design laboratories like those popularized by the South Kensington Museum in the nineteenth century, and de Forest, Kent and Bach all worked together to make the museum work for the people. The Metropolitan played a large role in influencing the aesthetics of the 1920s as American consumerism developed alongside institutional collaboration and

the professionalization of museums—the dynamics among departments and personalities at the Metropolitan Museum, and conflicting ideas about the social role of art museums, played out in ways that none of the progressive connoisseurs who had reformed the museum could have anticipated. Postwar cultural politics of social conservatism, and decisions to align the museum with industry at the expense of the needs of individual craftsmen and designers, ultimately reshaped a progressive museum agenda. Ironically, in shifting its education program to consumerism, the Metropolitan Museum proved that museums could indeed exert cultural influence beyond the spiritual uplift that traditional advocates of art museums had promoted. Americanism in Design and promises of consumer democracy proved to be the most lasting legacies of the Metropolitan Museum's early twentieth-century progressive museum agenda.

Depression Modern

Institutional Sponsors and Progressive Legacies

The Metropolitan Museum entered the 1930s with a reputation for making museums work for the people. As early as 1919, the *Boston Evening Transcript* had heralded the sea change in ideas about cultural democracy and museum pragmatism that would transpire at the Met during the 1920s. Progressive connoisseurs like Robert de Forest, Henry Kent, Richard Bach and Edward Robinson expanded upon ideas they had developed before World War I, implementing programs that used old American things to improve the quality of modern American industrial production. "Perhaps to the average individual, and certainly to far too many," declared the *Evening Transcript*, "an art museum is a high-brow sort of place where intellectuals gather to discuss shades of meaning quite beyond his comprehension and a repository for the treasures of the wealthy." "For a dozen years Henry W. Kent," reported the *Transcript*, "has been seeking to put the Museum to work, as he sometimes expresses it." For these progressive connoisseurs, putting the museum to work meant using collections to benefit as large a proportion of the population as possible. "Mr. Kent sees the Museum not only as a source of mental breadth and spiritual uplift, but as real utility and a vital force in everyday affairs." The Metropolitan Museum, the paper reported, "desires to be of any possible service to anyone who is doing creative work in the industries."[1]

Despite the Metropolitan's influences on public taste and the aesthetics of American design in the 1920s—whether through the American Wing and the vogue for colonial-revival furnishings, or through Bach's networking with industry and popularizing geometric modern design—the Met failed to maintain its progressive museum agenda into the 1930s. While the

institutional reforms they implemented were remarkably far-reaching, the Met's progressive connoisseurs did not successfully secure their programs into the future. The Metropolitan's sixtieth anniversary in 1930 should have provided an opportunity for pomp and celebration of the reforms of the previous twenty-five years, but instead the Met recognized its anniversary with a remarkably solemn affair that seemed to foreshadow the end of the era ushered in by the de Forest faction twenty-five years earlier. There were no ceremonial tributes or pageants in the Great Hall, nor speeches laying out the museum's future. Instead, the board of trustees quietly observed the Metropolitan's anniversary at their annual meeting in the museum's lecture room, where Kent read an address on behalf of de Forest, who was too ill to travel uptown to the museum.[2] The following year, the Metropolitan mourned the deaths of de Forest and Edward Robinson, as well as five of the trustees who had been part of the museum's institutional revolution of 1905.[3] Eventually, a new generation of trustees, curators and administrators rearticulated the Metropolitan's institutional direction and implemented changes of their own, but their transition was not as swift as the revolution de Forest's generation had orchestrated when the first generation of museum leaders died in 1904.

The de Forest faction swept into leadership after 1905 with modernizing ideals and an agenda for the education of civic taste: to improve American things in order to improve modern democratic society. The museums founded in the nineteenth century have always been urban institutions, and their histories have been tied to the economic and social dynamics of cities. But the new generation of progressive connoisseurs who emerged in the early twentieth century reformed museums and turned them into useful pubic institutions that could improve public taste and enhance civic democracy. Reform leaders like de Forest linked social and aesthetic reform because they believed in the power of beautiful, well maintained physical environments to make better citizens. In addition to his cultural and social reform work, de Forest also financed urban planning initiatives in the 1920s. The Sage Foundation founded and supported the Regional Plan Association as it developed twentieth-century plans for Greater New York. De Forest oversaw the institutional transition from a progressive interest in improving tenement homes and building model communities to professionalized urban planning and major public works projects. Many of the great civic works projects of the 1930s had their ideological, and institutional, roots in city beautification and

the search for a usable past to inform the aesthetics of the built environment of the industrial future.

Kent's desire to make the museum's galleries work as a resource for industrial production ultimately transformed the cultural hierarchy of things in art museums. The American Wing legitimized American decorative arts, and popularized public history told through things. After the American Wing opened in 1924, the cultural and economic value of American things soared. Art museums around the nation opened their own American wings filled with period-room galleries, middle-class consumers sought colonial revival interiors for themselves in department stores and road-side auction houses, and millionaires like Henry Ford and John D. Rockefeller, Jr. built their own American history villages. At the same time, the American things that Richard Bach presented in the Metropolitan's industrial design exhibits represented the introduction of aesthetic modernism into the museum. It strikes us as surprising that the Metropolitan became a showplace for aesthetic modernism at the same time it opened the American Wing, but this disjuncture is bound up in the larger paradoxes of the Metropolitan Museum's early twentieth-century era of modernization.

The seeming paradox of collecting and displaying old American things in a modern museum is explained by looking at the progressive connoisseurs who used those old things as part of the Metropolitan's progressive education reform programs. While historians usually see Americana collecting as an antimodern reaction to the changes of industrial society, de Forest and Kent actually used old things to help them shape the built environment of the industrial future. De Forest hoped those objects could be used to teach taste and influence the aesthetics of modern American homes because he believed, on the one hand, that homes were the center of civic character development, and on the other hand, that individuals' physical environment affected social conditions. In a democratic society, de Forest argued, taste education should be available to everyone. Drawing on de Forest's social philosophy that linked aesthetics and character development, Kent used American things as models to improve the quality of modern American industrial production. Like taste critics before them, de Forest and Kent believed that the everyday objects people surround themselves with contribute to their taste. By reaching out to New York City public schools to teach appreciation of beauty to future citizens and coordinating with manufacturers to improve the quality of objects available to household consumers, the Metropolitan tried to make its galleries work for a large public audience. By surrounding the people with

institutional reforms they implemented were remarkably far-reaching, the Met's progressive connoisseurs did not successfully secure their programs into the future. The Metropolitan's sixtieth anniversary in 1930 should have provided an opportunity for pomp and celebration of the reforms of the previous twenty-five years, but instead the Met recognized its anniversary with a remarkably solemn affair that seemed to foreshadow the end of the era ushered in by the de Forest faction twenty-five years earlier. There were no ceremonial tributes or pageants in the Great Hall, nor speeches laying out the museum's future. Instead, the board of trustees quietly observed the Metropolitan's anniversary at their annual meeting in the museum's lecture room, where Kent read an address on behalf of de Forest, who was too ill to travel uptown to the museum.[2] The following year, the Metropolitan mourned the deaths of de Forest and Edward Robinson, as well as five of the trustees who had been part of the museum's institutional revolution of 1905.[3] Eventually, a new generation of trustees, curators and administrators rearticulated the Metropolitan's institutional direction and implemented changes of their own, but their transition was not as swift as the revolution de Forest's generation had orchestrated when the first generation of museum leaders died in 1904.

The de Forest faction swept into leadership after 1905 with modernizing ideals and an agenda for the education of civic taste: to improve American things in order to improve modern democratic society. The museums founded in the nineteenth century have always been urban institutions, and their histories have been tied to the economic and social dynamics of cities. But the new generation of progressive connoisseurs who emerged in the early twentieth century reformed museums and turned them into useful pubic institutions that could improve public taste and enhance civic democracy. Reform leaders like de Forest linked social and aesthetic reform because they believed in the power of beautiful, well maintained physical environments to make better citizens. In addition to his cultural and social reform work, de Forest also financed urban planning initiatives in the 1920s. The Sage Foundation founded and supported the Regional Plan Association as it developed twentieth-century plans for Greater New York. De Forest oversaw the institutional transition from a progressive interest in improving tenement homes and building model communities to professionalized urban planning and major public works projects. Many of the great civic works projects of the 1930s had their ideological, and institutional, roots in city beautification and

the search for a usable past to inform the aesthetics of the built environment of the industrial future.

Kent's desire to make the museum's galleries work as a resource for industrial production ultimately transformed the cultural hierarchy of things in art museums. The American Wing legitimized American decorative arts, and popularized public history told through things. After the American Wing opened in 1924, the cultural and economic value of American things soared. Art museums around the nation opened their own American wings filled with period-room galleries, middle-class consumers sought colonial revival interiors for themselves in department stores and road-side auction houses, and millionaires like Henry Ford and John D. Rockefeller, Jr. built their own American history villages. At the same time, the American things that Richard Bach presented in the Metropolitan's industrial design exhibits represented the introduction of aesthetic modernism into the museum. It strikes us as surprising that the Metropolitan became a showplace for aesthetic modernism at the same time it opened the American Wing, but this disjuncture is bound up in the larger paradoxes of the Metropolitan Museum's early twentieth-century era of modernization.

The seeming paradox of collecting and displaying old American things in a modern museum is explained by looking at the progressive connoisseurs who used those old things as part of the Metropolitan's progressive education reform programs. While historians usually see Americana collecting as an antimodern reaction to the changes of industrial society, de Forest and Kent actually used old things to help them shape the built environment of the industrial future. De Forest hoped those objects could be used to teach taste and influence the aesthetics of modern American homes because he believed, on the one hand, that homes were the center of civic character development, and on the other hand, that individuals' physical environment affected social conditions. In a democratic society, de Forest argued, taste education should be available to everyone. Drawing on de Forest's social philosophy that linked aesthetics and character development, Kent used American things as models to improve the quality of modern American industrial production. Like taste critics before them, de Forest and Kent believed that the everyday objects people surround themselves with contribute to their taste. By reaching out to New York City public schools to teach appreciation of beauty to future citizens and coordinating with manufacturers to improve the quality of objects available to household consumers, the Metropolitan tried to make its galleries work for a large public audience. By surrounding the people with

good design, and teaching the public the importance of beauty, and principles of good taste such as restraint, simplicity and suitability, de Forest and Kent argued, the Metropolitan could improve public taste and enhance democracy. Rather than using old American things to retreat to a distant mythic past, the Metropolitan used old things to try to relate the values of the past to the present.

American decorative arts, however, challenged the cultural hierarchy of objects in art museums by expanding the art historical canon, which had previously been restricted to European fine art. At the core of debates about expanding museum collections to include decorative art lay arguments about the social function of museums. Advocates for traditional definitions of museums as centers for the exhibition of high art and the reification of cultural capital feared that expanding the canon too far would delegitimize American museums and turn them into either bazaars or places for cheap amusements. Kent and Bach advocated the inclusion of decorative arts in museum collections because they believed these objects could be used to teach manufacturers, craftsmen, and consumers alike the principles of design and good taste. Kent's friend and ally at the Newark Museum, John Cotton Dana, however, frequently criticized encyclopedic art museums like the Metropolitan Museum for focusing too narrowly on rare and costly things at the expense of everyday objects. Dana suggested that even Kent and Bach feared the taint of commercialism, and thus restricted their galleries to recognized masterpieces by master craftsmen. Dana likely had a point: the Metropolitan Museum carefully navigated the cultural waters in the 1920s by restricting the objects in its permanent collections to attributed craftsmanship, while promoting modern designs (by whatever modern aesthetic) in temporary loan exhibitions, under the umbrella of the museum's education department instead of its curatorial departments. Rather than follow Dana, most art museums in the United States followed the Met's lead and opened their own decorative art galleries filled with finely crafted things that could compete with the Metropolitan.

The Metropolitan's imperative of focusing on art-historical connoisseurship ultimately influenced the interpretation of history represented in its American Wing period rooms. Because Richard Halsey insisted on displaying masterpieces of American craftsmanship, the period rooms in the American Wing told a narrative of American home life that emphasized elite families. By using only high-quality American things and interior details from the finest old houses, Halsey told a story of American history based on his elite construction of the Art of Living. On the one

hand, Halsey was using the examples of fine craftsmanship in the American Wing to stake a claim for American things in the art museum's hierarchy of cultural production. He insisted that the tasteful designs exhibited in the new American Wing proved that America had its own art tradition. At the same time, he was also using those old things and old houses to prove that colonial and early republic Americans had refined taste, which, he argued, represented the Art of Living: a quality based on cultured education and characterized by civic responsibility. Halsey used the elite homes that represented the Art of Living to tell a narrow story of American history that erased social conflict and regional difference. By using American things to interpret history, Halsey told the first material-culture history of the United States; but by selecting, ordering and giving cultural value to those things in the first place, he skewed the interpretation presented in the American Wing to the particular story he wanted to tell.

Halsey's approach to telling American history profoundly influenced the interpretation of public history at museums like Colonial Williamsburg and most historic houses in the twentieth century. These material culture historical interpretations have almost exclusively privileged elite social life and the refined taste of "great men," emphasizing their patriotism and civic enlightenment. The professionalization of both museums and the preservation movement further affected those interpretations because it privileged the expertise of art and architectural historians, whose focus on accuracy of design and craft details ultimately led to the elite homes of those great men.[4] Ironically, the new cultural legitimacy of old American things that Kent and his collector friends pursued eventually made them obsolete as experts. Though they promoted Americana, in part, to increase their own cultural legitimacy, the popularity of American antiques after the American Wing opened quickly priced the early collectors out of the market for old things, and the collectors' cultural authority was reduced once younger, art-historically trained experts moved into curatorial positions in art museums. By the 1930s and 1940s, the only capital Kent and other founding members of the Walpole Society had among new wealthy collectors and curators in the club was the memories they could impart of the early days of collecting.

By promoting American things in both the American Wing and the museum's industrial art exhibitions, the Metropolitan Museum did have a significant impact on American taste. The Met contributed to the colonial revival aesthetic in home furnishings, and it introduced the modernist aesthetic of the nineteen thirties, and both these aesthetics had far-reaching cultural im-

pact due to the consumer education the museum pursued in the 1920s. The Metropolitan Museum also contributed to consumer advertising campaigns in the 1930s that highlighted the work of celebrated industrial designers. This consumer-driven impact on taste probably fell short of the civic impact museum leaders like de Forest and Kent originally had in mind, but the wide umbrella of progressive cultural politics required careful negotiation over the value of things.

The tensions surrounding museum policy with regard to aesthetic modernism in the decorative and the fine arts provide a window into the cultural politics of progressive education reform in art museums, and the progressives' calls for cultural democracy. For progressive connoisseurs, decorative arts represented the key that could make museums useful public institutions. To the men and women who modernized museums and integrated bureaucratic professionalization in the early twentieth century, cultural democracy meant something different than it does to critics, museum leaders and professionals today. Kent and de Forest believed that museums needed to produce practical, measurable results like other Progressive Era institutions. Taste critics in the nineteenth century had long argued that studying better design could lead to producing better design. Decorative arts in art museums seemed to offer a greater opportunity to improve American industrial production than the fine arts of paintings and sculpture. In a period of ascendant industrialization and consumer capitalism, the goal of improving American taste and the aesthetics of national consumer goods took on increasing civic importance. Political uncertainty as a result of massive immigration and urbanization contributed to the progressives' belief in the power of orderly, beautiful physical surroundings. Modern American things made more sense to them, for modern American lives, than did the abstractions of aesthetic modernism in the fine arts. The Metropolitan Museum, the American Federation of Arts, and many other museums, department stores, and other cultural institutions contributed to increasing American consumer attention to the problems of design, and to the possible solutions available through models in museums and other institutions with cultural authority. This awareness of consumer aesthetics is likely the greatest legacy the progressive connoisseurs left.

After the success of the 1929 exhibition, The Architect and the Industrial Arts, the geometric, modern style of the rooms that Bach's architectural committee presented there became increasingly popular.[5] The Museum of Modern Art (MOMA) opened three months after Bach's exhibit closed at the Met, and it ultimately took over the role of institutional showplace for modernist

industrial design. MOMA seized upon progressives' arguments for democ-
ratizing good design and promoting a modern aesthetic in the 1930s, but
MOMA privileged an international style of modernism in its galleries, rather
than the nationalizing aesthetic that progressive connoisseurs like Kent, Bach
and de Forest had sought. The progressive connoisseurs at the Met, whose
ideas about professionalization had been informed by the Progressive Era,
linked bureaucratic management, democratic access and Americanization.
But the cultural leaders at MOMA who promoted a new modern aesthetic
during the '30s, such as Alfred Barr and Philip Johnson, had developed their
professional training and their ideas about the relationship between muse-
ums and society in a different intellectual climate.

Whereas early museum professionals like Kent and Robinson drew equally
from European models and progressive ideas about democratic industrial so-
ciety, the new generation of museum professionals like Barr, who emerged
in the late 1920s, had specific museum training from dedicated academic
programs. Kent and Robinson did not develop their skills through formal
programs because there were none at the time. Rather, they constructed their
own educations. Robinson's education was more formal, including study at
Harvard and in German research universities, as well as careful observation
and study of objects and practices in European museums. Kent, on the other
hand, constructed his education from the ground up: he combined the skills
of library science he had learned assisting Melvil Dewey with knowledge
acquired through informal association with gentlemen collectors. Kent and
Robinson's reaction against what they considered the old-fashioned and un-
professional management of nineteenth-century museums led them to enact
educational reforms to enhance cultural democracy. The concurrent progres-
sive interest in improving the built environment and implementing bureau-
cratic standards further pushed many progressive connoisseurs to embrace
programs allying art and industry, as pioneered by the South Kensington Mu-
seum. The succeeding generation of museum professionals, however, gradu-
ated from formal museum-studies programs, which had been established in
the 1920s.

Two very different courses in the study of museums emerged in the 1920s
to teach new museum professionals: Paul Sachs developed a museum course
at Harvard in 1924 that operated out of the Fogg Museum, and John Cotton
Dana began a course teaching museum standards at the Newark Museum and
Library. Paul Sachs's Harvard course ultimately trained the men who moved
into positions of leadership in American museums from the 1930s through

the '40s and '50s, and influenced twentieth-century ideas about education, outreach and cultural democracy in museums. The Sachs museum course evolved out of a discussion with Henry Kent in 1919, but Sachs combined attention to professional standards with art-historical formalism. The Harvard program was run out of Charles Elliot Norton's former home, Shady Hill, and it followed his intellectual heritage by focusing on formal art history and elite traditions of connoisseurship. Sachs, a partner in the family firm Goldman Sachs and himself an avid collector, emphasized to his students the importance of moralism to museums. Sachs worried about the unethical influences of art dealers, and his explicit injunction against the taint of commercialism distinguished the lessons he taught his students from the messages Dana taught at the Newark Museum. Dana encouraged museum professionals to build their own "museums with brains," and he sent his students on mandatory observational study trips to the Metropolitan Museum to learn the skills of the trade from Henry Kent. Unlike the Harvard program, which attracted men interested in careers as art historians, Dana's program primarily attracted women interested in careers in public service. While many of the professionals trained under Dana and Kent moved into the museum profession, their bosses at the major cultural institutions throughout the United States were almost all men who had been trained by Sachs and imbued with his ideals for the museum profession. The cultural policies of mid-century museums illustrate the influence of a formalist art-historical training. Sachs students led the Museum of Modern Art, the Wadsworth Athenaeum, the National Gallery, the Cleveland Museum of Art, the Institute of Contemporary Art in Boston, and, of course, the Metropolitan Museum.[6]

The specialization of programs in museum studies, and its split into two professional directions, distinguishing popular education from connoisseurship, shaped the direction of art museums after the first generation of museum professionals (concentrated around networks developed at the Met) left museums in the 1930s and '40s. Art historian and cultural arbiter Alfred Barr, at MOMA, provides a clear example of the direction taken by Sachs students. Barr defined a modern art canon and exerted far-reaching cultural influence. But Holger Cahill—a protégé of Dana's at the Newark Museum—illustrates the less well-known direction taken by some progressive education programs for arts in the 1930s.

During the New Deal, Holger Cahill made the Federal Art Project a national organization for the promotion of cultural nationalism.[7] In many ways, the Federal Art Project developed from the same model de Forest had used

with the American Federation of Arts. But whereas de Forest consolidated the AFA as a federation of private institutions to expand democratic access to art, Cahill had the power (and the financing) of the federal government. When the de Forest faction faded from power at the Metropolitan, Kent and Bach lost administrative authority because they no longer had institutional sponsors. But an educational administrator like Cahill could use the funding and bureaucratic resources of the federal government to build community art centers and fund public art projects. When the Metropolitan Museum, and other institutions that followed its lead, expanded their education programming during the depression, they did so with Cahill's institutional funding.[8] Had Robert de Forest lived to see the public works programs of the New Deal, he might have also changed his Progressive Era ideas about private philanthropy, which influenced his decisions to finance projects like the American Wing and City Hall's interior restoration with private funds.

Today, many of our ideas about cultural democracy come not from progressive connoisseurs like de Forest and Kent, but rather from 1930s New Deal and 1960s Great Society arts and cultural programs. In many ways, these programs took up the social and cultural reforms of the Progressive Era and expanded them through public funding. The history of progressive connoisseurs and cultural reform in art museums during the early twentieth century is therefore a transitional story of institutional modernization and cultural compromise. Robert de Forest and his faction of younger trustees at the Met implemented rationalized, bureaucratic improvements into the museum's organizational structure, but they never quite gave up their nineteenth-century roots. While trustees delegated responsibilities to an efficient staff of professionally trained experts, they still remained as involved in minute decisions at the Met as had the founding generation, and their relations with the museum's professional staff also recalled nineteenth-century social deference and an ordered institutional hierarchy.

A few months after de Forest's eightieth birthday tribute in 1928 when he was enthroned as the "Abou Ben Adhem" of New York, the Metropolitan's staff gave a similar tribute to director Edward Robinson in celebration of his seventieth birthday. After being presented with a huge cake in the shape of a Greek temple by museum attendants in Greek costumes—as tribute to his classical scholarship—Robinson descended the museum's staircase to join his staff in the great hall, who were all assembled at attention and positioned so their bodies formed a giant seventy.[9] Robinson and Kent held the highest po-

sitions on the museum's staff, but Robinson's position as director overseeing curatorial decisions, and his art-historical academic credentials, positioned him far above Kent in the museum's institutional hierarchy. During this period of nascent professionalization, in which people like Kent were still working out their credentials, it was the custom for all staff members to stand while addressing trustees in board meetings. The symbolic importance of the museum's hierarchy was likewise reinforced through rituals like standing at attention, as well as at more ceremonial events like anniversaries and birthdays. Every year during the holidays, for example, trustees' wives donated old dresses and gowns to the wives of the museum's staff in an afternoon ritual in the museum's great hall, with Robinson's wife acting as the liaison between the wives of trustees and staff.[10]

That world, the world from which progressive connoisseurs came, however, quickly faded to memory during the 1930s. Just as the founding generation of trustees at the Metropolitan had died within a few years of each other at the beginning of the twentieth century, so too did the de Forest faction in the 1930s. While Kent stayed on at the museum another ten years, he saw the reforms he had implemented disappear because new leaders at the Metropolitan lacked the will to support them. By the middle of the twentieth century, art museums had dismantled almost all of the democratic reforms that progressive connoisseurs had implemented to make galleries accessible and put collections to work for industrial designers. The simple explanation for this shift in museum policy is that the generation of museum leaders who implemented progressive reforms died in the 1930s, but this explanation fails to explain why their democratic programs died with them. Kent himself trained a younger generation of museum professionals who went to work in museums across the country; they should have picked up the mantle and carried forward his goals of thinking about museums as public servants. But professionals like Kent could only accomplish so much without support from trustees.

In 1940, William Church Osborne, brother of American Museum of Natural History president Henry Fairchild Osborne, became president of the Met, and medievalist and Francophile Francis Henry Taylor became director.[11] Taylor came in with his own sweeping plans for the museum, which did not entail what he considered the clunky institutional programs that Kent had set up. Rather, Taylor streamlined the museum's structure by eliminating Kent's educational programs and many of his democratic policies. Taylor determined to make the museum an art museum par excellence. A graduate

of Sachs's program at the Fogg Museum, Taylor embodied what would later become the twentieth-century image of the all-powerful modern museum director. In contrast to Robinson, who maintained a position of deference to trustees, Taylor made the directorship of the museum the pinnacle of the Metropolitan's institutional hierarchy.[12] Without support from either Osborne or Taylor, Kent's museum programs died when his institutional sponsors died. His authority diminished because his ideas and management style were seen to be old fashioned and out of step by the new guard. Kent resigned in 1940 and spent his declining years communicating with a new generation of Walpole Society leaders, who were anxious to record memories of the society's early days before its representatives died, along with the vestiges of those early years of collecting Americana, already long gone.[13]

A second explanation for the shift away from a progressive museum agenda can be found in the answer to a larger historical question: why did the progressive movement fall apart? In many ways it did not, but rather many of its central tenets were incorporated into New Deal programs. For museums, the depression had the twin impact of both dissolving fortunes, like Robert de Forest's, which could have been used to fund long-running educational programs, and adding to the taint of socialism already associated with programs that linked art production and social justice. In art museums, only the organizational-management aspects of the reforms made by Kent and de Forest were incorporated into postwar museum policy. Across the nation after World War II, museums shifted gears and changed policies of programming to attract traditional art-museum audiences as people and their tax dollars moved out of cities and into suburbs. This change coincided with the entry of abstract modern art into the canon, which shifted the center of the art world from Paris to New York, thus altering the language of modernization and museums, and eliminating cultural insecurity from the agenda of American museums.

Museums like MOMA played a significant role, of course, in associating modern art with cultural authority in mid-century. So too did MOMA encourage association of modern furnishings with modern lifestyles. But MOMA's promotion of modern design—like the Met's in its 1929 exhibition—focused on the talent of designers, rather than the skills of artisans and craftsmen, on whom an earlier generation of museum and taste reformers had pinned their hopes for civic improvement. By the time New York became an international center for art, and its schools (and museums) of modern art defined a new canon, the promotion of American things in museums no

longer had the same value that progressive connoisseurs had constructed. Reformers like Richard Bach continued to advocate industrial art programs in museums—Bach proposed entire wings at the Metropolitan Museum devoted to education work, he conducted surveys of the state of the field of arts education, and he lobbied international agencies like the International Council of Museums to advance his agenda—but his demands for a return to an earlier definition of cultural democracy remained unmet.[14] Frustrated by the repeated dismissal and inattention of the Metropolitan's leadership, Bach retired in 1952.

The postwar museum followed the cultural politics of postindustrial cities. Museums tried to lure their audiences from the suburbs, cloaking themselves in the mantel of cultural authority. In fact, once New York became the cultural capital of the world, and modern art and design became symbols of urbanity and intellectual sophistication, art museums in cities stood as symbols of cultural distinction. In increasingly abandoned downtown districts, an urban art museum represented one of the few draws to sustain the urban economy. With fewer tax dollars to support municipal institutions, museums and libraries curtailed outreach programs. The combined factors of the economic decline that followed de-industrialization and shrinking tax revenues, which contributed to the white flight of middle-class Americans to suburban communities, also contributed to images of racially divided inner cities. To entice suburban visitors to make trips into the city, art museums revived ideas about the refining influences of art that a generation of museum reformers in the early twentieth century had worked so hard to overturn. Rather than focus on inner-city communities through the kind of outreach programs Kent had promoted in the early twentieth century, the museums in industrial cities like Cleveland and Detroit used their limited resources and energy to attract traditional museum visitors, who already had the cultural knowledge to appreciate art, to come into the city for the day. So successfully did subsequent generations of leaders in museums and other cultural institutions obscure the legacy of progressive connoisseurs that public and institutional memory has lost sight of the democratic ideas they promoted as they sought to make museums public institutions in the service of the people.

In May 2009, First Lady Michelle Obama presided over the ceremonial reopening of the American Wing. After almost two years of extensive renovation, which entailed updating anachronistic decoration and historical details, and reinterpreting the period room galleries, the American Wing now offers

the public a transparent explanation of its historic galleries. The museum's period rooms are now presented as colonial-revival interpretations, which themselves represent selective ideas about American history in the 1920s. Touch-screen monitors in individual rooms provide visitors art-historical information about the decorative arts and architectural features in the rooms, they explain the provenance of rooms and the histories of some of the families who lived in them, they tell visitors how the rooms got to the Metropolitan, and they provide social-history perspectives about the production and consumption of American things. "The American Wing," Obama said, captures the spirit of America by "providing a link to history for us to learn from, appreciate and be inspired by." The reinterpreted American Wing, under the leadership of a new museum director (the young scholar of tapestries Thomas Campbell, who replaced long-time director Philippe de Montebello) and opened by the spouse of a new American president, suggests a new idea of twenty-first century cultural democracy and inclusive public history. Obama applauded the Metropolitan for its public outreach, and she beamed to many of the children who attended the opening, "this is your place, too." "So we're very proud of the Met for the work that they've done."[15]

The new American Wing represents many of the institutional revisions museum professionals have made in the last two decades to make museums more democratic cultural and educational spaces, expanding their definitions of visiting publics to be more representative of the American public. Rather than catering only to an elite public of culturally educated visitors, museums have once again reached out to the urban communities they had largely ignored since World War II by broadening the scope of what they collect and present in galleries. To address the complicit role museums have played in reinforcing inequalities, many institutions have also revisited their own histories of collecting and interpreting objects from the past. As the Metropolitan has done with its new period-room galleries, museums now acknowledge the selective decisions involved in what they have collected and the narratives they presented to the public in the late nineteenth and early twentieth century. Public histories of the United States that celebrated elite social and political life frequently simplified patriotism by dropping social conflict and inequalities out of narratives. Today, the American Wing no longer claims that its period rooms represent typical American home life, nor does it celebrate the virtues of the Art of Living that Halsey exalted. Instead, the rooms are presented for what they are: art-historical stage settings to highlight a progression of excellence in American craftsmanship. Imported porcelains

from Asia, elaborately upholstered beds, and hand-turned furniture are also interpreted as markers of social status, reflecting the research of a new generation of material-culture scholars. The American Wing also provides interpretive maps that explain the triangular trade of slaves, mahogany, sugar and spices that maintained the colonial economies and the Atlantic exchange of goods. Considering what the Met has done with the American Wing, Michelle Obama indeed has much to be proud of.

"I am delighted," Obama announced, "to be here with you to celebrate American history through the arts." "From the beginning of our nation," she said, "the inspired works of our artists and artisans have reflected the ingenuity, creativity, independence and beauty of this nation." "It is the painter, the potter, the weaver, the silversmith, the architect, the designer whose work continues to create an identity for America that is respected and recognized around the world as distinctive and new." Linking art and industry, and sounding very much like Robert de Forest, Obama explained: "Our future as an innovative country depends on ensuring that everyone has access to the arts and to cultural opportunity." "Nearly 6 million people make their living in the non-profit arts industry," she continued, "and arts and cultural activities contribute more than $160 billion to our economy every year." Surely the First Lady did not read through Robert de Forest's speeches before coming to the ribbon-cutting ceremony, but her sentiments sound remarkably similar to the arguments de Forest consistently made throughout his tenure as New York's leading first citizen. "The intersection of arts and commerce is about more than economic stimulus," she insisted, "it's also about who we are as people." While Obama's reference to economic stimulus in 2009 is very different from the links Kent and Bach made between art and industry in the 1920s, her associations of art with national identity are similar to de Forest's ideals of the inherent right of all Americans to have access to art and beauty.

"The President and I," Obama promised, "want to ensure that all children have access to great works of art at museums like the one here." Much as de Forest promised to extend the resources of the Metropolitan to all of the children of New York, and beyond to the American people, the Obamas link art to the health of the nation, and they have called for a new kind of cultural democracy. "The arts are not just a nice thing to have or to do if there is free time or you can afford it." "We've been trying," Obama pointed out to the twenty-first century dignitaries and museum trustees in the American Wing's new sculpture garden, "to break down barriers that too often exist between major cultural establishments and the people in their immediate communities."[16]

The democratic changes represented in the American Wing's new educational interpretation do not reflect an unbroken ideological thread that traces back to Henry Watson Kent and Robert de Forest. Rather, they reflect new calls for cultural democracy that have more direct roots in the public arts programs of the New Deal and Great Society, and they also reflect recent collaboration between academic historians and art museum professionals to overturn several decades of one-sided interpretations of American public history. But in the early twentieth century a generation of progressive connoisseurs made their own attempts to redefine the public mission of art museums, from the image of elite warehouses of art that reinforced cultural distinctions, into more democratic educational institutions that could positively impact industrial society. They believed museums could make their most useful social contributions by providing models for tasteful household production, so they made decorative arts the cornerstone of museum education. Combining the progressive impulse to improve the built environment of cities with a commitment to bureaucratic professionalization and standardization, progressive connoisseurs tried to make museums into laboratories for improving public taste and, by extension, American society. Their belief that all people had a right to art and beauty led to expanded programs of outreach to public schools, immigrant communities, industrial manufacturers, and department stores; but their insistence on determining what constituted good taste, and their reliance upon private collectors for objects and expertise, ultimately helped to shape an interpretation of history that resulted in narrow ideas about American identity. Progressive connoisseurs had only limited vision of the kind of democratic work museums could do because traditions of connoisseurship and progressive ideology—however paradoxically—mutually upheld cultural hierarchies. Progressive connoisseurs set the terms for improving American taste and American things, much as progressive reformers defined the meaning of Americanization and social progress. Nevertheless, the new museum leaders and professionals who emerged at the turn of the century had remarkably bold ideas about cultural democracy and making museum galleries work for the people, which challenged nineteenth-century notions of art appreciation and moral uplift. Kent, de Forest, Robinson and Bach placed the Metropolitan Museum at the center of Progressive Era cultural politics by making it a model for other museums to break away from the mold of high culture and instead present themselves as agents of social change.

NOTES

Introduction

1. Henry W. Kent, "The Museum and Industrial Art," *Art in Industry*, ed. Charles R. Richards (New York: Macmillan Company, 1922), 436.

2. For histories of museums see Lara Kriegel, "After the Exhibitionary Complex: Museum Histories and the Future of the Victorian Past," *Victorian Studies* (Summer 2006): 681–704; Alan Wallach, *Exhibiting Contradiction: Essays on the Art Museum in the United States* (Amherst: University of Massachusetts Press, 1998); Brandon Taylor, *Art for Nation: Exhibitions and the London Public* (New Brunswick, N.J.: Rutgers University Press, 1999); Carol Duncan, *Civilizing Rituals: Inside Public Art Museums* (London: Routledge, 1995); Timothy Lukes, *Shows of Force: Power, Politics, and Ideology in Art Exhibitions* (Durham, N.C.: Duke University Press, 1992); Tony Bennett, *The Birth of the Museum: History, Theory, Politics* (London: Routledge, 1995); Ivan Karp and Steven Levine, *Exhibiting Cultures: The Poetics and Politics of Museum Display* (Washington, D.C.: Smithsonian Institute Press, 1991); Michael Kammen, *Mystic Chords of Memory: the Transformation of Tradition in American Culture* (New York: Knopf, 1991). For cultural debates about museums see Pierre Bourdieu, "The Field of Cultural Production, or The Economic World Reversed," in *The Field of Cultural Production: Essays on Art and Literature*, ed. Randal Johnson (New York: Columbia University Press, 1993). 35–37; and Bourdieu, *Distinction: A Social Critique of the Judgment of Taste,* trans. Richard Nice (Cambridge, Mass.: Harvard University Press, 1984); Boudieu and Alain Darbel, *The Love of Art: European Museums and their Public*, trans. Caroline Beattie and Nick Merriman (Stanford, Calif.: Stanford University Press, 1990); Duncan Cameron, "The Museum, a Temple or the Forum?" *Curator* 14 (1971): 11–24; Peter Vergo, *The New Museology* (London: Reaktion Books, 1989); Ivan Karp, Stephen Levine, and Christine Mullen Kreamer, eds., *Museums and Communities* (Washington, D.C.: Smithsonian Institution Press, 1992); Gustavo Buntix and Ivan Karp, "Tactical Museologies" *Museum Frictions* (Durham, N.C.: Duke University Press, 2006). Neil Harris and William Leach show that art museums participated in a larger network of cultural institutions that worked to define American taste and consumption in the early twentieth century. Neil Harris, *Cultural Excursions: Marketing Appetites and Cultural Tastes in Modern America* (Chicago: University of Chicago Press, 1990); William Leach, *Land of Desire: Merchants, Power and the Rise of a New Culture* (New York: Pantheon, 1993).

3. For intellectual and cultural history of social uplift ideology of art in America see Thomas Bender, *Toward an Urban Vision: Ideas and Institutions in Nineteenth Century America* (Baltimore: Johns Hopkins University Press, 1982); Roy Rosenzweig and Elizabeth Blackmar, *The Park and the People: A History of Central Park* (Ithaca, N.Y.: Cornell University Press, 1992); Rachel Klein, "Art and Authority in Antebellum New York City: The Rise and Fall of the American Art-Union," *The Journal of American History* 81:4 (March 1995): 1534–62; Lillian B. Miller, *Patrons and Patriotism: The Encouragement of the Fine Arts in the United States, 1790–1860* (Chicago: University of Chicago Press, 1966); Neil Harris, *The Artist in American Society: The Formative Years, 1790–1860* (1966; reprint, Chicago: University of Chicago Press, 1982); Kathleen McCarthy, "Creating the American Athens: Cities, Cultural Institutions, and the Arts, 1840–1930," *American Quarterly* 37:3 (1985): 426–39.

4. For narrative histories of the Metropolitan Museum see Winifred E. Howe, *A History of the Metropolitan Museum of Art with a Chapter on the Early Institutions of Art in New York* (New York: Metropolitan Museum of Art, 1913); Calvin Tomkins, *Masters and Masterpieces: The Story of the Metropolitan Museum of Art* (New York: E. P. Dutton & Co., 1973); Leo Lerman, *The Museum: One Hundred Years and the Metropolitan Museum of Art* (New York: Viking Press, 1969); Thomas Hoving, et al., *The Chase, the Capture: Collecting at the Metropolitan Museum of Art* (New York: MMA, 1975); and Hoving, *Making the Mummies Dance: Inside the Metropolitan Museum of Art* (New York: Simon & Schuster, 1993). See also Helen Lefkowitz Horowitz, *Culture and the City: Cultural Philanthropy in Chicago from the 1880s to 1917* (Lexington: University of Kentucky Press, 1976); Neil Harris, "The Gilded Age Revisited: Boston and the Museum Movement," *American Quarterly* 14:4 (Winter 1962): 545–66; Walter Muir Whitehill, *Museum of Fine Arts Boston: A Centennial History* (Cambridge, Mass.: Belknap Press, 1970); Steven Conn, *Museums and American Intellectual Life, 1876–1926* (Chicago: University of Chicago Press, 1998); David Bruce Brownlee, *Building the City: The Benjamin Franklin Parkway and the Philadelphia Museum of Art* (Philadelphia: University of Pennsylvania Press, 1989).

5. Cultural historians and social scientists who look at turn-of-the-century cultural policies reinforce historical distinctions between high- and low-brow art by arguing that cultural leaders consistently followed the intellectual arguments of Arnold and Norton, turning museums and other cultural institutions into elite temples that exalted the sacred status of art. Lawrence Levine, *Highbrow Lowbrow: The Emergence of Cultural Hierarchy in America* (Cambridge, Mass.: Harvard University Press, 1988); Paul di Maggio, "Progressivism and the Arts," *Society* 25:5 (July/August 1988): 70–76. See also di Maggio, "Changes in the Structure and Composition of Non-profit Boards of Trustees: Case Studies from Boston and Cleveland, 1925–1985," *Voluntas* 4 (1994): 271–300; di Maggio, "Notes on the Relationship between Art Museums and their Publics," in *The Economics of Art Museums*, ed. Martin Fieldstein (Chicago: University of Chicago Press, 1991); Charles L. Eastlake, *Hints on Household Taste in Furniture, Upholstery and Other Details* (1872; reprint, Salem, Mass.: Ayer Company Publishers, 1993); Clarence Cook,

The House Beautiful (1881; reprint, New York: Dover Publications, 1995); Linda Dowling, *Charles Eliot Norton: The Art of Reform in Nineteenth-Century America* (Hanover, N.H.: University Press of New England, 2007); Robert Dawidoff, *The Genteel Tradition and the Sacred Rage: High Culture vs. Democracy in Adams, James & Santayana* (Chapel Hill: University of North Carolina Press, 1992); T. J. Jackson Lears, *No Place of Grace: Antimodernism and the Transformation of American Culture, 1880–1920* (Chicago: University of Chicago Press, 1981); Matthew Arnold, *Culture and Anarchy* (New Haven, Conn.: Yale University Press, 1994). See also Douglass Shand-Tucci, *Boston Bohemia, 1881–1900* (Amherst: University of Massachusetts Press, 1995); David Sox, *Bachelors of Art: Edward Perry and the Lewes House Brotherhood* (London: Fourth Estate, 1991); Willa Silverman, *The New Bibliopolis: French Book Collectors and the Culture of Print, 1880–1914* (Toronto: University of Toronto Press, 2008); Elaine Showalter, *Sexual Anarchy: Gender and Culture at the Fin de Siècle* (New York: Viking, 1990); James Nelson, *Publisher to the Decadents: Leonard Smithers in the Careers of Beardsley, Wilde, Dowson* (University Park, Pa.: Pennsylvania State University Press, 2000).

6. George Fiske Comfort quoted in Howe, *History of the Metropolitan Museum*, 112.

7. See Leora Auslander, *Taste and Power: Furnishing Modern France* (Berkeley: University of California Press, 1996); Eileen Boris, *Art and Labor: Ruskin, Morris, and the Craftsman Ideal in America* (Philadelphia: Temple University Press, 1986), 4–12; E. P. Thompson, *William Morris: Romantic to Revolutionary* (New York : Pantheon Books, 1977); Fiona MacCarthy, *William Morris: A Life in Our Time* (New York: Alfred A. Knopf, 1995); Nikolaus Pevsner, *Pioneers of Modern Design, from William Morris to Walter Gropius* (London: Penguin Books, 1975); Elizabeth Cumming & Wendy Kaplan, *The Arts and Crafts Movement* (London: Thames and Hudson Ltd, 1993); Karen Livingstone and Linda Parry, eds., *International Arts and Crafts* (London: Victoria and Albert Museum, 2005). For industrial education see Lara Kriegel, *Grand Designs: Labor, Empire, and the Museum in Victorian Culture* (Durham, N.C.: Duke University Press, 2007); Edward Alexander, "Henry Cole and the South Kensington (Victoria and Albert) Museum: The Museum of Decorative Art," in *Museum Masters* (Nashville, Tenn.: American Association for State and Local History, 1983), 151–70; Ethan Robey, "The Utility of Art: Mechanics' Institute Fairs in New York City, 1828–1876" (Ph.D. diss., Columbia University, 2000).

8. Casey Nelson Blake, *Beloved Community: The Cultural Criticism of Randolph Bourne, Van Wyck Brooks, Waldo Frank and Lewis Mumford* (Chapel Hill: University of North Carolina Press, 1990); Daniel Borus, *Twentieth-Century Multiplicity: American Thought and Culture, 1900–1920* (Lanham, Md.: Rowman & Littlefield, 2009); Robert Crunden, *American Salons* (New York: Oxford University Press, 1993); Christine Stansell, *American Moderns* (New York: Metropolitan Books, 2000); Thorstein Veblen, *The Theory of the Leisure Class: An Economic Study in the Evolution of Institutions* (New York: Macmillan, 1912); Trygve Throntveit, "The Will to Behold: Thorstein Veblen's Pragmatic Aesthetics," *Modern Intellectual History* (2008): 519–46; John Dewey, *Art as Experience* (New York: Minton, Balch & Co, 1934); Robert Westbrook, *John Dewey and American*

Democracy (Ithaca, N.Y.: Cornell University Press, 1991); Randolph Bourne, *The Radical Will: Selected Writings, 1911–1918* (Berkeley: University of California Press, 1992).

9. Alan Dawley, *Struggles for Justice: Social Responsibility and the Liberal State* (Cambridge, Mass.: Belknap Press of Harvard University Press, 1991); Daniel T. Rodgers, *Atlantic Crossings: Social Politics in a Progressive Age* (Cambridge, Mass.: Belknap Press of Harvard University Press, 1998); Michael McGerr, *A Fierce Discontent* (New York: Free Press, 2003); John Recchiuti, *Civic Engagement* (Philadelphia: University of Pennsylvania Press, 2007); Paul Boyer, *Urban Masses and Moral Order in America, 1820–1920* (Cambridge, Mass.: Harvard University Press, 1978); Robert H. Wiebe, *The Search for Order, 1877–1920* (New York: Hill and Wang, 1967); Alfred Chandler, *The Visible Hand: The Managerial Revolution in American Business* (Cambridge, Mass.: Belknap Press of Harvard University Press, 1977).

10. Joan A. Saab, *For the Millions: American Art and Culture Between the Wars*, The Arts and Intellectual Life in Modern America Series, ed. Casey N. Blake (Philadelphia: University of Pennsylvania Press, 2004).

Chapter 1

1. Harry J. Carman, "Robert Weeks de Forest," *Dictionary of American Biography*, vol. 2 (American Council of Learned Societies, 1997) [CD-ROM].

2. Ripley Hitchcock, "The Metropolitan Museum," *Christian Union* (February 28, 1889), 263. The original 1880 building now sits in the middle of the Metropolitan, surrounded by later additions; its façade can be seen in the renovated Petrie Court. Today, guides at the museum often point out this old wall as an example of the Metropolitan's self-reflexive management.

3. Ripley Hitchcock, "New York's Art Museum," *Frank Leslie's Popular Monthly*, December 1889, 664.

4. Hitchcock provided Frank Leslie's readers a detailed gallery-by-gallery tour of the Metropolitan that today serves as a window onto the museum visitor experience in 1889. Hitchcock, "New York's Art Museum," 663–75.

5. Hitchcock, "The Metropolitan Museum."

6. Mrs. Schuyler Van Rensselaer, "The Metropolitan Museum," *The Independent*, January 3, 1889, 6.

7. Hitchcock, "The Metropolitan Museum."

8. *Annual Report of the Metropolitan Museum of Art* 9 (1889): 412.

9. In 1885, the Department of Public Parks sent their own request, and the city's Board of Estimate and Apportionment passed a resolution to open the museums and let it be known the city would withhold appropriations. This financial disruption was momentarily averted by a compromise worked out in 1888 whereby the museums agreed instead to open two additional evenings each week. Ibid., 236.

10. Rosenzweig and Blackmar, *Park and the People* , 360.

11. Quoted in Calvin Tomkins, *Masters and Masterpieces: The Story of the Metropolitan Museum of Art* (New York: E. P. Dutton & Co., Inc., 1973), 77.

12. *Annual Report of the Metropolitan Museum of Art* 19 (1889): 115.

13. Ibid., 423.

14. An 1891 petition read: "The undersigned, citizens of New York, join in petitioning the Trustees of the Metropolitan Museum of Art to open the Museum to the public on Sunday afternoon." "To Open the Museum Sundays," *New York Times*, March 20, 1891, 4.

15. "Celebrate Founding of the Art Museum," *New York Times*, February 22, 1910, 8.

16. Howe, *History of the Metropolitan Museum*, 243.

17. *Annual Report of the Metropolitan Museum of Art* 22 (1892): 500.

18. Ibid., 504.

19. Ibid., 501.

20. Howe, *History of the Metropolitan Museum*, 243; Tomkins, *Merchants and Masterpieces*, 78.

21. Roy Rosenzweig and Elizabeth Blackmar, *The Park and the People* (Ithaca, N.Y.: Cornell University Press, 1992), 359–63.

22. Ibid.; "The Slater Memorial Museum," *New York Times*, November 23, 1888, 5.

23. Alan Wallach, *Exhibiting Contradiction: Essays on the Art Museum in the United States* (Amherst: University of Massachusetts Press, 1998), 49–54; Walter Muir Whitehill, *Museum of Fine Arts Boston: A Centennial History* (Cambridge, Mass.: Belknap Press, 1970), 172–217.

24. Henry Watson Kent, *What I am Pleased to Call My Education* (New York: Grolier Club, 1949), 95.

25. Neil Harris, "The Gilded Age Revisited, Boston and the Museum Movement," *American Quarterly* (Winter 1962): 553.

26. Whitehill, *Museum of Fine Arts*, 30, 45–46.

27. Kent, *My Education*, 97.

28. Whitehill, *Museum of Fine Arts*, 76.

29. Correspondence between Robinson, academy director Robert Porter Keep and William Slater details Robinson's supervision of cast collection purchase, shipping and installation. Edward Robinson Correspondence, Archives of the Slater Museum at the Norwich Free Academy.

30. Edward Robinson, "The Cost of a Small Museum," *Nation*, November 21, 1889. Also reproduced in the *Evening Post*, November 23, 1889 and *The American Architect and Building News*, January 1890.

31. Ibid.

32. Kent, *My Education*, 56–57.

33. Though Robinson was only a few years older than Kent, his cultural authority as a formally trained art historian, respected by academics, provided him the position of sage giver of advice to Kent. Other letters in the Slater Museum Archives illustrate the subtle power dynamic at play between these two museum men. Quoted in Kent, *My Education*, 61; Robinson and Kent correspondence, Archives of the Slater Memorial Museum.

34. Kent, *My Education*, 61.

35. Ibid., 62.

36. Ibid., 61.

37. "To Have New Treasures: Plaster Casts for the Metropolitan Museum of Art," *New York Times*, February 26, 1891, 8.

38. Metropolitan Museum circular, reprinted in "For the Gallery of Casts," *New York Times*, February 26, 1891, 4.

39. In 1883, Levi Hale Willard had bequeathed $100,000 to be used to purchase architectural casts, but little had been done until this point. Tomkins, *Merchants and Masterpieces*, 70.

40. The cast committee consisted of Henry Marquand, Robert de Forest, Edward D. Adams, Howard Mansfield, George F. Baker, John S. Kennedy, Pierre Le Brun, Allan Marquand, Augustus Merriam, Francis D. Millet, Frederick Rhinelander, Augustus St. Gaudens, Louis Comfort Tiffany, J. Q. A. Ward, William Ware, and Stanford White. Many of the young men de Forest brought together later became board members when de Forest assumed the presidency of the museum in 1913. Adams, Baker, Mansfield, and Millet became trustees under de Forest after 1905. Howe, *History of the Metropolitan Museum*, 211, 252.

41. The Committee raised $60,000 by subscription in addition to donations of $10,000 from Henry Marquand, $20,000 from George M. Cullum, and $25,000 from Johnston's estate (secured by his son-in-law de Forest). Howe, *History of the Metropolitan Museum*, 252. See also "To Have New Treasures," *New York Times*, February 26, 1891, 8.

42. Robert de Forest to Henry Marquand, October 24, 1890, Cast Collection Folder: Casts—Special Com. To enlarge Coll. 1890 #C 2799, Office of the Secretary Records, The Metropolitan Museum of Art Archives [hereafter MMA Archives].

43. De Forest to Marquand, October 24, 1890, MMA Archives.

44. Ibid.

45. Louis di Cesnola to Henry Marquand, November 1, 1890, Cast Collection Folder: Casts—Special Com. To enlarge Coll. 1890 #C 2799, MMA Archives.

46. Hitchcock, "The Metropolitan Museum."

47. Robert de Forest to Henry Marquand, March 21, 1891, Cast Collection Folder: Casts—Special Com. To enlarge Coll. 1890 #C 2799, MMA Archives.

48. "Slater Memorial Museum: Norwich Visited by a Cast Committee," *New York Times*, May 3, 1891, 5.

49. Ibid.

50. Ibid.

51. New Yorkers like de Forest knew that planners in Chicago were also duplicating casts in the collection of the Trocadero for the upcoming Columbian Exposition. "The Fine Arts," *Chicago Daily Tribune*, August 2, 1891, 29.

52. Robert de Forest to Henry Marquand, undated, Casts Folder—Special Com. To enlarge Coll. 1890 #C 2799, MMA Archives.

53. "The Fine Arts," *Chicago Daily Tribune*, August 2, 1891, 29.

54. Kent, *My Education*, 100.

55. Tomkins, *Merchants and Masterpieces*, 81.

56. Ibid., 79.

57. Ibid., 80.

58. Louis di Cesnola to Henry Marquand, March 27, 1891, Casts Folder—Special Com. To enlarge Coll. 1890 #C 2799, MMA Archives.

59. Robert de Forest to Henry Marquand, March 28, 1891, Casts Folder—Special Com. To enlarge Coll. 1890 #C 2799, MMA Archives.

60. Robert de Forest to Louis di Cesnola, February 10, 1891, Casts Folder—Special Com. To enlarge Coll. 1890 #C 2799, MMA Archives.

61. *The American Architect and Building News*, November 28, 1891, 125.

62. Kent had attended the Norwich Free Academy in Norwich, Connecticut as a "scholarship boy." Founded in 1846 as an endowed academy for boys and girls as an alternative to public schools, and thus "fluctuations in public and political thinking," the Academy was a private institution that provided college preparatory training free to the public. In the nineteenth century, many of its alumni were able to compete with students from private schools for admission to selective universities in the northeast. Because Kent was not, however, from Norwich, he was charged tuition; William Gilman, older brother of Johns Hopkins president Daniel Coit Gilman, covered his tuition, and Kent boarded in town with local families. Kent, *My Education*, 21–24.

63. Ibid., 9.

64. Ibid. Aside from correspondence through various professional associations, Kent left no records, so his autobiography provides the clearest narrative documentary of his life; however, Kent constructed the story of his life to emphasize his self-made status as a museum professional. Throughout the narrative his social anxiety comes through, and this anxiety probably dictated both his professional self-making and what he left out: we don't know anything about his family background or the specific circumstances of his relations of patronage.

65. Ibid., 17.

66. Ibid., 11.

67. Ibid., 12.

68. Ibid., 17.

69. Dewey advocated a similar public service philosophy during the Lake Placid meetings that led to formation of the American Home Economics Association, and through his work as New York State secretary of libraries and home economics.

70. Kent, *My Education*, 43.

71. Ibid., 51.

72. "The Slater Memorial Museum," *New York Times*, November 23, 1888, 5.

73. Quoted in Kent, *My Education*, 51.

74. Ibid., 52.

75. Kent, *My Education*, 51.

76. Ibid., 55.

77. Ibid., 56.

78. Ibid.

79. Kent arranged entries by city and museum: information included entrance fee, hours/days of operation, articles checked, placement of turnstiles, presence of visitor's book; description of catalogues (languages, authors); buildings (plans, room descriptions, layout, lighting). H. W. Kent Museum Notebook, copy, Archives of the Slater Memorial Museum.

80. Kent's trip started in Greece and proceeded north to Germany and across northern Europe to England. Kent Museum Notebook.

81. Kent Museum Notebook, 70.

82. Ibid.

83. Ibid., 81.

84. Ibid., 70.

85. Unfortunately, Kent's original notebooks were destroyed in a 1938 hurricane, and the surviving copies at the Slater Museum stop in Berlin, before Kent visited either Bode's museum or the south Kensington in London. Therefore, Kent's reminiscence of his trip provides the only record of their impression upon him. Kent, *My Education*, 90.

86. James Sheehan, *Museums and the German Art World: From the End of the Old Regime to the Rise of Modernism* (New York: Oxford University Press, 2000); Edward P. Alexander, "Wilhelm Bode and Berlin's Museum Island: The Museum of World Art," *Museum Masters* (Nashville, Tenn.: American Association for State and Local History, 1983), 212.

87. In 1902, Bode established an official two-year course for curators at the Berlin Museums. Quoted in Alexander, "Wilhelm Bode," 214.

88. Ibid., 218.

89. This "mixed room" approach presented eighteenth-century art in rococo galleries, Dutch masters in council chambers or lounges, and Italian masters in Florentine salons. Though considered heresy at the time, this approach eventually dominated American museum practice, much due to Kent's influence (as I will later explain). Alexander, "Wilhelm Bode."

90. Lara Kriegel, *Grand Designs: Labor, Empire, and the Museum in Victorian Culture* (Durham, N.C.: Duke University Press, 2007); Alexander, "Henry Cole and the South Kensington (Victoria and Albert) Museum: The Museum of Decorative Art," in *Museum Masters*, 151–70.

91. Kent, *My Education*, 91.

92. Ibid., 52.

93. "Slater Loan Collections," Exhibition Notebook, Archives of the Slater Memorial Museum at the Norwich Free Academy.

94. Ibid., 60.

95. "Palmer Loan Collection of Chairs," 1/1894–2/1895, Exhibition Notebook, p. 14, Archives of the Slater Memorial Museum at the Norwich Free Academy.

96. Elizabeth Stillinger, *The Antiquers* (New York: Alfred A. Knopf, 1980).

97. Kent, *My Education*, 81.

98. Ibid., 4.

99. Kent became assistant librarian of the Grolier Club under Richard Hoe Lawrence, and was promoted to chief librarian in 1903. Kent, *My Education*, 113.

100. Ibid., 16.

101. Ibid., 114.

102. Ibid., 124.

103. Ibid., 129.

104. Ibid., 122.

105. Ibid.

106. Quoted in Tomkins, *Merchants and Masterpieces*, 81.

107. Ibid., 82.

108. "The Trouble in the Metropolitan," *The Critic: A Weekly Review of Literature and the Arts*, March 9, 1895, 191.

109. "Di Cesnola Cannot Stay," *New York Times*, March 4, 1895, 1.

110. Ibid.; Montague Marks, "My Notebook," *The Art Amateur*, May 1894, 154.

111. "Di Cesnola Cannot Stay," 1.

112. Quoted in Marks, "My Notebook," 83.

Chapter 2

1. Alan Dawley, *Struggles for Justice: Social Responsibility and the Liberal State* (Cambridge, Mass.: Belknap Press of Harvard University Press, 1991); Daniel T. Rodgers, *Atlantic Crossings: Social Politics in a Progressive Age* (Cambridge, Mass.: Belknap Press of Harvard University Press, 1998); Michael McGerr, *A Fierce Discontent* (New York: Free Press, 2003); John Recchiuti, *Civic Engagement* (Philadelphia: University of Pennsylvania Press, 2007).

2. *Annual Report of the Metropolitan Museum of Art*, 1905 (New York, 1905), 8.

3. George F. Baker, Howard Mansfield, and Francis D. Millet.

4. In 1906, Kent helped found the American Association of Museums, and de Forest established the Russell Sage Foundation. After 1913, both men led the American Federation of Art, which they also used to disseminate their progressive agenda.

5. Edith Wharton, *Custom of the Country* (1906; reprint, New York: Barnes & Noble, 2000), 37–38.

6. Alice Cooney Frelinghuysen "Emily Johnston de Forest," *The Magazine Antiques*, January 2000, 192.

7. Emily de Forest explained that her collecting hobby began during a lonely summer with her children on Long Island. Frelinghuysen, "Emily Johnston de Forest," 192.

8. Peter Pennoyer and Anne Walker, *The Architecture of Grosvenor Atterbury* (New York: W. W. Norton & Co., 2009).

9. For de Forest's institutional biography see Harry J. Carman, "Robert Weeks de Forest," *Dictionary of American Biography*, vol. 2 (New York: American Council of Learned Societies, 1997); *New York Times* obituary, May 7, 1931, 14; James Hijya, "Four

Ways of Looking at a Philanthropist: A Study of Robert Weeks de Forest," *Proceedings of the American Philosophical Society* 124, no. 6 (December 17, 1980): 404–18. For history of de Forest's social science reform see Anthony Jackson, *A Place Called Home: A History of Low-Cost Housing in Manhattan* (Cambridge, Mass.: MIT Press, 1976); Roy Lubove, *The Progressives and the Slums: Tenement House Reform in New York City, 1890–1917* (Pittsburgh: University of Pittsburgh Press, 1962).

10. Kent, *What I Am Pleased to Call My Education* (New York: Grolier Club, 1949), 139.

11. The Benedick was built by McKim, Mead, and White in 1880 at 79–80 Washington Square East. Edith Wharton took license and "moved" the Benedick uptown near Grand Central Station so Lily Bart could run into Lawrence Selden. In his autobiography, Kent took pride in emphasizing the fact that Wharton made his apartment house famous. Kent, *My Education*, 139; Edith Wharton, *House of Mirth* (1905; reprint, New York: W. W. Norton & Co., 1990); "The Wilbraham," Landmarks Preservation Commission, June 8, 2004, Designation List 354, LP-2153, 5.

12. De Forest often brought his institutional subordinates together for meetings at his city townhouse. While incorporating the American Federation of Arts, he held directors' meetings at the house before permanently moving those meetings to his offices at the Metropolitan. Minutes, November 10, 1916, box 1, Papers of the American Federation of Arts, Archives of American Art, Smithsonian Institution.

13. See Rodgers, *Atlantic Crossings*, 130–59.

14. Casey Blake, *Beloved Community: Randolph Bourne, Van Wyck Brooks, Waldo Frank and Lewis Mumford* (Chapel Hill: University of North Carolina Press, 1990).

15. Lawrence Veiller, "The Tenement-House Exhibition of 1899," *Charities Review* (1900–1901): 19–25.

16. Anthony Jackson, *A Place Called Home: A History of Low-Cost Housing in Manhattan* (Cambridge, Mass.: MIT Press, 1976), 112. See also Roy Lubove, *The Progressives and the Slums: Tenement House Reform in New York City, 1890–1917* (Pittsburgh: University of Pittsburgh Press, 1962).

17. Kenneth Jackson, ed., *The Encyclopedia of New York* (New Haven, Conn.: Yale University Press, 1995), s.v. "Charity Organization Society," by Alana J. Erickson, 201; ibid., s.v. "Josephine Shaw Lowell," by Jane Allen, 695.

18. Rodgers, *Atlantic Crossings*, 163, 193.

19. "The Reminiscences of Lawrence Veiller," 11, Columbia Oral History Collection, Rare Book and Manuscript Library, Columbia University.

20. Jackson, *Place Called Home*, 116.

21. Veiller, "Reminiscences," 13.

22. Ibid., 13–18.

23. Maren Stange traces the documentary movement from Jacob Riis's sensationalist photographs through the grid-like documentation of Veiller's Tenement House exhibit to New Deal photo documentation projects. Maren Stange, *Symbols of Life: Social*

Documentary Photography in America, 1890–1950 (Cambridge: Cambridge University Press, 1989).

24. Veiller, "Tenement Exhibit of 1899."

25. "Gov. Roosevelt on Tenement Reform," *New York Times*, February 11, 1900, 6.

26. Ibid.

27. Ibid.

28. On April 2, 1900, Theodore Roosevelt addressed the New York State legislature recommending passage of the Tenement House Commission Bill. Charles Z. Lincoln, ed., *State of New York, Messages from the Governors* (Albany, N.Y.: J. B. Lyon Company, State Publishers, 1909), 10: 100.

29. Jackson, *Place Called Home*, 117.

30. Roosevelt, *Messages from the Governors*, 101.

31. Rodgers explains that the 1901 New York tenement law was a borrowed and tightened variation of English building regulations. Rodgers, *Atlantic Crossings*, 193.

32. Robert W. de Forest and Lawrence Veiller, *The Tenement House Problem: Including the Report of the New York State Tenement House Commission of 1900* (New York: Macmillan & Co, 1903), 3.

33. Rodgers, *Atlantic Crossings*, 12.

34. Ibid., 20.

35. Jane Addams and Robert de Forest, "The Housing Problem in Chicago," *Annals of the American Academy of Political and Social Science* (July 1902): 103.

36. Chicago Housing Association report quoted in, "Housing Show in Order," *Chicago Daily Tribune*, March 20, 1900, 7.

37. Stange, *Symbols of Ideal Life*, 47–87.

38. Veiller, "Reminiscences," 182.

39. "Chicago: Exhibition of the Chicago Architectural Club and its Catalogue—Tenement House Improvement—The Arts and Crafts Society's Two-Room Tenement—The Strikes," *American Architect and Building News*, April 14, 1900, 12.

40. Rodgers, *Atlantic Crossings*, 163.

41. Ruth Crocker, *Mrs. Russell Sage: Women's Activism and Philanthropy in Gilded Age and Progressive Era America* (Bloomington: Indiana University Press, 2006).

42. Gregory Gilmartin, *Shaping the City: New York and the Municipal Art Society* (New York: Clarkson Potter, 1995), 270; Rodgers, *Atlantic Crossings*, 163.

43. Rodgers, *Atlantic Crossings*, 189–201; Gilmartin, *Shaping the City*, 270; Susan Klaus, *A Modern Arcadia: Frederic Law Olmsted, Jr. and the Plan for Forest Hills Gardens* (Amherst: University of Massachusetts Press, 2002); Pennoyer and Walker, *The Architecture of Grosvenor Atterbury*, 148–85.

44. Rodgers, *Atlantic Crossings*, 195.

45. Michele Bogart, *The Politics of Urban Beauty: New York and Its Art Commission* (Chicago: University of Chicago Press, 2006).

46. Rodgers, *Atlantic Crossings*. See Daniel Bluestone, *Constructing Chicago* (New Haven, Conn.: Yale University Press, 1991); Richard Guy Wilson, "Architecture, Land-

scape, and City Planning," in *The American Renaissance: 1876–1917* (New York: Brooklyn Museum, 1979); Gilmartin, *Shaping the City*, 4.

47. Max Page, *The Creative Destruction of Manhattan* (Chicago: University of Chicago Press, 1999); Randall Mason, *The Once and Future New York* (Minneapolis: University of Minnesota Press, 2009).

48. Richard Bach, "Books on Colonial Architecture," *Architectural Record* 38 (December 1915): 690–93.

49. Max Page and Randall Mason argue that preservation, planning, and ideas about progress coalesced in the early twentieth century. Randall Mason, "Historic Preservation, Public Memory, and the Making of Modern New York City," in *Giving Preservation a History: Histories of Historic Preservation in the United States*, ed. Max Page and Randall Mason (New York: Routledge, 2004); Bogart, *The Politics of Urban Beauty*; Page, *Creative Destruction of Manhattan*.

50. Bogart, *Politics of Urban Beauty*, 148.

51. Gerald McFarland, *Inside Greenwich Village: A New York City Neighborhood, 1898–1918* (Amherst: University of Massachusetts Press, 2001), 105–17.

52. At this point of nascent professionalization of museums, the only academic museum credentials available were through art history scholarship; the Met's new director and assistant director both had scholarly training in art history, extensive exposure to encyclopedic museum collections, and experience running other museums.

53. Libraries had begun issuing bulletins to their members in the late nineteenth century and museums had recently adopted this method of accountability: the American Museum of Natural History (AMNH) in 1900, the Pennsylvania Museum in 1903, the Museum of Fine Art in Boston (MFA) in 1903, and the Detroit Museum of Art 1903. *Bulletin of the Metropolitan Museum of Art* 1 (November 1905): 17.

54. *Bulletin of the Metropolitan Museum of Art* 1 (November 1905): 1.

55. Ibid., 136, 143.

56. Kent, *My Education*, 141.

57. Robert H. Wiebe, *The Search for Order, 1877–1920* (New York: Hill and Wang, 1967); Alfred Chandler, *The Visible Hand: The Managerial Revolution in American Business* (Cambridge, Mass.: Belknap Press of Harvard University Press, 1977).

58. In 1912, Winfred Howe wrote a review of the museum's educational initiatives since 1905. Howe, "Educational Work in the Museum: A Review," *Bulletin of the Metropolitan Museum of Art* 7 (September 1912): 158

59. From 1908, September issues of the *Bulletin* were devoted to Education Work in Museums. Howe, "Educational Work," 158.

60. Kent, *My Education*, 146.

61. *Bulletin of the Metropolitan Museum of Art* 6 (April 1911): 83.

62. Howe, "Educational Work," 158; Kent, *My Education*, 145.

63. Kent, *My Education*, 153.

64. MMA, *Annual Report* 42 (1911): 42.

65. Winifred E. Howe. *A History of the Metropolitan Museum of Art with a Chapter on the Early Institutions of Art in New York* (New York: MMA, 1913), 294.

Documentary Photography in America, 1890–1950 (Cambridge: Cambridge University Press, 1989).

24. Veiller, "Tenement Exhibit of 1899."

25. "Gov. Roosevelt on Tenement Reform," *New York Times*, February 11, 1900, 6.

26. Ibid.

27. Ibid.

28. On April 2, 1900, Theodore Roosevelt addressed the New York State legislature recommending passage of the Tenement House Commission Bill. Charles Z. Lincoln, ed., *State of New York, Messages from the Governors* (Albany, N.Y.: J. B. Lyon Company, State Publishers, 1909), 10: 100.

29. Jackson, *Place Called Home*, 117.

30. Roosevelt, *Messages from the Governors*, 101.

31. Rodgers explains that the 1901 New York tenement law was a borrowed and tightened variation of English building regulations. Rodgers, *Atlantic Crossings*, 193.

32. Robert W. de Forest and Lawrence Veiller, *The Tenement House Problem: Including the Report of the New York State Tenement House Commission of 1900* (New York: Macmillan & Co, 1903), 3.

33. Rodgers, *Atlantic Crossings*, 12.

34. Ibid., 20.

35. Jane Addams and Robert de Forest, "The Housing Problem in Chicago," *Annals of the American Academy of Political and Social Science* (July 1902): 103.

36. Chicago Housing Association report quoted in, "Housing Show in Order," *Chicago Daily Tribune*, March 20, 1900, 7.

37. Stange, *Symbols of Ideal Life*, 47–87.

38. Veiller, "Reminiscences," 182.

39. "Chicago: Exhibition of the Chicago Architectural Club and its Catalogue—Tenement House Improvement—The Arts and Crafts Society's Two-Room Tenement—The Strikes," *American Architect and Building News*, April 14, 1900, 12.

40. Rodgers, *Atlantic Crossings*, 163.

41. Ruth Crocker, *Mrs. Russell Sage: Women's Activism and Philanthropy in Gilded Age and Progressive Era America* (Bloomington: Indiana University Press, 2006).

42. Gregory Gilmartin, *Shaping the City: New York and the Municipal Art Society* (New York: Clarkson Potter, 1995), 270; Rodgers, *Atlantic Crossings*, 163.

43. Rodgers, *Atlantic Crossings*, 189–201; Gilmartin, *Shaping the City*, 270; Susan Klaus, *A Modern Arcadia: Frederic Law Olmsted, Jr. and the Plan for Forest Hills Gardens* (Amherst: University of Massachusetts Press, 2002); Pennoyer and Walker, *The Architecture of Grosvenor Atterbury*, 148–85.

44. Rodgers, *Atlantic Crossings*, 195.

45. Michele Bogart, *The Politics of Urban Beauty: New York and Its Art Commission* (Chicago: University of Chicago Press, 2006).

46. Rodgers, *Atlantic Crossings*. See Daniel Bluestone, *Constructing Chicago* (New Haven, Conn.: Yale University Press, 1991); Richard Guy Wilson, "Architecture, Land-

scape, and City Planning," in *The American Renaissance: 1876–1917* (New York: Brooklyn Museum, 1979); Gilmartin, *Shaping the City*, 4.

47. Max Page, *The Creative Destruction of Manhattan* (Chicago: University of Chicago Press, 1999); Randall Mason, *The Once and Future New York* (Minneapolis: University of Minnesota Press, 2009).

48. Richard Bach, "Books on Colonial Architecture," *Architectural Record* 38 (December 1915): 690–93.

49. Max Page and Randall Mason argue that preservation, planning, and ideas about progress coalesced in the early twentieth century. Randall Mason, "Historic Preservation, Public Memory, and the Making of Modern New York City," in *Giving Preservation a History: Histories of Historic Preservation in the United States*, ed. Max Page and Randall Mason (New York: Routledge, 2004); Bogart, *The Politics of Urban Beauty*; Page, *Creative Destruction of Manhattan*.

50. Bogart, *Politics of Urban Beauty*, 148.

51. Gerald McFarland, *Inside Greenwich Village: A New York City Neighborhood, 1898–1918* (Amherst: University of Massachusetts Press, 2001), 105–17.

52. At this point of nascent professionalization of museums, the only academic museum credentials available were through art history scholarship; the Met's new director and assistant director both had scholarly training in art history, extensive exposure to encyclopedic museum collections, and experience running other museums.

53. Libraries had begun issuing bulletins to their members in the late nineteenth century and museums had recently adopted this method of accountability: the American Museum of Natural History (AMNH) in 1900, the Pennsylvania Museum in 1903, the Museum of Fine Art in Boston (MFA) in 1903, and the Detroit Museum of Art 1903. *Bulletin of the Metropolitan Museum of Art* 1 (November 1905): 17.

54. *Bulletin of the Metropolitan Museum of Art* 1 (November 1905): 1.

55. Ibid., 136, 143.

56. Kent, *My Education*, 141.

57. Robert H. Wiebe, *The Search for Order, 1877–1920* (New York: Hill and Wang, 1967); Alfred Chandler, *The Visible Hand: The Managerial Revolution in American Business* (Cambridge, Mass.: Belknap Press of Harvard University Press, 1977).

58. In 1912, Winfred Howe wrote a review of the museum's educational initiatives since 1905. Howe, "Educational Work in the Museum: A Review," *Bulletin of the Metropolitan Museum of Art* 7 (September 1912): 158

59. From 1908, September issues of the *Bulletin* were devoted to Education Work in Museums. Howe, "Educational Work," 158.

60. Kent, *My Education*, 146.

61. *Bulletin of the Metropolitan Museum of Art* 6 (April 1911): 83.

62. Howe, "Educational Work," 158; Kent, *My Education*, 145.

63. Kent, *My Education*, 153.

64. MMA, *Annual Report* 42 (1911): 42.

65. Winifred E. Howe. *A History of the Metropolitan Museum of Art with a Chapter on the Early Institutions of Art in New York* (New York: MMA, 1913), 294.

66. Robert de Forest to George Story, April 25, 1905, Casts Folder—Installation & Exhibition Portal of St. Giles & Portico of Erechtheion 1905 #C 2772, Office of the Secretary Records, The Metropolitan Museum of Art Archives [hereafter referred to as MMA Archives].

67. Robert de Forest to J. A. Paine, May 11, 1905, Casts Folder—Installation & Exhibition 1905–06 #C 2772, Office of the Secretary Records, MMA Archives.

68. George Story to Robert de Forest, April 27, 1905. Casts Folder—Installation & Exhibition Portal of St. Giles & Portico of Erechtheion 1905 #C 2772, Office of the Secretary Records, MMA Archives.

69. Robert de Forest to John A. Paine, April 28, 1905, Casts Folder—Installation & Exhibition Portal of St. Giles & Portico of Erechtheion 1905 #C 2772, Office of the Secretary Records, MA Archives.

70. Notes on reports of Curator of Casts, January 1901 to December 1904, MMA Department of Plaster Casts, undated, Casts Folder—Curator—Monthly Reports 1905 #C 2771, Office of the Secretary Records, MMA Archives.

71. Kent, *My Education*, 135–36.

72. MMA Report of Committee on Casts, February 8, 1907, Casts & Reproductions Folder—Comm. on 1905-07 #C 2780, Office of the Secretary Records, MMA Archives.

73. Robert de Forest, "Children's Use of the Metropolitan Museum of Art," *Bulletin of the Metropolitan Museum of Art* 6 (March 1911): 60.

74. Ibid.

75. *Bulletin of the Metropolitan Museum of Art* 6 (January 1911): 10.

76. The Child Welfare Exhibit was held at the Seventy First Regiment Armory from January 18 to February 12, 1911. The Sage, Carnegie, and Rockefeller foundations contributed funds, and representatives from every cultural and educational institution in the city served as committee members, including Alfred Boulton, Charles C. Burlington, Nicholas Murray Butler, Gilbert Colegate, Frederic R. Courdert, R. Fulton Cutting, Robert W. de Forest, Cleveland H. Dodge, John H. Finley, Mrs. James Terry Gardiner, E. R. L. Gould, Miss Helen Gould, Mrs. Wm. Pierson Hamilton, Dr. L. Emmet Holt, John Sherman Hoyt, Charles Rann Kennedy, Wm. H. Kingsley, Henry M. MacCracken, V. Everit Macy, Alfred E. Marling, Louis Marshall, Wm. Fellows Morgan, Thomas M. Mulry, Rollo Ogden, Wm. Church Osborn, Eugene A. Philbin, Franklin H. Sargent, Wm. Jay Schieffelin, E. R. A. Seligman, Felix M. Warburg, Evert Jansen Wendell, Alfred T. White, Egerston L. Winthrop, Jr.

77. *The New York Child Welfare Exhibition*, New York Child Welfare Committee (New York, 1911), 12, Box 48, Folder 23, John Shaw Billings Papers, Collection # RG6, Manuscripts and Archives Division, New York Public Library.

78. Marion Fenton, "Work With Children at the Museum," *Bulletin of the Metropolitan Museum of Art* 6 (March 1911): 46.

79. *The New York Child Welfare Exhibition*, p. 40.

80. Winifred Howe, "The Museum's Educational Credo," *Bulletin of the Metropolitan Museum of Art* 13 (September 1918): 192.

81. Ibid.

82. C. Howard Walker, "The Museum and the Designer," *Bulletin of the Metropolitan Museum of Art* 8 (September 1913): 2.

83. Ibid., 3.

84. Ibid.

85. The museum devoted its September 1917 *Bulletin* to "Museum Extension Work in Fostering Public Taste." *Bulletin of the Metropolitan Museum of Art* 12 (September 1917): 182.

86. Homer Eaton Keyes, "Commercial Tendencies and an Aesthetic Standard in Education," *Bulletin of the Metropolitan Museum of Art* 12 (September 1917): 184.

87. Ibid., 184–85.

88. Laura Scales, "The Museum's Part in the Making of Americans," *Bulletin of the Metropolitan Museum of Art* 12 (September 1917): 191.

89. Scales, "Making of Americans," 191.

90. Ibid.

91. Ibid., 192.

92. Agnes L. Vaughan, "A Suggestion on Correlating the Instruction Given in the Museums of a Community," *Bulletin of the Metropolitan Museum of Art* 12 (September 1917): 186.

93. Museum reformers argued that shorter working hours had given working men and women more time to pursue education in museums. Labor advances were an important part of the reasons for these programs being introduced at this point. Anna D. Slocum, "Possible Connections Between the Museum and the School," *Bulletin of the Metropolitan Museum of Art* 7 (September 1912): 163.

94. Jane Addams, *Twenty Years at Hull House* (1910; reprint, New York: Macmillan Company, 1925).

95. Slocum, "Possible Connections," 163.

96. Ibid., 164.

97. "R. W. de Forest, 80, Honored in Pageant," *New York Times*, April 27, 1928, 1.

98. De Forest was quoted in his *New York Times* obituary: "De Forest a Leader in Charities Here: Civic and Art Leader Dead at 83," *New York Times*, May 7, 1931, 14.

99. Paul Marshall Rea, "Educational Work of American Museums," *Report of the Commissioner of Education for the Year Ended June 30, 1915* (Washington, D.C.: Washington Printing Office, 1915), 304.

100. Ibid, 304–5.

101. *Bulletin of the Metropolitan Museum of Art* 9 (September 1914): 188.

102. "R. W. de Forest, 80, Honored in Pageant."

Chapter 3

1. Steven Conn, *Museums and American Intellectual Life, 1876–1926* (Chicago: University of Chicago Press, 1998).

2. Translated letter, Wilhelm Bode to Edward Robinson, August 15, 1907, Valen-

tiner Folder—General # V 235, Office of the Secretary Records, Metropolitan Museum of Art Archives [hereafter referred to as MMA Archives].

3. *Bulletin of the Metropolitan Museum of Art* 3 (January 1908): 14.

4. *Bulletin of the Metropolitan Museum of Art* 4 (December 1909): 219.

5. *Bulletin of the Metropolitan Museum of Art* 4 (January 1909): 42.

6. *Bulletin of the Metropolitan Museum of Art* 7 (September 1912): 158.

7. Radio speech, arranged through the American Federation of Arts, box 1, R. T. H. Halsey Papers, The Winterthur Library: Joseph Downs Collection of Manuscripts and Printed Ephemera [hereafter referred to as Halsey Papers].

8. Clarence Cook, quoted in Marshall Davidson, "Those American Things," *Metropolitan Museum Journal* 3 (1970): 222.

9. De Wolfe's columns were compiled and reprinted in her 1913 decorating advice guide, Elsie de Wolfe, *The House in Good Taste* (Century, 1913; reprint, New York: Rizzoli, 2004), 149, 153.

10. Draft of speech for the Baltimore Museum of Art, Box 1, Col. 56, Halsey Papers.

11. H. W. Kent, *What I Am Pleased to Call My Education* (New York: The Grolier Club, 1949), 162.

12. Ibid.

13. Ibid.; Halsey, Baltimore Museum speech, Halsey Papers.

14. *Annual Report of the Metropolitan Museum of Art* 39 (1908): 59.

15. *Bulletin of the Metropolitan Museum of Art* 3 (June 1908): 111.

16. Ibid.

17. Ibid.

18. Frank Kingdon, *John Cotton Dana: A Life* (Newark, N.J.: Public Library and Museum, 1940); Edward Alexander, *Museum Masters: Their Museums and Their Influence* (Walnut Creek, Calif.: AltaMira Press, 1995); William Penniston, ed., *The New Museum: Selected Writings by John Cotton Dana* (Newark Museum and the American Association of Museums, 1999); Kevin Mattson, "The Librarian as Secular Minister to Democracy: The Life and Ideas of John Cotton Dana," *Libraries & Culture* 35, no. 4 (Fall 2000).

19. John Cotton Dana, *A Plan for a New Museum: The Kind of Museum It Will Profit a City to Maintain* (Woodstock, Vt.: Elm Street Press, 1920).

20. Kent, *My Education*, 102–3.

21. Kent's installation is largely left *in situ* at the Springfield Library; it represents the only exhibition of casts left in the country to reflect Kent's original nineteenth-century display techniques. While the Slater Museum still displays its original cast collection (as few other museums do: both the Metropolitan and the Carnegie Institute, for example, have long since relegated their collections to off-site storage or sold them through auction), its installation has been revised over the years, and only one of Kent's original cases remains, representing something of an homage to its designer among the small group of museum scholars and cast enthusiasts in the United States.

22. Kent, *My Education*, 102.

23. In 1900, Kent's reputation as a museum professional and expert of casts also led to the publication of his own pamphlet on casts for the Springfield Library. Unlike Robinson's influential art-historical pamphlet on German cast collections, however, Kent's pamphlet on casts focused on practical issues such as cost and details of installation. Henry Watson Kent, "The Horace Smith Collection of Casts of Greek and Renaissance Sculpture: A Brief Statement of the Cost and Manner of its Installation," published by The City Library Association of Springfield, Massachusetts, 1900, in the collection of the Archives of the Springfield Library.

24. Dana correspondence, Archives of the Springfield Library.

25. Kent to Dana, May 18, 1901, Dana correspondence, Archives of the Springfield Library.

26. Kent, *My Education*, 103.

27. Carol Duncan, *A Matter of Class: John Cotton Dana, Progressive Reform, and the Newark Museum* (Pittsburgh: Periscope, 2009).

28. Dana, "A Plan for a New Museum," in *The New Museum: Selected Writings by John Cotton Dana*, ed. William Penniston (Newark, N.J.: Newark Museum/AAM, 1999), 63.

29. Dana, *The Gloom of the Museum* (Woodstock, Vt.: Elm Tree Press, 1917), 14.

30. Ibid.

31. Ibid., 21.

32. Ibid., 8.

33. Dana, "The New Museum," *The New Museum*, 73.

34. John Cotton Dana "An Industrial Exhibit in a Municipal Museum," *The American City* 13, no. 1 (July 1915); *The New Museum*, 154.

35. Nicholas Maffei, "John Cotton Dana and the Politics of Exhibiting Industrial Art in the U.S., 1909–1929," *Journal of Design History* 13, no. 4 (2000); Christine Laidlaw, "The Metropolitan Museum of Art and Modern Design, 1917–1929," *Journal of Decorative and Propaganda Arts* 8 (Spring 1988); Jay Cantor, "Art and Industry: Reflections of the Role of the American Museum in Encouraging Innovation in the Decorative Arts," in *Winterthur Conference Report*, ed. Ian Quimby and Polly Anne Earl (Charlottesville: University of Virginia Press, 1973).

36. Nikolaus Pevsner, *Pioneers of Modern Design, from William Morris to Walter Gropius* (1936; reprint, New York: Penguin, 1975).

37. Leila Mechlin, "Modern German Applied Arts," *Art and Progress* (1912): 586.

38. Edward Robinson to J. C. Dana, September 28, 1911, John Cotton Dana Folder, MMA Archives.

39. Dana, "New Museum," 110.

40. John Cotton Dana, "The Use of Museums," *Nation* 115, no. 2988 (October 11, 1922).

41. Kent to the Editor, *Newark, N.J., News*, October 26, 1922.

42. Dana to Kent, November 8, 1922, John Cotton Dana Folder, 1911, 1913, 1919–20, 1922, 1926–27, 1929, MMA Archives.

43. Ibid.

44. H. W. Kent and J. C. Dana Correspondence, Newark Museum Association Folder, MMA Archives.

45. Kent to Dana, November 14, 1922. John Cotton Dana Folder, MMA Archives.

46. Benjamin Altman to Edward Robinson, September 13, 1909, 1909 Hudson-Fulton Celebration Loan Folder—Lenders—Altman & Duveen Bros. #L 7806, MMA Archives.

47. Ibid.

48. Minutes, Sub-committee of Arts Exhibits of the Hudson-Fulton Celebration Commission, April 1909; Kent to Robert de Forest, April 27, 1909, Hudson-Fulton Celebration Loan Exhibitions Folder—Corres. with R. W. de Forest 1908–9 #L 7806, MMA Archives.

49. Minutes, Sub-Committee of Arts Exhibits of the Hudson-Fulton Celebration Commission, December 24, 1908, Hudson-Fulton Celebration Loan Exhibitions Folder—H. F. Commission— Committee on Art—Minutes # L 7806, MMA Archives.

50. Kent to Lockwood, February 6, 1909, Hudson-Fulton Celebration Loan Exhibitions Folder—Lenders—Lockwood 1909 # L 7806, MMA Archives.

51. Kent to Bigelow, March 17, 1909, Hudson-Fulton Celebration Loan Exhibitions Folder—Lenders—Bigelow 1909–10 #L 7806, MMA Archives.

52. Bigelow to Kent, March 18, 1909, Hudson-Fulton Celebration Loan Exhibitions Folder—Lenders—Bigelow 1909–10 #L 7806, MMA Archives.

53. Bigelow to Kent, April 30, 1909, Hudson-Fulton Celebration Loan Exhibitions Folder—Lenders—Bigelow 1909–10 #L 7806, MMA Archives.

54. Albert Pitkin to Florence Levy, June 10, 1909 Hudson-Fulton Celebration Loan Exhibitions Folder—Lenders—Pitkin 1909 #L 7806, MMA Archives.

55. Elizabeth Stillinger, *The Antiquers* (New York: Alfred A. Knopf, 1980), 130.

56. Letter, Eugene Bolles to Kent, March 27, 1909, Hudson-Fulton Celebration Loan Exhibitions Folder—Lenders—Bolles 1909 #L 7806, MMA Archives.

57. Bolles to Kent, April 20, 1909, Hudson-Fulton Celebration Loan Exhibitions Folder—Lenders —Bolles 1909 #L 7806, MMA Archives.

58. Bolles to Kent, May 14, 1909, Hudson-Fulton Celebration Loan Exhibitions Folder—Lenders —Bolles 1909 #L 7806, MMA Archives.

59. See Hudson-Fulton Celebration Loan Exhibitions Folder—Publicity—Letters to Press 1909 # L 7806, MMA Archives.

60. Kent to Walter Gillis, July 30, 1909, Hudson-Fulton Celebration Loan Exhibitions Folder—Catalogue—Gillis Corres. 1909 #L 7806, MMA Archives.

61. Kent to Gillis, August 5, 1909, Hudson-Fulton Celebration Loan Exhibitions Folder—Catalogue—Gillis Corres. 1909 #L 7806, MMA Archives.

62. Kent to Gillis, August 28, 1909, Hudson-Fulton Celebration Loan Exhibitions Folder—Catalogue—Gillis Corres. 1909 #L 7806, MMA Archives.

63. "Throng at Museum," *New York Times*, November 6, 1909, 7.

64. *Bulletin of the Metropolitan Museum of Art* 4 (December 1909): 219.

65. Ibid., 230; *Bulletin of the Metropolitan Museum of Art* 5 (March 1910): 63.

66. Ibid.

67. J. P. Rome, "The Trade Press—Its Functions," *Bulletin of the Metropolitan Museum of Art* 13 (May 1918): 108.

68. Ibid.

69. Kent, *My Education*, 160.

70. Michele Bogart, *Politics of Urban Beauty* (Chicago: University of Chicago Press, 2006), 147–50.

71. Gregory Gilmartin, *Shaping the City: New York and the Municipal Art Society* (New York: Clarkson Potter, 1995), 24; Bogart, *Politics of Urban Beauty*, 39–157.

72. Robert de Forest was on the board of all three of the civic organizations that coordinated City Hall's preservation: the Art Commission, the Municipal Art Society, and the American Scenic and Historic Preservation Society. Randall Frambes Mason, "Memory Infrastructure: Preservation, 'Improvement' and Landscape in New York City, 1898–1925" (Ph.D. diss., Columbia University, 1999); Randall Mason, "Historic Preservation, Public Memory, and the Making of Modern New York City," in *Giving Preservation a History: Histories of Historic Preservation in the United States*, ed. Max Page and Randall Mason (New York: Routledge, 2004).

73. Mary Beth Betts, *The Governor's Room, City Hall, New York* (New York: Art Commission of the City of New York, 1983); Peter Pennoyer and Anne Walker, *The Architecture of Grosvenor Atterbury* (New York: W. W. Norton & Co., 2009), 140–47.

74. James Lindgren, *Preserving Historic New England: Preservation, Progressivism, and the Remaking of Memory* (New York: Oxford University Press, 1995), 37–41; Lindgren, "A Spirit that Fires the Imagination," in *Giving Preservation a History*, ed. Max Page and Randall Mason (New York: Routledge, 2004), 113–17.

75. "The Restoration of Fraunces Tavern," *New York Times*, March 17, 1907; William H. Mesereau, "How Fraunces Tavern Was Restored," *New York Times*, March 17, 1907; Mason, "Historic Preservation," 144–46.

76. Bach, "Books on Colonial Architecture," 282, Richard Bach Archives, Avery.

77. Bach, "Books on Colonial Architecture," 189, Richard Bach Archives, Avery.

78. Bach, "Books on Colonial Architecture," 286, Richard Bach Archives, Avery.

79. Bach, "Books on Colonial Architecture," 91, Richard Bach Archives, Avery.

80. Bach, "Books on Colonial Architecture," 388, Richard Bach Archives, Avery.

81. Ibid.

82. "Books on Colonial Architecture," 693, Richard Bach Archives, Avery.

83. Ibid.

84. Dana, "The New Museum," 76.

85. Ibid., 72.

86. Dana to Kent, February 4, 1920, John Cotton Dana Folder, Office of the Secretary Records, MMA Archives.

87. Kent: unsigned typescript, 1925. Hand notation: "Mr. Kent re JC Dana's letter." John Cotton Dana Folder, MMA Archives.

Chapter 4

1. Robert de Forest, "Art and Civilization," address given at 1917 AFA convention, reprinted in *Bulletin of the Metropolitan Museum of Art* 12 (June 1917): 163.

2. David Kennedy, *Over Here: The First World War and American Democracy* (New York: Oxford University Press, 1980); Alan Dawley, *Struggles for Justice: Social Responsibility and the Liberal State* (Cambridge, Mass.: Harvard University Press, 1991); Daniel Rodgers, *Atlantic Crossings: Social Politics in a Progressive Age* (Cambridge, Mass.: Harvard University Press, 1998); Michael McGerr, *A Fierce Discontent: The Rise and Fall of the Progressive Movement in America, 1970–1920* (New York: Oxford University Press, 2003).

3. J. B., "The Plus Quality of Art," *Bulletin of the Metropolitan Museum of Art* 13 (September 1918): 197.

4. Leila Mechlin, "The American Federation of Arts: A Review of the Year's Work," *Art and Progress*, July 1914, 340.

5. *Art and Progress*, November 1909, 18.

6. Minutes, November 10, 1916, box 1, Papers of the American Federation of Arts, Archives of American Art, Smithsonian Institution [hereafter referred to as AFA Papers]. New York's courthouse district eradicated the notorious Five Points section of the city, which had personified urban problems of poverty, disease, crime, and machine politics.

7. Through its chapters the AFA advocated institutional protest against objectionable, intrusive advertising that "despoils scenic beauty and architecture." Hoping to politicize the "obstruction of private business upon public rights," the federation wrote editorials to explain to communities and businesses that "such objectionable advertising causes widespread resentment and that its largest return to them is a name for bad taste and poor citizenship." Minutes, June 23, 1923, box 1, AFA Papers.

8. Elihu Root, undated address, box 1, AFA Papers.

9. James Bryce, "The Hope of Art in America," *Art and Progress*, November 1911, 383–85.

10. Henry White, "The Value of Art to a Nation," *Art and Progress*, December 1915, 45–51.

11. Nikolaus Pevsner, *Pioneers of Modern Design from William Morris to Walter Gropius* (1936; reprint, New York: Penguin, 1975), 26; Elizabeth Cummings and Wendy Kaplan, *The Arts and Crafts Movement* (London: Thames and Hudson, 1991).

12. C. R. Ashbee, "Art in England at War Times," *The American Magazine of Art*, November 1916, 11.

13. *American Magazine of Art*, July 1917, 356.

14. Ibid., 361.

15. Ralph Adams Cram paraphrased in *American Magazine of Art*, January 1916, 117.

16. *American Magazine of Art*, January 1916, 117.

17. Birge Harrison, "Art and the European War," *American Magazine of Art*, May 1916, 270.

18. James Haney quoted in Florence Levy, "Art Education in the Elementary Schools of New York," *Art and Progress*, March 1910, 122–23.

19. C. Howard Walker, "Relation of Industrial Art to Education," *Art and Progress*, October 1913, 1132.

20. Ibid., 1139.

21. Constance Hare, "Finding Positions for Workers in the Art Trades," *Art and Progress*, August 1910, 293–95.

22. Ralph Adams Cram, "The Craftsman and the Architect," *Art and Progress*, October 1913, 1124.

23. Ibid., 1120.

24. Ibid., 1122.

25. Ibid., 1130.

26. C. Russell Hewlett, "Relation of Industrial Art to Manufactures," *Art and Progress*, October 1913, 1147.

27. Ibid., 1149.

28. Ibid.

29. Ibid., 1150.

30. "Beauty or Ugliness?" *Art and Progress*, November 1915, 35.

31. "Art and the People," *American Magazine of Art*, June 1916, 332.

32. Charles Hutchinson, "The Democracy of Art," *American Magazine of Art*, August 1916, 397.

33. Ibid., 398.

34. Ibid.

35. "The War and Art," *American Magazine of Art*, May 1917, 286.

36. Florence Levy quoted in *American Magazine of Art*, April 1917, 245.

37. R. W. de Forest, "The Peace Program of the Federation—Its Opportunities—The Extension of Activities," 1919 Convention, Convention Files, box 14, AFA Papers.

38. Ibid.

39. Ibid.

40. Maude Howe Elliott, "Keep the Home Fires Burning: The Scared Flame of Art," *American Magazine of Art*, February 1918, 157–59.

41. *American Magazine of Art*, March 1918, 204.

42. William Merit Chase paraphrased in *American Magazine of Art*, July 1916, 375.

43. "The Old Museum," *American Magazine of Art*, August 1917, 416.

44. *American Magazine of Art*, October 1917, 498–99.

45. Duncan Phillips, "Art and War," *American Magazine of Art*, June 1918, 303.

46. *Bulletin of the Metropolitan Museum of Art* 13 (February 1918): 74.

47. *Annual Report of the Metropolitan Museum of Art* 48 (1918): 4.

48. *Bulletin of the Metropolitan Museum of Art* 12 (October 1917): 206.

49. *Bulletin of the Metropolitan Museum of Art* 12 (October 1917): 206; 13 (February 1918): 53; 13 (November 1918): 247; 12 (August 1917): 178.

50. *Bulletin of the Metropolitan Museum of Art* 12 (August 1917): 178.

51. *Annual Report of the Metropolitan Museum of Art* 48 (1918): 30.

52. Ibid., 20.

53. Jennifer Fronc, *New York Undercover: Private Surveillance in the Progressive Era* (Chicago: University of Chicago Press, 2009); Christopher Capozzola, *Uncle Sam Wants You: World War I and the Making of the Modern American Citizen* (New York: Oxford University Press, 2008); Peter Novick, *That Noble Dream: The Objectivity Question and the American Historical Profession* (New York: Cambridge University Press, 1988).

54. *Bulletin of the Metropolitan Museum of Art* 13 (February 1918): 34.

55. Richard Bach, "Industrial Art—A War Emergency," *Bulletin of the Metropolitan Museum of Art* 13 (September 1918): 196.

56. Lizabeth Cohen, *Making a New Deal: Industrial Workers in Chicago, 1919–1939* (New York: Cambridge University Press, 1990); William Leach, *Land of Desire: Merchants, Power and the Rise of a New American Culture* (New York: Vintage Books, 1993); Lawrence Glickman, *A Living Wage: American Workers and the Making of Consumer Society* (Ithaca, N.Y.: Cornell University Press, 1997).

57. Richard Bach, "Mobilizing Art Industries," *New York Times*, June 9, 1918, 65.

58. Richard Bach to H. W. Kent, April 5, 1918, Richard Bach Folder 1918–1919 #B1223, Office of the Secretary Records, Metropolitan Museum of Art Archives [hereafter referred to as MMA Archives].

59. H. W. Kent to Robert de Forest, April 11, 1918, Richard Bach Folder 1918–1919 #B1223, Office of the Secretary Records, MMA Archives.

60. Richard Bach to H. W. Kent, April 5, 1918, Richard Bach Folder 1918–1919 #B1223, Office of the Secretary Records, MMA Archives.

61. Richard Bach to H. W. Kent, April 5, 1918, Richard Bach Folder 1918–1919 #B1223, Office of the Secretary Records, MMA Archives.

62. Bach, "Mobilizing Art Industries," 65.

63. Bach, "Industrial Art—A War Emergency," 196.

64. Bach, "Mobilizing Art Industries," 65.

65. Pevsner, *Pioneers of Modern Design*, 26.

66. Bach, "Mobilizing Art Industries," 65.

67. Ibid.

68. *New York Times* editorial reprinted in "Industrial Art Education," *Bulletin of the Metropolitan Museum of Art* 13 (November 1918): 240.

69. Bach, "Industrial Art—A War Emergency," 196.

70. Ibid.

71. *Bulletin of the Metropolitan Museum of Art* 13 (February 1918): 34.

72. Walter McEwen, "Art Matters in France," *Art and Progress*, May 1911, 195.

73. "Beauty or Ugliness?" *Art and Progress*, November 1915, 34–35.

74. "Frightfulness in Art," *American Magazine of Art*, April 1917, 244.

75. Ibid.

76. Gerald McFarland, *Inside Greenwich Village: A New York City Neighborhood, 1898–1918* (Amherst: University of Massachusetts Press, 2001), 210. See also Christine Stansell, *American Moderns: Bohemian New York and the Creation of a Modern Century* (New York: Metropolitan Books, 2000).

77. 1921 French Paintings Folder—Corres. Re: Protest #L 7806, Office of the Secretary Records, MMA Archives.

Chapter 5

1. Robert de Forest, "Addresses on the Occasion of the Opening of the American Wing," in *Museum Studies*, ed. Bettina Carbonell (Malden, Mass.: Blackwell, 2004), 290.

2. Mike Wallace, "Visiting the Past: History Museums in the United States," *Mickey Mouse History and Other Essays on American Memory* (Philadelphia: Temple University Press, 1996), 4–27.

3. Diane H. Pilgrim, "Inherited from the Past: The American Period Room," *American Art Journal* 10 (May 1978): 5.

4. Christopher Monkhouse, "Cabinetmakers and Collectors: Colonial Furniture and its Revival in Rhode Island," in *American Furniture in Pendleton House*, ed. Christopher Monkhouse and Thomas Michie (Providence: Rhode Island School of Design, 1986), 33; Minutes, April 26–27, 1912, box 1, folder 1, Walpole Society Papers, Winterthur Museum Library: Joseph Downs Collection of Manuscripts and Printed Ephemera.

5. James Lindgren, *Preserving Historic New England: Preservation, Progressivism, and the Remaking of Memory* (New York: Oxford University Press, 1995), 154.

6. R. T. H. Halsey, draft of speech, Baltimore Art Museum, 1924, Box 1, Halsey Papers, Winterthur Museum Library: Joseph Downs Collection of Manuscripts and Printed Ephemera [hereafter referred to as Halsey Papers, Winterthur].

7. De Forest, "Addresses on the Occasion of the Opening of the American Wing," 291.

8. H. W. Kent, "The Bolles Collection. The Gift of Mrs. Russell Sage," *Bulletin of the Metropolitan Museum of Art* 5 (January 1910): 14.

9. *Annual Report of the Metropolitan Museum of Art* 46 (1916): 10.

10. As early as 1919, de Forest promised significant contributions to the American Wing and began covering its expenses. Robert de Forest to Edward Robinson, December 30, 1919, American Wing Building Folder 1919–20 Correspondence # B868, Office of the Secretary Records, Metropolitan Museum of Art Archives [hereafter referred to as MMA Archives].

11. Elihu Root, "Addresses on the Occasion of the Opening of the American Wing," 294.

12. Ibid.

13. In 1910, Emily de Forest anonymously donated a room from Woodbury, Long Island; the museum's *Annual Report* simply reported that the museum acquired panel-

ing from a colonial room, while the *Bulletin* reported nothing among its acquisitions, despite the fact that it reported that Emily de Forest donated linen and needlework that year, and, with her husband, a fifteenth-century Arabic window. In 1911, the museum purchased a second paneled room, and in 1912 it purchased two more rooms from Salem, Massachusetts, that, the *Bulletin* reported, were likely designed by master architect and craftsman Samuel McIntire. *Annual Report of the Metropolitan Museum of Art* 40 (1910): 34; *Bulletin of the Metropolitan Museum of Art* 6 (July 1911): 155; 7 (August 1912): 144.

14. In 1908, the museum purchased two seventeenth-century chests and an eighteenth-century ladder-back chair for the Hudson-Fulton show; Bolles's collection added to these three museum pieces. *Annual Report of the Metropolitan Museum of Art* 38 (1908): 59.

15. Halsey to Alfred Jones, June 29, 1917, R. T. H. Halsey Letterbook, vol. 2, R. T. H. Halsey Papers, New York Stock Exchange Archives [hereafter referred to as Halsey Papers, NYSE].

16. Halsey to Friedley, January 18, 1918, R. T. H. Halsey Letterbook, vol. 2, Halsey Papers, NYSE.

17. Halsey to Friedley, December 13, 1916, R. T. H. Halsey Letterbook, vol. 2, Halsey Papers, NYSE.

18. Ibid.

19. *Bulletin of the Metropolitan Museum of Art* 7 (March 1912): 60.

20. Stillinger, *Antiquers*, 138.

21. Halsey to Alphonso Clearwater, January 20, 1915; January 12, 1916, R. T. H. Halsey Letterbook, vol. 1; March 21, 1916, Halsey Letterbook, vol. 2, Halsey Papers, NYSE.

22. Halsey to Durr Friedley, February 20, 1915, R. T. H. Halsey Letterbook, vol. 1, Halsey Papers, NYSE.

23. Ibid.

24. *Bulletin of the Metropolitan Museum of Art* 18 (February 1923): 51.

25. Christopher Monkhouse quotes an 1893 letter from George Palmer to Henry Waters in Salem in which Palmer said that he hoped his collection would end up in a public institution. Monkhouse, "Cabinetmakers and Collectors," 18.

26. Kent, *My Education*, 7.

27. Halsey to Palmer, marked "Confidential," July 1, 1918, R. T. H. Halsey Letterbook, vol. 2, Halsey Papers, NYSE.

28. Bolles appraised a highboy with six turned legs for $800 and a matching lowboy for $400; the most expensive item ($2500) had provenance associating it with Mayflower passenger Peregrine White. Stillinger, *Antiquers*, 96; Halsey to Palmer, July 1, 1918, R. T. H. Halsey Letterbook, vol. 2, Halsey Papers, NYSE.

29. Stillinger, *Antiquers*, 192.

30. Halsey to Palmer, July 1, 1918, R. T. H. Halsey Letterbook, vol. 2, Halsey Papers, NYSE.

31. Ibid.

32. Ibid.

33. John S. Kennedy left the museum $2,600,000 in stocks with no conditions; therefore, de Forest could use its funds selectively. Calvin Tomkins, *Merchants and Masterpieces* (New York: E. P. Dutton, 1973), 165; *Bulletin of the Metropolitan Museum of Art* 13 (November 1918): 243.

34. Charles Hosmer, *Presence of the Past* (New York: Putnam, 1965), 219.

35. Lindgren, *Preserving Historic New England*, 114.

36. Hosmer, *Presence of the Past*, 222–31.

37. Lindgren, *Preserving Historic New England*, 108.

38. William Sumner Appleton to Edwin Hipkiss, February 21, 1920, Jaffrey Parlor Notebook, Department of Decorative Arts Archives, Museum of Fine Arts.

39. Hosmer, *Presence of the Past*; Michael Holleran, "Roots in Boston, Branches in Planning and Parks," in *Giving Preservation a History*, ed. Max Page and Randall Mason (New York: Routledge, 2004), 81–107; James Lindgren, "'A Spirit That Fires the Imagination': Historic Preservation and Cultural Regeneration in Virginia and New England, 1850–1950," in *Giving Preservation a History*, 107–30; James Lindgren, *Preserving Historic New England*.

40. Patricia West, "Inventing a House Undivided: Antebellum Cultural Politics and the Enshrinement of Mount Vernon," in *Domesticating History* (Washington, D.C.: Smithsonian Institution Press, 1999), 1–38; West, "Campaigning for Monticello," in *Domesticating History*, 93–128; Robert Weyeneth, "Ancestral Architecture: The Early Preservation Movement in Charleston," in *Giving Preservation a History*, 257–82.

41. Preservation historian Charles Hosmer explains how Fredericksburg, Virginia architect Frank Baldwin tipped Halsey off about a paneled room in a local plantation called "Marmion" that was for sale and could be had for a reasonable price; after Halsey's scout Durr Friedley sent back information, the museum bought the room in 1917. Hosmer, *Presence of the Past*, 219.

42. Halsey to Friedley, November 29, 1916, R. T. H. Halsey Letterbook, vol. 2, Halsey Papers, NYSE.

43. Ibid.

44. Ibid.

45. Halsey to Friedley, March 10, 1917, R. T. H. Halsey Letterbook, vol. 2, Halsey Papers, NYSE.

46. In 1904, annual income from the Rogers Fund yielded $200,000. Tomkins, *Merchants and Masterpieces*, 91.

47. Hosmer, *Presence of the Past*, 220.

48. Halsey to Lockwood, January 19, 1917, R. T. H. Halsey Letterbook, vol. 2, Halsey Papers, NYSE.

49. See Alan Axelrod, ed., *The Colonial Revival in America* (New York: W. W. Norton, 1985); Michael Kammen, *Mystic Chords of Memory* (New York: Alfred A. Knopf, 1991); Stillinger, *Antiquers*; Briann Greenfield, "Old New England in the Twentieth Cen-

tury Imagination: Public Memory in Salem, Deerfield, Providence, and the Smithsonian Institution" (Ph.D. diss., Brown University, 1996).

50. Ultimately, the Metropolitan never moved the Wentworth-Gardner House from Portsmouth. After various plans to either move the entire house to Central Park and install it beside the American Wing, or remove selected rooms to install inside the wing, the Met negotiated with local preservation groups who wanted to retain local possession of the house. Hosmer, *Presence of the Past*, 231. Historian James Lindgren claimed that the museum ultimately took an upstairs room from the house, but the Met's Wentworth room from Portsmouth actually came from a different house, which was much earlier than the Georgian-style house Nutting offered to SPNEA and the Metropolitan in 1918. The Wentworth room in the American Wing was purchased with Sage Foundation funds in 1926. Lindgren, *Preserving Historic New England*, 163; Amelia Peck, "The Wentworth Room," in *Period Rooms in the Metropolitan Museum of Art*, ed. Peck et al. (New York: Metropolitan Museum of Art, 1996), 177.

51. Multiple drafts of Halsey's speeches and public addresses reflect these two overlapping social and aesthetic interpretations of Americana and craft character. R. T. H. Halsey Papers, col. 56, Halsey Papers, Winterthur.

52. R. T. H. Halsey, Speech at opening of American Wing, Box1, Halsey Papers, Winterthur.

53. Francesca Moran argues that the Daughters of the American Revolution pursued progressive-style inclusive and assimilationist Americanization reform until 1920, when they shifted their agenda to a more reactionary and restrictive position toward immigrants. Morgan, *Women and Patriotism in Jim Crow America* (Chapel Hill: University of North Carolina Press, 2005). See also James R. Barrett, "Americanization from the Bottom Up: Immigration and the Remaking of the Working Class in the United States, 1880–1930," *Journal of American History* 79, no. 3 (December 1992): 996–1020; Oscar Handlin, *The Uprooted: The Epic Story of the Great Migration That Made the American People* (1951; reprint, Boston, Mass.: Little, Brown & Co., 1973; John Higham, *Strangers in the Land: Patterns of American Nativism, 1860–1925* (1955; reprint, New Brunswick, N. J.: Rutgers University Press, 1992); William Leuchtenberg, *The Perils of Prosperity, 1914–1932* (Chicago: University of Chicago Press, 1958); Warren Susman, "Culture and Civilization in the Nineteen-Twenties," in *Culture as History* (New York: Pantheon, 1984).

54. Memorandum, Assay Office Façade, November 1924, American Wing Building Folder—1924 Assay Office, Office of the Secretary Records, MMA Archives. See also I. N. Phelps Stokes, "Removal and Re-erection of the Old Assay Office, 1915–1923," in *Random Recollections of a Happy Life* (New York: privately printed, 1932; reprint of 41 copies, 1941), 149.

55. The American Wing stood on the same footprint in the park it occupies today, but neither the glass-enclosed Engelhard Court (which is where the colonial garden originally was) nor the American painting galleries (to the American Wing's immediate west) existed at that time. Both were added to the museum during the American Wing's 1980 reinstallation. In 1924 American paintings were part of the Department of Paintings, and exhibited with other paintings elsewhere in the museum.

56. The 1909 "Morgan Wing," which housed European decorative arts, is today occupied by the Metropolitan's arms and armor and musical instrument galleries.

57. R. T. H. Halsey, speech, "The American Wing—Its Character and Its Purpose," box 1, Halsey Papers, Winterthur.

58. Kent, *My Education*, 163.

59. Grosvenor Atterbury, "Addresses upon the Opening of the American Wing," 292.

60. Halsey initially lent six hundred pieces of furniture, silver, and other decorative objects for the American Wing's opening. See Peter Kenny, "R. T. H. Halsey: American Wing Founder and Champion of Duncan Phyfe," *Magazine Antiques*, January 2000, 191.

61. See correspondence files in American Wing records, 1924 American Wing folder (Atterbury Corresp. Jan), Office of the Secretary Records, MMA Archives.

62. See Lindgren, *Preserving Historic New England*; West, *Domesticating History*; Kevin D. Murphy, "The Politics of Preservation," in *A Noble and Dignified Stream*, ed. Sarah L. Giffen and Kevin Murphy (York, Maine: Old York Historical Society, 1992).

63. See Francesca Morgan, "'Home and Country:' Women, Nation and the Daughters of the American Revolution, 1890–1939" (Ph.D. diss., Columbia University, 1998), chap. 3.

64. Emily Johnston de Forest, *John Johnston of New York, Merchant* (New York: privately printed, 1909); Emily Johnston de Forest, *A Walloon Family in America; Lockwood de Forest and His Forbears 1500–1848, by Mrs. Robert W. de Forest; Together with A Voyage to Guiana, Being the Journal of Jesse de Forest and His Colonists 1623–1625* (New York: Houghton Mifflin Company, 1914).

65. William Hosley, "Hartford's Role in Antique Collecting," unpublished paper presented at the Dublin Seminar for New England Folklife, June 19, 2004.

66. *Bulletin of the Metropolitan Museum of Art* 17 (October 1922): 214.

67. *Bulletin of the Metropolitan Museum of Art*: 5 (June 1910): 156; 6 (February 1911): 46; 8 (June 1913): 113; 9 (January 1914): 25.

68. *Bulletin of the Metropolitan Museum of Art* 5 (March 1910): 82; 5 (April 1910): 103; 5 (June 1910): 156.

69. Edward Robinson to Robert de Forest, November 10, 1924, American Wing Building Folder—Exercises 1924 # B868, MMA Archives; Elihu Root, "Addresses upon the Opening of the American Wing," 295.

70. See correspondence with Metropolitan superintendent Conrad Hewitt. Conrad Hewitt to G. F. Dow, November 3, 1923, 1923 American Wing Building Folder (Atterbury Corres. July–Dec) # B868; also 1924 American Wing Building Folder (Atterbury Corres. Feb and Mar) # B868, MMA Archives.

71. Edward Robinson to R. T. H. Halsey, July 21, 1919 and July 26, 1919; Robert de Forest to R. T. H. Halsey, July 28, 1919, 1919 American Wing Folder—Corres. 1919–20 # B868, MMA Archives.

72. Atterbury, "Addresses upon the Opening of the American Wing," 293.

73. R. T. H. Halsey, draft of speech "Government and Culture in Maryland," given to students at St. John's College, undated, box 1, Halsey Papers, Winterthur.

74. Ibid.

75. R. T. H. Halsey, speech "Social Life in Eighteenth-century Maryland," given to the Annapolis University Club, undated, box 1, Halsey Papers, Winterthur.

76. See Francesca Constance Morgan, "Home and Country," chap. 2.

77. R. T. H. Halsey, speech, given at Andover, undated, box 1, Halsey Papers, Winterthur.

78. R. T. H. Halsey and Charles Over Cornelius, *A Handbook of the American Wing: Opening Exhibition*, 2nd ed., with corrections (New York: MMA, 1925), xvii.

79. R. T. H. Halsey and Elizabeth Tower, *The Homes of Our Ancestors: As Shown in the American Wing of the Metropolitan Museum of Art of New York* (New York: Doubleday, Page and Co., 1925), xxi.

80. Ibid.

81. Halsey and Cornelius, *Handbook,* 64.

82. Ibid., 72. In 1936 the Metropolitan finally succeeded in buying the Hart room and installing the original in its galleries. Amelia Peck, "The Hart Room," in *Period Rooms in the Metropolitan Museum of Art*, 171. Dow's 1913 restoration of parts of the Parson Capen house angered Appleton because he used "guesswork" to fill in (literal) holes; in response, Appleton prepared a guide of what not to do when restoring old houses. Lindgren, *Preserving Historic New England*, 138.

83. Halsey and Tower, *The Homes of Our Ancestors*, 8.

84. Ibid., 9.

85. Ibid., 8.

86. Ibid., 40.

87. Halsey and Cornelius, *Handbook,* 81; Richard Bushman, *The Refinement of America: Persons, Houses, Cities* (New York: Random House, Vintage, 1992), chap. 4.

88. Halsey and Tower, *The Homes of Our Ancestors*, 114.

89. Ibid.

90. Ibid.

91. Ibid.

92. The Metropolitan allowed the Pennsylvania Museum to take the more elegant front parlor in the spirit of preserving local pride. Alexandra Alevizatos Kirtley, "Upstairs Front Parlor of the Powel House, Philadelphia, 1768," unpublished paper delivered at the Museum and the American Period Room, a symposium organized by the Philadelphia Museum of Art, September 17, 2005. The Powel House was "saved" in 1931 as the first property of the Philadelphia Society for the Preservation of Landmarks. Amelia Peck, "The Powel Room," in *Period Rooms in the Metropolitan*, 194.

93. Ibid.

94. Halsey and Tower, *The Homes of Our Ancestors*, 118.

95. Ibid., 287.

96. Ibid.

97. Halsey, speech at Johns Hopkins, box 1, Halsey Papers, Winterthur.

98. Ibid.

99. Letter, Henry Watson Kent to R. T. H. Halsey, July 7, 1924, American Wing Building Folder—Publicity 1924–25 #B 868, Office of the Secretary Records, MMA Archives.

100. Richard Bach, draft letter, undated, American Wing Building Folder—Publicity 1924–25 #B 868, Office of the Secretary Records, MMA Archives.

101. Donna Haraway, "Teddy Bear Patriarchy: Taxidermy in the Garden of Eden, New York City, 1908–1936," *Social Text* 11 (Winter 1984–85): 20–64; Victoria Cain, "Selling Nature: American Natural History Museums, 1869–1942" (Ph.D. diss., Columbia University, 2006).

Chapter 6

1. Murdock Pemberton, "A Man, a Museum—and Their Secret Vice," *New Yorker* (September 12, 1925): 12–13.

2. Ibid.

3. Clipping, "Girl of 1921 Only Mirrors Arts of Past, Museum Shows," *Evening Telegraph*, undated, Exhibitions Folder—Manufacturers & Designers 1920–1921 Clippings # Ex 484, Office of the Secretary Records, Metropolitan Museum of Art Archives [hereafter referred to as MMA Archives].

4. Richard Bach, "Mobilizing the Art Industries," *New York Times*, June 9, 1918, 65.

5. In 1915, the MMA had presented a traveling exhibition of industrial art that was organized by the Art in Trades Club, an organization dedicated to promoting American things. At the same time, the Met collaborated with *Women's Wear Daily* to present an exhibition of textiles. *Bulletin of the Metropolitan Museum of Art* 12 (April 1917): 92. Textiles in the *Women's Wear Daily* exhibition had to be inspired by either the Met, the American Museum of Natural History, or the New York Public Library. *Bulletin of the Metropolitan Museum of Art* 12 (January 1917): 16.

6. "The Designer and the Museum: An Exhibition in Class Room B," *Bulletin of the Metropolitan Museum of Art* 12 (April 1917): 93.

7. Report, "The Metropolitan Museum of Art Exhibition of Objects Showing Influence by the Manufacturer," Exhibitions Folder—Manufacturers & Designers 1917 (Misc.) # Ex 484, Office of the Secretary Records, MMA Archives.

8. "The Designer and the Museum," 93.

9. Unsigned letter to J. C. Dana, March 31, 1917, Exhibitions Folder—Manufacturers & Designers 1917 # Ex 484, Office of the Secretary Records, MMA Archives.

10. "Art in the Trades Shown in Museum," *New York Times*, January 12, 1919, 26.

11. Richard Bach, "The Museum as a Laboratory," *Bulletin of the Metropolitan Museum of Art* 14 (January 1919): 2.

12. Ibid.

13. Ibid., 3.

14. Ibid., 2.

15. "Art in the Trades Shown in Museum," *New York Times*, January 12, 1919, 26.

16. *Bulletin of the Metropolitan Museum of Art* 14 (February 1919): 40.

17. Bach, "Museum as a Laboratory," 3.

18. Bach, "Exhibition Work by Manufacturers and Designers," *Bulletin of the Metropolitan Museum of Art* 15 (February 1920): 34.

19. *Bulletin of the Metropolitan Museum of Art* 15 (February 1920): 35.

20. Christine Laidlaw, "The Metropolitan Museum of Art and Modern Design: 1917–1929," *Journal of Decorative and Propaganda Arts* (Spring 1988): 93.

21. Richard Bach, manuscript draft, "The Artist in Industry," from *Good Furniture* for March 1918, box 1, folder c, Richard Bach Papers, Avery Architectural and Fine Arts Library.

22. Richard Bach, "Fourth Exhibition of Work by Manufacturers and Designers," *Bulletin of the Metropolitan Museum of Art* 15 (March 1920): 49.

23. Ibid.

24. Ibid.

25. Bach, "Artist in Industry."

26. Ibid.

27. Ibid.

28. Bach, "War Emergency," *Bulletin of the Metropolitan Museum of Art* 13 (September 1918): 196. William Leach has pointed out the relationship between museums, manufacturers and retailers during this period. Leach argues, "they were all opportunists who suspended judgment about businessmen and climbed on the bandwagon of catering to business needs." Leach, *Land of Desire: Merchants, Power, and the Rise of a New American Culture* (New York: Vintage Books, 1993), 164–73.

29. *Bulletin of the Metropolitan Museum of Art* 17 (December 1922): 250.

30. See Laidlaw, "Metropolitan Museum and Modern Design," 97.

31. *Bulletin of the Metropolitan Museum of Art* 10 (March 1915): 58; ibid., 12 (April 1917): 98.

32. Ibid., 12 (October 1917): 211.

33. Richard Bach, "Sidelights of the Fifth Exhibition of Industrial Art," *Bulletin of the Metropolitan Museum of Art* 16 (January 1921): 4.

34. Ibid.

35. "The Museum in Use," *Bulletin of the Metropolitan Museum of Art* 17 (December 1922): 265.

36. *Bulletin of the Metropolitan Museum of Art* 16 (September 1921): 178.

37. Ibid., 16 (October 1921): 238.

38. Ibid. 17 (December 1922): 250.

39. "Museum Lecture Courses," *Bulletin of the Metropolitan Museum of Art* 18 (September 1923): 207.

40. "Industrial Arts Shown in the Museum," *New York Times*, February 3, 1923, 12.

41. Ibid.

42. The $10,000 gift would be renewed five times. *Bulletin of the Metropolitan*

Museum of Art 17 (June 1922): 146; Laidlaw, "Metropolitan Museum and Modern Design," 93.

43. "Modern Art Show at Metropolitan," *New York Times*, February 10, 1923, 12. The American objects Breck purchased were "art pieces," which were not produced for mass consumption, and therefore would not have been eligible for display in Bach's industrial art exhibitions.

44. Joseph Breck, "Modern Decorative Arts," *Bulletin of the Metropolitan Museum of Art* 18 (February 1923): 34.

45. "Modern Art Show at Metropolitan," 12.

46. Ibid.

47. Breck's modern collection included works by Émile Gallé, Jean Dunand, Georg Jensen, and Adelaide Alsop Robineau. Laidlaw, "Metropolitan Museum and Modern Design," 94.

48. Joseph Breck, "Modern Decorative Arts," *Bulletin of the Metropolitan Museum of Art* 18 (October 1923): 244.

49. Bach, "Motive, Material, Market: The Designer at Work in the Museum," *Bulletin of the Metropolitan Museum of Art* 18 (September 1923): 209.

50. Ibid.

51. Ibid.

52. Bach, "The Exhibition of American Industrial Art," *Bulletin of the Metropolitan Museum of Art* 18 (December 1923): 280.

53. George Creel, *How We Advertised America* (New York: Harper & Brothers, 1920).

54. David Kennedy, *Over Here: the First World War and American Society* (1980; reprint, New York: Oxford University Press, 2004), 90–91.

55. Bach, "American Industrial Art," *Bulletin of the Metropolitan Museum of Art* 14 (January 1924): 2.

56. Ibid.

57. Ibid.

58. Joseph Breck, "Modern Decorative Arts: A Loan Exhibition," *Bulletin of the Metropolitan Museum of Art* 21 (February 1926): 36.

59. Richard Bach to H. W. Kent, August 8, 1925, Richard Bach Folder 1922–1926 # B1223, Office of the Secretary Records, MMA Archives.

60. *Annual Report of the Metropolitan Museum of Art* 25 (1925): 30; "1929 Report of the Division of International Arts," box 1, Papers of American Federation of Arts, Archives of American Art, Smithsonian Institution; *Report of the Commission Appointed by the Secretary of Commerce to Visit and Report Upon the International Exposition of Modern Decorative and Industrial Art in Paris, 1925* (Washington, D.C.: U.S. Department of Commerce, 1926).

61. Charles Richards to Leroy Latham, undated, Industrial Exposition of Modern Decorative and Industrial Art Folder (1923–25) # IN 976, Office of the Secretary Records, MMA Archives.

62. Correspondence, 1925 International Exposition Folder, Box 3 Folder 11, Richard F. Bach Records, 1913–1935, MMA Archives.

63. Marilyn Friedman, "The United States and the 1925 Paris Exposition: Opportunity Lost and Found," *Studies in the Decorative Arts* (2006): 94–120.

64. Historians of design have criticized the privilege contemporary taste makers gave to the stylized aesthetic that would later become known as art deco over the more simplified style that art and design historians now call Modernism. Likewise, they question the contemporary use of the term *modern* to describe the art deco style. See Judith Gura, "Modernism and the 1925 Paris Exposition," *Magazine Antiques* 158 (August 2000): 194–203.

65. Richard Bach to H. W. Kent, August 25, 1925, Richard Bach Folder 1922–1926 # B1223, Office of the Secretary Records, MMA Archives.

66. Joseph Breck, "Swedish Contemporary Decorative Arts," *Bulletin of the Metropolitan Museum of Art* (January 1927): 3.

67. Romy Golan, *Modernity and Nostalgia: Art and Politics in France Between the Wars* (New Haven, Conn.: Yale University Press, 1995); Kenneth Silver, *Esprit de Corps: the Art of the Parisian Avant-garde and the First World War, 1914–1925* (Princeton, N.J.: Princeton University Press, 1989); Silver, "Neo-Romantics," in *Paris New York: Design, Fashion, Culture, 1925–1940*, ed. Donald Albrecht (New York: Museum of the City of New York, 2008).

68. Breck, "Modern Decorative Arts," 36.

69. "French Decorative Art on Exhibition," *New York Times*, February 28, 1926, SM10.

70. Breck, "Modern Decorative Arts," 36.

71. Joseph Breck, "The Current Exhibition of Modern Decorative Arts," *Bulletin of the Metropolitan Museum of Art* 21 (March 1926): 66.

72. "French Decorative Art on Exhibition," 10.

73. Breck, "Current Exhibition of Modern Decorative Arts," 66.

74. Verb tense changed for clarity. *Annual Report of the Metropolitan Museum of Art* 56 (1925): 29

75. Ibid.

76. Ibid.

77. William Leach explains the influence this exposition had on other department stores throughout the United States. Leach, *Land of Desire,* 314.

78. De Forest chaired the Exposition's advisory committee, which included Richard Bach; Mary Linton Ackerman, president of the Decorator's Club; John Agar, president of the National Arts Club; Bruce Barton, president of Barton, Durstine & Osbourne; Alon Bement, director of the Arts Center; John Finley, associate editor of the *New York Times* and president of the Arts Council of New York City; Florence Levy, long-time Metropolitan educator and executive secretary of the Arts Council of New York; Henry McBride, art critic for the *New York Sun*; Frank Alvah Parsons, president of the New York School of Applied and Fine Art; Charles Richards, director of industrial art for the

General Education Board; Mrs. George Palen Snow, editor at *Vogue*; Alexander Trowbridge, president of the Architectural League of New York; and Richardson Wright, editor of *House & Garden*. Advertisement, *New York Times*, May 1, 1927, 11.

79. Ibid.

80. Ibid.

81. Ibid.

82. Ibid.

83. *Bulletin of the Metropolitan Museum of Art* 22 (June 1927): 180.

84. Ibid.

85. Ibid.

86. "1929 Report of the Division of Industrial Arts," box 1, Papers of the American Federation of Arts, Archives of American Art, Smithsonian Institution.

87. Edward Alden Jewell, "Industrial Art Show at the Metropolitan," *New York Times,* February 11, 1929, 124.

88. *Annual Report of the Metropolitan Museum of Art* 59 (1928): 32.

89. Ibid.

90. Richard Bach to H. W. Kent, April 14, 1928, Manufacturers and Designers Exhibition Folder 1928 # Ex 484, Office of the Secretary Records, MMA Archives.

91. Robert de Forest to Ely Kahn, April 30, 1928, Manufacturers and Designers Exhibition Folder 1928 # Ex 484, Office of the Secretary Records, MMA Archives.

92. H. W. Kent to Robert de Forest, May 26, 1928, American Industrial Art Exhibition Folder 1929 General Discussion # Ex 484, Office of the Secretary Records, MMA Archives.

93. H. W. Kent to Edward Robinson, October 22, 1928, American Industrial Art Exhibition folder 1929 General Discussion # Ex 484, Office of the Secretary Records, MMA Archives.

94. *Annual Report of the Metropolitan Museum of Art* 60 (1929): 8.

95. E. B. Grier at the Metropolitan's information desk reported to Kent that attendance at the 1929 industrial art exhibit within the first 56 days soared above attendance at other recently successful exhibits: whereas the Architect and the Industrial Arts had brought in 105,428 visitors to date, the Spanish paintings exhibit El Greco to Goya had brought in 86,610 visitors and the AFA's Swedish contemporary design show had yielded 67,502 visitors. Note, E. B. Grier to H. W. Kent, April 8, 1929, American Industrial Art Exhibitions Folder—General Discussion # Ex 484, Office of the Secretary Records, MMA Archives.

96. "The Skyline," *New Yorker*, March 9, 1929, 80.

97. Ely Kahn, "Backyard Garden," *The Architect and the Industrial Arts: An Exhibition of Contemporary American Design* (New York: MMA, 1929), 31–34.

98. Leon Solon, *The Architect and the Industrial Arts* (New York: MMA, 1929), 15.

99. Raymond Hood, "Business Executive's Office," *The Architect and the Industrial Arts* (New York: MMA, 1929), 71–73.

100. Raymond Hood, "Apartment House Loggia," *The Architect and the Industrial Arts* (New York: MMA, 1929), 67–69.

101. Publicity article, accompanied with letter, Winifred Howe to Robert de Forest, February 5, 1929, American Industrial Art Exhibition Folder—1929 Publicity # Ex 484, Office of the Secretary Records, MMA Archives.

102. Ibid.

Epilogue

1. J. Olin Howe, "An Art Museum Looking for Work," *Boston Evening Transcript*, February 19, 1919.

2. "Art Museum Marks 60th Anniversary," *New York Times*, April 15, 1930, 22.

3. Trustees Henry Waters, George F. Baker, Edward D. Adams, Daniel Chester French, and advisory trustee Charles W. Gould died in 1931, as well as president Robert de Forest and director Edward Robinson. *Annual Report of the Metropolitan Museum of Art* 61 (1931): 1.

4. Mike Wallace, "Visiting the Past: History Museums in the United States," in Wallace, *Mickey Mouse History* (Philadelphia: Temple University Press, 1996), 14–15; Patricia West, "Campaigning for Monticello," in West, *Domesticating History: The Political Origins of America's House Museums* (Washington, D.C.: Smithsonian, 1999), 93–128; Lindgren, *Preserving Historic New England: Preservation, Progressivism, and the Remaking of Memory* (New York: Oxford University Press, 1995), 134–70.

5. For a contemporary account of the impact of the "modern" aesthetic on industrial design in the 1930s, see Shelden and Martha Candler Cheney, *Art and the Machine: An Account of Industrial Design in Twentieth-Century America* (New York: McGraw-Hill, 1936).

6. Sybil Gordon Kantor, *Alfred H. Barr and the Intellectual Origins of the Museum of Modern Art* (Boston: MIT, 2002), 36–85. For Dana's museum program see E. T. Booth, *Apprenticeship in the Museum* (Newark, N.J.: Newark Museum, 1928).

7. J. C. Dana had died in 1929.

8. The main focus of education programs in the 1930s consisted of local circulating Neighborhood Exhibits. *Annual Report of the Metropolitan Museum of Art* 65 (1935): 42. See also Works Progress Administration Folder—Museum Employment (1933–1936) # W 8918, Office of the Secretary Records, Metropolitan Museum of Art Archives [hereafter MMA Archives].

9. Calvin Tomkins, *Master and Masterpieces* (New York: E. P. Dutton, 1973), 217.

10. Stories about these museum policies are also part of the museum's institutional memory, and their repetition cements the ideas of professional deference (still very much alive at the Metropolitan, despite its continuing professionalization and institutional modernization over the course of the last century), much as traditional attitudes about the cultural value of decorative arts reinforce curators' perceived position in the museum's cultural hierarchy.

11. Trustee, Art in Trades founder, and social progressive William Sloane Coffin succeeded de Forest as president of the Metropolitan, and he vowed to continue de Forest's museum policies, but he only lived two more years. Throughout the 1930s, the

Metropolitan underwent a gradual institutional transformation under the direction of the also short-lived presidency of George Blumenthal and the directorship of Egyptian art scholar Herbert Winlock.

12. This articulation of cultural authority centered in the position of art museum directors continues to this day at the Metropolitan and most other art museums. Institutional histories like Met director Thomas Hoving's memoir illustrate the supremacy of "modern" art museum directors. Thomas Hoving, *Making the Mummies Dance: Inside the Metropolitan Museum of Art* (New York: Simon & Schuster, 1993). See also Thomas Hoving et al., *The Chase, the Capture: Collecting at the Metropolitan Museum of Art* (New York: MMA, 1975).

13. Both Luke Vincent Lockwood and Kent shared their memories of the Walpole Society in their final days (leading to the thirtieth anniversary commemoration of the Walpole Society), but their correspondence reflects their very different social positions, and the differences in meaning the Walpole Society and the objects they collected had for them. Lockwood's wife took care of him as he aged, and she handled his correspondence from their estate in Greenwich, Connecticut. Kent, however, with no one to take care of these personal details, corresponded from his Manhattan apartment directly with then Walpole Society secretary Chauncey Nash. Kent's increasingly scrawled handwriting in his detailed letters reveals the social differences between these two Walpole Society founders. Correspondence between Chauncey Nash and Luke Vincent Lockwood and Henry Watson Kent, box 13, col. 386, Walpole Society Papers, The Winterthur Library: Joseph Downs Collection of Printed Ephemera.

14. See correspondence in Richard Bach Records: Box 3, Folder 9—International Council of Museums; Box 4, Folder 1, MMA postwar Building Plans; Proposed Post-War Works Program, NYC Planning Commission, 1942; Box 4, Folder 6, Museum Council of New York; Box 4, Folders 7–10, Study on Museum relation to Industry, 1952, Richard F. Bach Papers, MMA Archives.

15. Michelle Obama, "Remarks by the First Lady at the Ribbon Cutting Ceremony for the Metropolitan Museum of Art American Wing," Office of the First Lady, White House Press Release, May 18, 2009.

16. Ibid.

BIBLIOGRAPHY

Archival Collections

Henry Watson Kent Papers. Archives of the Slater Memorial Museum and Library.

John Cotton Dana Correspondence. Springfield Museum and Library (Mass.).

Office of the Secretary Records. The Metropolitan Museum of Art Archives.

Papers of the American Federation of Arts. Archives of American Art, Smithsonian Institution.

R. T. H. Haines Halsey Papers. New York Stock Exchange Archives.

R. T. H. Haines Halsey Papers. Winterthur Museum Library: Joseph Downs Collection of Manuscripts and Printed Ephemera.

Richard Bach Papers. Avery Architectural and Fine Arts Library.

Richard Bach Papers. The Metropolitan Museum of Art Archives.

Walpole Society Papers. Winterthur Museum Library: Joseph Downs Collection of Manuscripts and Printed Ephemera.

Published Work

Addams, Jane. *Twenty Years at Hull House*. 1910; reprint, New York: Macmillan Company, 1925.

Alexander, Edward P. "Artistic and Historical Period Rooms." *Curator* 7, no. 4 (1964): 263–81.

———. *Museums and Motion*. Nashville, Tenn.: American Association for State and Local History, 1979.

———. *Museum Masters*. Nashville, Tenn: American Association for State and Local History, 1983.

Arnold, Matthew. *Culture and Anarchy*. New Haven, Conn.: Yale University Press, 1994.

Auchincloss, Louis. *J.P. Morgan: The Financier as Collector*. New York: Abrams, 1990.

Auslander, Leora. "Beyond Words." *American Historical Review* 110, no. 4 (October 2005): 1015–45.

———. *Taste and Power: Furnishing Modern France*. Berkeley: University of California Press, 1996.

Axelrod, Alan, ed. *The Colonial Revival in America*. New York: W. W. Norton & Co., 1985.

Ballon, Hilary. *The Paris of Henri IV, Architecture and Urbanism*. New York: Architectural History Foundation; Cambridge, Mass.: MIT Press, 1990.

Barquist, David. *American Tables and Looking Glasses in the Mable Brady Garvan and Other Collections at Yale University.* New Haven, Conn.: Yale University Art Gallery, 1992.

Barrett, James R. "Americanization from the Bottom Up: Immigration and the Remaking of the Working Class in the United States, 1880–1930." *Journal of American History* 79, no. 3 (December 1992): 996–1020.

Beckert, Sven. *The Monied Metropolis: New York City and the Consolidation of the American Bourgeoisie, 1850–1896.* Cambridge: Cambridge University Press, 2001.

Bender, Thomas. *Toward an Urban Vision: Ideas and Institutions in Nineteenth Century America.* Baltimore: Johns Hopkins University Press, 1982.

Benjamin, Walter. *Illuminations.* Edited by Hannah Arendt. Translated by Harry Zohn. New York: Shocken Books, 1968.

Benson, Susan Porter, Stephen Brier, and Roy Rosenzweig, eds. *Presenting the Past: Essays on History and the Public.* Philadelphia: Temple University Press, 1986.

Berman, Marshall. *All That Is Solid Melts into Air.* New York: Penguin Books, 1982.

Bernstein, Ivers. *The New York City Draft Riots: Their Significance for American Society and Politics in the Age of the Civil War.* New York: Oxford University Press, 1990.

Bennett, Tony: *The Birth of the Museum: History, Theory, Politics.* London: Routledge, 1995.

Betts, Mary Beth. *The Governor's Room, City Hall, New York.* New York: Art Commission of the City of New York, 1983.

Blake, Casey. *Beloved Community: The Cultural Criticism of Randolph Bourne, Van Wyck Brooks, Waldo Frank, & Lewis Mumford.* Chapel Hill: University of North Carolina Press, 1990.

Bluestone, Daniel. "Academics in Tennis Shoes: Historic Preservation and the Academy." *Journal of the Society of Architectural Historians* 58, no. 3 (September 1999): 300–307.

———. *Constructing Chicago.* New Haven, Conn.: Yale University Press, 1991.

Bodner, John. *Remaking America: Public Memory, Commemoration, and Patriotism in the Twentieth Century.* Princeton, N.J.: Princeton University Press, 1992.

Bogart, Michele. *The Politics of Urban Beauty: New York and Its Art Commission.* Chicago: University of Chicago Press, 2006.

Boris, Eileen. *Art and Labor: Ruskin, Morris, and the Craftsman Ideal in America.* Philadelphia: Temple University Press, 1986.

Borus, Daniel. *Twentieth-Century Multiplicity: American Thought and Culture, 1900–1920.* Lanham, Md.: Rowman & Littlefield, 2009.

Bourdieu, Pierre. *Distinction: A Social Critique of the Judgement of Taste.* Translated by Richard Nice. Cambridge, Mass.: Harvard University Press, 1984.

Bourdieu, Pierre and Alain Darbel. *The Love of Art: European Museums and Their Public.* Translated by Caroline Beattie and Nick Merriman. Stanford, Calif.: Stanford University Press, 1990.

Bourne, Randolph. *The Radical Will: Selected Writings, 1911–1918.* Berkeley: University of California Press, 1992.

Boyers, Paul. *Urban Masses and Moral Order in America, 1820–1920*. Cambridge, Mass.: Harvard University Press, 1978.

Boylan, James. *Revolutionary Lives: Anna Strunsky & William English Walling*. Amherst: University of Massachusetts Press, 1998.

Brownlee, David Bruce. *Building the City: The Benjamin Franklin Parkway and the Philadelphia Museum of Art*. Philadelphia: University of Pennsylvania Press, 1989.

Buntix, Gustavo and Ivan Karp. *Museum Frictions*. Durham, N.C.: Duke University Press, 2006.

Burke, Doreen Bolger. *In Pursuit of Beauty: Americans and the Aesthetic Movement*. New York: Metropolitan Museum of Art, 1986.

Burrows, Edwin G. and Mike Wallace. *Gotham: A History of New York City to 1898*. New York: Oxford University Press, 1999.

Bushman, Richard L. *Refinement in America: Persons, Houses, Cities*. New York: Vintage Books, 1992.

Cain, Victoria. "Selling Nature: American Natural History Museums, 1869–1942." Ph.D. diss., Columbia University, 2006.

Cameron, Duncan. "The Museum, a Temple or the Forum?" *Curator* 14 (1971): 11–24.

Cantor, Jay. "Art and Industry: Reflections of the Role of the American Museum in Encouraging Innovation in the Decorative Arts." In *Winterthur Conference Report*, ed. Ian Quimby and Polly Anne Earl. Charlottesville: University of Virginia Press, 1973.

Cappazolla, Christopher. *Uncle Sam Wants You: World War I and the Making of the Modern American Citizen*. New York: Oxford University Press, 2008.

Carbonell, Bettina Messias, ed. *Museum Studies: An Anthology of Contexts*. Malden, Mass.: Blackwell Publishing, 2004.

Chambers, John Whiteclay II. *The Tyranny of Change: America in the Progressive Era, 1890–1920*. New Brunswick, N.J.: Rutgers University Press, 1992.

Chandler, Alfred. *The Visible Hand: The Managerial Revolution in American Business*. Cambridge, Mass.: Belknap Press of Harvard University Press, 1977.

Cheney, Sheldon and Martha Candler Cheney. *Art and the Machine: An Account of Industrial Design in Twentieth-Century America*. New York: McGraw-Hill, 1936.

Clements, Kendrick A. *Hoover, Conservation, and Consumerism: Engineering the Good Life*. Lawrence: University Press of Kansas, 2000.

Cohen, Lisabeth. *A Consumer's Republic: The Politics of Mass Consumption in Postwar America*. New York: Knopf, 2003.

———. *Making a New Deal: Industrial Workers in Chicago, 1919–1939*. New York: Cambridge University Press, 1990.

"A Collector's Portrait." Reprinted from *American Collector*. *Walpole Society Notebook*. The Walpole Society, 1935.

Conn, Steven. *Museums and American Intellectual Life, 1876–1926*. Chicago: University of Chicago Press, 1998.

Cook, Clarence. *The House Beautiful*. New York: Scribner's Sons, 1881; reprint, New York: Dover Publications,1995.

Corn, Wanda. *The Great American Thing: Modern Art and National Identity, 1915–1935.* Berkeley: University of California Press, 1999.

Creel, George. *How We Advertised America.* New York: Harper & Brothers, 1920.

Crocker, Ruth. *Philanthropy and Industry in Victorian America.* Bloomington: Indiana University Press, 2006.

Crunden, Robert. *Body and Soul: The Making of American Modernism.* New York: Basic Books, 2000.

Cumming, Elizabeth and Wendy Kaplan. *The Arts and Crafts Movement.* London: Thames and Hudson Ltd., 1993.

Cummings, Neil and Marysia Lewendowska. *The Value of Things.* Basel: Birkhaüser, 2000.

Cushman, Karen. "Museum Studies: The Beginnings, 1900–1926." *Museum Studies Journal* 1 (Spring 1984): 8–18.

Dana, John Cotton. "An Industrial Exhibit in a Municipal Museum." *American City* 13, no. 1 (July 1915): 20–22.

———. *A Plan for a New Museum: The Kind of Museum It Will Profit a City to Maintain.* Woodstock, Vt.: The Elm Street Press, 1920.

———. *The Gloom of the Museum.* Woodstock, Vt.: Elm Tree Press, 1917.

Davidson, Marshall. "Those American Things." *Metropolitan Museum Journal* 3 (1970): 222.

Dawidoff, Robert. *The Genteel Tradition and the Sacred Rage.* Chapel Hill: University of North Carolina Press, 1992.

Dawley, Alan. *Struggles for Justice: Social Responsibility and the Liberal State.* Cambridge, Mass.: Belknap Press of Harvard University Press, 1991.

de Forest, Emily Johnston. *John Johnston of New York, Merchant.* New York: privately printed, 1909.

———. *A Walloon Family in America; Lockwood de Forest and his Forbears 1500–1848, by Mrs. Robert W. de Forest; Together with A Voyage to Guiana, Being the Journal of Jesse de Forest and his Colonists 1623–1625.* New York: Houghton Mifflin Company, 1914.

de Forest, Robert W. and Lawrence Veiller. *The Tenement House Problem: Including the Report of the New York State Tenement House Commission of 1900.* New York: Macmillan & Co., 1903.

de Grazia, Victoria. *Irresistible Empire: America's Advance through Twentieth-Century Europe.* Cambridge, Mass.: Belknap University Press, 2005.

de Wolfe, Elsie. *The House in Good Taste.* 1913; reprint, New York: Rizzoli, 2004.

Denenberg, Thomas Andrew. *Wallace Nutting and the Invention of Old America.* New Haven, Conn.: Yale University Press, 2003.

Denning, Michael. *The Cultural Front: The Laboring of American Culture in the Twentieth Century.* London: Verso, 1997.

Dewey, John. *Art as Experience.* 1934; reprint, New York: Pedigree, 1980.

di Maggio, Paul. "Changes in the Structure and Composition of Non-profit Boards of

Trustees: Case Studies from Boston and Cleveland, 1925–1985." *Voluntas* 4 (1994): 271–300.

———. "Notes on the Relationship between Art Museums and their Publics." In *The Economics of Art Museums*, ed. Martin Fieldstein. Chicago: University of Chicago Press, 1992.

———. "Progressivism and the Arts." *Society* 25, no. 5 (July/August 1988): 70–76.

Donahue, Mary Elizabeth. "Design and the Industrial Arts in America, 1894–1940: An Inquiry into Fashion Design and Art and Industry." Ph.D. diss., City University of New York, 2001.

Douglas, Ann. *Terrible Honesty: Mongrel Manhattan in the 1920s*. New York: The Noonday Press, 1995.

Drakin, M. L. "Throwing Out the Period Room." *History News* 42, no. 5 (September/ October 1987): 13–17.

Duncan, Carol. "Art Museums and the Ritual of Citizenship." In *Interpreting Objects and Collections*, ed. Susan M. Pearce. London: Routledge, 1994.

———. *Civilizing Rituals: Inside Public Art Museums*. London: Routledge, 1995.

———. *A Matter of Class: John Cotton Dana, Progressive Reform, and the Newark Museum*. Pittsburgh: Periscope, 2009.

Duncan, Sally Anne. "Paul J. Sachs and the Institutionalization of Museum Culture Between the World Wars." Ph.D. diss., Tufts University, 2001.

Eastlake, Charles L. *Hints on Household Taste in furniture, upholstery and other details*. London: Longmans, Green, and Co., 1872; reprint, New York: B. Blom, 1971.

Eccles, David. *On Collecting*. London: Longmans, 1968.

Einreinhofer, Nancy. *The American Art Museum: Elitism and Democracy*. London: Leicester University Press, 1997.

Ellis, Megan J. *Stir It Up: Home Economics and American Culture*. Philadelphia: University of Pennsylvania Press, 2008.

Ekirch, Arthur, Jr. *Progressivism in America: A Study of the Era from Theodore Roosevelt to Woodrow Wilson*. New York: New Viewpoints, 1974.

Elsner, John and Roger Cardinal, eds. *The Cultures of Collecting*. London: Reaktion, 1994.

Erving, Henry Wood. *Random Notes on Colonial Furniture*. Hartford, 1931.

———. "Random Recollections of an Early Collector." *The Twenty-Fifth Anniversary Meeting of the Walpole Society*. Walpole Society, 1935.

———. "The Hartford Chest." In *Connecticut Tercentenary Commission*, no. 22. New Haven, Conn.: Yale University Press, 1934.

Ettema, Michael J. "History Museums and the Culture of Materialism." In *Past Meets Present*, ed. Jo Blatti. Washington, D.C.: Smithsonian Institution Press, 1987.

Fairbanks, Jonathan and Elizabeth Bidwell Bates. *American Furniture, 1620 to the Present*. New York: Richard Marek Publishers, 1981.

Fieldstien, Martin, ed. *The Economics of Art Museums*. Cambridge: National Bureau of Economic Research, 1992.

Flagler, Harry Harkness. *Harry Watson: An Appreciation*. Privately printed, 1949.

Fleming, E. McClung. "Artifact Study: A Proposed Model." *Winterthur Portfolio* 9 (1974): 153–73.

———. "The Period Room as a Cultural Publication." *Museum News* (June 1972): 39–43.

Fox, Daniel. *Engines of Culture: Philanthropy and Art Museums.* New Brunswick, N.J.: Transaction, 1963.

Fox, Richard Wightman and T. J. Jackson Lears, eds. *The Power of Culture: Critical Essays in American History.* Chicago: University of Chicago Press, 1993.

Frelinhuysen, Alice Cooney. "Emily Johnston de Forest." *Magazine Antiques* 157 (January 2000): 192–96.

Fronc, Jennifer. *New York Undercover: Private Surveillance in the Progressive Era.* Chicago: University of Chicago Press, 2009.

Giffen, Sarah L. and Kevin Murphy. *A Noble and Dignified Stream.* York, Maine: Old York Historical Society, 1992.

Gilmartin, Gregory. *Shaping the City: New York and the Municipal Art Society.* New York: Clarkson Potter, 1995.

The Graphic Regional Plan: Atlas and Description. Vol. 1. New York: Regional Plan of New York and Its Environs, 1929.

Grant, Julia. "Modernizing Mothers: Home Economics and the Parent Education Movement, 1920–1945." In *Rethinking Home Economics: Women and the History of a Profession,* ed. Sarah Stage and Virginia B. Vincenti. Ithaca, N.Y.: Cornell University Press, 1997.

Greenfield, Briann. "Old New England in the Twentieth Century Imagination: Public Memory in Salem, Deerfield, Providence, and the Smithsonian Institution." Ph.D. diss., Brown University, 1996.

Gura, Judith. "Modernism and the 1925 Paris Exposition." *Magazine Antiques* 158 (August 2000): 194–203.

Hall, Peter Dobkin. *The Organization of American Culture, 1700–1900: Private Institutions, Elites, and the Origins of American Nationality.* New York: New York University Press, 1982.

Halsey, R. T. H. and Charles Over Cornelius. *A Handbook of the American Wing: Opening Exhibition.* 2nd ed. New York: Metropolitan Museum of Art, 1925.

Halsey, R. T. H. and Elizabeth Tower. *The Homes of Our Ancestors: As Shown in the American Wing of the Metropolitan Museum of Art of New York.* New York: Doubleday, Page and Co., 1925.

Handler, Richard and Eric Gable. *The New History in an Old Museum: Creating the Past at Colonial Williamsburg.* Durham, N.C.: Duke University Press, 1997.

Handlin, Oscar. *The Uprooted: The Epic Story of the Great Migration That Made the American People.* 1951; reprint, Boston: Little, Brown & Co., 1973.

Haraway, Donna. "Teddy Bear Patriarchy: Taxidermy in the Garden of Eden, New York City, 1908–1936." *Social Text* 11 (Winter 1984–85): 20–64.

Harris, Neil. *The Artist in American Society: The Formative Years, 1790–1860*. New York: George Braziller, 1966; reprint, Chicago: University of Chicago Press,1982.

———. "Collective Possession: J. Pierpont Morgan and the American Imagination." In *J. Pierpont Morgan, Collector: European Decorative Arts from the Wadsworth Atheneum*, ed. Linda Roth. Hartford: Wadsworth Atheneum, 1987.

———. *Cultural Excursions: Marketing Appetites and Cultural Tastes in Modern America*. Chicago: University of Chicago Press, 1990.

———. "The Gilded Age Revisited: Boston and the Museum Movement." *American Quarterly* 14 (Winter 1962): 545–66.

Herbst, John A. "Historic Houses." In *History of Museums in the United States: A Critical Assessment*, ed. Warren Leon and Roy Rosenzweig. Urbana: University of Illinois Press, 1989.

Higham, John. *Strangers in the Land: Patterns of American Nativism, 1860–1925*. 1955; reprint, New Brunswick, N.J.: Rutgers University Press, 1992.

Hijya, James. "Four Ways of Looking at a Philanthropist: A Study of Robert Weeks de Forest." *Proceedings of the American Philosophical Society* 124, no. 6 (December 17, 1980): 404–18.

Hodder, Ian, ed. *The Meaning of Things: Material Culture and Symbolic Expression*. London: Unwin Hyman, 1989.

Hooper-Greenhill, Eilean. *Museums and the Shaping of Knowledge*. London: Routledge, 1992.

Horowitz, Helen Lefkowitz. *Culture and the City*. Chicago: University of Chicago Press, 1976.

Hosmer, Charles. *Presence of the Past*. New York: Putnam, 1965.

Hoving, Thomas, and Dietrich Von Bothmer. *The Chase, the Capture: Collecting at the Metropolitan*. New York: Metropolitan Museum of Art, 1995.

———. *Making the Mummies Dance: Inside the Metropolitan Museum of Art*. New York: Simon & Schuster, 1993.

Howe, Winifred E. *A History of the Metropolitan Museum of Art with a Chapter on the Early Institutions of Art in New York*. 1913; reprint, New York: Arno Press, 1974.

Hutchison, Janet. "American Housing, Gender, and the Better Homes Movement." Ph.D. diss., University of Delaware, 1989.

Jackson, Anthony. *A Place Called Home: A History of Low-Cost Housing in Manhattan*. Cambridge, Mass.: MIT Press, 1976.

Jackson, Kenneth, ed. *The Encyclopedia of New York*. New Haven, Conn.: Yale University Press, 1995.

Kantor, Sybil Gordon. *Alfred H. Barr and the Intellectual Origins of the Museum of Modern Art*. Cambridge, Mass.: MIT Press, 2002.

Kaplan, Wendy. "R. T. H. Halsey: An Ideology of Collecting American Decorative Arts." Master's thesis, Winterthur, University of Delaware, May 1980.

———, ed. *"The Art That is Life": The Arts and Crafts Movement in America, 1875–1920*. Boston: Little, Brown and Company and the Museum of Fine Arts, Boston, 1987.

Kammen, Michael. *Mystic Chords of Memory*. New York: Knopf, 1991.

Karp, Ivan and Steven Levine. *Exhibiting Cultures*. Washington, D.C.: Smithsonian Institution Press, 1991.

Kent, Henry Watson. *Drawings and Measurements of Furniture Used by the Museum*. New York: Metropolitan Museum of Art, 1923.

———. "The Museum and Industrial Art." In *Art in Industry*, ed. Charles R. Richards. New York: Macmillan Company, 1922.

———. *The Walpole Society: A Tribute to Its Founders and Original Members, and Other Walpoleans of Their Time*. Boston: Walpole Society, 1948.

———. "The Walpole Society, 1910–1935: A Quarter Century in American Collecting." In *The Walpole Society: A Tribute to Its Founders and Original Members*. Boston: Walpole Society, 1948.

———. *What I Am Pleased to Call My Education*. New York: Grolier Club, 1949.

Kent, Henry Watson and Florence N. Levy. *The Hudson-Fulton Exhibition, Catalogue of an Exhibition of American Paintings, Furniture, Silver, and Other Objects of Art, 1625–1825*. New York: Metropolitan Museum of Art, 1909.

Kingdon, Frank. *John Cotton Dana: A Life*. Newark, N.J.: Public Library and Museum, 1940.

Klein, Rachel Naomi. "Art Authenticity in Antebellum New York City: The Rise and Fall of the American Art-Union." *Journal of American History* 81, no. 4 (March 1995): 1534–61.

———. "Art Museums and Public Life in Historical Perspective." *Intellectual History Newsletter* 23 (2001): 35–43.

Klaus, Susan. *A Modern Arcadia: Frederic Law Olmsted, Jr. and the Plan for Forest Hills Gardens*. Amherst: University of Massachusetts Press, 2002.

Kennedy, David. *Over Here: The First World War and American Democracy*. New York: Oxford University Press, 1980.

Kenny, Peter. "R. T. H. Halsey: American Wing Founder and Champion of Duncan Phyfe." *Magazine Antiques* 157 (January 2000): 186–91.

Kloppenberg, James T. *Uncertain Victory: Social Democracy and Progressivism in European and American Thought, 1870–1920*. New York: Oxford University Press, 1986.

Kriegel, Lara "After the Exhibitionary Complex: Museum Histories and the Future of the Victorian Past." *Victorian Studies* (Summer 2006): 681–704;

———. *Grand Designs: Labor, Empire, and the Museum in Victorian Culture*. Durham, N.C.: Duke University Press, 2007.

Kulik, Gary. "Designing the Past: History-Museum Exhibitions from Peale to the Present." In *History of Museums in the United States*, ed. Warren Leon and Roy Rosenzweig. Urbana: University of Illinois Press, 1989.

Laidlaw, Christine Wallace. "The Metropolitan Museum of Art and Modern Design: 1917–1929." *Journal of Decorative and Propaganda Arts* 8 (Spring 1988): 88–103.

Lasch, Christopher. *The New Radicalism in America*. New York: W. W. Norton & Company, 1965.

Leach, William. *Land of Desire: Merchants, Power, and the Rise of a New American Culture*. New York: Vintage Books, 1993.

Lears, T. J. Jackson. *Fables of Abundance: A Cultural History of Advertising in America*. New York: Basic Books, 1994.

———. *No Place of Grace: Antimodernism and the Transformation of American Culture, 1880–1920*. Chicago: University of Chicago Press, 1981.

Leon, Warren and Roy Rosenzweig. *History of Museums in the United States*. Urbana: University of Illinois Press, 1989.

Lerman, Leo. *The Museum: One Hundred Years and the Metropolitan Museum of Art*. New York: Viking Press, 1969.

Levine, Lawrence. *Highbrow Lowbrow: The Emergence of Cultural Hierarchy in America*. Cambridge, Mass.: Harvard University Press, 1988.

Lincoln, Charles Z., ed. *State of New York, Messages from the Governors*. Vol. 10. Albany: J. B. Lyon Company, State Publishers, 1909.

Livingston, Karen and Linda Perry, eds. *International Arts and Crafts*. London: V&A Publications, 2005.

Leuchtenburg, William. *The Perils of Prosperity*. Chicago: University of Chicago Press, 1958.

Lindgren, James M. "'A Spirit That Fires the Imagination': Historic Preservation and Cultural Regeneration in Virginia and New England, 1850–1950." In *Giving Preservation a History*, ed. Max Page and Randall Mason. New York: Routledge, 2004.

———. *Preserving Historic New England: Preservation, Progressivism, and the Remaking of Memory*. New York: Oxford University Press, 1995.

Lockwood, Luke Vincent. *Colonial Furniture in America*. New York: Charles Scribner's Sons, 1901; reprint, New York: Castle Books, 1926.

Lowenthal, David. *The Past is a Foreign Country*. New York: Cambridge University Press, 1985.

Lubove, Roy. *The Progressives and the Slums: Tenement House Reform in New York City, 1890–1917*. Pittsburgh: University of Pittsburgh Press, 1962.

Lukes, Timothy. *Shows of Force: Power, Politics, and Ideology in Art Exhibitions*. Durham, N.C.: Duke University Press, 1992.

Lyon, Irving. *Colonial Furniture in New England*. Boston: Houghton Mifflin, 1891.

Martin, Paul. *Popular Collecting and the Everyday Self: The Reinvention of Museums*. London: Leicester University Press, 1999.

Mason, Randall Frambes. "Historic Preservation, Public Memory, and the Making of Modern New York City." In *Giving Preservation a History: Histories of Historic Preservation in the United States*, ed. Max Page and Randall Mason. New York: Routledge, 2004.

———. "Memory Infrastructure: Preservation, 'Improvement' and Landscape in New York City, 1898–1925." Ph.D. diss., Columbia University, 1999.

Mattson, Kevin. "The Librarian as Secular Minister to Democracy: The Life and Ideas of John Cotton Dana." *Libraries & Culture* 35, no. 4 (Fall 2000).

May, Henry F. *The End of American Innocence: A Study of Our Own Time, 1912–1917.* New York: Knopf, 1959; reprint, New York: Columbia University Press, 1992.

Menand, Louis. *The Metaphysical Club.* New York: Farrar, Straus & Giroux, 2001.

Miller, Lillian B. *Patrons and Patriotism: The Encouragement of the Fine Arts in the United States, 1790–1860.* Chicago: University of Chicago Press, 1966.

MacCarthy, Fiona. *William Morris: A Life in Our Time.* New York: Alfred A. Knopf, 1995.

McCarthy, Kathleen. "Creating the American Athens: Cities, Cultural Institutions and the Arts, 1840–1930." *American Quarterly* 37, no. 3 (1985): 426–39.

McFarland, Gerald. *Inside Greenwich Village: A New York City Neighborhood, 1898–1918.* Amherst: University of Massachusetts Press, 2001.

McGerr, Michael. *A Fierce Discontent.* New York: Free Press, 2003.

Monkhouse, Christopher. "Cabinetmakers and Collectors: Colonial Furniture and Its Revival in Rhode Island." In *American Furniture in Pendleton House*, ed. Christopher Monkhouse and Thomas Michie. Providence: Museum of Art, RISD, 1986.

Monkhouse, Christopher P. and Thomas S. Michie. *American Furniture in Pendleton House.* Providence: Museum of Art, RISD, 1986.

Montgomery, David. *Fall of the House of Labor: The Workplace, the State, and American Labor Radicalism, 1865–1925.* Paris: Cambridge University Press, 1987.

Morgan, Francesca Constance. "'Home and Country:' Women, Nation, and the Daughters of the American Revolution, 1890–1939." Ph.D. diss., Columbia University, 1998.

Mumford, Lewis. *The Culture of Cities.* New York: Harcourt Brace & Co., 1938; reprint, Westport, Conn.: Greenwood Press, 1970.

Murphy, Kevin D. "The Politics of Preservation." In *A Noble and Dignified Stream*, ed. Sarah L. Giffen and Kevin Murphy. York, Maine: Old York Historical Society, 1992.

Museum Studies in Material Culture. Washington, D.C.: Smithsonian Institute Press, 1991.

Nelson, James. *Publisher to the Decadents: Leonard Smithers in the Careers of Beardsley, Wilde, Dowson.* University Park: Pennsylvania State University Press, 2000.

Novick, Peter. *That Noble Dream: The "Objectivity Question" and the American Historical Profession.* Cambridge: Cambridge University Press, 1988.

Page, Max. *The Creative Destruction of Manhattan.* Chicago: University of Chicago Press, 1999.

Page, Max and Randall Mason, eds. *Giving Preservation a History: Histories of Historic Preservation in the United States.* New York: Routledge, 2004.

Pearce, Susan and Alexandra Bounia, eds. *The Collector's Voice: Critical Readings in the Practice of Collecting.* Burlington, Vt.: Ashgate, 2000.

Peck, Amelia, et al., eds. *Period Rooms in the Metropolitan Museum of Art.* New York: Metropolitan Museum of Art, 1996.

Penniston, William A., ed. *The New Museum: Selected Writings by John Cotton Dana.* Newark, N.J.: Newark Museum Association, 1999.

Pennoyer, Peter and Anne Walker. *The Architecture of Grosvenor Atterbury.* New York: W. W. Norton & Co., 2009.

Pevsner, Nikolaus. *Pioneers of Modern Design, from William Morris to Walter Gropius.* London: Penguin Books, 1975.

Pilgrim, Diane. "Inherited from the Past: The American Period Rooms." *American Art Journal* 10, no. 3 (May 1978): 4–23.

Pommerehne, Werner W. and Lars D. Feld. "The Impact of Museum Purchase on the Auction Prices of Paintings." *Journal of Cultural Economics* 21 (1997): 249–71.

Prown, Jules. "Material Culture: Can the Farmer and the Cowman Still be Friends?" In *Learning from Things: Method and Theory of Material Culture Studies*, ed. W. David Kingery. Washington, D.C.: Smithsonian Institution Press, 1996.

———. "Mind in Matter: An Introduction to Material Culture Theory." In *Interpreting Objects and Collections*, ed. Susan Pearce. London: Routledge, 1994.

Recchiuti, John. *Civic Engagement.* Philadelphia: University of Pennsylvania Press, 2007.

Report of the Commission Appointed by the Secretary of Commerce to Visit and Report Upon the International Exposition of Modern Decorative and Industrial Art in Paris, 1925. Washington, D.C.: U.S. Department of Commerce, 1926.

Robertson, Cheryl. "House and Home in the Arts and Crafts Era: Reform for Simple Living." In *"The Art that is Life": The Arts and Crafts Movement in America, 1875–1920*, ed. Wendy Kaplan. Boston: Little, Brown and Company and the Museum of Fine Arts, Boston, 1987.

Robey, Ethan. "The Utility of Art: Mechanics' Institute Fairs in New York City, 1828–1876." Ph.D. diss., Columbia University, 2000.

Rodgers, Daniel T. *Atlantic Crossings: Social Politics in a Progressive Age.* Cambridge, Mass.: Belknap Press of Harvard University Press, 1998.

Rosenzweig, Roy and Elizabeth Blackmar. *The Park and the People.* Ithaca, N.Y.: Cornell University Press, 1992.

Ross, Dorothy. *Modernist Impulses in the Human Sciences, 1870–1930.* Baltimore: Johns Hopkins University Press, 1994.

Ross, Dorothy. "Modernism Reconsidered." In *Modernist Impulses in the Human Sciences, 1870–1930*, ed. Dorothy Ross. Baltimore: Johns Hopkins University Press, 1994.

Rudolph, Frederick. *The American College and University.* New York: Knopf, 1962; reprint, Athens: University of Georgia Press, 1990.

Saab, Joan A. *For the Millions: American Art and Culture Between the Wars.* Philadelphia: University of Pennsylvania Press, 2004.

Singleton, Esther. *The Furniture of Our Forefathers.* New York: Doubleday, 1906.

Saunders, Richard H. "American Decorative Arts Collecting in New England, 1840–1920." Master's thesis, University of Delaware, 1973.

Schlereth, Thomas. *Cultural History and Material Culture: Everyday Life, Landscape, Museums*. Charlottesville: University Press of Virginia, 1990.

———. "Material Culture and North American History." In *Museum Studies in Material Culture*, ed. Susan Pearce. Washington, D.C.: Smithsonian Institution Press, 1991.

Seale, William. *Recreating the Historic House Interior*. Nashville, Tenn.: American Association for State and Local History, 1979.

Sheehan, James. *Museums and the German Art World: From the End of the Old Regime to the Rise of Modernism*. New York: Oxford University Press, 2000.

Showalter, Elaine. *Sexual Anarchy: Gender and Culture at the Fin de Siècle*. New York: Viking, 1990.

Silverman, Willa. *The New Bibliopolis: French Book Collectors and the Culture of Print, 1880-1914*. Toronto: University of Toronto Press, 2008.

Sox, David. *Bachelors of Art: Edward Perry & the Lewes House Brotherhood*. London: Fourth Estate, 1991.

Shand-Tucci, Douglass. *Boston Bohemia, 1881-1900*. Amherst: University of Massachusetts Press, 1995.

Shi, David. *The Simple Life: Plain Living and High Thinking in American Culture*. New York: Oxford University Press, 1985.

Shiffrar, Genevieve Ruth. "'Its Future Beyond Prophecy . . . The City of New Jersey, Worthy Sister of New York': John Cotton Dana's Vision for the Newark Museum, 1909-1929." Ph.D. diss., University of Arizona, 1994.

Smith, Charles Saumerez. "Museums, Artifacts, and Meanings." In *The New Museology*, ed. Peter Vergo. London: Reaktion Books, 1989.

Stage, Sarah. "Ellen Richards and the Social Significance of the Home Economics Movement." In *Rethinking Home Economics: Women and the History of a Profession*, ed. Sarah Stage and Virginia B. Vincenti. Ithaca, N.Y.: Cornell University Press, 1997.

Stage, Sarah and Virginia B. Vincenti. *Rethinking Home Economics: Women and the History of a Profession*. Ithaca, N.Y.: Cornell University Press, 1997.

Stange, Maren. *Symbols of Life: Social Documentary Photography in America, 1890-1950*. Cambridge: Cambridge University Press, 1989.

Stansell, Christine. *American Moderns*. New York: Metropolitan Books, 2000.

Stein, Roger. "Artifact as Ideology: The Aesthetic Movement in Its American Cultural Context." In *In Pursuit of Beauty: Americans and the Aesthetic Movement,* ed. Doreen Bolger Burke. New York: Metropolitan Museum of Art, 1986.

Stillinger, Elizabeth. *The Antiquers*. New York: Alfred A. Knopf, 1980.

Stokes, I. N. Phelps. *Random Recollections of a Happy Life*. New York: privately printed, 1932; reprint, 1941.

Strouse, Jean. *Morgan: American Financier*. New York: Random House, 1999.

Susman, Warren. *Culture as History: The Transformation of American Society in the Twentieth Century*. New York: Pantheon, 1984.

Taylor, Brandon. *Art for the Nation: Exhibitions and the London Public, 1747-2001*. New Brunswick, N.J.: Rutgers University Press, 1999.

Tentative Report of the Committee on Home Furnishing and Decoration. Washington, D.C.: President's Conference on Home Building, 1931.

Thompson, E. P. *William Morris: Romantic to Revolutionary.* New York: Pantheon Books, 1977.

Throntveit, Trygve. "The Will to Behold: Thorstein Veblen's Pragmatic Aesthetics." *Modern Intellectual History* 5, no. 3 (2008): 519–46.

Tomkins, Calvin. *Masters and Masterpieces: The Story of the Metropolitan Museum of Art.* New York: E. P. Dutton, 1970.

Ulrich, Laurel Thatcher. *The Age of Homespun: Objects and Stories in the Creation of an American Myth.* New York: Vintage, 2001.

Upton, Dell. "Inventing the Metropolis: Civilization and Urbanity." In *Art and the Empire City: New York, 1825–1861*, ed. Catherine Hoover Voorsanger and John Howat. New York: Metropolitan Museum of Art Press, 2000.

Veblen, Thorstein. *The Theory of the Leisure Class: An Economic Study in the Evolution of Institutions.* New York: Macmillan, 1912.

Vergo, Peter. *The New Museology.* London: Reaktion Books, 1989.

Voorsanger, Catherine Hoover. "'Gorgeous Articles of Furniture:' Cabinetmaking in the Empire City." In *Art and the Empire City*, ed. Voorsanger and Howat. New York: Metropolitan Museum of Art Press, 2000.

Voorsanger, Catherine Hoover and John Howat, eds. *Art and the Empire City: New York, 1825–1861.* New York: Metropolitan Museum of Art Press, 2000.

Wallach, Alan. *Exhibiting Contradiction: Essays on the Art Museum in the United States.* Amherst: University of Massachusetts Press, 1998.

Wallace, Mike. *Mickey Mouse History.* Philadelphia: Temple University Press, 1996.

———. "Visiting the Past: History Museums in the United States." In *Presenting the Past: Essays on History and the Public*, ed. Susan Porter Benson, Stephen Brier, and Roy Rosenzweig. Philadelphia: Temple University Press, 1986.

Wallace Nutting General Catalogue: Supreme Edition. Framingham, Mass.: Wallace Nutting, 1930; reprint, Eaton, Pa.: Schiffer Limited, 1977.

Ware, Caroline. *Greenwich Village, 1920–1930.* Boston: Houghton Mifflin Co., 1935; reprint, Berkeley: University of California Press, 1994.

West, Patricia. *Domesticating History: The Political Origins of America's House Museums.* Washington, D.C.: Smithsonian Institution Press, 1999.

Weyeneth, Robert. "Ancestral Architecture: The Early Preservation Movement in Charleston." In *Giving Preservation a History*, ed. Max Page and Randall Mason. New York: Routledge, 2004.

Wharton, Edith. *Custom of the Country.* 1906; reprint, New York: Barnes & Noble, 2000.

———. *House of Mirth.* 1905; reprint, New York: W. W. Norton & Co., 1990.

Wharton, Edith and Ogden Codman, *The Decoration of Houses.* 1897; reprint, New York: W. W. Norton & Company, 1997.

Wheeler, Candace. *Principles of Home Decoration, with Practical Examples.* New York: Doubleday, Page & Company, 1908.

Wiebe, Robert H. *The Search for Order, 1877–1920*. New York: Hill and Wang, 1967.

Wilentz, Sean. *Chants Democratic: New York City and the Rise of the American Working Class, 1788–1850*. New York: Oxford University Press, 1984.

Wilson, Richard Guy. "Architecture, Landscape, and City Planning." In *The American Renaissance: 1876–1917*. New York: Brooklyn Museum, 1979.

———. "American Arts and Crafts Architecture: Radical though Dedicated to the Conservative Cause." In *"The Art that is Life": The Arts & Crafts Movement in America, 1875–1920*, ed. Wendy Kaplan. Boston: Little, Brown & Co. and the Museum of Fine Arts, Boston, 1987.

Westbrook, Robert. *John Dewey and American Democracy*. Ithaca, N.Y.: Cornell University Press, 1991.

Whitehill, Walter Muir *Museum of Fine Arts Boston: A Centennial History*. Cambridge, Mass.: Belknap Press, 1970.

INDEX

ACKNOWLEDGMENTS

This book could not have been written without the help of many individuals. In particular, I want to thank Betsy Blackmar. Betsy's generosity, careful reading, and incisive comments sharpened my ideas, refined my writing, and strengthened this project. I am also grateful to Casey Blake for both his commitment to my research and his constructive suggestions for integrating it into the larger intellectual culture of the early twentieth century. Richard Bushman's insightful comments have also been invaluable. I would like to thank Hilary Ballon and Randall Mason for providing thoughtful suggestions, as well as Lisa Tierston and Nan Rothschild for their helpful comments during the early stages of my research.

I am also indebted to friends and colleagues for their humor and generosity and for their critical engagement with my work. They have helped me clarify my ideas and more confidently stake my claims. I am grateful to many people, but I want to call out Reiko Hillyer, Jennifer Fronc, Monica Gislofi, Jung Pak, Jim Downs, and Kim Phillips-Fein. Cindy Lobel, Delia Mellis, and Peter Vellon provided camaraderie, laughter, and persistent deadlines. I have also benefited from the careful reading and helpful suggestions of several writing groups: I am grateful to Jonathan Soffer and Jennifer Morgan for providing the opportunity to present my work to fellow historians, and I thank in particular Lara Vapnek, Anne Kornhauser, Nick Bloom, and Dan Katz. I also thank Jennifer Stampe, Haidy Geismar, Miriam Basilio, and Bruce Altshuler for their invaluable suggestions from disciplinary perspectives beyond history. Lastly, I am grateful for the enduring friendship of the folks who have been there from the beginning of this project: Maurita Mondanaro, Liz Greenberg, Stephanie Ovide, Michelle Tollini, and Albina De Meio.

I could not have completed this book without the expertise and patient assistance of many archivists and librarians. At the Metropolitan Museum, I thank Jim Moske and Barbara File in the museum archives and Julie Zeftel in the image library. I am also grateful to William Penniston and Jeffrey Moy

at the Newark Museum, Vivian Zoe at the Slater Museum, Michelle Plourde-Barker at the Springfield Museum (Massachusetts), Judith Strom at the Archives of American Art, Julie Tozer at the Avery Architecture and Fine Arts Library, and Steven Wheeler at the New York Stock Exchange. I also thank the many librarians and archivists at Columbia University's Rare Book and Manuscript Library, the New York Public Library, the Brooklyn Museum, and the New-York Historical Society. The Winterthur Museum provided a fellowship to use their collections, and I thank its curators, staff, and librarians for their generosity. I have also benefited from the wisdom and assistance of museum curators at the Metropolitan Museum of Art and the Museum of Fine Arts in Boston, especially Peter Kenny and Dennis Carr.

Bob Lockhart, my editor at the University of Pennsylvania Press, has provided encouragement, patience, and kind professional engagement at every level. His careful reading of my manuscript helped me refine my arguments and clarify my writing. Once again, I am grateful to Casey Blake for his continued support of my project. I also thank Steven Conn and Joan Saab for reading my manuscript and providing thoughtful suggestions and challenging questions.

Finally, I thank Frederic Viguier for being there through it all. Frederic has helped me build a home base from which we can both work, live, and play—his intellectual engagement with my work and his real-world support have made this book possible. Thank you.